T0228219

EXTRAORDINARY AESTHETES:
DECADENTS, NEW WOMEN,
AND FIN-DE-SIÈCLE CULTURE

THE UCLA CLARK MEMORIAL LIBRARY SERIES

EXTRAORDINARY AESTHETES

DECADENTS, NEW WOMEN, AND FIN-DE-SIÈCLE CULTURE

Edited by Joseph Bristow

Published by the University of Toronto Press in association with the UCLA Center for Seventeenth- and Eighteenth-Century Studies and the William Andrews Clark Memorial Library

© The Regents of the University of California 2023
Toronto Buffalo London
utorontopress.com

ISBN 978-1-4875-4608-3 (cloth) ISBN 978-1-4875-4609-0 (EPUB)
 ISBN 978-1-4875-4610-6 (PDF)

Library and Archives Canada Cataloguing in Publication

Title: Extraordinary aesthetes : decadents, new women,
and fin-de-siècle culture / edited by Joseph Bristow.
Names: Bristow, Joseph, editor.
Series: UCLA Clark Memorial Library series.
Description: Series statement: UCLA Clark Memorial Library series |
Includes bibliographical references and index.
Identifiers: Canadiana (print) 20220479526 |
Canadiana (ebook) 20220479577 | ISBN 9781487546083 (hardcover) |
ISBN 9781487546090 (EPUB) | ISBN 9781487546106 (PDF)
Subjects: LCSH: Aesthetic movement (Art) – Great Britain. |
LCSH: Aestheticism (Literature) | LCSH: Decadence (Literary movement) –
Great Britain. | LCSH: Women artists – Great Britain – History –
19th century. | LCSH: Women artists – Great Britain – History – 20th century. |
LCSH: Women authors, English – 19th century. | LCSH: Women authors,
English – 20th century. | LCSH: Women authors, Irish – 19th century. |
LCSH: Women authors, Irish – 20th century. | LCSH: Women authors,
Scottish – 19th century. | LCSH: Women authors, Scottish – 20th century.
Classification: LCC N6767.5.A3 E98 2023 | DDC 701/.170941 – dc23

We wish to acknowledge the land on which the University of Toronto
Press operates. This land is the traditional territory of the Wendat, the
Anishnaabeg, the Haudenosaunee, the Métis, and the Mississaugas of
the Credit First Nation.

This book has been published with the help of a grant from the UCLA
Center for Seventeenth- and Eighteenth-Century Studies.

University of Toronto Press acknowledges the financial support of
the Government of Canada, the Canada Council for the Arts, and
the Ontario Arts Council, an agency of the Government of Ontario,
for its publishing activities.

Contents

Illustrations

Acknowledgments

Extraordinary Aesthetes: Decadents, New Women, and Fin-de-Siècle Culture has its distant origins in a National Endowment for the Humanities summer seminar titled "The Decadent 1890s: English Literary Culture and the Fin de Siècle," which I had the privilege of directing at the William Andrews Clark Memorial Library, University of California, Los Angeles, from 22 June to 24 July 2009. The seminar was followed by a two-day conference, "The Decadent 1890s" (19–20 November 2010), which was also kindly hosted at the Clark Library. My thanks go to the participants in both the seminar and the conference: Kasey Bass; S. Brooke Cameron; Tracy J.R. Collins; Marc di Paolo; Lisa Hager; Emily Harrington; Simon Joyce; Kate Krueger; Megan Becker-Leckrone; Kristin Mahoney; Diana Maltz; Beth Newman; So Young Park; Julie Townsend; and Julie M. Wise. Our visiting scholarly experts, Margaret D. Stetz and Mark Samuel Lasner, enriched our understanding of this vibrant period of literary and cultural history. At NEH, Rebecca Boggs provided much-appreciated advice on the seminar program. At the Clark Library, our seminar and our conference benefited from the exceptional support of several colleagues: Jennifer Bastian; Chris Bulock; Rebecca Fenning Marschall; Carol Sommer; Suzanne Tatian; and Alastair Thorne. We are particularly grateful to Bruce Whiteman, who was Clark Librarian at the time, for the warm welcome that he gave to everyone involved in both of these activities. At the Center for 17th- and 18th-Century Studies, which oversees all of the public programming at the Clark Library, Peter H. Reill, former director of the Center and the Clark, generously made resources available to host both the seminar and the conference. The Center's staff members, especially Elizabeth Landaw, Kathy Sanchez, and Candis Snoddy, ensured that the arrangements for these two events ran as smoothly as possible.

My gratitude also goes to Helen Deutsch, former director of the Center (2017–20), and Bronwen Wilson, current director, for their concerted support and encouragement toward this project. Two former graduate students gave much-appreciated practical assistance to "The Decadent 1890s." I express my gratitude to Justine Pizzo and Daniel P. Williford, who served as research assistants during the seminar.

During the past decade, my understanding of fin-de-siècle literary culture has been greatly enriched through the opportunity to advise several former UCLA doctoral candidates, especially Anthony Camara, Ronjaunee Chatterjee, Dustin Friedman, Amanda Hollander, Crescent Rainwater, Lindsay Puawehiwa Wilhelm, and Amy Ruei Wong. I am particularly grateful to Mack Gregg for checking a page reference in a rare volume held at the British Library. Rebecca N. Mitchell kindly copied a special "Eights Week" issue of the *Oxford Magazine*, which appeared on 18 May 1893. My colleague Kristopher Kersey provided guidance on matters relating to *ukiyo-e*. Neil Hultgren's paper on John Davidson's *Earl Lavender* (1895) at UCLA's QGrad conference on 9 October 2009 inspired a section in the introduction. My graduate students in English 252 (Aestheticism and Decadence) during spring 2021 shared invaluable insights into W.B. Yeats's early poetry. Diana Maltz kindly read and commented on a working draft of the detailed introduction to the present volume. The two external readers provided invaluable observations and suggestions that have strengthened *Extraordinary Aesthetes* as a whole. Do Mi Stauber prepared the detailed index.

We wish to acknowledge several copyright holders and literary executors for granting permission to reproduce materials in this volume. In chapter 8, all quotations from the Mary Coleridge archive here appear by kind permission of the Provost and Fellows of Eton College. A short version of chapter 4 appeared as "Alice Meynell, Walter Pater, and Aestheticist Temporality," *Victorian Studies* 53, no. 3 (2011): 495–505. We thank Indiana University Press for permission to reprint portions of that essay here. Parts of chapter 10 appeared in an ealier version in Kristin Mahoney, *Literature and the Politics of Post-Victorian Decadence* (Cambridge University Press, 2015); it is reproduced by permission.

Figure 0.1 appears by kind permission of Tate Britain. Figures 0.2–0.10, 3.1–3.8, and 3.10–3.16 are reproduced by kind permission from Mark Samuels Lasner Collection, University of Delaware Library, Museums and Press. Figure 0.7 is © Estate of Max Beerbohm and is reproduced by kind permission of Berlin Associates. Figures 6.1–6.9 are held

at the William Andrews Clark Memorial Library, University of California, Los Angeles, are © Estate of Max Beerbohm, and are reproduced by kind permission of Berlin Associates. Figures 1.1, 1.2, and 1.5 are reproduced by kind permission of the Victoria & Albert Museum, London. Figure 1.3 is reproduced by kind permission of the J. Paul Getty Museum, Los Angeles. Figure 1.6 is reproduced by kind permission of Alamy Stock Photo. Figures 1.7 and 1.8 are © The Metropolitan Museum of Art and are reproduced by kind permission of Art resource. Figure 1.9 is reproduced by kind permission of the Philadelphia Museum of Art. Figure 3.9 is reproduced by kind permission of the Southern Regional Library Facility, University of California. Figures 7.1, 7.2, and 7.3a and 7.3b are reproduced by kind permission of the William Andrews Clark Memorial Library, University of California, Los Angeles. Figure 9.1 is reproduced by kind permission of So Young Park. Figure 10.1 is from Joseph Bristow's private collection, is © Estate of Max Beerbohm, and is reproduced by kind permission of Berlin Associates.

Scott Jacobs at the Clark Library (UCLA) and Marissa Kings at the Charles E. Young Research Library (UCLA) kindly assisted with several reprographic orders. Sandra Farfan-Gracia, Interlibrary Borrowing Lead, at UCLA's Young Research Library, assisted in supplying one of the figures. In the UCLA English Department, the business manager, Melinda Huang, and her assistant, Christian Salazar, were unfailing in their efforts to clear permissions and process payments for a large number of the figures. Megan Becker-Leckrone, at the University of Nevada, Las Vegas, kindly arranged for the transfer of substantial funds to cover some of the permissions fees. Mark Samuels Lasner offered generous assistance in providing image files of a large number of materials held in the Mark Samuels Lasner Collection, University of Delaware Library, Museums and Press.

Finally, I wish to emphasize my appreciation of the contributors for their support and patience during the long period that it took to finalize the contents of this volume. The result is the product of considerable collaboration that has kept us in much-appreciated critical dialogue with one another for more than decade.

J.E.B.
Los Angeles

EXTRAORDINARY AESTHETES

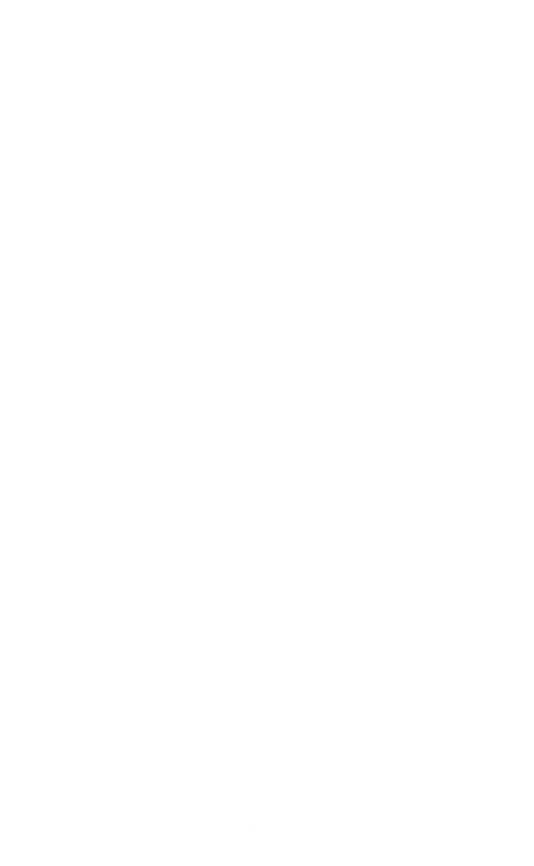

Introduction

JOSEPH BRISTOW

Extraordinary Aesthetes: Decadents, New Women, and Fin-de-Siècle Culture sheds fresh critical light on a range of remarkable English and Irish literary and visual artists whose careers in poetry, fiction, and illustration flourished during the concluding years of the nineteenth century. The fin de siècle, as we see here, marked not only the end of the Victorian epoch but also significant turns towards modernism. Each of the ten chapters in this book illuminates a range of established and increasingly acknowledged yet lesser-known figures, ones whose contributions to this brief but remarkably intense cultural period warrant close critical attention. These authors and illustrators include the immensely talented Amy Levy, who had completed three novels and as many collections of poetry by the time she took her life, aged twenty-seven, in 1889. By comparison, the accomplished Ella D'Arcy built an outstanding reputation as a fiction writer in the era's most notorious (and, in many respects, distinguished) journal, *The Yellow Book* (1894–7). The period also witnessed the rise of the exceptional Mabel Dearmer, whose stunning colour designs – particularly in Evelyn Sharp's books of children's radical fairy tales – have a visual impact like no other for their time. The studies that follow turn as well to the revered Catholic poet and essayist Alice Meynell, whose reputation as a formidable exponent of both the lyric and the essay form came to widespread notice with her 1893 volumes *Poems* and *The Rhythm of Life*. The concluding years of the nineteenth century drew plentiful attention (not all of it complimentary) to the works of Richard Le Gallienne, whose abundant poems, essays, reviews, and novels made his name, if not his personal dandyish style, synonymous with the age. Equally identified with the artistic 1890s is the long-lived satirist Max Beerbohm, whose witty satirical prose and unforgettable caricatures of

fin-de-siècle celebrities emerged when he was still a student at Oxford. Meanwhile, the adept socialist poet Dollie Radford wrote movingly about several connected matters in her life – including political comradeship, suburban existence, emotional intimacy, and women's labour, especially the care of children. By comparison, Mary E. Coleridge, who belonged to a close-knit group of women intellectuals, produced some of the most technically adroit, as well as sexually cryptic, poems of the age. In the same period, the poet and sculptor Dora Sigerson – who studied alongside W.B. Yeats at the Dublin School of Art – produced verses that became central to the Irish Literary Revival in an age campaigning for Home Rule. All of these artists and writers had ties to several of the decisive movements that left a deep impression on these years, whether in relation to urgent debates about the New Woman, the activities of the Rhymers' Club, the flourishing Celtic Revival, the risqué works of the Decadent Movement, or the growth of avant-garde magazines that included not only *The Yellow Book* but also *The Savoy* (1896). The contents of both of these short-lived periodicals had the power to shock conservative sensibilities. Moreover, as we can already tell, the larger proportion of the fin-de-siècle aesthetes discussed in the present volume are women: a constituency whose substantial contributions to the cultural advances of the time enjoy prominence in the chapters that follow.

Extraordinary Aesthetes both rebalances and broadens the scope of our critical insights into this dynamic cultural moment. The artists and writers discussed here were the direct descendants of the Aesthetic Movement that gained widespread attention in the mid-1860s, 1870s, and early 1880s. The aesthetes earned a sometime scandalous reputation for advocating art for art's sake in the face of puritanical moralizing. Such individuals included the agnostic and republican poet Algernon Charles Swinburne, whose insubordinate *Poems and Ballads* (1866) upheld the unabashed desires that he associated with the pagan Classical world. In "Hymn to Proserpine," for example, his speaker praises the fertility goddess associated with springtime rejuvenation. He laments her supersession at a crucial historical moment: the year 310 AD, when Emperor Constantine declared Christianity as the faith of Rome. "Wilt thou," Swinburne's poetic voice defiantly asks Jesus Christ, "take all, Galilean? But these thou shalt not take, / The laurel, the palms and the pæan, the breast of the nymphs in the brake."[1] Equally important was the aesthetic critic Walter Pater: a fellow of Brasenose College Oxford, whose path-breaking *Studies in the History of the Renaissance* (1873) turned to the French historian Jules Michelet's newly established term "Renaissance" in order to

identify a welcome "revival of classical antiquity in the fifteenth century," a revival that involved an "outbreak of the human spirit."[2] This shift, as Pater saw it, had its beginnings in the Middle Ages, and it led in turn to "an enlightening of the mind," one that cultivated a stimulating "care for physical beauty, the worship of the body."[3] In particular, Pater cherished the significance of experiencing "one's own impression" of art, in such a manner that one "need not trouble [oneself] with the abstract question of what beauty is in itself."[4] By far the best aesthetic experience for Pater emerged from the self's immersion in "the poetic passion, the desire of beauty, the love of art for its own sake."[5]

Such assertions, which resisted the moral imperatives of the day, had a profound impact on Oscar Wilde, who fashioned himself in his early career as a poetic heir to Swinburne and a critic devoted to Pater's teaching. In the late 1870s, Wilde came before the public as an iconic aesthete whose somewhat derivative poetry and florid declarations about the urgent need to celebrate beauty in modern culture made him the butt of jokes, along with some amusing caricatures. "Into the secure house of Beauty," Wilde told his audience members when lecturing on the Aesthetic Movement in New York City in January 1882, "the true artist will admit nothing that is harsh or disturbing, nothing gives pain, nothing that is debatable, nothing about which men argue."[6] As one can tell, Wilde upheld an idealistic perspective on the commanding role that art should play in society. This was a belief to which Wilde remained committed throughout his life, and it was one that inspired many of the fin-de-siècle artists and writers discussed in the present volume.

Before introducing the ten chapters in greater detail below, I explain why *Extraordinary Aesthetes* opens up several critical avenues, ones that extend and transform the most powerful observations that a noteworthy generation of critics made about the period not long after the *siècle* had reached its *fin*. During the early twentieth century, publishers issued a succession of significant monographs about the unforgettable artistic careers and controversies that rendered the 1890s so decidedly modern in character. In order to understand the scholarly advances that *Extraordinary Aesthetes* makes, it is important to acknowledge the leading observations these early inquiries established in their influential approaches to the era. The first of these studies was by W. Blaikie Murdoch, who reprinted a group of informative feature articles from the Scottish press in his *Renaissance of the Nineties* (1911). In his landmark book, Murdoch paid close attention to a cohort of mostly (though not exclusively) male artists.[7] The second such study was Holbrook Jackson's compendious *Eighteen Nineties:*

A Review of Art and Ideas at the Close of the Nineteenth Century (1913), which remains an important point of reference for any student of the decade. These two thoughtful accounts of fin-de-siècle culture reveal why the legacy of this transformative cultural moment continued to resonate in the early twentieth century. As *Extraordinary Aesthetes* demonstrates, Murdoch's and Jackson's respective perspectives on fin-de-siècle culture remain invaluable in our comprehension of the modernizing cultural shifts that occurred during the concluding years of Victoria's reign.

Here, the detailed discussion begins by following several of the significant leads that Murdoch and Jackson followed when considering the epoch, since their works identified many of the foundational male figures who shaped the literary culture of the time. Thereafter, the introduction turns to the distinctive ways in which the contributors to the present volume strengthen the ongoing reassessment of this vibrant age, especially with regard to art and writing by women, together with works by several men who at times have previously been placed in the margins of critical discussion.

Imagining the Renaissance of the 1890s: Arthur Symons, John Davidson, and W.B. Yeats

By drawing on the critical term "Renaissance," Murdoch demonstrates that the pivotal year 1890 marked the moment when several key fin-de-siècle male figures came of age. The male writers whose careers he emphasizes – Arthur Symons, John Davidson, and W.B. Yeats – merit attention, since their works help us identify certain artistic trends these young men helped shape and develop. Murdoch's *Renaissance of the Nineties* prepares the way for journeys of discovery into an epoch in which we can see a presiding creative impulse shared among aesthetes and Decadents to counterpoint cultural revivals with artistic modernizations.

To begin with, the writings of twenty-seven-year-old Arthur Symons – a Welsh-born writer of Cornish descent – underscore several developments not only in the practice of poetry but also in the modern theorization of the genre. His sexually unapologetic lyrics and his pivotal essay "The Decadent Movement in Literature" (1893), which appeared in the transatlantic *Harper's New Monthly Magazine*, came to define some of the more advanced theoretical stances that several of his peers also adopted. Murdoch is unstinting in his praise for this writer: "Mr. Symons is preeminently the subtle and delicate poet of his movement and period, if not the most subtle and delicate English poet since the Renaissance of

Wonder" – by which he means the English Romantics.[8] Even if some commentators found Symons's poetry "unwholesome" (Murdoch mentions the insult that a critic angled against the "faint smell of patchouli" in the verses), it remains the case that this author's imposing oeuvre demonstrates the "ability of conveying to the consciousness of the reader, abstract and elementary impressions."[9] The focus on conveying fundamental impressions becomes evident when we turn to Symons's oustanding second volume *Silhouettes* (1892, rev. 1896). Like many ground-breaking collections from the 1890s, this one appeared from Elkin Mathews and John Lane: the publishing partnership that brought attention to a fresh generation of poets – many of them linked with the fin-de-siècle avant-garde – who at times produced audacious departures both in poetic form and in literary decorum. Symons's collection assembles a range of striking lyrics that depict a man's experiences of intimacy with women, often in sensuous nighttime settings. Taken together, his succinct poems, as the title of the volume makes clear, evoke the haunting visible properties of the silhouette: a nineteenth-century technique in portraiture that involves outlining on black paper a human profile, and sometimes a whole body, by means of its crisply defined shadow.

Typical in this regard is "Pastel," a lyric of three tercets that constitute mostly three-beat lines, whose incomplete rhyme scheme (*abb cdd eff*) leaves key words at the end of the first, fourth, and seventh lines in haunting suspension. The title of Symons's poem acknowledges the renewed prominence that pastel paintings had recently enjoyed in Europe. Certainly, pastel was a long-established medium. As Thea Burns observes, "fabricated coloured pigment sticks ... were produced in great numbers and sold in sets in the later seventeenth century."[10] Still, pastel, even if used impressively by such noted artists as Rosalba Carriera and Leonardo da Vinci, seldom held the prestige attached to oils. Like several decisive developments in nineteenth-century art, the inventive engagement with pastel – whose powdery texture is well suited to capturing evanescent instants – owed much to its revival in France, where it proved central in the work of several eminent painters. Leading exponents included Mary Cassatt, Edgar Degas, and Claude Monet, all of whom were associated with French Impressionism. The growing commitment to the medium resulted in the formation of the Société de Pastellistes in 1885. In London, the shadowy attributes of the medium and its suitability for depicting natural tones caught the public eye through several widely noticed exhibitions. One such event was the display of the London-based American artist James McNeill Whistler's pastels of Venice in 1881. By comparison,

three hundred or so works by diverse painters were mounted at the fashionable Grosvenor Gallery both in 1888 and in 1889.

Symons's fine poem acknowledges this affiliation with French culture by noting that the stanzas date from 20 May 1890 and were composed in Paris: a city often associated, in the prejudiced British mind, with louche morals. Especially important, as we see in the opening lines, is the illumination that radiates from another modern item: "The light of our cigarettes / Went and came in the gloom."[11] By this period, cigarettes, which remain noticeably unrhymed here, were mass-produced consumables that proved increasingly popular with men across different social classes. The sight of a woman smoking, however, was a different matter. As Lady Colin Campbell observed in 1893, "many men are still absurdly shocked if they see a woman enjoying a cigarette."[12] In "Pastel," the very idea that both a man and a woman might together take pleasure in smoking therefore appears mildly transgressive. Once their cigarettes smoulder in the darkened room, the speaker not only glimpses the woman's hand through a sudden "flash, a glow"; he also catches sight of an item of glinting jewellery upon her finger ("a ring I know"). It remains uncertain whether the ring that flickers in the darkness signifies their marital union. Possibly, the ring gestures towards their adulterous activity or serves as a love token. But one thing is clear: the intimate "flash" and "glow" transmute into a more intense "flush / Ruddy and vague." The quickened rush of blood to the skin, which reddens the woman's complexion, leads the speaker's gaze to "the grace / ... of her lyric face." To be sure, the wording hints that these partners have just experienced joyful sexual tenderness. Still, no matter how we choose to imagine the unrhymed "flush," it stands as the climactic pastel in a poem that creates evocative connections between the woman's briefly glimpsed beauty, a fleeting lyric form, and a revived artistic medium known for conjuring images of moments that will soon dissolve.

A year after *Silhouettes* appeared, Symons published "The Decadent Movement in Literature," a pioneering essay that did much to link his own name and the reputations of many of his peers with a term that, at least for British readers, had previously been understood largely in relation to Montesquieu's *Considérations sur les causes de la grandeur des Romains et de leur décadence* (1734) and (under Montesquieu's influence) Edward Gibbon's *History of the Decline and Fall of the Roman Empire* (1776–89). In France, however, Decadence had by then gained attention through several articles the novelist Paul Bourget published in the

Nouvelle revue during the early 1880s. In his essay on Charles Baudelaire's legacy, Bourget (as Alex Murray has observed) identifies Decadence with the main characteristic that led to the decline of the "social machine" of Classical Rome; he also traces in modern writing a style that has "no future," in a manner that leads "to alterations of vocabulary, and subtleties of terminology."[13] Such art (again, so Murray contends) points to a new type of literature, one of immediate "dissipation": a term that at once evoked intemperate behaviour and the squandering of resources.[14] In Britain, critics were not slow to acknowledge the growing idea that avant-garde works of poetry and prose were engaging with a dissipation of both physical and universal energies. As the *Author* observed in 1891, there was by then "much talk" about the modern "*decadent*" writer who inhabited the period now called, in some circles, the "*fin de siècle*."[15] A largely French phenomenon, this type of Decadent author was thought to produce work that "reflects decay"; he was "always a literary voluptuary," one who "generally dabbles in psychology."[16]

Symons, however, promoted a very different concept from the decay associated with the collapse of Classical Rome and the experimental *poètes maudits* such as Stéphane Mallarmé, whose countercultural excesses or presumed outsider status had become iconic through an anthology the French poet Paul Verlaine edited in 1884. To be sure, Symons turned here to a largely French body of recent writings that included both Mallarmé's and Verlaine's poetry. Still, he elaborates that Decadent qualities for him signify not so much the decay of an ancient empire as a type of modern alienated consciousness that marks a decisive intellectual break with both Classical and Romantic aesthetic principles. As Symons points out, the Classical has long been regarded as "the supreme art – those qualities of perfect simplicity, perfect sanity, perfect proportion."[17] In laying out this definition, Symons extends the language Walter Pater uses in his influential essay "Romanticism" (1876), in which he observes the "charm ... of what is classical in art or literature" arises from "the absolute beauty of its form."[18] Not only that, but the Classical for Pater also possesses "the tranquil charm of familiarity."[19] Meanwhile, the "romantic character," in Pater's view, involves "the addition of strangeness to beauty" as well as what he styles as "curiosity": a desire, that is, for "new impressions, new pleasures."[20] As Symons also recognizes, the idea of the Romantic stands "as the old antithesis of the Classic."[21] This duality of Romantic and Classical had several nineteenth-century precedents, including G.W.F. Hegel's lectures on the fine arts, which he first delivered in the 1820s. (Pater counted among a small group of readers fluent

in German who brought Hegelian thinking to the attention of Oxford University in the 1870s, 1880s, and 1890s.)

In notable contrast to the distinction between the Classical and the Romantic, for Symons, Decadence – particularly as it manifests itself in the works of Mallarmé and Verlaine – presents an innovative third possibility that features those "qualities that mark the end of great periods."[22] Symons enlarges upon these characteristics as follows: "an intense self-consciousness, a restless curiosity in research, an over-subtilizing refinement upon refinement, a spiritual and moral perversity."[23] From this perspective, the idea of Decadence calls to mind a heightened critical awareness, a scholarly craving for unearthing knowledge, an obsession with finessing one's exquisite discoveries, and an absorption in whatever appears contrary, wilful, or rebellious. In this regard, Decadence dispenses with the different types of reverence that both the Classical and the Romantic conventionally paid to beauty.

Symons's account of literary Decadence, however, does more than just turn its back on these established traditions that appreciate, if in antithetical ways, the beautiful. In his view, this "newest moment in literature" can be viewed as "a new and beautiful and interesting disease."[24] His phrasing here is striking. Around the time Symons published his essay, there was an increase in the discovery of modern ailments, along with a growing awareness of their risks to public health. This was a period when doctors were studying sexual diseases such as syphilis and engaging in battles with epidemics of anthrax (caught from cattle), salmonella (from contaminated food), and rabies (from infected animals). This was an era in which advances in the nascent sciences of bacteriology and virology – driven by notable figures such as Joseph Lister, Robert Koch, and Louis Pasteur – alerted Victorian culture to what journalists referred to as the germ theory of disease. So it is not surprising that Symons links Decadence with *la névrose*: a form of neurological debility evident in modern French writing.[25] He maintains that this degenerate condition indicates a privileged "civilization grown over-luxurious, over-inquiring, too languid for the relief of action, too uncertain for any emphasis of opinion or in conduct."[26] As we can tell, Symons views Decadence as operating within a contradictory economy of excess and depletion. Its aesthetic impulses are at once ominously disproportionate and insufficiently robust. For this reason, he characterizes this literary movement as "but another form of the *maladie fin de siècle*."[27] The manifest styles of enervation he finds in his selection of end-of-the-century writings are symptoms of a far-reaching cultural sickness and decay afflicting the aesthetics of the age.

Only one English poet drew Symons's attention within his newly conjured Decadent Movement: William Ernest Henley, author of "In Hospital" (1875), a striking series of nine sonnets that address the poet's twenty-month treatment for tuberculosis, which involved having a leg amputated while he was in Joseph Lister's care at the Edinburgh Infirmary. "In Hospital" first appeared in Leslie Stephen's *Cornhill Magazine*, which had garnered a reputation for serializing high-quality fiction. The opening quatrain of "Before Operation," for example, vividly depicts the preparation of the speaker's body for a surgical procedure. "Behold me gruesome," the poetic voice declares, "waiting for the knife! / A little while, and at a leap I storm / The thick sweet mystery of chloroform, / The drunken dark, the little death-in-life."[28] To Symons, such lines, which describe slipping out of consciousness into a death-like state (a faintly orgiastic one – note the allusion to *le petit mort*), plainly evoke for him the mood of Decadence. Symons became acquainted with Henley's unapologetic account of his disability when the sonnets reappeared, with some revisions, in *A Book of Verses* (1888). Henley's collection, which was widely appreciated in the press, also contains several experimental poems in *vers libre* that address the poet's profound sense of incapacitation within the infirmary. Such works include "Nocturn," which glances at the London-based American painter James Abbott McNeill Whistler's widely noted application of the term to his night-time scenes of the metropolis.

Such a title also appealed to Symons. *Silhouettes* includes four brief "Nocturnes." But where Symons's male romantic voice evokes "the magical light" of "moonlight" that suffuses "the night-wind" sighing his "desire,"[29] Henley's modern free verse presents a convalescent who is subjected to a very different kind of nocturnal world:

At the barren heart of midnight,
When the shadow shuts and opens
As the loud flames pulse and flutter,
I can hear a cistern leaking.[30]

If any aesthetic experience is to be found in this cheerless universe, it lies in the "dripping, dropping" that repeats "in a rhythm, / Rough, unequal, half-melodious / Like the measure aped from nature / In the infancy of music."[31] Such lines show that the trickles from the water tank eerily pulsate with an uncouth, primordial, but nonetheless gripping prosody.

Symons perceives that such verses constitute a "poetry of Impressionism," a poetry that communicates "the note of a new personality, the

touch of a new method."[32] "The ache and throb of the body," he observes, "in its long nights on a tumbled bed, and as it lies on the operating-table," had "brought home to us" an understanding of "physical sensations" not to be found elsewhere in poetry.[33] As Jerome H. Buckley remarks, "Henley had no interest in understanding the peculiar connotation that Symons attached to the term 'Decadence.'"[34] Still, as Buckley adds, the "eulogy in general was too warm to despise."[35] Wilde, who socialized with Henley in the late 1880s, was almost equally impressed. In a review of *A Book of Verses*, Wilde was particularly struck by several lines in a rondeau: one of several *formes fixes* from fourteenth- and fifteenth-century French poetry that had become fashionable in Britain after Edmund Gosse published "A Plea for Certain Exotic Forms of Verse" (1877). Among these "exotic forms," Gosse notes, the rondeau, "a poem written in iambic verse of eight or ten syllables, and in thirteen lines ... seems as specially adapted to crystallise modern wit as the sonnet to enclose modern reflection."[36] Wilde had closely followed this growing interest in the ways that a rising generation of authors met the technical challenges posed by these otherwise forgotten and intricate poetic forms. As his lectures from the early 1880s suggest, Wilde was probably acquainted with the discussion about the modern appeal of these antique genres through Théodore de Banville's *Petit traité de la poésie française* (1872).

The lines from Henley's rondeau that stand out for Wilde give voice to a man who speculates on what it would mean to have unbounded power to create art of any kind, whether exquisite or disagreeable: "If I were king," Henley's voice asserts, "Art should aspire, yet ugliness be dear; / Beauty, the shaft, should speed with wit for feather, / And love, sweet love, should never fall to sere."[37] In Wilde's eyes, it remains clear that Henley is "seeking to find new methods of poetic expression"; the poet is an "artist ... who has not merely a delicate sense of beauty and a brilliant fantastic wit, but a real passion also for what is horrible, ugly, or grotesque."[38] This mixture of the exquisite and the hideous is most visible for Wilde in "Rhymes and Rhythms in Hospital," though he is averse to Henley's "constant rejection of rhyme," since Wilde contends that rhyme remains "one of the secrets of perfection."[39] If Wilde regrets Henley's emancipation from rhyme in some parts of *A Book of Verses*, he nonetheless is impressed by the poet's fascination with fresh pictorial techniques. Some of the verses, Wilde says, "are like bright, vivid pastels; others like charcoal drawings, with full blacks and murky whites; others like etchings with deeply-bitten lines and abrupt contrasts, and clever colour-suggestions."[40] In similar ways to their use of pastel, European artists had for

centuries worked in charcoal, whose particulate structure had made it somewhat resistant to sticking fast to paper. At the moment Wilde was writing, however, it had become common for artists to use fixatives that ensured that charcoal better adhered to the surface. Moreover, towards the end of the nineteenth century the monochromatic affordances of the medium proved especially suitable for night scenes, including ones featuring ghostly apparitions.

Since visual elements are so conspicuous in *A Book of Verses*, it is not surprising that another of Henley's poems, "Of a Toyokuni Colour-Print" (dedicated to "W. A."), catches Wilde's eye. The initials refer to the prominent collector William Anderson, whose imposing study *The Pictorial Arts of Japan* appeared in 1886, the year in which an impressive selection of *ukiyo-e* went on exhibition at the Burlington Fine Arts Club. Henley's poem on this Japanese art form belongs to a cluster of ballades: another fashionable *forme fixe*, one that brings together three eight-line stanzas (*ababbcbc*) and a four-line envoi (*bcbc*), in which the final *c* rhyme marks a refrain. Like the other fixed forms whose pronounced artificiality enjoyed a vogue in the 1880s, the ballade struck Gosse as "the most lordly and imposing of the forms commonly used in archaic French," especially by urban medieval writers such as François Villon.[41] Even though we cannot tell from the ballade the particular *ukiyo-e* the poet has in mind (there are dozens by Utagawa Tokoyuni I, II, and III from Anderson's immense collection in the British Museum), Henley – who wrote extensively on Japanese prints – revives the French form to consider how the print inspires a fantasy of having at one time inhabited the fantastic world of kabuki actors, samurai, and geisha associated with these artists. "Was I a Samurai renowned," the poetic voice wonders, "Two-sworded, fierce, immense of bow?"[42] He also muses whether in a former life he might have been a "histrion," "priest," or "porter." He has "forgotten clean" the precise memory, yet he still knows that at one time he adored his beloved "in old Japan."[43] In this slight Orientalist fantasy, his lover appears "flowing-gowned / And hugely sashed."[44] Certainly, the poem has no pretensions to seriousness. All the same, the synthesis of different cultural sensibilities – ones adopted from Villon's ballades, a Toyokuni woodblock print from 1800 or thereabouts, and a modern poetic world in London that engages with these previously unfamiliar forms – marks a cosmopolitan turn in fin-de-siècle art.

Wilde emphasizes that Henley's ballade possesses "fantastic charm."[45] The qualities that make the subject matter so charming become clear in Wilde's shrewd essay in dialogue, "The Decay of Lying" (1889, revised

1891 and 1894), in which the main speaker Vivian contends that Japanese art holds special appeal because it has no pretence to realism. "If," Vivian observes, "you set a picture by Hokusai, or Hokkei, or any of the great native painters, beside a real Japanese gentleman or lady, you will see that there is not the slightest resemblance between them."[46] "In fact," Vivian goes on to add, "the whole of Japan is an invention."[47] The same thought is present in Henley's ballade, since the highly constructed idea of Japan is assembled from standard elements – "rice fields," "Two cranes," a "blue canal," and a "bamboo bridge" – that reappear in the numerous images Anderson made available to the public.[48] Henley and Wilde are hardly unusual in demonstrating an interest in the movement that became known as *japonisme*. Here, Whistler's art provides a well-known point of comparison, one that dates from his early encounters with *ukiyo-e* through the painter Félix Bracquemond's collection in Paris. His *Nocturne Blue and Gold – Old Battersea Bridge* (c. 1872–5) (figure 0.1) absorbs and transmutes elements of such prints as Katsushika Hokusai's *Under the Mannen Bridge at Fukagawa* (c. 1830–2) and Utagawa Hiroshige's *Bamboo Yards, Kiyobashi Bridge* (12th Month, 1857). Whistler's muted urban scene, which in 1877 would appear alongside several of his other nocturnes at the Grosvenor Gallery, was – as Stefano Evangelista observes – one of several "formally accomplished works that ... revealed a deeper understanding and sympathy with Japan, even as he ostensibly depicted European cityscapes and fashionable interiors in Paris and London."[49]

Furthermore, Whistler's innovative techniques for depicting nighttime metropolitan scenes lent him, at least on one well-publicized occasion, considerable notoriety. In an infamous libel suit, Whistler took John Ruskin (the Slade Professor of Art at Oxford) to court for stating that the American artist had been "flinging a pot of paint in the public's face."[50] In his 1890 recollections of this and other controversies that had done so much to propel his reputation as an audacious artist, Whistler quotes one of the more absurd exchanges from the proceedings. When the painting was displayed in the courtroom, the judge Baron Huddlestone expressed his perplexity at what the artwork supposedly meant: "Which part of the picture is the bridge?"[51] The moment when those onlookers in court started to chuckle, the justice expressed his stern displeasure. "Do you say," he asked Whistler, "that this is a correct representation of Battersea Bridge?"[52] In the face of such frustrating questions, Whistler calmly responded by stating that it was not his intention to remain faithful to a correct depiction. "Are those figures on top of the bridge

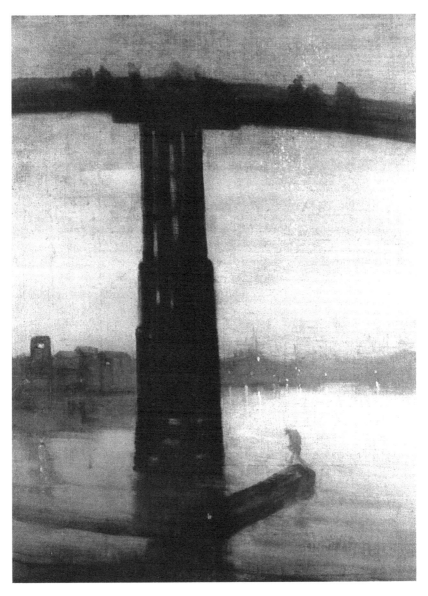

Figure 0.1 James McNeill Whistler, *Nocturne: Blue and Gold Battersea Bridge –
Old Battersea Bridge, c.* 1872–4. Oil paint on canvas. 68.3 × 51.2 cm.
(Reproduced by kind permission of Tate Britain. Photograph
from World History Archive / Alamy Stock Photo.)

intended for people?" the judge wished to know.[53] "They are," Whistler calmly replied, "just as you like."[54] The immense gap between Whistler's aesthetic (he declared that he sought "to bring about a certain harmony of colour") and Huddlestone's common-sense philistinism ("What is that gold-coloured mark on the right of the picture like a cascade?") tells us much about the difficulties that boldly progressive art encountered when it sought to redefine the boundaries of pictorial representation.[55] In such circumstances, it is perhaps unsurprising that, even after the jury found in Whistler's favour, the judge deemed that the damages should amount to just one farthing – the least valuable coin of the realm.

Murdoch's *Renaissance of the Nineties* provides a different route into the period when we look at the second of his figures who came of age during the fin de siècle. He held in high esteem the prolific John Davidson, whom several commentators concur ranks as the most significant Scottish poet to emerge between Walter Scott and Hugh MacDiarmid. Davidson turned thirty-three in 1890. Moreover, he had – after enduring many personal difficulties – taken his life just two years before Murdoch's study appeared. Even though little in Davidson's expansive oeuvre has found a firm place in the canon, his uneven exploits in poetry, drama, non-fiction, and narrative prose alert us to a characteristic 1890s repurposing of established literary genres for distinctly modern ends. In particular, Murdoch cherishes several spirited stanzas from one of Davidson's *Fleet Street Eclogues* – a title that mentions the thoroughfare associated with the national newspaper industry and points to the urban refashioning of the English pastoral colloquy developed, most famously, by Edmund Spenser in *The Shepheardes Calendar* (1579). Davidson, who belongs to a larger group of fin-de-siècle poets who address metropolitan experience, remains unique in his consistent focus on placing jobbing journalists and their reporting at the heart of the modern city. His male protagonists frequently bemoan, as Brian does in "New Year's Day," how they reap their humble earnings from a questionable profession. Such complaints, however, are voiced in highly articulate and decisive couplets:

> The trade that we ply with the pen,
> Unworthy of heroes and men,
> Assorts ever less with my humour:
> Mere tongues in the raiment of rumour,
> We review and report and invent:
> In drivel our virtue is spent.[56]

Still, even if the ungallant labours of such ordinary men involve telling tall tales in order to keep their industry going, it also the case that Brian – and his colleagues Basil and Sandy – inhabit an urban landscape that for them possesses a redeeming aesthetic. Murdoch maintains that the following quatrain by Basil, with alternating rhymes, counts among "some of the best English poetry of the nineties":[57]

> From the muted tread of the feet
> And slackening wheels, I know
> The air is hung with snow,
> And carpeted the street.[58]

Davidson's responsiveness to a wintertime scene in London, where the snow creates a haunting stillness by whitening the otherwise grimy thoroughfares, demonstrates how the eclogue has undergone a remarkable transformation. In Davidson's hands, the pastoral form has displaced the springtides of Classical Arcady with the freezing centre of the British capital's newspaper industry. Then again, amid the slowdown the snowfall brings to the cold city, the urban landscape continues to exude a pulsating energy, albeit one connected with fabricating falsehoods and creating masses of waste: "They," Brian says of his fellow journalists who clamour on Fleet Street, "must live by a traffic of lies."[59] Meanwhile, "Newspapers flap o'er the land, / And darken the face of the sky."[60] Certainly, to Brian the murky world of newsprint, in which "No nightingale sings," suggests that "the end of the world [has] begun."[61] He remains adamant that the "News and scandals and lies" that come from a "A drop of printer's ink" result in brainwashing: "Who reads the daily press, / His soul's lost here and now."[62] By way of countering this belief, Basil captures the paradoxical vitality and devastation created by the human bodies that both thrive within and visibly despoil their contemporary environment: "Sweet rivers of living blood / Poured into an ocean of mud."[63] In the end, the hopeful Sandy persuades his pals that journalism, regardless of how deeply his profession remains entangled in distorting the truth, still has a purposeful role to play in supporting social justice, and it can so do in a somewhat chivalrous fashion. "We wear," he proclaims, "enchanted armour, / We wield enchanted swords. / To us the hour belongs; / Our daily victory is / O'er hydras, giant wrongs."[64] Sandy's optimism triumphs. The eclogue concludes with the trio toasting their profession with glasses of old-fashioned wassail (presented here as the Anglo-Saxon "wass hael"), which summons a joyful holiday spirit.[65] As this poem about the celebratory

New Year shows, Davidson's project was to reutilize ancient forms and traditions in order to embrace the mixed threats and opportunities of metropolitan modernity.

Davidson demonstrates his engagement with several other powerful currents of fin-de-siècle writing, especially those that relate to types of emboldened or perverse sexual desire. One of the riskiest poems on which his reputation rests is "A Ballad of a Nun," which – like several of his most memorable works – made its debut in *The Yellow Book*. The ballad, which draws on the literary revival of the genre by Thomas Percy in the 1760s and by Percy's chief critic Joseph Ritson in the 1780s, explores the unrestrainable nature of female sexuality. Davidson's nun proves unable to discipline her desires, notwithstanding the degree to which she engages in self-flagellation: "Then she would ply her knotted scourge / Until she swooned."[66] Ecstasy, as we can see from these lines, arises from the very instrument that is supposed to tame it. Once it proves impossible for the nun to control her longings, she casts aside "The ring and bracelet that she wore / As Christ's betrothed."[67] "I shall," she announces, "taste of love at last!"[68] As she walks "Half-naked through the town," the community watches her head towards a "grave youth nobly dressed," to whom she confesses her desire: "I bring you," she says, "my virginity."[69] In response, he kisses her, and they make love. Sexual intimacy, however, destroys her beauty, and she, feeling wretched and forlorn, returns disgraced to the convent, where she intends to make her grave. Yet once she falls at "the wardress' feet," she learns that she has prostrated herself before the Virgin Mary. At this point, "God's mother" restores the nun by clothing her with the "Bracelet and fillet, ring and veil" she had previously discarded.[70] In this extraordinary scene, the Virgin Mary redeems an otherwise fallen woman by declaring that the nun is "sister to the mountains now; / And sister to the day and night; / Sister to God."[71]

In a twist on Jesus Christ's redemption of Mary Magdalene, Davidson's "A Ballad of a Nun" thus reaches a striking conclusion. The Virgin Mary not only forgives the nun who has erred sexually but also positively approves of the woman's eagerness to exult in her sexuality. To several observers, the poem made a very favourable impression. H.D. Traill praised the "wonderful word-magic" evident in Davidson's diction, and he admired "the intensity and sincerity with which [the poem] has been felt."[72] Meanwhile, Arthur Quiller-Couch (the influential editor and Cambridge professor later best-known as "Q") acclaimed the quality that "stands beyond and above mere beauty of language," namely the "spirit of charity" that appears "so earnest."[73] It was left to Harry Quilter, a

conservative who habitually claimed the moral high ground, to condemn Davidson's poem as "one of the most nasty ones" that he had "ever seen put into verse or prose."[74] "If," he says, we take "A Ballad of a Nun" "as an allegory, the obvious lesson taught is that the more utterly we give way to the beast within us, the more surely we receive the grace of the divinity above."[75] Such harsh comments provide a fair indication of the radical, if not sacrilegious, impulses that guide Davidson's poem.

For Quilter, however, the outspokenness of the ballad looks timid when compared to another of Davidson's recent productions. "This author," Quilter intones, "has ... within the past few months ... produced some work which appears to me to be frankly blasphemous, and unprovokedly immoral."[76] "He has done this in poetry," Quilter continues, "and in prose he has a written a book which positively beggars description, but of which the character may be guessed from the frontispiece by Mr. Aubrey Beardsley, which represents a half-naked woman with pendulous breasts, flogging the back of a man who kneels before her" (figure 0.2).[77] The fiction in question is *Earl Lavender* (1895), an urban picaresque that takes place in central London, where two nomadic bachelors find themselves in an "Underground City."[78] It is here, in a scene that aims to humour us, that they discover the following spectacle:

> There were three couples present when Earl Lavender and Lord Brumm were led in; and two of the men and one of the women were being soundly flogged by the other three. The chastisers counted the lashes aloud, and in each case twelve were administered. As soon as the punishment had been inflicted, the seeming culprits gathered their robes around them, received the whips, which were of knotted cords, from the hands of those who had wielded them, and the punishers became the punished. Then the couples, having thus been reciprocally lashed, laid their whips on one of the couches, dancing to a measure which was clearly heard, and evidently proceeded from a band of music in the neighbouring apartment.[79]

In Victorian culture, the practice of flagellation for sexual purposes was not entirely unknown to the press. The public had grown aware of cases involving the assault of teenage women at the hands of whipmasters in private dwellings. A notorious instance involved Sarah Potter, whose brothels on Wardour Street, in the West End of London, and on the King's Road, Chelsea, caught attention in 1863. In a vivid account in *Lloyd's Newspaper*, the proceedings against Potter at the Westminster Police Court disclosed that she had instructed Ellen Wilton, aged

Figure 0.2 Aubrey Beardsley, frontispiece in John Davidson, *A Full and True Account of the Wonderful Mission of Earl Lavender, which Lasted One Night and One Day; with a History of the Pursuit of Earl Lavender and Lord Brumm by Mrs. Scamler and Maud Emblem* (London: Ward & Downey, 1895). (Reproduced by kind permission of the Mark Samuels Lasner Collection, University of Delaware Library, Museums and Press.)

seventeen, to give a man strapped to a ladder "some cuts with a rod on his bare body."[80] Later, Wilton herself was tied down so that the man she had flogged could in turn flagellate her. Once Potter had administered "some cuts with the rod" upon the young woman, the gentleman took the whip and gave Wilton "some hard cuts" as well.[81] Such activities were expensive. Wilton recalled that the client parted with £10 to Potter, who then handed her £2 for her suffering. As Ian Gibson observes: "The

Potter case produced much excitement in the porno-flagellant circles of London."[82] Soon after, "the underground press brought forth a pamphlet arising from the Potter revelations."[83]

Once we turn to Henry Spencer Ashbee's *Index Librorum Prohibitorum* (1875), a significant bibliography of clandestine erotica, we see that *Mysteries of Flagellation* (1863) belonged to a well-established genre. Swinburne contributed to this particular tradition; he produced *The Flogging Block*, a series of eclogues composed between 1862 and 1881, which pays tribute to the flagellation of schoolboys. (The poem remained in manuscript until only recently.) Swinburne also contributed poems to *The Whippingham Papers* (1887), which appeared from the pornographer Edward Avery. Such works circulated in constant jeopardy of prosecution: a threat that intensified so much during the 1890s that several of the companies issuing such titles decamped to Paris. What is striking about *Earl Lavender*, in which a woman tells the protagonist that "the scourge frees the soul and quells the body," is that it appeared from Ward & Downey, a respectable publisher.[84] Even more pointedly, the inclusion of Beardsley's drawing as a frontispiece tested the limits of good taste. Little wonder that Quilter applauded the decisions that Mudie's, a stuffy subscription library, made to remove *Earl Lavender* from its lists.

Davidson's somewhat heavy-handed fiction marked his most daring venture into a style of Decadent writing that sought to bring taboo sexuality into the world of trade publishing. Furthermore, Davidson offered his story as a lightly ironic commentary on the pervasive mood of cultural decline widely associated with the fin de siècle. He makes this point in the proem to *Earl Lavender* (another of his contributions to *The Yellow Book*): "Though our thoughts turn ever Doomwards, / Though out sun is well-nigh set, / Though our Century totters tombwards, / We may laugh a little yet."[85] Still, even if Davidson's flagellant narrative adopts a wry and knowing perspective that mocks the supposed excesses of Decadence, there is one aspect that nevertheless situates his volume explicitly in the avant-garde camp: Beardsley's provocative frontispiece.

No other artist enjoyed such a controversial meteoric rise as Beardsley during the mid-1890s. Once the young artist had come to attention through Joseph Pennell's 1893 essay in a new magazine, *The Studio*, the publisher J.M. Dent commissioned Beardsley to provide the exquisite drawings for the stunning edition of Thomas Malory's *Morte Darthur*. Just as promptly, Elkin Mathews and John Lane appointed Beardsley as their lead designer. Immediately it became clear that he possessed

an unrivalled talent. Critics were taken aback by Beardsley's distinctive technique in black-and-white ink, which achieved its singular sharpness of line and intensity of contrast through a photomechanical printing process developed in the early 1890s. Part of Beardsley's uniqueness stemmed from his supreme ability to reconceive images and styles drawn from a truly eclectic range of materials. Observers quickly grasped that his uncompromising art owed much to Japanese prints, modern fashion plates featuring women's couture and accessories, and scientific representations of bodily maturation, such as became visible in the nascent field of embryology. Besides having an extensive knowledge of Western iconography, he was inspired by indigenous items held in museums, such as the owl-cap that features in several of his drawings. Taken together, this resourceful ensemble of images revels in making the human body – whether extravagantly attired or stripped of clothing – appear at once flamboyantly debonair and alluringly grotesque. Everywhere, his figures display perverse elongations and distortions, together with fetching decorative touches, that exude a barefaced delight in artifice, masquerade, and sexual longing. Moreover, in presenting such distinctive physiques Beardsley's art demonstrates his familiarity with different types of Classical and Western pornography (as well as Japanese *shunga*), since his drawings show little restraint in giving astonishing shape to plump breasts, protuberant phalluses, and vulval curves.

In such light, the frontispiece that Beardsley designed for Davidson's volume – whatever Quilter's revulsion at the artwork – appears somewhat tame. As Linda Gertner Zatlin remarks, there is an elegance in the scene, given "the cool classical setting and Regency mantel," along with the woman's graceful dress that – even with the falling shoulder straps – ensures she is not denuded.[86] The somewhat casual act of flagellation with a triple-tail lash communicates little in the way of intense eroticism. The same, however, might not at first glance be said of *Juvenal Scourging a Woman* (figure 0.3), which initially appeared – in tactfully censored form – in Beardsley's posthumous *Later Work* (1901), where we see only the Roman satirist's prancing body with his genitals concealed. This provocative drawing, which takes Juvenal's sixth satire as its inspiration, became best-known through a special edition of Beardsley's oeuvre that appeared from John Lane in 1925. Here the animated Juvenal, who cavorts while sporting his laurels, exercises a knotted whip upon the fleshy body of a woman whose legs are fastened to an upright post that metaphorically penetrates her. The drawing has attracted a variety of interpretations,

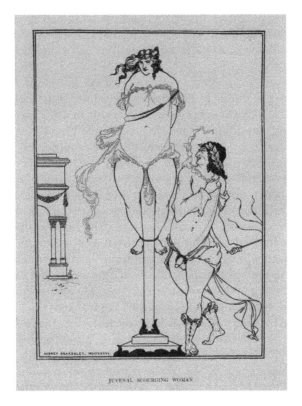

Figure 0.3 Aubrey Beardsley, *Juvenal Scourging a Woman*. Illustration for
the *Sixth Satire of Juvenal*, in *Issue of Five Drawings Illustrative of Juvenal and Lucian*
(London: Leonard Smithers, 1896). (Reproduced by kind permission of
the Mark Samuels Lasner Collection, University of
Delaware Library, Museums and Press.)

including ones that point to the facially grotesque Juvenal's apparent
lack of priapic excitement in this ritual. Meanwhile, the woman's own
expression communicates not torture or pain but rather a defiance that
withstands the cruelty inflicted on her body. Whichever way we choose
to construe this complex image, it demonstrates that Beardsley's art aims
to do far more than titillate. Certainly, there is a taunting sexual naugh-
tiness in these scenes of sexual perversion. Nonetheless, this counts
among several instances in Beardsley's oeuvre that draw into question

those orgiastic pleasures that flagellation is supposed to arouse. This point might also be made when we study the frontispiece to *Earl Lavender*, in which the woman looks mildly indifferent to the flogging she is administering.

Without question, *Juvenal Scourging a Woman* was too indecent to be placed before the public in Beardsley's own time. Nonetheless, his two-volume *Book of Fifty Drawings*, which came out in 1897, depicted eroticism explicitly enough for some readers to recoil in disgust. Soon after Beardsley's death the following year, *The Speaker* observed that *Book of Fifty Drawings* presented "all the elements of Decadence in extreme form," and it correspondingly deplored the "main motive" of this artist's productions: "an emotion which we are accustomed to ignore and crush out of sight as something shameful and ignoble, the link that binds us to our brute ancestors."[87] In other words, "the mark of the beast, the trail of sexuality, is all over his work."[88] Even if, however, Beardsley's art appeared practically satanic in its ambition, by 1898 it still made him into "the great high priest of an advanced civilisation that had somehow fallen out of the main line of progress."[89] As *The Speaker* admits, Beardsley's art had recovered erotic impulses from the pagan cultural past that a refined modernity would have preferred to repress or sanitize in the name of evolutionary development. In an unforgiving commentary from 1897, Margaret Armour captured a similar point. To her eyes, Beardsley's art, since it is "so excellent in technique and so detestable in spirit," ultimately awakens "more repugnance than praise."[90] For this reason, Beardsley by turns impresses and revolts so viscerally that his drawings – even if one might wish to repudiate them morally – cannot be pushed out of view.

Beardsley arguably earned greatest notoriety through his somewhat short-lived role as co-editor of *The Yellow Book*; on its pages, his culturally attuned and highly stylized drawings proved legendary. These brilliant artworks once again affronted decorum. To begin with, Beardsley's picture for the magazine's prospectus features a nighttime scene in which the elegantly gloved hand of a finely dressed woman hovers above a box of assorted books, from which she is about to choose one or two titles (figure 0.4). Meanwhile, a bespectacled bookseller, garbed (rather eccentrically) in the costume of a Pierrot, pouts at her disapprovingly as she reviews the available volumes. The Pierrot, which held special appeal for Beardsley, is a stock figure from *commedia dell'arte*. In his loose-fitting clown's costume, the Pierrot's white-painted face, forlorn expression, and heartbroken gestures communicate his alienation

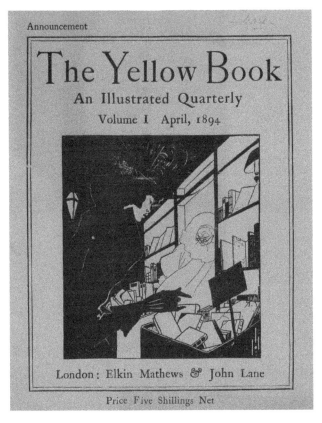

Figure 0.4 Aubrey Beardsley, drawing for the front cover of the prospectus
for *The Yellow Book* (London: Elkin Mathews and John Lane, 1894).
(Reproduced by kind permission of the Mark Samuels Lasner
Collection, University of Delaware Library, Museums and Press.)

from the erotic world. In this instance, critics have suggested that the
vendor who stares in contempt at the woman customer is the pub-
lisher Elkin Mathews. If this is the case, it shows Beardsley's character-
istic lack of deference towards his sponsors. By the time the first issue
appeared in April 1894, *The Yellow Book* contained three of Beardsley's
mischievous images. The cover presents a buxom woman revelling at a
bal masqué with a devilish-looking male leering over her left shoulder,
presumably fixing his eyes on her ample cleavage.

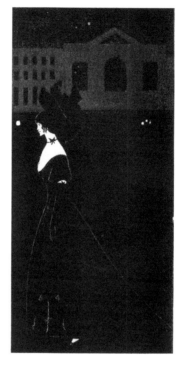

Figure 0.5 Aubrey Beardsley, *Night Piece,* in *The Yellow Book* 1 (1894): 127.
(Reproduced by kind permission of the Mark Samuels Lasner Collection,
University of Delaware Library, Museums and Press.)

Inside the hardbound covers of the quarterly *The Yellow Book,* its earliest
readers found several of Beardsley's other shameless depictions of mod-
ern femininity. In *L'Éducation sentimentale,* for example, which derives
its title from Gustave Flaubert's 1869 novel of a young man's romantic
infatuation, there are two female figures. The one is a thickset older
woman, nicely attired, who has a notebook raised to her face, while the
other is a young girl with her abundant hair worn down, her shoulders
bare, and her arms held behind her back so that her chest stretches
forward. It does not take much to see that the lesson at stake here is a
sexual one, in ways that aimed to incense the middle-class puritanism of
Beardsley's contemporaries. A few pages on, we encounter Beardsley's
Night Piece (figure 0.5), in which a solitary stylish woman in décolletage

and butterfly-adorned choker walks in profile through London's commercial streets (a warehouse advertising "Costumes" appears in the background). In her long, dark, and fashionable dress, the woman moves with purpose through this shadowy landscape, in a manner suggesting that she belongs very firmly on this terrain. There are no recognizable signs that she trades in sexual services; however, the title of the drawing had for centuries served as street slang for a harlot.[91]

Beardsley's controversial position as the upstart provocateur who held a commanding role in *The Yellow Book* grew stronger on 5 April 1895, just one year after the garish-looking quarterly had been launched. What transpired on that day changed the direction of his spectacular career. Late in the afternoon, at the Cadogan Hotel, in the West End of London, two police officers arrested Oscar Wilde for the crime of engaging in homosexual acts. At the time, Wilde commanded the London stage, with two brilliant society comedies – *The Importance of Being Earnest* (1895) and *An Ideal Husband* (1895) – in production at the St James's Theatre and the Theatre Royal, Haymarket, respectively. Journalists reporting Wilde's arrest claimed that as officers escorted him out of the building, he held a copy of *The Yellow Book* under his arm. (As it turned out, this observation was inaccurate.) There was more than a measure of irony in this mistaken coverage, since Beardsley had previously made it clear to the publishers that Wilde – whose retelling (in French, in 1892) of the biblical tragedy *Salome* had appeared in English with the young artist's sharp-witted drawings from Mathews and Lane in 1894 – should be excluded from the journal. Beardsley, as several of the unflattering images in *Salome* show, was not exactly enamoured of Wilde's imposing personality and corpulent frame (see figure 3.3). The moment that reports about Wilde's interest in *The Yellow Book* began to circulate, Lane became agitated, and some of his authors – with the imperialist poet William Watson and the Catholic writer Alice Meynell leading the fray – urged the publisher to remove all of Wilde's books from his lists and fire Beardsley from the journal. Lane's business manager, Frederic Chapman, promptly obliged.

The industrious Beardsley, however, remained unintimidated. His trailblazing career did not falter. In 1896, with Symons, he co-edited *The Savoy*, which found a fresh home for the types of avant-garde art and poetry that had featured in early issues of *The Yellow Book*. (The journal is also memorable for presenting Beardsley's own highly accomplished poetry and fiction. *The Savoy* failed, however, since booksellers refused to stock it.) Beardsley's usual puckishness comes to the fore in the draft drawing for the front cover of the opening number. Here, in a typical

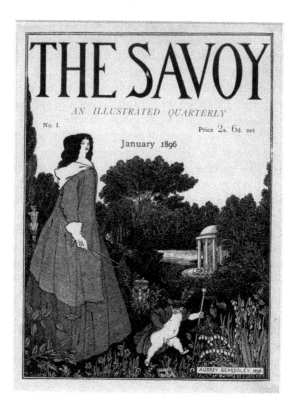

Figure 0.6 Aubrey Beardsley, cover design for *The Savoy* 1 (1896). Black ink and graphite on white wove paper. 30.5 × 23 cm. (Reproduced by kind permission of the Mark Samuels Lasner Collection, University of Delaware Library, Museums and Press.)

scene of perversity, we witness the towering figure of a copiously attired woman with a riding crop in her right hand following a small, rotund page boy with a precociously muscular physique through the country-side. The disproportionate pair, we may assume, are lovers. In the midst of his cavorting, he stops to stare down at a publication that has been cast upon the ground. On closer inspection, we see that the item is *The Yellow Book*, upon which the impish figure is urinating (figure 0.6). Very possibly, it was Smithers who ordered some tactful changes to the printing block before it went into production. When the periodical appeared in

January 1896, the boy's privates and the befouled *The Yellow Book* had disappeared. Still, the peculiarity of the pairing, which points to intergenerational desire, retains its power to shock.

So far, we have followed Murdoch's *Renaissance of the Nineties* down paths of discovery that have led to Symons's and Davidson's very different engagements with Decadence, together with their close connections to Beardsley's impenitent artworks. Murdoch's third poet who came of age in the 1890s is W.B. Yeats, a pre-eminent writer who in later years would emerge – especially during the politically volatile period following the Easter Rising – as one of Europe's leading modernist poets: a fact confirmed by his receipt of the Nobel Prize in Literature in 1923. Murdoch draws attention to Yeats's observation, made in 1890, that a radical change was afoot in Irish culture: "a new Irish literary movement ... will show itself in the first lull of politics."[92] Yeats soon became a figurehead of the Irish Literary Revival, which found great inspiration in adapting a wealth of ancient Irish folklore, legend, and myth at a time of mounting pressure for Home Rule. In reviving interest in ancient Irish culture, Yeats had several significant forerunners, such as the poet Samuel Ferguson, whose epic poem *Congal* (1872) draws on the chronicle *Cath Muighe Turieadh* (*Battle of Magh Turieadh*), which tells of how the Tuatha Dé Danann (the deities of pre-Christian Ireland) reclaimed the country from the Fir Bolg, who – after escaping years under slavery in Greece – had settled in the land. This powerful mythology is recorded in a sixteenth-century manuscript that seems to compile materials assembled six hundred years previously. Ferguson shared his early drafts of *Congal* through the "patriotic labours" of the Irish Archaeological Society in 1842.[93]

Yeats appreciated such observations. Even so, he remained disappointed that Ireland had no record of the nation's bardic literature that compared to Homer's epics as well as to the fine poetry in the Old Norse *Poetic Edda* and the German *Nibelungenlied* (*Song of the Nibelungs*), which dates from around 1200. (During the nineteenth century, these epic works were subject to increased editorial attention.) In a short essay, "Bardic Ireland," which he contributed to Henley's journal, Yeats acknowledges the recovery of ancient Irish culture through the various scholarly efforts of not only Samuel Ferguson and Standish O'Grady but also Mary Catherine Ferguson and Sophie Willock Bryant. Yeats's growing familiarity with Ireland's pre-Christian past alerted him to the fact that at the time when comparable European nations "were beginning to write out their sagas and epics in deliberate form," Ireland was being held back by "the trappings of the warrior ages": it was a country ruled

by divided monarchs who could not unite in order to fend off, once and
for all, invading forces.[94] In his view, no matter how revered the Irish
bards were as chroniclers of their culture, it was still the case that "pas-
sionate bardic inspiration died away" in a convulsive period of expulsions
and incursions: "No sooner were the Danes expelled," he remarks, "than
Strongbow came in."[95] At that point, he claims, after Strongbow (i.e.,
Richard de Clere) led the Anglo-Norman invasion of Ireland in 1169,
political disorder within the country frustrated the attempts of scribes
to record Ireland's bardic prowess: "Instead of the well-made poems we
might have had, there remains but a wild anarchy of legends – a vast pell-
mell of monstrous shapes: huge demons driving swine on the hill-tops;
beautiful shadows whose hair has a peculiar life and moves responsive
to their thought; and here and there some great hero like Cuchullin,
some epic needing only deliberate craft to be scarce less than Homer."[96]
As Yeats sees it, "behind the Ireland of to-day, lost in the ages, this chaos
murmurs like a dark and stormy sea full of the sounds of lamentation."[97]
One of Yeats's main tasks in the 1880s and 1890s was to bring his own
well-honed poetic craft to bear upon this ever-murmuring "chaos" so
that Ireland's ancient heroic culture could take its rightful place in the
European pantheon. He was, too, deeply engaged with modern Irish
writing. In 1892 he founded the National Literary Society in Dublin. One
of the main results of this initiative was his anthology, *A Book of Irish Verse*
(1895), which features a broad sweep of modern works that begin with
an extract from Oliver Goldsmith's "The Deserted Village" (1770) and
concludes with Dora Sigerson's lyric "Cean Duv Deelish" ("Dear Black
Head"), which he selected from her first volume, *Verses* (1893).

 Although the recovery of ancient Irish culture as well more recent
national traditions did much to guide Yeats's early poetic career, he was
not based solely in his homeland at the time. Nor was he, during this
period, invested in political activism. (He would later serve two terms
as senator in the newly founded Irish Free State.) Instead, in the clos-
ing decades of the nineteenth century he held a singular place in the
literary world of London; indeed, his immersion in Irish cultural history
developed in part while he was strengthening his contacts in England
as well as in his homeland. Born in Sandymount, Dublin, Yeats in his
youth moved back and forth between England and Ireland. For much
of his adolescence he resided in London, where his father John Butler
Yeats trained as an artist. Holidays were spent with his mother Susan
Mary Pollexfen's mill-owning family in County Sligo, where the rural
landscape and the seashore became his spiritual home. Later, he was

based in the Irish capital, where he pursued – though hardly excelled at – art school training. Yeats was largely averse to London life; even so, in 1890 he co-founded there the informal grouping called the Rhymers' Club, whose up-and-coming poets, including Symons and Davidson, met regularly at Ye Olde Cheshire Cheese public house on Fleet Street and the Café Royal on Regent Street, where they shared their verses. The club's attendees included Edwin J. Ellis, with whom Yeats in 1893 edited three volumes of the works of William Blake, the English Romantic poet. Yeats's deep interest in Blake's unique cosmography contributed to his intensifying engagement with alternative forms of spiritual belief, which included his membership in the Hermetic Order of the Golden Dawn, one of the most significant organizations linked with late nineteenth-century occulture. It was during the 1890s that he began developing his knowledge of the diverse forms of esotericism; this culminated in his book-length prose study *A Vision* (1925). In addition, Yeats contributed to *The Savoy* an essay on Blake, a story about a love triangle derived from Irish mythology, and several lyric poems. His poetry also appeared in the final issue of *The Yellow Book* (April 1897). That same year, his lyrics based on Celtic legend were included in the early issues of *The Dome*, another London-based avant-garde quarterly – one that brought together literature, music, architecture, and the graphic arts and that featured a rather different stable of up-and-coming writers, including the English poets Francis Thompson and Stephen Phillips, who earned high reputations. Meanwhile, Yeats advocated for his country's rich cultural heritage through the Irish Literary Society, which he co-founded in London during 1891.

By the time Yeats turned twenty-five in 1890, he possessed a strong sense of the need to recover long-obscured mythologies in the name of reshaping the cultural and political future of the modern Irish nation. One of his earliest poems, "Song of the Last Arcadian" (later retitled "Song of the Happy Shepherd"), reveals an acknowledgment of the grim truth that the time when "the world on dreaming fed" has been and gone and a concurrent wish to revive a mythical past associated (as the allusion to Arcady indicates) with Greek pastoral. The poetic voice utters his mixed sentiments of despair and desire in a style that intimates that it may still be possible to find a purpose for the vanished universe of imaginative reverie. "The woods of Arcady are dead," he states with great finality, "And over is their antique joy."[98] But no sooner has he observed the "stammering schoolboy" stumbling over his translation of ancient Greek verses (implicitly those of writers such as Bion and Theocritus)

than he proposes that there remains the possibility of upholding a pastoral ideal that will inspire and transform modern life.[99] The poet urges us to contemplate worlds that are not subject to the "optic glass" of empirical science that verifies the "whirling ways of stars that pass."[100] If, he says, we follow the astronomers in their "cold star-bane" we will discover that "all their human truth" is decidedly "dead."[101] The time has come, he contends, to take action by placing one's lips to a "twisted, echo-harbouring shell" whose eerie sounds promise to unfold anew the listener's life story – "Rewarding in melodious guile, / Thy fretful words a little while."[102] Such "words alone," he claims, "are certain good," not in a moralizing but in a reassuring way.[103] Moreover, these freshly articulated "words" that emerge from the echoing shell produce an alternative to "truth" in the form of an antiquated-sounding but nonetheless enduring "sooth": a term that deliberately evokes otherworldly soothsaying as a fitting replacement for the hard factuality of scientific observation.[104] In the end, the poetic voice asserts that this turn to "sooth," in a moment of captivating wordplay, will allow him to occupy a new Arcady so that he may at last "soothe the hapless faun," whose death is recorded in Greek pastoral.

These hopes that the ancient past will revive in order to strengthen Ireland's cultural future become clearest in Yeats's early narrative poem, "The Wanderings of Oisin," which, as the title suggests, draws on the legends of Oisín (usually spelt with a *fada*), the ancient bard whose tales about the exploits of the warrior Fionn mac Cumhaill and his followers the Fianna constitute the Fenian Cycle of myths. These legends were transmitted through oral tradition before they appeared in a series of works in Old Irish beginning in the seventh century. In some respects the developing Irish engagement with the Fenian Cycle intensified after James Macpherson issued *The Works of Ossian* (1765), which collects Scottish renditions of these Celtic stories. By the 1850s the Ossianic Society of Dublin was publishing scholarly investigations of ancient documents that shed fresh light on the annals of the Fenians. As several commentators remarked at this time, the moment had arrived when modern scholars could examine this otherwise little-understood period of pre-Christian history, which in many ways revealed that Ireland possessed a distinguished classical culture.

Still, it was not only ancient Irish legend but also the irrevocable sanctuary that modern Ireland could provide that drew Yeats's impassioned attention. In the twelve-line "The Lake Isle of Innisfree," an assertive poetic voice declares that the day has come for him to take his leave for

Innisfree: "I will arise and go now," he states, in a spirit of renewal, "and go to Innisfree."[105] His destination is an uninhabited island on Lough Gill, County Sligo, close to where Yeats's mother had been raised. Like his parent, Yeats found in Sligo a refuge from the urban life he deplored in London.

On Innisfree (the Island of Heather), Yeats's speaker imagines a sustainable existence. In an expansive line that moves steadily across six unhurried beats, he states that he will "a small cabin build there, of clay and wattles made": the materials used since ancient times to erect the simplest of dwellings. His inverted syntax, which quietly defies convention by placing the verbs after the corresponding nouns, persists in the next line: "Nine bean rows will I have there, a hive for the honey bee." By means of this rhetorically adept technique, each item in the landscape – "a small cabin," the carefully counted "Nine bean rows," and "a hive" – gains as much priority and purpose as the determined subject that resolves to subsist in this untouched environment. Moreover, the speaker believes – in phrasing that reveals great auditory control – that he will "*live* a*lo*ne in the bee-*lo*ud g*la*de," in which the letter *el* wraps the tip of the tongue around the finely modulated vowel sounds. The intimate connection between the poetic voice's steadfastness and the natural world's unerring cycles develops in the clauses that follow: "And I shall have some peace there, for peace comes dropping slow, / Dropping from the veils of the morning to where the cricket sings." The deliberate pace of these long lines connects the insistence of the poet's heavily stressed desire ("I shall have some peace there") with the equally "slow" but nonetheless active "dropping" of an all-encompassing "peace" found in the "glimmer" of "midnight," the "purple glow" of "noon," and the "evening full of linnet's wings." In the end, the speaker claims that he is compelled to travel to Innisfree because no matter where is he located in the modern urban world ("on the roadway or on the pavements gray"), he uninterruptedly hears the "lake water lapping with low sounds on the shore." "The Lake Isle of Innisfree" thus sets an immutable Irish ecology, one filled with soothing sounds and colours, against the bleak monochrome of the imperial metropolis. All things considered, Murdoch's line-up of three 1890s poets shows how they defined their art either within or against the modern city. Moreover, Symons, Davidson, and Yeats all display an 1890s impulse to reassess artistic traditions, established media, and traditional genres in order to face up to competing cultural pressures of the fin de siècle.

Holbrook Jackson, *The Eighteen Nineties* (1913), and "Art and Ideas at the Close of the Nineteenth Century"

If Murdoch's *Renaissance of the Nineties* encourages us to look in greater depth at the impressive poetry of Symons, Davidson, and Yeats, together with the cultural contexts in which their works appeared, Holbrook Jackson's influential *Eighteen Nineties: A Review of Art and Ideas at the Close of the Nineteenth Century* (1913) takes a broader and altogether more detailed view of what one of his reviewers, Filson Young, called "the remarkable efflorescence of intellectual and artistic activity which made the last decade of the century remarkable."[106] In the year before the outbreak of the Great War, Jackson produced a far-reaching study that demonstrates not only his exceptional familiarity with the culture of this period but also his dexterity in identifying specific artistic and literary trends that emerged during the fin de siècle. To Jackson, the defining figure of the era is unquestionably Beardsley, whose image appears opposite the title page in the well-known studio photograph (often known as the "gargoyle portrait") that Frederick H. Evans took in 1894 and exhibited at the Dudley Gallery, London, that year. Even if Jackson alludes to the ways in which 1890s figures such as Max Beerbohm claimed to "belong to the Beardsley period," *The Eighteen Nineties* nonetheless expands well beyond Beardsley's impactful career.[107] The twenty-two chapters open with discussions of the faddishness associated with the adjective "fin-de-siècle" ("Anything strange or uncanny, anything which savoured of freak and perversity, was swiftly labelled *fin de siècle*").[108] The volume closes with a detailed account of the ways in which "our native genius for all forms of black and white art" reached its apogee in the accomplished decorated books that were designed by such gifted artists as Beardsley as well as Walter Crane, Laurence Housman, and Charles Ricketts.

Between these bookends, Jackson covers an immense amount of ground. Particularly significant is the way in which he acknowledges specific breaks that fractured the fin de siècle. His early wide-ranging discussion of Decadence, for example, reminds us that six years after Symons published his powerful 1893 essay, the author dispensed with the very term that he had used to define a modern movement in literature. By 1899, when Symons substantially revised and lengthened his previous discussion, Symons limited the application of Decadence "to style ... to that ingenious deformation of language, in Mallarmé for instance, which can be compared with what we are accustomed to call the Greek and Latin of the Decadence."[109] By this point, Symons had set aside his

preferred term for the movement he once labelled Decadent, replacing it with "something more serious ... under the form of Symbolism, in which art returns to the one pathway, leading through beautiful things to the eternal beauty."[110] By adapting the French term *Symbolisme*, Symons was able to dissociate his earlier powerful observations about Decadence as a movement linked with cultural malaise and instead dignify it as "an attempt to spiritualise literature, to evade the old bondage of exteriority" and ensure that the "regular beat of verse is broken" so that "words may fly, upon subtler wings."[111] Such phrasing shows that Symons's interests had shifted to figuring modern art as a "kind of religion, with all the duties and responsibilities of the sacred ritual."[112] As Jackson acknowledges, Symons was turning his attention away from "the very definite interpretation of Decadence" that in 1893 had characterized some of the riskier elements of fin-de-siècle art and writing, ones that by the turn of the twentieth century proved somewhat hard to bear.[113]

The fin-de-siècle figure who arguably caused the greatest consternation among his peers was not so much Beardsley as Wilde: the man who, once his homosexual life had suffered public exposure, was condemned by Henley's *National Observer* as the "High Priest of the Decadents."[114] (The phrasing made Wilde sound like the leader of a pagan cult.) On 25 May 1895, Justice Alfred Wills meted out a two-year sentence against Wilde for violating the ban on "gross indecency" defined in the eleventh section of the Criminal Law Amendment Act 1885. This was the harshest possible prison term under the provisions of that law. To Jackson, Wilde's downfall brought about a symbolic end to the overriding "literary and artistic renaissance" that occurred during the first half of the 1890s: "In 1895," he writes, "the literary outlook in England had never been brighter; an engaging and promising novelty full of high vitality pervaded the Press and the publishers' lists, and it was even commencing to invade the stage, when with the arrest of Oscar Wilde the whole renaissance suffered a sudden collapse."[115] There were, as Jackson sees it, several consequences to the immense public scandal. Certain forces conspired to make it look as if this was not just a troublingly Decadent but also a racially degenerate age, a view reinforced through the English translation of Max Nordau's *Degeneration*, published in London by William Heinemann in early 1895. (Nordau's polemic, which envisions degeneration in many of the cultural and sexual changes afoot at the time, had appeared as *Entartung* in Germany three years before.) In his tirade against Wilde, Nordau protests Wilde's assertion in *Intentions* that "aesthetics are higher than ethics."[116] Since such thinking, Nordau contends, "affirms ... that [the] work

of art is its own aim," Wilde therefore agrees "with the Diabolists" that art "need not be moral – nay, were better to be immoral."[117] Moreover, in Nordau's view Wilde's questionable aesthetics align with those of "the Decadents," who cherish the belief that art should "avoid, and be diametrically opposed to, the natural and true."[118] Thus, Nordau diagnoses Wilde's exultation in art's supremacy as a sure sign of the "ego-mania of degeneration."[119]

To Jackson, Nordau's remonstrations with modern art went hand in hand with the disturbing rise of populist imperialism. Especially important here was the founding of Alfred Harmsworth's *Daily Mail*, which appealed to lower-middle-class tastes and "openly fanned the Jingo flame."[120] By 1897, when the Diamond Jubilee of Her Majesty the Queen filled the streets with flag-waving crowds, along with pomp and ceremony throughout the nation, "the pride of race reached so unseemly a pitch" that even Rudyard Kipling – the avowed bard of empire – sounded a warning note to those imperialists who had become "drunk with sight of power."[121] Two years later, imperial zeal was at its apogee when British forces invaded South Africa in order to seize control of the independent Boer states, where diamonds had been discovered. The war, which lasted from 1899 to 1902, ensured that the "people, bitten by an unseeing pride … forgot art and letters and social regeneration, and marched headlong into Mafeking Night": the beginning of the siege in which Boer guerillas forced the British military to retrench for no fewer than 217 days.[122] In hindsight, Jackson could tell that the Siege of Mafeking, which displayed both the British forces' endurance and their vulnerability, marked a turning point in the empire's desire to maintain control over territories where it believed it should exert utmost authority. The war took an immense toll on the Black and Boer populations, especially in the unsanitary concentration camps into which more than 120,000 people were corralled after the British army razed farms and properties to the ground. This spurred a parliamentary commission, one that – uniquely for its time – was led by women. Britain's own loss of life was huge: 55,000. Moreover, the war was enormously expensive for Britain, which incurred financial losses over £211,000,000. The main result of this intensely violent conflict was that in 1910 the Union of South Africa became part of the British Empire. This relationship would last twenty-one years.

Jackson, though, proves fairly resistant to the view that the rising tide of imperialist sentiment came to dominate 1890s culture. This point becomes evident when he discusses the spirited poems the prolific Anglo-Indian writer Kipling collected in *Barrack-Room Ballads*

(1892), a volume containing outspoken verses voiced through the Cockney idiom of a common foot soldier named Tommy Atkins. In "Fuzzy-Wuzzy," for instance, Tommy (despite his racist perception of Black African hair) finds much to praise in the enemy, who fought boldly during the Sudanese Mahdist War (1881–99). That war featured another legendary siege, of Khartoum (13 March 1884–26 January 1885), where the British general Charles George Gordon had been sent to help the Egyptian troops withdraw from their garrison in the face of thousands of Sudanese forces supporting the Mahdi (Muhammad Ahman bin Abd Allah), a Sufi religious leader who had turned the region into a large Islamist state. The siege ended with a high death toll, including the murder of Gordon, whose severed head was reportedly delivered to the Mahdi.

Kipling's raucous Tommy sees in the Muslim Beja warriors supporting the Mahdi a force more fighting-fit than any that have previously engaged in resisting British rule: "We took our chance among the Kyber 'ills," he observes, mindful of the British retreat from Afghanistan after the Second Anglo-Afghan War (1878–80).[123] Thereafter, Tommy recalls: "The Boers knocked us silly a mile" – a reference to the earlier Anglo-Boer War (1880–1), in which the British suffered a humiliating defeat.[124] "The Burman," Tommy adds, "give us Irriwaddy chills, / And a Zulu *impi* dished us up in style."[125] These two latter wars – the one bringing about British rule over Burma in 1886, the other resulting in British domination of the Zulu *impi* (i.e., army) in 1879 – equally tested the empire's mettle. Still, Tommy has no hesitation in paying tribute to the fortitude of the Beja soldiers in a jolting aitch-dropping speech: "So 'ere's *to* you, Fuzzy-Wuzzy, at your 'ome in the Soudan; / You're a pore benighted 'eathen but a first-class fighting' man."[126] The unaspirated words, which carry several of the heaviest stresses in these lines, had seldom been given such prominence in English poetry. Kipling's ballads of this type had (as *The Athenæum* noted) "delighted readers" when they first appeared in the *Scots Observer* (the forerunner of Henley's *National Observer*).[127] The same reviewer concluded that the accomplished novelty of *Barrack-Room Ballads* made these poems "superior to anything of the kind that English literature has previously produced."[128] Jackson is of a similar turn of mind: "Such ballads … are as peculiar in their way, and as separate from the rest of English poetry, as the designs of Aubrey Beardsley are separate things in English pictorial art."[129]

Of the remaining 1890s artists and writers to whom Jackson devotes a detailed single chapter, there is one who stands out more than any

other: the brilliant caricaturist and satirist whom George Bernard Shaw, in a tribute dating from 1898, styled the "Incomparable Max."[130] Shaw conjured the phrase in honour of the twenty-six-year-old Beerbohm, who was poised to succeed Shaw as the resident theatre critic of the *Saturday Review*. At the time, Shaw, who had yet to secure success as a playwright, was best known for his music and theatre journalism and his political involvement in the reformist socialism of the Fabian Society. A defender of Henrik Ibsen's controversial dramas and a shrewd foe of Max Nordau's tirades, Shaw – like so many of his contemporaries – had for the past few years been diverted by Beerbohm's pointed fun-poking drollery. Beerbohm took pleasure in hyperbolizing many of the idiosyncrasies of artists, writers, politicians, and – in an early work – various "club styles." As Megan Becker-Leckrone points out later in this volume (220), by 1922, when Jackson reprinted *The Eighteen Nineties* for a fresh generation of readers, he dedicated it to Beerbohm. This was an unsurprising move. During the interwar years, Beerbohm had strengthened his reputation as the definitive chronicler of the literary crazes that had made the fin de siècle the stuff of legend. His long career led to a knighthood for his services to his country, which included his acclaimed broadcasts on British radio (collected in *Mainly on the Air* [1946]). At the time of his death in 1956, "Max" – as he was fondly known – had become a national institution (even though he had spent half a century living abroad in Rapallo, Italy). Two years later, the cartoonist Osbert Lancaster issued *Max's Nineties*, featuring forty-six memorable caricatures, including ones of Beerbohm himself, Wilde, Yeats, and Beardsley. These iconic images, such as the one that elongates Beardsley's frail long-limbed build and short geometrical haircut with its eye-catching centre parting (figure 0.7), became inseparable from an age whose mannerisms and pretensions Beerbohm celebrated and ridiculed at once.

After making his mark at Oxford in several student periodicals as well as in the popular *Strand Magazine*, Beerbohm developed close ties with the queer circle around Oscar Wilde. (Beerbohm was a contemporary of Wilde's male lover, Alfred Douglas, at Oxford; his half-brother, the actor-manager Herbert Beerbohm Tree, produced two of Wilde's society comedies.) Beerbohm gained his greatest public attention for his burlesquing prose in the first four volumes of *The Yellow Book*. There, in the first number, he published "A Defence of Cosmetics" (1894), an amusing meditation on the evident rise of women's daubing of make-up

Figure 0.7 "Max" [Max Beerbohm], "Caricature of Aubrey Beardsley," in
The Savoy 2 (1896): 161. (Reproduced by kind permission of the Mark
Samuels Lasner Collection, University of Delaware Library, Museums and
Press and Berlin Associates. © Estate of Max Beerbohm. Reproduced
by kind permission of Berlin Associates.)

in the fashionable metropolitan world: "We need but walk down any
modish street and peer into the little broughams that flit past, or (in
Thackeray's phrase) under the bonnet of any woman we meet, to see
how wide a kingdom rouge reigns."[131] Unfortunately, Beerbohm's lev-
ity – which drew knowingly on Baudelaire's essay "Éloge du maquillage"
(In Praise of Makeup [1860]) – was lost on some readers. The next
issue features Beerbohm's equally funny "Note on George the Fourth,"
a tongue-in-cheek homage to the supposed exemplarity of the Prince
Regent, whose lavish lifestyle and spendthrift habits, both before and

after his coronation in 1820, were still notorious. The present moment, Beerbohm teasingly remarks, cannot do justice to the apparent dignity of the otherwise disrespected monarch: historians, he says, have harshly judged George IV "by the moral standard of the Victorian age."[132] "He was," Beerbohm enthuses, "so young and so handsome, and so strong that can we wonder if all the women fell at his feet?"[133] On this view, it is wholly unfair to condemn the Prince Regent as "a hardened and cynical profligate, an Elagabalus in trousers."[134] "Meanwhile," Beerbohm cautions, 1890s society would do well to acknowledge the dilapidated condition of its own age: "We to-day," he pronounces, "are living a Decadent life ... There is nothing but feebleness in us."[135] As these comments wryly suggest, it is odd to imagine that the fin de siècle, by any measure of the imagination, should appear as corrupt or as enervated as the Regency.

With its special focus on Beardsley and Beerbohm, Jackson's *Eighteen Nineties* certainly resonated with his critics. The volume bore witness to a fact that Young observed in 1913: the "eighteen nineties really made such a commotion that people do not seem to realise that anything in art or literature has happened since."[136] Nevertheless, the various types of uproar that Jackson identifies with the era, no matter how much material he seeks to bring within his purview, extend only so far. What is especially noticeable about his chapters is that female cultural figures are conspicuously marginal. The prolific co-authors Katharine Bradley and Edith Cooper, who produced some of the finest lyric poetry of the time under the name of Michael Field, appear on a sparse four occasions. There are slightly more references to the Irish fiction writer George Egerton (Mary Chavelita Dunne Bright), whose collection of stories *Keynotes* (1893) caused a sensation in the press, besides giving the title to the thirty-three volumes of prose fiction that featured in John Lane's "Keynotes" series, which carried Beardsley's designs and included such outstanding works as her second collection *Discords* (1894), Ella D'Arcy's *Monochromes* (1895), and Arthur Machen's *The Great God Pan* (1894). In Jackson's study, the only woman writer to receive attention through substantial quotation is Alice Meynell, whose lyric "The Shepherdess" he praises because it expresses "the idea of the mystery of white innocence with such immaculate grace."[137] Such writing, Jackson states, belongs to a larger "acute colour sense of the period," in which *The Yellow Book* has taken a prominent role. Elsewhere there are occasional references to the poet Olive Custance, the aesthetic critic and fiction writer Vernon Lee (Violet Paget), and socialist authors such as E. Nesbit and Dollie Radford. Each of the writers whom Jackson mentions in passing has

in recent decades received increasing amounts of critical attention.[138] How and why, we might wonder, did Jackson allow so many women who enjoyed prominence in the 1890s to elude his study? This was, after all, the era of female aesthetes as much it was of the dandified male figures of Beardsley, Wilde, and Beerbohm. It was also the epoch that marked the rise of the New Woman, whose presence in the fiction and journalism of the period was immense. *Extraordinary Aesthetes* builds on the broadening scholarly inquiries that continue to assist in correcting this aspect of Jackson's otherwise trenchant and thoughtful *Eighteen Nineties.*

Extraordinary Aesthetes and the Broadening Scope of the fin de siècle

The ten studies in the present volume are divided into four parts. Part I, "New Women, Female Aesthetes, and the Emergence of Decadence," begins with S. Brooke Cameron's exploration of Amy Levy's first novel, *The Romance of a Shop* (1888). This remarkable narrative, which focuses on the power of sibling bonds, unfolds the lives of the four middle-class Lorimer sisters, who as young women find that they have no more than £600 between them once their widowed father dies. With great ingenuity, two of the sisters – Gertrude and Lucy – resolve to turn their amateur interest in photography into a professional business. Once their household belongings have been sold in the well-to-do suburb of Campden Hill, they use their resources to settle into a modest new flat at 20B Upper Baker Street, in the heart of London's bustling West End. On these premises, they establish a photographer's studio. Such a venture, it must be said, was not entirely far-fetched for young women at the time. Several years later, the respected photographer Alice Hughes established a studio at 20 Gower Street, Bloomsbury, the district in central London where Levy lived with her family after 1885. Then again, the fact that Gertrude and Lucy concentrate their energies on developing a successful business presents a fresh alternative to traditional opportunities, such as governess or lady's companion, that were open to well-educated young women.

The shop provides the sisters with a transitional space between the domestic family home they have lost and their future intimate lives with men. In the urban world surrounding their flat, they experience newfound freedoms in what Levy's narrator calls the "familiar pageant" of London: the unrolling procession of streets populated with people going about their business, carriages moving back and forth, and – as Cameron points out – passengers travelling on omnibuses such as the Atlas, where

Gertrude sits on the top-deck "summit" with "her hair blowing gaily in the breeze, her ill-gloved hands clasped about a bulky notebook."[139] This striking image of a new type of unchaperoned female passenger, one who could at last loosen her hair and undo her gloves, captured the attention of several female urban aesthetes at the time. Cameron contends that this emancipated figure embodies the modernity of the *flâneuse*: the woman who traverses the cityscape with a freedom and authority that rivals that which Charles Baudelaire accorded to the *flâneur*. As Baudelaire describes him, this type of urban male spectator ventures along the streamlined boulevards of Baron von Haussmann's rebuilt Paris fixing his gaze on female *passantes* or passers-by. Cameron demonstrates that *The Romance of a Shop* does more than reverse the male gaze that Baudelaire's *flâneur* fixes upon the female bodies espied on the city streets. The novel's exploration of the Lorimer sisters' practice of photography informs the complex ways in which they perceive themselves and others in the metropolis. Cameron identifies several passages where Gertrude's eyes rove across details as if they have been trained by the lens of a camera, with an empowering capacity to record and reflect upon the fresh demands of a bustling urban experience. For this reason, it is as if, as Cameron observes, Gertrude's "consciousness is transformed into a photographic negative" (85). There is no question that Gertrude has a highly critical and attentive eye, one that not only strengthens her professional skills but also confirms that her private suspicions about her sister Phyllis's dastardly lover Sidney Darrell are right. Nonetheless, in *The Romance of a Shop* Gertrude and Lucy's labours in the studio do not last for more than a few years, and the sisters' lives are ultimately defined through their relations with men. Three of them find husbands, while Phyllis – the one betrayed by an untrustworthy paramour who is already married – succumbs to tuberculosis.

By the time Levy committed suicide (her close friend Eleanor Marx confided that the gifted young writer was "inclined to hopeless melancholy"), she was poised to take her place as a pre-eminent literary figure.[140] The growing body of research on Levy's distinguished canon, which has developed considerably during the past thirty years, attunes scholars' attention to her interconnected positions as both a metropolitan and cosmopolitan aesthete, a secular Jewish feminist, a Schopenhauerian thinker, and an exponent of lesbian lyric. Over time, historians have shed light on Levy's social circle, which included close friendships with the South African novelist Olive Schreiner, the fiction writer and trades unionist Clementina Black, and the established critic Vernon Lee. In

Levy's substantial oeuvre, *The Romance of a Shop* holds a significant place. The novel, given its emphasis on young women's desire to enter largely male occupations, is now widely regarded as a precursor to the substantial body of 1890s feminist fiction that focused on the New Woman.

It is worth pausing for a moment on the impact made by the New Woman: an extraordinary figure – one linked with women's demands for sexual freedom and professional respect – that came into the public eye through a controversy attending the Irish novelist Sarah Grand's polemical essay "The New Aspect of the Woman Question" (1894), which appeared in the *North American Review*. Sarah Grand (the professional name of Frances Elizabeth Bellenden McFall) had already attracted attention with her long, uncompromising novel, *The Heavenly Twins* (1893). Grand's forthright narrative compares the sexual fates of three young women, one of whom (Edith Beale, the naive daughter of a bishop) gives birth to a child with secondary syphilis before suffering insanity from the disease that soon leads to her demise. The author's 1894 essay opens with a volley against the "Bawling Brothers who have hitherto tried to howl down every attempt on the part of our sex to make the world a pleasanter place to live in."[141] She declares that we are now in an age when "the new woman" has emerged from a "sudden and violent upheaval of the suffering sex in all parts of the world."[142] "Man deprived us," Grand says, looking back past generations, "of all proper education, and then jeered at us because we had no knowledge."[143] On this account, such days of suffering are decisively over. In response, the conservative-minded Ouida (Maria Louise Ramé), the prolific writer of lavish aesthetic romances, promptly dismissed Grand's protests: "The error of the New Woman (as of many an old one) lies in speaking of woman as the victims of men, and entirely ignoring the frequency with which men are the victims of women."[144] Meanwhile, Ouida – who attached the capitals to the term New Woman – saw no point in offering higher education to the female sex, since such exposure to "a college curriculum" would "only be hardening and deforming."[145] In many ways, this blunt exchange belonged to a series of long-standing Victorian disputes dating from at least the 1850s about women's bids for equality in the face of sexual oppression.

Be that as it may, what proved unreservedly different about the New Woman was the rapid manner in which popular culture elevated her to an icon for the times. Caricatures of her supposedly mannish bearing and professional aspirations abounded in the press. The playwright Sydney Grundy capitalized on her presence in *The New Woman*, a satirical comedy depicting contending types of femininity that refused to occupy

Figure 0.8 Albert Morrow, poster for Sydney Grundy, *The New Woman*,
Comedy Theatre, London (London: David Allen & Sons, 1894).
Colour lithograph. 7.24 × 5.08 cm. (Reproduced by kind
permission of the Mark Samuels Lasner Collection, University
of Delaware Library, Museums and Press.)

the sexually subordinate role that Ouida deemed natural for all women.
Albert Morrow's famous poster for the production at London's Com-
edy Theatre, which opened on 1 September 1894, draws into focus the
various attributes that were commonly associated with this supposedly
outrageous figure (figure 0.8). Seen in sturdy profile with pince-nez (an
accessory that draws attention to her studiousness), the seated woman
in her long, sober gown clutches her knee in a gesture that suggests her
autonomy, determination, and defiance. Scattered around her stool are

untidy piles of manuscripts, folders, and pamphlets, two of which have titles – *Naked but Not Ashamed* and *Man, the Betrayer* – that are referred to in Grundy's drama. Plainly enough, Morrow's New Woman is a prolific reader and writer. Two other visuals shed further light on her unconventional female identity. In the foreground, we see a discarded cigarette, which reminds us of Lady Colin Campbell's commentary on the general censure of women indulging in the male pastime of smoking. Meanwhile, in the background we notice a framed metal latchkey that alludes both to George Egerton's scandalous *Keynotes*, with its sexually assertive female protagonists, and to the fictions that Lane issued in the "Keynotes" series with Beardsley's signature design (see figure 0.8).

On closer inspection, however, it becomes clear that each of these elements in the poster points to a rather different conception of the New Woman. On the one hand, Sarah Grand was committed to social purity; although syphilis drives Edith Beale to an early grave, her contemporary Evadne Frayling avoids succumbing to infection by tutoring herself about the "heredity of vice," which means that she eventually exerts authority over her congenitally afflicted lover, Colonel George Colquhoun: "With his ancestry," she states, "he must have come into the world foredoomed to a life of dissipation and disease."[146] On the other hand, George Egerton's close attention to a modern woman's desires is striking in its attention to physical detail; in "A Cross Line," the main character, who is known only by her nickname "Gypsy," spends her leisure time smoking while assessing her husband's sexual fitness: "She draws in the smoke contentedly, and her eyes smile back with a general vague tenderness."[147] As for Grundy, he grasped – in one of the earliest exchanges in *The New Woman* – that there was disagreement among a rising generation of women about the roles the sexes could and should occupy. Enid Bethune, author of *Man, the Betrayer*, informs her companion Victoria Vavish "that a man, reeking with infamy, ought not to be allowed to marry a pure girl."[148] In response, Vavish, who has published *Ye Foolish Virgins! – A Remonstrance*, advocates that young women should champion their desires on an equal footing with men: "*She* ought to reek with infamy as well."[149] As Sally Ledger has noted, it is as if this contentious dialogue had been conducted between Sarah Grand and George Egerton.[150] For all their differences, *The Heavenly Twins* and *Keynotes* stand as two of the best-known examples of the hundred or so New Woman fictions that were issued during the 1890s. Moreover, these works, which also share (albeit from divergent perspectives) an interest in eugenics, commanded such high sales that it remains hard to understand why Jackson did not give them pride of place in his 1913 study.

On occasion, modern critics writing about the 1890s have tended to see the forthright New Woman as a figure very much out of sync with the male Decadent of Symons's imagining. The New Woman sought highly politicized liberation from oppressive sexual domination by men; the male Decadent relished a curious, perverse, and restless existence that typified the *maladie du siècle*. Still, as Linda Dowling has pointed out, during the final decade of the nineteenth century "the Decadent and the New Woman were twin apostles of social apocalypse."[151] Both of these figures converged on the idea that desire was to some degree diseased, and both perceived that modern society required forms of intimacy that would free men and women from the petrified institution of marriage. In chapter 2, Kate Krueger turns her attention to Ella D'Arcy, the immensely gifted fiction writer whose work linked Decadence with the limitations to modern manhood that New Woman writers frequently critiqued. The most frequent contributor of short stories to *The Yellow Book*, D'Arcy also served, albeit unofficially, as Harland's subeditor once Beardsley had been dismissed. Her career, which began in 1890 with a rather melodramatic tale in *Temple Bar*, flourished mainly in the mid-1890s when her three outstanding volumes – *Monochromes* (1895), *Modern Instances* (1898), and *The Bishop's Dilemma* (1898) – received encouraging notices. In a favourable review of the first of these books, Israel Zangwill stated that "the story of the Pleasure-Pilgrim is the cleverest story in the cleverest volume of short stories that the year has given us."[152] In "The Pleasure-Pilgrim," which follows several tourists boarding at the Schloss Alternau in Germany, a sexually conservative Englishman named Campbell cannot comprehend the outlandish femininity embodied by Lulie Thayer, a young American leisure-class woman. The devastating ending to the story (the passionate Lulie unexpectedly takes her life) belongs to a larger pattern of stark episodes punctuating *Monochromes*, a pattern that reveals a distinct lack of empathy among characters who remain ill-suited to one another.

Diana Maltz, in chapter 3, turns to a different aspect of Decadence, this time in relation to the prolific Mabel Dearmer, a Welsh-born artist, poet, fiction writer, and dramatist who moved in circles closely linked with *The Yellow Book*. (Dearmer supplied the cover for the twelfth volume of the journal. She was the only woman whose art enjoyed such prominence in the periodical.) Trained at Hubert von Herkomer's art school in Bushey, Hertfordshire, Dearmer had already in her early twenties earned a strong reputation for her poster designs. In an important study, *Picture Posters* (1895), which draws attention to the pre-eminence of

the genre during the fin de siècle, Charles Hiatt remarks on Dearmer's evident responsiveness to Beardsley's eye-catching poster for a double bill of plays by John Todhunter and W.B. Yeats at the Avenue Theatre on 29 March 1894 (figure 3.4). In Hiatt's view, her attractive drawing for a recital she gave from sections of Henrik Ibsen's *Brand* (1865) and Richard Brinsley Sheridan's *School for Scandal* (1777) reveals that she had been "affected by the simplicity and directness which are so conspicuous among the merits of Mr. Beardsley" (figure 3.6).[153] Maltz identifies exactly how, at this early stage of Dearmer's career, the gifted young artist adapted and rethought Beardsley's poster art. Beardsley's colour-block prints, with their solid black outlines, certainly inspired Dearmer's recital poster, in which a fashionable woman in a deep red frock holds a theatre program or script intently before her submerged gaze, while the masks of comedy and tragedy dangle from her right wrist. The image focuses our interest on a woman's meaningful connection with the theatrical world, where she appears as much as a producer as a performer. To Dearmer, posters were not simply advertisements. In 1895, she humoured a journalist by stating that they were "our modern substitutes for frescoes – the frescoes of the Democracy."[154] A committed Christian socialist, member of the Fabian Society, and (in the years leading up to the Great War) a suffragist, Dearmer remained dedicated to producing art that registered social change, upheld her religious principles, and – as her main biographer Stephen Gwynn remarks – demonstrated "her deepest conviction that a woman no less than a man must be free to follow her own work and her own ideal wherever these may lead."[155]

During the fin de siècle, Dearmer's Decadent art, which brought her much-needed remuneration, soon pivoted towards her own distinctive approach to colour-blocking. Maltz unfolds the experimental independence of the stunning drawings Dearmer prepared for Evelyn Sharp's books of fairy tales, *Wymps* (1897) and *All the Way to Fairyland* (1898) (see figures 3.5 and 3.10–3.15), and of her feminized version of the Pierrot that appears in the 1897 volume of *The Studio*. Exceptionally adept in this area of illustration, Dearmer rapidly developed a unique style that attracted attention in several other beautifully printed volumes, including *The Parade: An Illustrated Gift Book for Boys and Girls* (1897), edited by the art critic (and editor of *The Studio*) Gleeson White. In this exquisite publication, which contains contributions by several figures who came to notice in the 1890s (Max Beerbohm, Laurence Housman, and Richard Le Gallienne), Dearmer's striking image "The Frog Princess" faces the title page featuring Beardsley's elegant lettering and decoration (figure 0.9). The hand-coloured print,

Figure 0.9 Mabel Dearmer, *The Frog Princess*, in ed. Gleeson White, *The Parade:*
An Illustrated Gift Books for Boys and Girls 1897 (London: H. Henry, 1897).
opp. title page. (Reproduced by kind permission of the Mark Samuels Lasner
Collection, University of Delaware Library, Museums and Press.)

which illustrates Dearmer's retelling of "The Frog Prince" by the Broth-
ers Grimm that comes later in this Christmas gift book, contrasts areas of
black and white with a burnt-orange tone that connects the orchard fruits,
the princess's long gown, and the magical golden ball the frog holds in
his mouth. Meanwhile, the princess, accompanied by her maids of hon-
our, ventures boldly across a white block representing dry ground to a dark
block marking the moist soil that surrounds the pond. As she leans forward,
hitching her dress above the mud, the princess is about to communicate
with the creature: a pivotal event that will bring about much-needed reform

in her otherwise autocratic career, in ways that finally enable her to love a humble gardener's boy without any fear that class differences will impede their romance.

Such artworks formed a significant part of Dearmer's busy professional life, which eventually involved writing novels (*Gervase* [1909] ranked highly among reviewers), children's books such as *A Noah's Ark Geography* (1900) and *A Child's Life of Christ* (1909) (the first of these inspiring a children's play *The Cockyolly Bird* [1914], which appeared as part of the Children's Theatre at the Court), and adult dramas that took the form of morality or mystery plays, including *The Soul of the World* (Gwynn counts this religious work among her finest productions). In her successful marriage to the church historian, hymnologist, and socialist Percy Dearmer, with responsibility for two sons, Mabel Dearmer remained immensely productive until her untimely death in 1915, at the age of forty-two, from typhus she had developed while serving for several months as an orderly at Mabel Stobart's field hospital in Kagujevac, Serbia. Her sacrifice came to public notice through Gwynn's edition of the moving letters she had mailed to him during her time there. When he issued these documents in December 1915, *The Sphere* commented on the "very considerable fame" that Dearmer had won through "her numerous books and symbolical plays."[156]

Part II of *Extraordinary Aesthetes*, "Femininity, Masculinity, and Fin-de-Siècle Aesthetics," opens with Beth Newman's assessment of Alice Meynell's "aesthetic conservatism" (155). A Roman Catholic convert, Meynell was in her mid-forties when her two 1893 volumes, *Poems* and *The Rhythm of Life*, attracted critical attention. By this time, Meynell had built up a prolific body of journalism, much of it in the field of art history. The two 1893 books, which came out from Mathews and Lane, gathered together some of the poems she had issued as A.C. Thompson in *Preludes* (1875) (nicely decorated by her illustrious older sister, the war artist Elizabeth Butler), and the succinct essays she had contributed in the 1880s and early 1890s to both her own journal *Merry England* and Henley's *National Observer*. *Preludes* marked a debut in a career in which she made a very favourable impression on several Catholic writers. In 1876, one of her most enthusiastic readers, the young author Wilfrid Meynell, who had praised her first collection in the *Pall Mall Gazette*, published a glowing poetic tribute to her in *The Irish Monthly*. Mutual contacts led to an introduction, and by 1 January 1877 they were engaged. Between 1882 and 1891, she bore eight children while building an increasingly commanding literary career. Several of the lyrics from *Preludes* that the

poet preserved in *Poems* reveal that she had already established the foundations of her carefully wrought poetics at an early stage of her career. Moreover, *Preludes* shows that by the mid-1870s she was particularly responsive to the Catholic writer Coventry Patmore's distinctive comprehension of poetry as a form that "should always seem to *feel*, though not to *suffer from*, the bonds of verse."[157] Her lyrics, as several recent critics have observed, contend that such prosodic "bonds" need to be embraced rather than resisted.[158]

Newman's discussion considers the critical manner in which Meynell's idiosyncratic approach to metrical recurrence runs counter, perhaps deliberately, to Pater's well-known "Conclusion" to *Studies in the History of the Renaissance*. In the final sentence of that volume, Pater asserts that "the poetic passion, the desire for beauty" emerges once one allows art "to give nothing but the highest quality to your moments as they pass, and simply for those moments' sake."[159] To Pater, the exhilarating "moment" seized upon the senses, accentuated physical pleasure, and dissipated at the very point one tried to cognize it. He celebrated such moments – such as the "delicious recoil of the flood of water in summer heat" – because they heightened our awareness of the "perpetual motion" of atomic elements that weave and unweave our "physical life."[160] From this perspective, human experience consists of "impressions unstable, flickering, inconstant," that remain specific in their unique transitoriness to each individual.[161] The finest impressions, Pater urges, come from those moments when we try – in language borrowed from scientific discourses of the time – to "burn always with this hard gem-like flame."[162] Meynell's approach to temporality of this kind diverges radically from this viewpoint. As Newman observes, whenever Meynell's poems address an arresting moment such as a religious festival that evolves from the all-embracing laws of periodicity, they "hollow ... out" these "climactic moments" in a manner that makes such events "negative epiphanies that can be remarked only retrospectively if at all, from a moment of belated integration" (167).

Newman's epithet "negative" captures a persistent quality in Meynell's poetics. To begin with, the adjective relates to what the author called, in an essay memorializing her father, the "significant negatives" of "a man whose silence seems better worth interpreting than the speech of many another."[163] Here, the negativity of disciplined reticence remains implicitly superior to the ostensible positivity of outspoken utterance. Moreover, Meynell's apprehension that a spiritually endowed moment remains in a condition of belated restoration speaks to a broader concern, voiced in both of the 1893 volumes, about becoming degenerate or Decadent. To

Meynell, it remains exceptionally difficult in a universe governed by previ-ous repeated patterns to produce art that does not exude "the failure of derivation."[164] As a means of thwarting the threat of derivation in the hope of maintaining high aesthetic value, Meynell appeals to an abstract belief in "refinement" – a term that correlates with an impulse to "overtake exag-geration and arrest it" in the name of simplicity. Where Pater exulted in optimizing the experiential "moment," Meynell celebrates the "great and beautiful quality of fewness."[165] For her, such beauty arises from an asceticism steeped in rejections and refusals. On this view, "refinement is not negative" in itself, since "it must be compassed by many negations."[166] Thus, it follows that where Pater extolled the experiential "hard gem-like flame," Meynell claims that "refinement" always "demands immolations, it exacts experience."[167] In other words, Meynell's experiential refinement extinguishes the intense moments that Pater sought to keep alight.

In chapter 4, Emily Harrington turns to the largely neglected career of the prolific young Liverpool-born essayist, fiction writer, and poet Richard Le Gallienne, who in the 1890s gained as much notoriety for his dandyish persona as for his ubiquity as a reviewer in a wide swath of periodicals, including the heavyweight *Nineteenth Century*, *The Yellow Book*, and *The Star* (Ernest Parke's radical halfpenny evening paper). His con-spicuous presence in fin-de-siècle literary circles in London ensured that his hallmark personal style, his abundant critical notices, and his uneven poetry became sources of very mixed commentary. As we can see from an impressive studio photograph taken in 1902 (figure 0.10), Le Gallienne cut a dash, with his finely tailored clothes, chiselled looks, and copious hair, which became this aesthete's distinguishing trait. In 1927, Stephen Gwynn provided a memorable image of the visual impact Le Gallienne made at the get-togethers Mabel Dearmer hosted at her home on Mon-day evenings during the mid-1890s:

> His good looks were dazzling; the profuse black hair, with a ripple in it, parted in middle and combed out sideways in mediæval fashion, set off his fine regular features and wide eyes. Beauty so obvious and so cultivated is rather disconcerting in a man, and Le Gallienne's looks were discussed in his presence as if he were some beautiful woman. Mabel Dreamer, who then had all the tormenting devilishness of a young woman, used (so she told me one day) frequently to praise the regularity of his teeth, because she thought they were a feature with which he had provided himself. But what I remember best about him is the pleasant impression his strong frank grip made when we shook hands. The foppishness was only a veneer.[168]

RICHARD LE GALLIENNE

Figure 0.10 Pirie Macdonald, 1867–1942. *Richard Le Gallienne.* Photogravure touched with gouache (Brooklyn, NY: J.F. MacCarthy, 1902). (Reproduced by kind permission of the Mark Samuels Lasner Collection, University of Delaware Library, Museums and Press.)

A creature of great self-invention (he inserted the article "Le" before his family name to enhance its Frenchness), Le Gallienne presented himself as an icon of male aestheticism. In many ways, his exemplar was Wilde. In October 1883, the teenage Le Gallienne heard the finely accoutred Wilde lecture on "Personal Impressions of America" at Birkenhead. Enraptured by this event, he determined upon a literary career, with his privately published first book *My Ladies' Sonnets, and Other "Vain and Amorous" Verses* (1887) appearing when he was twenty-one. He sent a presentation copy to Wilde. During the late 1880s, when the young author was striving to establish himself in London, Wilde

welcomed him to an "at-home." A kind host, Wilde gave Le Gallienne a copy of *Poems* (1881), which Wilde inscribed to his acolyte as both "poet and lover."[169] The exchange continued in the form of a flattering poem from Le Gallienne, in which he recalled the fleeting hours he spent in the company of his idol: "With Oscar Wilde, a summer day / Passed like a yearning kiss way."[170] The elegiac sentiment suggests that they enjoyed an intimate affair. The more likely truth is that both men were enjoying a literary flirtation. Over the next few years, Le Gallienne and Wilde maintained a respectful friendship, with the younger writer contributing to *The Star* one of the most detailed and thoughtful reviews of Wilde's *Salome*.

More than thirty-five years later, when he published his engaging *Romantic '90s* (1925), Le Gallienne warmly acknowledged Wilde's "accustomed generosity" in a period when the long-deceased Irishman's reputation remained somewhat sullied.[171] By the time Le Gallienne died at Menton aged eighty-one, his bibliography included dozens of volumes. Nevertheless, even in old age he remained indissociable from the fin de siècle. In 1943, his publisher Grant Richards stated that while Le Gallienne had come to treasure his adopted home of France, it remained the case (as Richards remarked) that this self-styled "*humble member of the writing fraternity*" was still a child of the early 1890s: "*as for his work, his manner, his handling of the English language, they now seem to have changed hardly at all.*"[172] Richards, who established his own influential publishing house in 1897, recalls that in the early 1890s Le Gallienne caught attention through *English Poems* (1892), a popular collection that John Lane had designed in a "*light straw-coloured paper board*" so that it looked "*divinely beautiful.*"[173] Although *English Poems* was issued at the same time as Symons's *Silhouettes*, the cultural temper of Le Gallienne could not have been more distinct: he "*loved not modern France – nor its versifiers.*"[174] "*He was,*" Richards adds, "*repelled by the literary 'Decadence' that was then fashionable.*"[175] Le Gallienne makes his contempt for this emergent literary development plain enough in "The Décadent to His Soul," in which this new type of supposedly immoral French artist despises the godly soul: "His face grew strangely sweet – / As when a toad smiles. / He dreamed of a new sin: / An incest 'twixt the body and the soul."[176]

As Harrington shows, several of the works in Le Gallienne's *English Poems* appeal to an English tradition of revered poetry, and these particular works intimate that modern national poetry remains in a mood of belated disappointment. In "Autumn," for example, his speaker laments

that fin-de-siècle English verse "Hath lost the early magic of [Keats's] tongue."[177] Moreover, he rejects the critical consensus that Keats is an exemplary poetic icon worthy of emulation. In adopting this stance, Le Gallienne is not alone among the Rhymers. G.A. Greene, for example, assumes that his lyric moves in a state of directionless "drifting," one that no longer has a ready-made audience: "I cannot tell what echoes of my breath / Are caught by listeners on the riverside: / I and my song glide onward unto death."[178] Even in the realm of romance, the Rhymers at times express disillusionment. Ernest Radford reminds us that long gone are the days when "sweet maidens" and "Strong men" expressed awe at the prospect of feeling Cupid's arrows pierce the flesh.[179] Harrington reveals that several of these poets embrace a type of effete, domesticated, and demoralized manhood that prefers suburban home life to the commercial rat race of the metropolitan marketplace. This preference, she observes, reveals their attempts at shoring up their pronounced sense of diminished poetic potency. As we see in chapter 5, there is a discernible pattern among several Rhymers of repudiating commerce only to identify with, and arguably colonize, what Harrington characterizes as types of "feminine ennui" (194).

Megan Becker-Leckrone, in chapter 6, focuses on a significant but somewhat understudied aspect of Beerbohm's extraordinary creativity: his "improved" (or, as some critics call them, "altered") personal books, many of which contain exceptionally detailed drawings that fill the endpapers, title pages, and margins of editions that captivated him. Many of these "improved" volumes only became known when Beerbohm's private library went up for auction at Sotheby's in 1960, at which time most of the items were quickly dispersed among various British and American libraries. The "improved" copies were not for exhibition or publication, although they contain drawings that resemble those that won Beerbohm rapid fame in the 1890s. Especially important here is Beerbohm's devotion to caricaturing Wilde, in ways that are ambivalently affectionate and taunting. In 1893, as an undergraduate, Beerbohm furnished a drawing titled "The New Culture" for a special "Eights Week" edition of the *Oxford Magazine*. In the bottom right-hand corner, an obese Wilde, with cascading double chins, is smoking what we may reasonably assume is an opium-charged hookah, one that seems to have been magicked by a genie floating aloft. (Meanwhile, a policeman and a begowned don look as if they wish to discipline several male students adopting effete poses in different parts of the drawing.) The style bears comparison with the unflattering

caricature of Wilde that Beerbohm published the following year in the heavily illustrated comic journal *Pick-Me-Up*, which advertised itself as "A Literary and Artistic Tonic for the Mind."[180] Moreover, the irreverent *Pick-Me-Up* caricature of a heavyset Wilde has more than one or two features in common with Beerbohm's drawing of an obese, dandified George IV in the third volume of *The Yellow Book*.

Beerbohm's impudent drawings from 1893 and 1894, together with the ones in *A Peep into the Past* (an amusing essay, dating from 1893, that pokes fun at the fêted Wilde as "an old gentleman" who was once "in his way quite a celebrity"),[181] bear an intimate relation with those that he carefully inscribed in two 1891 editions of Wilde's *Intentions*, the volume that established Wilde as a major essayist. Still, as Becker-Leckrone observes, the pains Beerbohm took with his humorous, and sometimes merciless, depictions of the portly aesthete Wilde are much greater than in the drawings he shared with the public. Moreover, these amusing images take risks with representing Wilde's homosexuality, which had become such a source of gossip at Oxford when he was consorting there with his lover Alfred Douglas.

In chapter 7, Julie Wise focuses on the deceptively lucid lyrics of Dollie Radford, a skilful poet who gained notice in the early 1880s under her unmarried name (Caroline Maitland) in the radical, anti-establishment magazine *Progress*, co-edited by the freethinkers G.W. Foote and Edward Aveling. At the time, Radford moved in a circle of highly accomplished women who congregated at the Reading Room of the British Museum. She maintained friendships with feminists such as Amy Levy, Eleanor Marx, Beatrice Potter, and Olive Schreiner. In the years following her marriage to Ernest Radford in 1883, her characteristically unelaborate lyrics began to appear in a broad range of journals, including the shilling monthlies *London Society* and *Argosy* as well Edmund Yates's fashionable *Time*. When Radford's first volume, *A Light Load*, was brought out by Elkin Mathews in 1891, it received a commendatory review from Symons in *The Academy*. Symons immediately grasps "the prettily and whimsically modest title" of a collection in which each of the succinct lyrics appears "finished in style."[182] Moreover, Symons praises the "delicate, remote echoes of the poets who have written the most haunting of lyrics – of [Heinrich] Heine, of [Alfred] Tennyson."[183] These observations draw attention to the understated but knowledgeable manner in which Radford's ostensibly unburdened poems reflect thoughtfully on the genre of song: the term that gives the title to the larger proportion of the forty-six works she brings together in *A Light Load*.

Wise concentrates her attention on a distinctive aspect of Radford's songs: their recognition that adult relations with lyric are complicated by the assumption that the genre should express a consoling simplicity, a simplicity that her poetry often connects with the world of children. "Night," for example, recognizes the enshrouding presence of that entity through the atmospheric "mists of violet light" as well as "the purple clouds" that enwrap the moon. Still, night – at least for the poetic voice – has appeared "too soon."[184] Even though "Sleep" is the feminine "fair love" of the implicitly male "Night," she is not yet ready to turn her "sweet face to the skies"; instead, she lingers among shadows, where her lips "kiss our children's eyes."[185] As Wise shows, in the broader scope of *A Light Load*, Radford's lyrics often acknowledge that the domestic world is separated between the lives of adults and those of the children for whom they care. Even if childcare places a limit on the poet's capacity to sing, it is still the case that in her role as a mother she derives joy from the time she spends playing with her charges before bedtime. Since Radford also wrote poetry for children, her polished prosody and straightforward diction appear sensitive to any accusations of naivety that might be levelled against her art.

Wise's discussion pursues Radford's identity as both a poet and a mother in relation to a photograph that appears in a calendar titled *Modern Poets* that Marcus Ward & Co. issued in 1897. This publisher, who was known for his role as "Illuminator to the Queen," had been recognized since the 1870s for his colour-illustrated calendars featuring the work of the admired artist Kate Greenaway, who was also celebrated for her children's books. As Wise discovered in Radford's archive, held at UCLA's Clark Library, the attractive image of the poet gazing upward at the camera has undergone careful treatment. The original photograph adapted for the calendar features Radford as a young mother with an infant nestling in her arms. By 1897, when Radford enjoyed prominence as an increasingly political poet in journals such as *The Yellow Book*, her oldest child was a teenager and her youngest eight years old. To Wise, the treated image raises significant questions about the "absent children" (236) whose presence hovers off-scene in lyrics such as "Night." Through a series of highly attentive analyses, Wise detects that the understated lyric voice that we find, for example, in "Spring-Song," acknowledges that children, just before they go to sleep, "Look up to see the young moon hold / The old moon to her breast."[186] Here, the moon, with its close association with maternal love, augurs a universe in which "young hopes beat within a heart / Grown old in loving you."[187] Ultimately, the double

aspect of the moon suggests that a child's heart continues to beat in adult life, in ways that ensure that one's "hopes" for the future remain infinite.

Moons, however, as Kasey Bass shows in chapter 8, had a rather different range of associations for the outstanding exponent of lyric Mary Coleridge, a London-born and privately educated writer who grew up in an artistic family with a distinguished literary pedigree. As several scholars have observed, Coleridge – whose historical fiction came to attention in 1893 – has proved a little hard to place within the literary history of the fin de siècle. She had no close ties with any of the aforementioned writers, she was not linked with the Decadence of *The Yellow Book*, her writings do not suggest any direct engagement with feminist politics, and – although two of her volumes were issued by Elkin Mathews – her essays, novels, and poetry mainly attracted the attention of conservative male authors such as Robert Bridges and Henry Newbolt, who were known, respectively, for their hymnody ("All My Hope on God Is Founded" is a good example) and imperialist verse ("Vitaï Lampada" proved popular among schoolboys). Bridges, a deeply Christian thinker who gained recognition as a poet in late middle age, was responsible for encouraging C.H.O. Daniel, fellow of Worcester College, to publish Coleridge's first volume, *Fancy's Following* (1896), which appeared under the Greek name "Anodos" in a fine letterpress edition of 125 copies.

By the time of her sudden death from appendicitis in 1907, when she was forty-five years old, Coleridge had completed a substantial oeuvre. In a memorial essay published two months after her demise, Bridges compared her lyrics favourably with those of Heinrich Heine, with which she had deep acquaintance. In the preface to the posthumous volume of *Poems* (1908), Newbolt acknowledges that Coleridge's output was not as spare as some critics might imagine, given that she left no fewer than three hundred poems. Still, when reflecting on this large canon, Newbolt admits that there are somewhat unsettling aspects of the "thought ... clothed in so slender a form."[188] He sounds a little apologetic when he speaks of her affective "inconsistency."[189] Even though she could transform "sorrow into a more perfect mode of being," she still "wrote down in frank words the bitterness of a moment's agony."[190] What is more, he appears troubled that her lyrics on occasion stage enigmatic scenarios. Newbolt remains struck by the frequent "times when she entered the very deep shadows filled with strange shapes, that may move a timid soul or two to ask if it be safe to follow her."[191]

As Newbolt's comments suggest, the rather eerie spectral presences that populate the lyrics on which Coleridge built her reputation retain

their power to amaze. The most famous work is arguably "The Other Side of a Mirror," a lyric in which the troubled poetic voice recalls staring at her "glass one day," where she "conjured up a vision bare."[192] In regular four-beat lines, she remembers witnessing a "vision of a woman, wild," with a caesura announcing the disconcerting nature of the female image that looked back at her.[193] "Her lips were open," we read, "not a sound / Came through the parted lines of red."[194] Heather L. Braun has suggested that the astounding reflection is that of a femme fatale: a familiar icon of monstrous female sexuality that Victorian readers knew from imperial romances such as H. Rider Haggard's *She* (1883).[195] As the five stanzas unfold, the poetic voice remembers witnessing the image's "lurid eyes," in which there was at once the "dying flame of life's desire," "the leaping fire / Of jealousy," and "fierce revenge, / And strength that could not change nor tire."[196] In principle, the horrifying figure that haunts the silvered surface could not be more different from the decorous female speaker. Nonetheless, once Coleridge's lyrical "I" demands that the "shadow of the glass" never "more return," she cannot help but whisper her stunned recognition that we find in her last three words: "I am she!"[197] In the end, all the contemptible attributes that the lyric voice has repudiated in the reflection's female subjectivity promptly transform into an admission of the woman speaker's otherwise repressed identity.

Bass dwells on a less familiar but equally distinguished lyric, "In Dispraise of the Moon." In her searching analysis, one that draws on the largely untapped resources of the Coleridge archive at Eton College, Bass explores why Coleridge might wish to "dispraise" an icon that has such a close connection, as it has for Meynell, with femininity. By examining the ways in which the lyric engages with Coleridge's preoccupation with the resonances of the moon, Bass demonstrates how Coleridge's fine lyric discloses that "the 'Moon' and even the poetic 'I' are literary devices, ones laden with the weight of cultural assumptions that one might want to question and even reimagine" (263). Especially significant here is Coleridge's perception that the "dim, uncoloured, voiceless hosts" that her speaker espies on the moon's surface may not have their own source of radiation but still point to the fact that the lunar satellite, in a differently conceived way, is its own "sun of ghosts."[198] In other words, the moon may not be a source of light but she still glimmers with spectral reflections.

Part III of *Extraordinary Aesthetes* contains two chapters that consider the political and cultural legacies of the artistic fin de siècle. In chapter 9, So Young Park examines the largely neglected career of the Irish poet Dora

Sigerson, who met her husband – the eminent editor Clement Shorter – at the London home of her friend, compatriot, and fellow poet Katharine Tynan in 1894. As Park points out, even though Sigerson published extensively for three decades, with several works making crucial interventions supporting the Irish nationalist struggle, little is known about her career. After placing several poems in the Catholic *Irish Monthly*, Sigerson's first collection, *Poems*, attracted mixed attention in the press. In a review that Tynan published in *The Sketch*, a striking three-quarter photographic portrait of her occupies much of the left-hand column of a page. (In the right-hand column, a similarly large portrait of a nicely bow-tied Le Gallienne presents him looking directly back at the reader.) "Hers is not," Tynan writes, "an exquisite little gift, early perfected."[199] Instead, Sigerson shows great promise of what will eventually mature as "a large gift." Even though such opinions sound somewhat belittling, Tynan shrewdly perceives that the guiding preoccupation of Sigerson's *Poems* is empathy. "This young writer," we read, "has puzzled over things that trouble at most but transiently the young heart. The oppression of the weak, the sacrifice to, not our needs, but our luxuries, of our brothers and sisters, the beasts and birds, the common law of sickness and sorrow and death, the kingdom of evil upon earth – these are the things which in her earnest poems give her pause for sadness and for questioning."

Park's inquiry is among the first to focus on Sigerson's developing poetics of radical empathy, which grew increasingly contentious over time. This searching discussion reveals how Sigerson's second collection, *The Fairy Changeling* (1898), which John Lane issued in a finely printed edition, beseeches an English audience to recognize the urgent political plight of the Irish nation. A few years earlier, in 1893, the Second Home Rule Bill had won the support of the House of Commons, only to suffer a veto in the House of Lords. Like Yeats's nationalism, Sigerson's was immersed in Irish folklore. She came from an eminent Dublin household; her famous parents, George and Hester Sigerson, were central to the Irish Literary Revival and the Gaelic Revival as well as the hosts of an influential salon that brought together key nationalist figures like Patrick Pearse and Roger Casement. *The Fairy Changeling*, as Park shows, follows in the tradition that shaped much of Yeats's early writings, though in Sigerson's case there is a noticeable emphasis on "strong women characters who resist capture, steal precious wine, or fight for their lives with haunting power" (297).

The Great War was a particular source of devastation to Sigerson because it resulted in the deaths of thousands of Irish people at a time

of intense nationalist resistance. Her broadside poems, which appeared in a very limited edition issued by her husband in 1916, address topics that were highly volatile in Britain at the time. Her poetry deplores controversial matters such as the British execution by hanging of Casement for treason; it also sets the British subjection of Ireland in a broad global context that acknowledges how imperial power has oppressed other populations, an example being Japan's annexation of Korea in 1910. As Park explains, it has proved rather difficult for literary historians to engage with Sigerson's forthright political poetry since Tynan advanced the view that the poet's health deteriorated after the Easter Rising and the horrors of the 1914–18 war "broke her heart."[200] The truth is that Sigerson did everything in her power to honour the "sixteen dead men" who died for their country. And she did so not only in verse but also through sculpture, as we see in her *Monument to Patrick Pearse and His Comrades*, which stands at the entrance to Glasnevin Cemetery, Dublin (figure 9.1).

In the tenth and final chapter, Kristin Mahoney returns our attention to the insistent afterlife of fin-de-siècle culture. As Mahoney observes, there has long been a tendency to trust a literary-historical narrative that conforms with the view that an aggressive publication such as Wyndham Lewis's *BLAST* (1914) brought about a decisive rupture with the Decadent culture of the 1890s. With its large, bold-faced typography, Lewis lists in his "Manifesto" each and every cultural, literary, and political figure who must be blasted, as it were, to smithereens. Among the individuals Lewis wishes to pulverize are "Mr. and Mrs. Dearmer" and "Clan Meynell": a sure sign that these artists and writers were sufficiently significant at the time to become targets worthy of obliteration.[201] Mahoney points as well to Ezra Pound, whom Elkin Mathews approached to edit the poetry of Lionel Johnson, a queer poet who came to prominence through the Rhymers' Club. This was a task that Pound regarded with some scepticism, since he believed that the commission involved keeping a clearly superannuated poet's reputation undeservingly alive. Still, as Mahoney reveals, it proved hard to eradicate the memory of the fin de siècle, as we see not only in the studies by Murdoch and Jackson but also in other significant inquiries, including Bernard Muddiman's *The Men of the Nineties* (1920), Osbert Burdett's *The Beardsley Period* (1925), and Le Gallienne's *Romantic '90s* (1925). Even though the reputations of Mabel Dearmer and Alice Meynell declined during the interwar period, it was still the case that both Elkin Mathews and John Lane remained committed to the writers whose works they had issued during the close of the Victorian epoch. More to the point, both of these publishers embraced

prominent modernists as well. Mathews brought out Pound's earliest collections: *Exultations* (1909), *Canzoni* (1911), *Ripostes* (1915), *Cathay* (1915), and *Umbra* (1920). Besides *BLAST*, Lane's company put into print the first authorized edition of James Joyce's *Ulysses* in 1936. Assuredly, Lane himself had died eleven years before. Nonetheless, his legacy was instrumental in ensuring that readers in Britain at last had access to a major work that had suffered needless censorship both there and in the United States.

The task of recovering the exceptional breadth of fin-de-siècle art and writing began concertedly in the postwar era, with path-breaking studies such as Frank Kermode's *Romantic Image* (1957), which restored Symons's position as a high-ranking critic who "saw how to synthesise the earlier English tradition – particularly Blake" with "Pater and those European Symbolists he knew so well."[202] Twenty years later, Linda Dowling, in her invaluable annotated bibliography *Aestheticism and Decadence* (1977), presciently observed that the developing critical investigations into the field "will insist ... upon the diversity, vitality, and experimental richness of fin de siècle literary culture."[203] Two decades further along, the editors of *Women and British Aestheticism* (1999) drew close attention to the achievements of several key figures – including Vernon Lee and Rosamund Marriott Watson – who were subsequently the subject of full-length biographies. Ever since, scholarship in the field has continued to flourish.[204] As I hope to have shown in this introduction, *Extraordinary Aesthetes* belongs to the unfolding rediscovery of the period's intense artistic energies, a period whose determination to confront a recognizably modern world retains such resonance in our own time.

NOTES

1 Algernon Charles Swinburne, "Hymn to Proserpine," in *Poems and Ballads* (London: John Camden Hotten, 1866), 78.

2 Walter Pater, *Studies in the History of the Renaissance* (London: Macmillan, 1873), xi. Pater's volume went through three further revised editions under the title *The Renaissance: Studies in Art and Poetry* in 1877, 1888, and 1893.

3 Pater, *Studies*, xi.

4 Pater, viii.

5 Pater, 213.

6 Oscar Wilde, "The English Renaissance of Art," *The Collected Works of Oscar Wilde*, ed. Robert Ross, 14 vols. (London: Methuen, 1908), 14:257.

7 W. Blaikie Murdoch makes passing reference to the work of the artists Alethea Gyles and Pamela Coleman Smith; see *The Renaissance of the Nineties* (London: Alexander Moring, 1911), 17 and 177. On Gyles, see Kristin Mahoney, "Irish Decadence, Occultism, and Sacrificial Myth: The Martyrdom of Althea Gyles," in *Literature and the Politics of Post-Victorian Decadence* (Cambridge: Cambridge University Press, 2015), 118–52; on Smith, see Stuart R. Kaplan, with Mary K. Greer, Elizabeth Foley O'Connor, and Melinda Boyd Parsons, *Pamela Coleman Smith: The Untold Story* (Stamford: US Games Systems, 2018).

8 Murdoch, *The Renaissance of the Nineties*, 39. As Murdoch acknowledges, the term "Renaissance of Wonder" is elaborated by Theodore Watts-Dunton in his essay, "The Renascence of Wonder," in *Chambers' Cyclopædia of English Literature*, ed. David Patrick, 3 vols. (London: Chambers, 1904), 3:1–10. The phrase enjoyed some critical currency during this period. (The spelling, in Chambers, is "Renascence.")

9 Murdoch, *The Renaissance of the Nineties*, 46. In the preface to the second revised edition of his collection, Symons discusses one reviewer's disparaging observation that his volume *Silhouettes* (1892) had an "unwholesome … faint smell of Patchouli about them" (London: Leonard Smithers, 1896, [xiii]). Catherine Maxwell, in *Sense and Sensibility: Perfume in Victorian Literary Culture* (Oxford: Oxford University Press, 2017), 264, observes that the scent, which was imported into Britain around 1850, had by the fin de siècle earned a "cheap, louche, and unsubtle reputation," for it was associated with female prostitutes. In Symons's "Love and Art," in *The Second Book of the Rhymers' Club* (London: Elkin Mathews and John Lane, 1894), 45, the poetic voice recalls the "odour of patchouli" as a "gay scent" that he detects from a female passer-by.

10 Thea Burns, *The Invention of Pastel Painting* (London: Archetype, 2007), xvii.

11 Arthur Symons, "Pastel," in *Silhouettes* (London: Elkin Mathews and John Lane, 1892), 13; further quotations appear on this page.

12 Lady Colin Campbell, "A Plea for Tobacco," *English Illustrated Magazine* 121 (1893), 81.

13 Paul Bourget, "Psychologie contemporaine : notes et portraits – Charles Baudelaire," *La Nouvelle revue* 13 (November–December 1881), 398–416, quoted in Alex Murray, "Introduction: Decadent Histories," in *Decadence: A Literary History*, ed. Murray (Cambridge: Cambridge University Press, 2020), 5.

14 Murray, "Introduction," 5.

15 [Anon.], "Fin de Siècle," *Author* 1 (1891), 177.

16 [Anon.], "Fin de Siècle," 178.

17 Arthur Symons, "The Decadent Movement in Literature," *Harper's New Monthly Magazine* 87 (1893): 859.

18 Walter Pater, "Romanticism," *Macmillan's Magazine* 35 (1876), 65.

19 Pater, "Romanticism," 65.

20 Pater, 65.

21 Symons, "The Decadent Movement," 858.

22 Symons, 859.

23 Symons, 859.

24 Symons, 859.

25 Symons, 859.

26 Symons, 859.

27 Symons, 859.

28 William Ernest Henley, "Before Operation," in "Hospital Outlines: Sketches and Portraits," *Cornhill Magazine* 32 (1875), 122.

29 Symons, "In the Night," in *Silhouettes*, 75.

30 William Ernest Henley, "Nocturn," in "In Hospital: Rhythms and Rhymes," *A Book of Verses* (London: David Nutt, 1888), 43.

31 Henley, "Nocturn," 44.

32 Symons, "The Decadent Movement," 867.

33 Symons, 867.

34 Jerome Hamilton Buckley, *William Ernest Henley: A Study of the Counter-Decadence of the 'Nineties* (Princeton: Princeton University Press, 1945), 184.

35 Buckley, *William Ernest Henley*, 185.

36 E.W.G. [Edmund W. Gosse], "A Plea for Certain Exotic Forms of Verse," *Cornhill Magazine* 36 (1877), 59.

37 Henley, "If I Were King," in *A Book of Verses*, 163.

38 Oscar Wilde, "A Note on Some Modern Poets," *Woman's World* 2 (1888–9), 108.

39 Wilde, "A Note of Some Modern Poets," 108.

40 Wilde, 108.

41 Gosse, "A Plea for Certain Forms of Exotic Verse," 65.

42 Henley, "Of a Toyokuni Colour-Print," in *A Book of Verses*, 117.

43 Henley, "Of a Toyokuni Colour-Print," 117.

44 Henley, 117.

45 Wilde, "A Note on Some Modern Poets," 109.

46 Oscar Wilde, "The Decay of Lying," in *Criticism: Historical Criticism, Intentions, The Soul of Man*, ed. Josephine M. Guy, in *The Complete Works of Oscar Wilde*, 11 vols. to date (Oxford: Oxford University Press, 2000–), 4:98.

47 Wilde, "The Decay of Lying," 4:98.

48 Henley, "Of a Toyokuni Colour-Print," 118.

49 Stefano Evangelista, *Literary Cosmopolitanism in the English* Fin de Siècle*: Citizens of Nowhere* (Oxford: Oxford University Press, 2021), 75.

50 James Abbott McNeill Whistler, *The Gentle Art of Making Enemies* (London: William Heinemann, 1890), 3. John Ruskin's comment appears in "Letter LXXIX," 18 June 1877, in *Fors Clavigera: Letters to the Workmen and Labourers of Great Britain* 4 (Orpington: George Allen, 1877), 73. The case *Whistler v Ruskin* was heard at the Queen's Bench Division of the High Court of Justice in November 1878. Linda Merrill reproduces the proceedings of the case in *A Pot of Paint: Aesthetics on Trial in Whistler v Ruskin* (Washington, DC: Smithsonian Institution Press, 1992), 133–216.

51 Whistler, *The Gentle Art of Making Enemies*, 7.

52 Whistler, 8.

53 Whistler, 8.

54 Whistler, 8.

55 Whistler, 8.

56 John Davidson, "New Year's Day," in *Fleet Street Eclogues* (London: Elkin Mathews and John Lane, 1893), 3.

57 Murdoch, *The Renaissance of the Nineties*, 36.

58 Davidson, "New Year's Day, 3–4.

59 Davidson, 4.

60 Davidson, 4.

61 Davidson, 5.

62 Davidson, 9.

63 Davidson, 4.

64 Davidson, 12.

65 Davidson, 14.

66 Davidson, "A Ballad of a Nun," in *Ballads and Songs* (London: John Lane, 1894), 54. The poem appeared as "The Ballad of a Nun," *The Yellow Book* 3 (1894), 273–9.

67 Davidson, "A Ballad of a Nun," 55.

68 Davidson, 56.

69 Davidson, 57.

70 Davidson, 61.

71 Davidson, 61.

72 H.D. Traill, "Two Modern Poets," *Fortnightly Review* 57 (1895), 406.

73 Arthur Quiller-Couch, "A Literary Causerie: Mr. Davidson's Ballads," *Speaker*, 24 November 1894: 573.

74 Harry Quilter, "The Gospel of Intensity," *Contemporary Review* 67 (1895), 776.

75 Quilter, "The Gospel of Intensity," 776.

76 Quilter, 775.

77 Quilter, 775.

78 John Davidson, *A Full and True Account of the Wonderful Mission of Earl Lavender, which Lasted One Night and One Day: With a History of the Pursuit of Earl Lavender and Lord Brumm by Mrs. Camler and Maud Emblem* (London: Ward & Downey, 1895), 126.

79 Davidson, *A Full and True Account*, 126.

80 [Anon.], "Trials at the Old Bailey," *Lloyd's Newspaper*, 19 July 1863, 4.

81 [Anon.], "Trials at the Old Bailey," 4.

82 Ian Gibson, *The English Vice: Beating, Sex, and Shame in Victorian England and After* (London: Duckworth, 1978), 250.

83 Gibson, *The English Vice*, 250.

84 Davidson, *Earl Lavender*, 135–6.

85 Davidson, iv. The poem appears as "Proem to 'The Wonderful Mission of Earl Lavender,'" *The Yellow Book* 4 (1895), 284–5.

86 Linda Gertner Zatlin, *Aubrey Beardsley: A Catalogue Raisonné*, 2 vols. (New Haven: Yale University Press, 2016), 2:160.

87 A.M.S., "The Art of Aubrey Beardsley," *The Speaker*, 26 March 1898, 387.

88 A.M.S., "The Art of Aubrey Beardsley," 387.

89 A.M.S., 388.

90 Margaret Armour, "Aubrey Beardsley and the Decadents," *Magazine of Art* 20 (1897), 12.

91 See entry for "Night-Bird," in John S. Farmer, ed., *Slang and Its Analogues Past and Present: A Dictionary, Historical and Comparative of the Heterodox Speech of All Classes of Society for More than Three Hundred Years*, 7 vols. (London: privately printed, 1890–1904), 5:42.

92 W.B. Yeats, "Introduction," in *Representative Irish Tales*, ed. Yeats, 2 vols. (New York: G.P. Putnam's, 1891), 1:15–16, quoted in by Murdoch, *The Renaissance of the Nineties*, 17.

93 Samuel Ferguson, "Preface," in *Congal: Poem in Five Books* (Dublin: Edward Ponsonby; London; Bell and Daldy, 1872), vii.

94 W.B. Yeats, "Bardic Ireland," *Scots Observer*, 4 January 1890, 183.

95 Yeats, "Bardic Ireland," 183.

96 Yeats, 183.

97 Yeats, 183.

98 W.B. Yeats, "Song of the Happy Shepherd," in Yeats, *The Poems*, 2nd ed., ed. Richard J. Finneran (New York: Scribner, 1997), 1. The poem first appeared in *Crossways* (1889).

99 Yeats, "Song of the Happy Shepherd," 1.

100 Yeats, 1.

101 Yeats, 2.

102 Yeats, 2.

103 Yeats, 2.

104 Yeats, 2.

105 W.B. Yeats, "The Lake Isle of Innisfree," in *The Poems*, 35; further quotations appear on this page. The poem previously appeared in the *National Observer*, 12 December 1890: 96, and in *The Book of the Rhymers' Club* (London: Elkin Mathews, 1892), 84.

106 Filson Young, "The Tyranny of the Eighteen-Nineties," *Saturday Review*, 8 November 1913, 585.

107 Beerbohm's phrase appears in "Diminuendo," in *The Works of Max Beerbohm* (London: John Lane, 1896), 164, quoted in Holbrook Jackson, *The Eighteen Nineties: A Review of Art and Ideas at the Close of the Nineteenth Century* (London: Grant Richards, 1913), 17.

108 Jackson, *The Eighteen Nineties*, 21.

109 Arthur Symons, *The Symbolist Movement in Literature* (London: William Heinemann, 1899), 8. Symons dedicates the volume to Yeats. In a prefatory note, Symons observes that Yeats is the "*chief representative*" of the "*Irish literary movement*," a development that belongs to similar movements "*spreading throughout other countries*" (v; emphasis in original).

110 Symons, *The Symbolist Movement*, 9.

111 Symons, 9.

112 Symons, 10.

113 Jackson, *The Eighteen Nineties*, 66.

114 [Anon.], "Notes," *National Observer*, 6 April 1895, 547.

115 Jackson, *The Eighteen Nineties*, 62.

116 Oscar Wilde, "The Critic as Artist," in *Criticism*, ed. Guy, 4:204, quoted in Max Nordau, *Degeneration*, trans. anon. (London: William Heinemann, 1895), 322.

117 Nordau, *Degeneration*, 322.

118 Nordau, 322.

119 Nordau, 322.

120 Jackson, *The Eighteen Nineties*, 63.

121 Jackson, 63–4.

122 Jackson, 64.

123 Rudyard Kipling, "Fuzzy-Wuzzy (Soudan Expeditionary Force)," in *Ballads and Barrack-Room Ballads* (London: Macmillan, 1892), 141.

124 Kipling, "Fuzzy-Wuzzy," 141.

125 Kipling, 141.

126 Kipling, 142.

127 [Anon.], Review of Kipling, *Barrack-Room Ballads and Other Verses*, *The Athenæum*, 14 May 1892, 629. Kipling's popular ballads also met with scepticism.

Francis Adams, for example, observed that the speech of Kipling's Tommy "has the true contagion of the best music-hall patter song of the hour," but he also questioned whether the undoubtedly "clever doggerel, attractive doggerel" was truly "inspired doggerel." Adams, "Mr. Kipling's Verse," *Fortnightly Review* 54 [1893], 597.

128 Adams, "Mr. Kipling's Verse," 597.

129 Jackson, *The Eighteen Nineties*, 293.

130 G.B.S. [George Bernard Shaw], "Valedictory," *Saturday Review*, 21 May 1898, 683.

131 Max Beerbohm, "A Defence of Cosmetics," *The Yellow Book* 1 (1894), 67.

132 Max Beerbohm, "Note on George the Fourth," *The Yellow Book* 2 (1894), 249.

133 Beerbohm, "Note on George the Fourth," 252–3.

134 Beerbohm, 256. Elagabalus (or Heliogabalus) (*c.* 204–22) was a Roman emperor notorious for his sexual transgressions.

135 Beerbohm, 249.

136 Young, "The Tyranny of the Eighteen-Nineties," 585.

137 Jackson, *The Eighteen Nineties*, 170.

138 Jackson, 170.

139 Amy Levy, *The Romance of a Shop* (London: T. Fisher Unwin, 1888), 101.

140 Eleanor Marx quoted in Max Beer, *Fifty Years of International Socialism* (London: George Allen & Unwin, 1935), 73.

141 Sarah Grand, "The New Aspect of the Woman Question," *North American Review* 158 (1894): 271.

142 Grand, "The New Aspect of the Woman Question," 271.

143 Grand, 272.

144 Ouida, "The New Woman," *North American Review* 158 (1894), 615.

145 Ouida, "The New Woman," 614.

146 Sarah Grand, *The Heavenly Twins*, 3 vols. (London: William Heinemann, 1893), 3:253.

147 George Egerton, "A Cross Line," in *Keynotes* (London: Elkin Mathews and John Lane, 1893), 11.

148 Sydney Grundy, *The New Woman: An Original Comedy, in Four Acts* (London; Chiswick Press, 1894), 28.

149 Grundy, *The New Woman*, 28.

150 See Sally Ledger, "The New Woman and Feminist Fiction," in *The Cambridge Companion to the Fin de Siècle*, ed. Gail Marshall (Cambridge: Cambridge University Press, 2007), 153–4.

151 Linda Dowling, "The Decadent and the New Woman in the 1890s," *Nineteenth-Century Fiction* 33, no. 4 (1979): 447.

152 Israel Zangwill, "Without Prejudice," *Pall Mall Magazine* 7 (1895): 157.

153 Charles Hiatt, *Picture Posters: A Short History of the Illustrated Placard* (London: George Bell, 1896), 224.

154 [Anon.], "Mrs. Percy Dearmer ay Home," *Sketch*, 26 June 1895, 485. The interview features a full-length portrait of Dearmer and her design for Richard Le Gallienne's bookplate.

155 Stephen Gwynn, *Experiences of a Literary Man* (London: Publisher, 1926), 69.

156 [Anon.], "With the British Nurses in Serbia," *Sphere*, 25 December 1915, 328.

157 [Coventry Patmore], "English Metrical Criticism," *North British Review*, 27 (1857): 69.

158 See Yopie Prins, "Patmore's Law, Meynell's Rhythm," in *The Fin-de-Siècle Poem: English Literary Culture and the 1890s*, ed. Joseph Bristow (Athens: Ohio University Press, 2005), 261–84; and Meredith Martin, *The Rise and Fall of Meter: Poetry and English National Culture, 1860–1930* (Princeton: Princeton University Press, 2012), 198–203.

159 Pater, *Studies in the History of the Renaissance*, 213.

160 Pater, 207.

161 Pater, 209.

162 Pater, 210.

163 Alice Meynell, "A Remembrance," in *The Rhythm of Life and Other Essays* (London: Elkin Mathews and John Lane, 1893), 12.

164 Meynell, "Decivilised," in *The Rhythm of Life*, 9.

165 Meynell, "Rejection," in *The Rhythm of Life*, 81.

166 Meynell, "Rejection," 82.

167 Meynell, 82.

168 Gwynn, *Experiences of a Literary Man*, 138.

169 This information is given in Richard Ellmann, *Oscar Wilde* (New York: A.A. Knopf, 1988), 283; Neil McKenna, *The Secret Life of Oscar Wilde* (London: Century, 2003), 89; and Matthew Sturgis, *Oscar: A Life* (London: Head of Zeus, 2018), 370. Wilde continued to make hyperbolic gestures in his correspondence with Le Gallienne; on receiving a copy of the young writer's *George Meredith: Some Characteristics* (1890), he wrote: "I hope so much to see you … I hope your laurels are not too thick across your brow for me to kiss your eyelids" (in *The Complete Letters of Oscar Wilde*, ed. Merlin Holland and Rupert Hart-Davis [London: Fourth Estate, 2000], 457).

170 The poem, which is in manuscript, appears in *The Complete Letters of Oscar Wilde*, 367.

171 Richard Le Gallienne, *The Romantic '90s* (New York: Doubleday, Page, 1925), 260.

172 Grant Richards, "To an Old Friend – Homage," in Le Gallienne, *In a Paris Garret* (London: Richards Press, 1943), v.

173 Richards, "To an Old Friend – Homage," v.

174 Richards, v.

175 Richards, v.

176 Le Gallienne, "The Décadent to His Soul," in *English Poems* (London: Elkin Mathews and John Lane, 1892), 106.

177 Le Gallienne, "Autumn," in *English Poems*, 85. The poem first appeared as "To Autumn" in *The Book of the Rhymers' Club*, 67–8.

178 G.A. Greene, "Drifting," in *The Book of the Rhymers' Club*, 82.

179 Ernest Radford, "Love and Death (Æsop's Fable)," in *The Book of the Rhymers' Club*, 13.

180 Max Beerbohm's caricature of Wilde, which appears in *Pick-Me-Up*, is reproduced in Joseph Bristow, "Introduction," in *Wilde Writings: (Con)textual Conditions*, ed. Bristow (Toronto: University of Toronto Press, 2003), 19.

181 Max Beerbohm, *A Peep into the Past* (n.p.: privately printed, 1923), 9.

182 Arthur Symons, review of Dollie Radford, *A Light Load*, *Academy*, 13 June 1881, 557.

183 Symons, review of Dollie Radford, 557.

184 Dollie Radford, "Night," in *A Light Load* (London: Elkin Mathews, 1891), 37.

185 Radford, "Night," 37.

186 Dollie Radford, "Spring-Song," in *A Light Load*, 1.

187 Radford, "Spring-Song," 1.

188 Henry Newbolt, "Preface," in Mary E. Coleridge, *Poems* (London: Elkin Mathews, 1908), xii.

189 Newbolt, "Preface," vi.

190 Newbolt, xi–xii.

191 Newbolt, xii.

192 Coleridge, "The Other Side of a Mirror," in *Poems*, 8.

193 Coleridge, "The Other Side of a Mirror," 8.

194 Coleridge, 9.

195 See Heather L. Braun, "'Set the crystal surface free': Mary E. Coleridge and the Self-Conscious Femme Fatale," *Women's Writing* 14 (2007): 496–509.

196 Coleridge, "The Other Side of a Mirror," 9.

197 Coleridge, 9.

198 Coleridge, "In Dispraise of the Moon," in *Poems*, 60.

199 K.T. [Katharine Tynan], "Dora Sigerson's Poems," *Sketch*, 6 December 1893, 319; further quotations appear on this page.

200 Katharine Tynan, "Dora Sigerson: A Tribute and Some Memories," in Sigerson, *The Sad Years* (London: Constable, 1918), xii.

201 Wyndham Lewis, "Manifesto – II," *BLAST: Review of the Great English Vortex* 1 (1914): 21.

202 Frank Kermode, *Romantic Image* (London: Routledge and Kegan Paul, 1957), 107.
203 Linda C. Dowling, *Aestheticism and Decadence: A Selective Annotated Bibliography* (New York: Garland, 1977), xxi.
204 See Kathy Alexis Psomiades and Talia Schaffer, eds., *Women and British Aestheticism* (Charlottesville: University of Virginia Press, 1999); Vineta Colby, *Vernon Lee: A Literary Biography* (Charlottesville: University of Virginia Press, 2003); and Linda K. Hughes, *Graham R: Rosamund Marriott Watson, Woman of Letters* (Athens: Ohio University Press, 2005).

PART I

NEW WOMEN, FEMALE AESTHETES, AND THE EMERGENCE OF DECADENCE

Impressionistic Photography and the *Flâneuse* in Amy Levy's *The Romance of a Shop*

S. BROOKE CAMERON

Amy Levy's novel, *The Romance of a Shop* (1888), opens with both trag-edy and excitement. The four adult sisters – Gertrude, Lucy, Phyllis, and Fanny Lorimer – have lost their father and, with him, a long-term finan-cial means of support. The women are in deep mourning, but they are also extremely enthusiastic at the possibility of embracing a new life of employment and self-subsistence. The siblings together decide they will move from suburban Campden Hill to central London and set up a pho-tography studio. As part of this new life, the women will redefine typical Victorian gender roles:

> "Gertrude and I," went on Lucy, "would do the work, and you Fanny, if you would, should be our housekeeper,"
> "And I," cried Phyllis, her great eyes shining, "I would walk up and down outside, like that man in High Street, who tells me every day what a beauti-ful picture I should make."[1]

Lucy and Gertrude will essentially fulfil the roles of the man, by working and financially supporting the household. Fanny, the oldest, will play the role of a typical Victorian wife and tend to the house, an assignment that makes sense given that – as Lucy previously disclosed – her older sister "was behind the ages ... belonging by rights to the period when young ladies played the harp, wore ringlets, and went into hysterics" (56). It is perhaps Phyllis's contribution (or lack thereof) that is the most interest-ing. Phyllis will not work within (or out of) the house; instead, she plans to keep herself occupied with strolls through the city. Yet her description of these walks is notable precisely for its reference to the *man* who walks about the metropolis enjoying sights such as Phyllis herself, the "beauti-

ful picture." Phyllis's self-conscious construction of herself as a "picture" reminds us of the complex role of Victorian photography in creating narratives of the self. On the one and practical hand, this technology will buy the sisters access to the city and, with it, the financial rewards necessary to reimagining themselves as economically independent New Women. On the other and more abstract hand, photography also presents the sisters with a new medium through which to frame themselves and their world, a new technology or medium of selfhood.

Over the last two decades, several critics have offered illuminating scholarship on the complex role of Victorian photography in constructing narratives of selfhood. Scholars such as Jennifer Green-Lewis, Nancy Armstrong, Daniel Novak, and Patrizia Di Bello have focused on photography's role in the tension between realism and fiction, or narratives of life as it is and life as it ought to be.[2] In *Framing the Victorians* (1996), Green-Lewis promises to read "particular photographs *in* history, studying the development of the idea of photography *through* history, and considering the shaping influence of photography in historical debate between differing accounts of the experiential world."[3] Following in Green-Lewis's footsteps, Armstrong's touchstone work *Fiction in the Age of Photography* (1999) looks at the critical role of photography in the emergence of realist narratives, explaining how realist fiction and photography in tandem participate in the construction of a new culture founded upon visual memory, one wherein selfhood depends upon a process of identification and differentiation with the visual type.

This development marks the advent of a new cultural narrative founded upon the image or a visual order of things.[4] The idea of a self-conscious language of the visual is taken up by and extended in Novak's *Realism, Photography, and Nineteenth-Century Fiction* (2008). Like Armstrong, Novak pursues the interdependence between media, arguing that Victorians "read photography as a form of literary fiction and literary fiction as a form of photographic representation."[5] Yet whereas Armstrong focuses on the photograph's illusion of the real, Novak shifts our attention to the photographic image as constructed, citing the Victorians' passion for collage and pastiche. As Novak argues, "it is precisely the abstract nature of photographic representation – its tendency to homogenize details and identities" – that provides "the enabling condition of a certain [realist] kind of literary narrative."[6] Complementing Novak, Di Bello in *Women's Albums and Photography* (2007) argues that photographic collage is central to Victorian narratives of selfhood. By shifting the focus to questions of gender, she explains how "photographic albums, collage, and mixed

media techniques were, by the mid-nineteenth century, already suited to a self-conscious and questioning representation of the contradictions, problems and pleasures of femininity within modernity, even before they were taken up by avant-garde or feminist artists."[7]

While Phyllis's effort to imagine a new urban selfhood draws on the language of photography, it also references the notion of city wandering, or *flânerie*. Tied to her fantasy of pictures is the idea of wandering about and enjoying – if not becoming one of – the city's pleasurable images. This mode of visual consumption is thus both the means to and reward of the sisters' work as urban photographers. I am not the first to point to the central role of *flânerie* in Levy's works and writing on female self-fashioning. Anne-Marie Richardson's "The Consenting Silence" (2019) looks at how the four newly orphaned Lorimer sisters defy traditional expectations of women in such situations – including expectations of marriage and suitable guardians (as articulated by Aunt Caroline Pratt) – in order to act as one another's chaperones in laying claim to women's equal rights to the modern cityscape.[8] Richardson's analysis builds on a longer tradition of feminist scholarship, including Deborah Epstein Nord's *Walking the Victorian Streets* (1995), a book that appreciates Levy's aesthetic response to the city as – in particular – a place of sexual danger.[9] As Nord writes, "the metropolis offered anonymity, community, and distance from provincial and familial expectations, but it also proved a difficult and threatening place to be a woman alone."[10] In *The Romance of a Shop*, Nord finds a frank and realistic representation "conveying how difficult and yet how exhilarating it was to be a woman alone in London in the 1880s."[11] The sisters' experiments in *flânerie* are what make the city a location of excitement as well as possibility. Picking up on this last idea, Kate Flint's "'The Hour of Pink Twilight'" (2009) looks at how such experiments in female *flânerie* open up for women new avenues of sexual transgression and sexual self-fashioning.[12] In novels such as Levy's *Romance of a Shop*, Flint sees fin-de-siècle New Woman novelists imagining alternative and pleasurable urban communities of women and what might even become a kind of underground lesbian form of slumming.

Only recently have critics shifted our attention to the central role of photography in *The Romance of a Shop*. David Wanczyk's "Framing Gertrude" (2015), for example, looks at how the camera facilitates an introspective and affective realist point of view in Levy's novel, while Elizabeth F. Evans and Kate Flint focus more extensively on gender and the role of professional photography in underwriting women's urban mobility.[13] In an exploration of women in public space and the new vocation of the

self-employed shop girl, Evans's "'We Are Photographers, Not Mounte-banks!'" (2010) argues that Levy's Lorimer sisters "challenge popular and literary expectations for shop girls and New Women … [By] manipu-lating the gaze of spectators and turning the lens outward, Levy's new public women negotiate their own representation to forge both inde-pendent and respectable London lives."[14] In "Photographic Memory" (2009), Flint views *The Romance of a Shop* as part of a larger cultural invest-ment in "photographic memory" as it "is related to the popular under-standing of the potential, and the limitations, of the material attributes of the medium of photography."[15]

Yet whereas Flint concentrates on the flashback and memory, I instead want to focus on the novel's investment in the female photographer's immediate perception. How might we connect the novel's use of flash technology with its dual investment in *flânerie* or, rather, in looking as an embodied and sensory experience? As Di Bello points out, we must not forget the tactile aspect of the image, that which we touch and, in turn, which touches or affects us: "all touch has a reflective element, it feels not just the world out there, but oneself touching it."[16] After all, Phyllis's comment begs us to consider how photography and *flânerie* fit together, particularly in terms of female self-fashioning through embodied look-ing. And as Phyllis knows, she is both looking and looked at: a dynamic that suggests a highly mediated concept of self through types or a shared cultural vocabulary of the image. This is, as critics such as Nord and Flint emphasize, the particular dilemma of the late-Victorian *flâneuse*: How can a woman enjoy the pleasures of the cityscape when she is, all the while, circumscribed within cultural expectations that reduce her to an object – not subject – of the gaze. In Levy's novel, the photograph is critical to women's transformation into agents of the gaze and, by exten-sion, the cultural image. To make this point, then, this chapter sets out to demonstrate that Levy's novel is invested in not just flash technology but, specifically, the artistic movement of impressionistic photography. With reference to the latter, *The Romance of a Shop* offers a new female form – or visual type – who frames herself and her gaze through a self-conscious medium of visual gender types. At the same time, through her negotia-tion of this visual language, she also claims for herself the pleasurable gaze and, in this way, the opportunity to write a new frame or visual type for female self-fashioning. By claiming photography as a medium for the feminine gaze, Levy's innovative novel helps pave the way for many extraordinary feminist aesthetes and gender radicals in the subsequent decade of the 1890s.

The Romance of the Shop and the Female *flâneur*

By the end of the nineteenth century, as many commentators have observed, the *flâneur* was a popular figure in urban fiction and poetry. The *flâneur* casually strolls through the city sampling the sights. He has no explicit path or purpose; rather, he walks aimlessly, drifting from experience to experience. As Susan David Bernstein writes, the term *flâneur* itself refers to "an urban wanderer who observes the varieties of urban culture from a distance."[17] The idea of *flânerie* was first made popular by the nineteenth-century Parisian poet Charles Baudelaire.[18] In his famous essay "The Painter of Modern Life" (1863), Baudelaire describes how the *flâneur* wanders the city in search of stimulation. He is part of the crowd and yet set apart by virtue of his voyeurism:

> The crowd is his element, as the air is that of birds and water of fishes. His passion and his profession are to become one flesh with the crowd. For the perfect *flâneur*, for the passionate spectator, it is an immense joy to set up house in the heart of the multitude, amid the ebb and flow of movement, in the midst of the fugitive and the infinite. To be away from home and yet to feel oneself everywhere at home; to see the world, to be at the centre of the world, and yet to remain hidden from the world – impartial natures which the tongue can but clumsily define. The spectator is a prince who everywhere rejoices in his incognito.[19]

The *flâneur*'s city strolls are marked by a unique form of "passionate" spectatorship. As Baudelaire explains, it is the *flâneur*'s "profession" to "become one flesh with the crowd," yet this infiltration of the city sphere and its crowd is marked by a persistent distance or separation. His true passion or joy depends upon his privilege of seeing without being seen: "he is a prince who everywhere rejoices in his incognito." Baudelaire's description of the *flâneur* as set apart ("incognito") – or what Bernstein calls "distance" – concentrates attention on the separation and power divide between the one who looks and the object at which he looks. As a result, most critics agree that the *flâneur* is typically an upper-class masculine subject, for it is usually men who enjoy the social, economic, and political power necessary to such detached, leisurely visual consumption. Phyllis's comment would seem to align the act of urban looking with men and herself, a woman, with the city objects available for the *flâneur*'s visual pleasure.

So, a pressing question emerges: is such a phenomenon as the female *flâneur* – or *flâneuse* – possible? Feminist critics such as Janet Wolff have struggled with this inquiry. As Wolff explains in "The Invisible Flâneuse"

(1990), "there is no question of inventing the *flâneuse*; the essential point is that such a character was rendered impossible by the sexual divisions of the nineteenth century."[20] As Wolff writes, the urban women who do appear in Baudelaire's poems and essays include the prostitute, the widow, the old lady, the lesbian, the murder victim, and the passing unknown woman.[21] For Wolff, "what is missing in this literature is any account of life outside the public realm, of experience of 'the modern' in its private manifestations, and also of the very different nature of the experience of those women who *did* appear in the public arena: a poem written by 'la femme passante' about her encounter with Baudelaire, perhaps."[22] The present chapter takes up Wolff's challenge and suggests that Levy's novel addresses those women who appeared in the public realm and dared to look back at Baudelaire's *flâneur*. For as we see in Levy's novel, and as shown in a wealth of recent scholarship, the last two decades of the Victorian era saw a major influx of women into the cities and the modern marketplace. These women happily wandered the city window shopping,[23] worked in the shops as attendants,[24] wore bloomers, and rode bicycles,[25] and many rather innovative women were even successful at setting up and personally running urban shops.[26] Levy's novel encourages us to consider the unique challenges faced by these women as they lay claim to this city space and its pleasures. As I argue, Levy's *flâneuse* is inescapably framed in terms of gender, which then influences how others respond to her urban gaze.

Levy's *Romance of the Shop* is an attempt to imagine this female *flâneur*: the urban woman who enjoys the city and, more important, looks back at her male counterpart. In the opening scene, the Lorimer sisters embrace this idea of gender and economic independence with enthusiasm. Yet, as we see in later episodes, it is Gertrude, and not Phyllis, who becomes the true *flâneuse*. Indeed, it is during Gertrude's omnibus ride to the British Library that we have the first real example of the woman's urban gaze:

> Gertrude mounting boldly to the top of an Atlas omnibus.
>
> "Because one cannot afford a carriage or even a hansom cab," she argued to herself, "is one to be shut up away from the sunlight and the streets?"
>
> Indeed, for Gertrude, the humours of the town had always possessed a curious fascination. She contemplated the familiar London pageant with an interest that had something of passion in it; and, for her part, was never inclined to quarrel with the fate which had transported her from the comparative tameness of Campden Hill to regions where the pulses of the great city would be felt distinctly as they beat and throbbed. (80)[27]

It is important to note that Gertrude is travelling to the library to read a "course" of books on photography. This self-education will help her build her shop and reputation as a professional photographer. In other words, she is not only taking in the sights of the city but also making that critical move from the private world of female domesticity to the public realm of the city and economic independence.

Even before *The Romance of a Shop* appeared, photography had established itself as a rare field open to average individuals and, importantly, to women. In an 1851 census, fifty-one British citizens listed their occupation as "photographer" – and this was just over a decade after the invention of photography.[28] Suddenly, aristocratic amateurs such as Henry Fox Talbot could take up the camera and make their mark in the history of art. Even more impressive, this category of the upper-class amateur was open to women, including such notable contributors as Julia Margaret Cameron and Lady Clementina Hawarden.[29] As Mary Warner Marien writes, it was easier for women to obtain training in professional photography than in sculpture or painting, and while women were excluded from many art academies, photography studios regularly advertised for female students or apprentices.[30] All of this, Marien adds, was part of the medium's convergence with democratic movements and the growth of the middle class over the course of the century.[31] As Di Bello has more recently pointed out, women were key players in imagining and even stretching the limits of what photography could do and mean. Di Bello looks at the ways in which "idiosyncratic images of amateurs like ... Julia Margaret Cameron," with their clear investment in fiction and collage, tested the distinctions between "manual and mechanical methods of portrait making."[32] Such "elaborately and obviously set up" portraits forced critics and consumers of photography to ask probing questions about what is "real" and what is "authentic," what is art and what is science.[33]

At the same time, these women used photography to redefine gender roles, thereby pushing the boundaries of what the respectable woman should look like. Should she be safely framed by her family within the domestic sphere? Di Bello cites important contributions from "photographers like Clementina Hawarden and Julia Margaret Cameron, whose work transcends the need to celebrate upper-class values."[34] Hawarden is best-known for her portrait series of women (often her own daughter) posed beside a window or mirror, meditations on the female gaze and self-reflection that provocatively anticipate Levy's own study of the

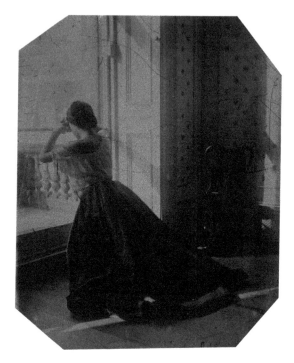

Figure 1.1 Lady Clementina Hawarden, *Clementina, Maude, 5 Princess Gardens* (1862). (© Victoria and Albert Museum, London, 457:410-1968.)

female as spectator (figures 1.1 and 1.2). With their own modest urban photography shop, the Lorimer sisters build on the legacy of these early female photographers; but they add to this history a new perspective on the camera as a tool for the *flâneuse* as she encounters the modern city and its impressionistic experiences.

The Female Photographer and the Impressionistic Gaze

Before I delve into the female photographer's impressionistic gaze, I must first quickly trace Levy's discussion of the *flâneuse* and women's access to the city. As Nord writes, "Levy's first novel shares the urban sensibility of her 'London Plane Tree' poems but combines it with a self-consciously female urbanism."[35] What Nord means is that the woman cannot move about the city undetected, like Baudelaire's *flâneur*; rather,

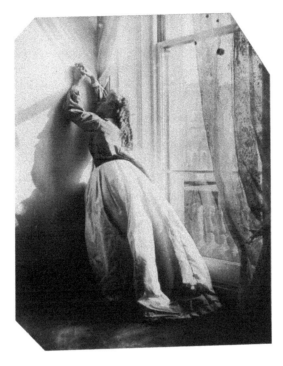

Figure 1.2 Lady Clementina Hawarden, *Clementina, Maude* (*c.* 1862–3).
(© Victoria and Albert Museum, London, 457:454-1968.)

the urban woman is always acutely aware of her gender as a factor limiting her urban gaze. Consequently, Nord continues, "the *flâneuse* remains a thing of the imagination; the gaslight must be enjoyed by women in private."[36] Yet as we have already seen, Gertrude *does* step out of the private domestic sphere in order to sample the pleasures of urban spectatorship. As Evans argues, "Levy illustrates how a natural desire to enjoy greater participation in urban life is incompatible with restrictions on what respectable women with limited financial resources might do without damage to their reputations."[37] In other words, finances or economic means are of first and foremost importance in freeing up women's urban mobility and enabling them to enjoy the city without risking their social reputation. The photography studio, Evans adds, will give the sisters this kind of uncompromised liberation:

Making both a home and a business for themselves in the urban market-
place, the Lorimer sisters challenge popular and literary expectations for
shops girls and New Women. By manipulating the gaze of spectators and
turning the lens outward, Levy's new public women negotiate their own
representation to forge both independent and respectable London lives.[38]

The transition to professional photographer enables the Lorimer sisters
to "seek a precarious balance in their self presentation."[39] The siblings,
Evans explains, "not only produce images for the marketplace by run-
ning a photography studio but also become spectacles as women in busi-
ness and participants in urban life."[40] Building on Evans's work, I am
interested in not only how the professional New Women photographer
gains access to the city (as both object and subject of the gaze), but also
how she then uses this precarious position to look back at the *flâneur* and
to produce a new form of female *flânerie*.

It is important to observe that, as the previous passage shows, Gertrude
does not just observe the city at a distance; the sights and energy of this
urban environment have a powerful affect upon her physical senses. She
looks around with a "curious fascination," which suggests that central
London in some way both awes and transfixes her. Watching from her
omnibus perch, she projects a "passion" onto the passing pageant, thus
signalling a deep emotional investment in what she sees. But it is the
energy or "pulses" of the city that penetrate her skin, to the point that we
can't tell whether the "beating" and "throbbing" is the city or her own
excited heart. The syntax of the sentence is deliberately ambiguous, for
the verb "felt" suggests a transmission of "pulses" from the city to the
viewer.

This notion of urban viewership as a profoundly stimulating experi-
ence is perhaps best captured in Georg Simmel's well-known sociological
study, "The Metropolis and Mental Life" (1903). We can imagine why
a fin-de-siècle sociologist like Simmel would be drawn to this equation
between Gertrude's "fascination" and her highly stimulated state. As Sim-
mel explains, the city does indeed excite the senses, and this stimulation
in turn awakens our consciousness. Urban impressions thus give way to
the psychological process of differentiation:

> Man is a differentiating creature. His mind is stimulated by the difference
> between a momentary impression and the one which preceded it. Last-
> ing impressions, impressions which differ only slightly from one another,
> impressions which take a regular and habitual course and show regular and

habitual contrasts – all these use up, so to speak, less consciousness than does the rapid crowding of changing images, the sharp discontinuity in the grasp of a single glance, and the unexpectedness of onrushing impressions. These are the psychological conditions which the metropolis creates.[41]

It takes a psychologically attuned mind to tell the difference between impressions, those "lasting" differences within a series. But most important here is Simmel's comment that the metropolis "creates" these psychological conditions. The newness of this urban condition is something that Gertrude herself seems to recognize when she draws a comparison between the "tameness of Campden Hill to regions where the pulses of the great city would be felt distinctly as they beat and throbbed." Her observation echoes Simmel's claim regarding the difference between urban and rural environments: "With each crossing of the street, with the tempo and multiplicity of economic, occupational and social life, the city sets up a deep contrast with small town and rural life with reference to the sensory foundations of psychic life." Rural life is slow and methodical. It is the city, with its "rapid crowding" of sensations, that awakens the mind and thus forms the psychological individual. The city awakens those processes of "discrimination"; urban individuals need, first of all, to think, and they need, second of all, to think quickly.

The novel's investment in photography can be explained in terms of the rapid flux of this highly stimulating urban environment. More to the point, Levy's *flâneuse* requires a new way of seeing and experiencing this urban environment. Enter photography. New technologies of representation are needed to capture the now lightning-fast pace of urban experience. At one point, the narrative even drops an offhand reference to the new Waverly Pen – a new type of fountain pen designed for fast and uninterrupted writing (73).[42] Yet it is in the novel's form that we best sense an alignment between the new technologies of photography and representation of the urban experience. The story is fast-paced, with a heavy emphasis on dialogue-driven episodes. It is as if we are given, as Bernstein suggests, a series of "snapshots" of the Victorian city.[43] The narrative only slows down in order to paint a detailed picture of looking, or the now urban photographer's gaze.

The best example of this kind of shift from rapid snapshots to a distilled and focused frame occurs early in the story when Gertrude is called upon to photograph Lord Watergate's deceased wife. Initially, Gertrude is visually overwhelmed by the situation: "Here the blinds had been raised, and for a moment Gertrude was too dazzled to be aware with any

great clearness of her surroundings" (86). Then her eyes adjust and she
begins to take in and focus on the image of her surroundings. Note the
attention to superficial detail or "appearances":

> Drawn forward to the middle of the room, well within the light from the
> windows, was a small, open bedstead of wrought brass. A woman lay, to all
> appearance, sleeping there, the bright October sunlight falling full on the
> upturned face, on the spread and shining masses of matchless golden hair. A
> woman no longer in her first youth; haggard with sickness, pale with the last
> strange pallor, but beautiful withal, exquisitely, astonishingly beautiful. (86)

There are two important developments in this scene. First, there is Ger-
trude's photographic attention to detail; and second, there is the incred-
ible attention to surface over and above depths of meaning. Like a camera,
Gertrude's gaze moves across and captures the visual terrain, noting for
example the way the sunlight falls across the woman's "upturned face,"
and how she looks "haggard" yet "beautiful" all the same. We would not
realize, from an initial glance at this passage, that Lady Watergate is dead.[44]

But she is, of course, dead. And it is noteworthy that a deep or pen-
etrating reading (meaning and comprehension) is only achieved once
Gertrude sets up and looks through the camera. At first, Gertrude
"instinctively refrain[s] from glancing in the direction of [the] second
figure," Lord Watergate; yet only seconds later, "her faculties stimulated
to curious accuracy, set to work with camera and slide" (86). Camera
in hand, she can then focus on and accurately see, or understand, the
spectacle before her:

> As she stood, her apparatus gathered up, on the point of departure, the
> man by the window rose suddenly, and for the first time seemed aware of
> her presence.
>
> For one brief, but vivid moment, her eyes encountered the glance of
> two miserable grey eyes, looking out with a sort of dazed wonder from a
> pale and sunken face. The broad forehead, projecting over the eyes; the
> fine, but rough-hewn features; the brown hair and beard; the tall, stooping,
> sinewy figure: these together formed a picture which imprinted itself as by
> a flash on Gertrude's overwrought consciousness, and was destined not to
> fade for many days to come. (87)

As before, Gertrude's gaze moves across surfaces, recording with detail
the visual composition of this scene: the man's "broad forehead," his

rough-hewn features," and "two miserable grey eyes." This scene, in turn, shapes Gertrude's "consciousness." Her mind works like the camera, recording the image permanently – as if her consciousness is transformed into a photographic negative. The very idea of the scene "flashing" upon her brain replicates the technology of the camera wherein the flash of light moves from the object to the camera, where its image is then imprinted upon the plate. Kate Flint describes such references to this technology as an example of the way Levy's novel "points, whether wittingly or otherwise, to the potential that flash and photography, working together, brought to the formulation of ideas about how memory function[s] – ideas ... encapsulated in the cinematographic flashback."[45] Yet the technology of flash in this scene also refers to the present and to photography's affective potential. In her earlier encounter with the deceased wife, Gertrude quickly glossed over details in rapid succession; by contrast, her visual impression of Lord Watergate is transformed into single focused negative that is fixed or imprinted upon her brain to last "for many days to come."

Gertrude's turn inward, from the image outside to the image flashing upon her brain, reminds us of what many scholars have described as the intensely introspective possibilities of the photographic medium. These critics see in Victorian photography not just an effort to make sense of and organize the world "out there" but also an interrogation of the self vis-à-vis this visual terrain. In her own pioneering work, Green-Lewis frames this as a series of questions: "Where does the image exist? Beyond the eye? In the eye? In the brain? And to what degree, therefore does the onlooker affect the sight of the perceived?"[46] Green-Lewis prompts us to ponder where seeing begins and whether the image is in fact a representation of the real world or, rather, a projection of the observer's "brain." We must also wonder whether this observer thus affects this outer world, including the perceived and its ability to look back or make itself understood in terms other than those expected and projected. We can certainly see this returned gaze in that moment when the "two miserable grey eyes" look back in "dazed wonder" as if demanding recognition and dialogue. By looking back, these two eyes disrupt Gertrude's expectations, her efforts to frame the room; the eyes thus reverse the feed, so to speak, so that looking is no longer directed outward but now works inward like a flash on her brain.

More recently, critics such as Novak have taken up Green-Lewis on her implicit suggestion that the image serves as the visual medium through which one constructs narratives of selfhood. Novak tells the story of

photography not as "fact," in the sense of capturing the real, but rather as "fiction": a process of projection and collage in which bodies and identities are built through an assemblage of parts – hence the interdependency between literature and photography. As Novak writes, Victorians "read photography as a form of literary fiction and literary fiction as a form of photographic representation."[47] In his analysis of nineteenth-century fiction and photography, particularly photographic albums, he examines the Victorian relish for disassembling and reassembling images so as to violate the body's integrity in order to create alternative and desirable fictions of identity and selfhood. In his conclusion, Novak remarks that these "photographic fictions ... defined and produced the impossible and the abstract."[48] Gertrude's photographic method is no different. We can assuredly see, in the above scene, a form of collage and the abstract in the way in which she gathers together and eventually processes visual data. Everything is in parts: from the eyes, to the forehead, to the hair and beard. We have a complete body or image of the body only after it is all pasted together and framed as a negative flashing upon her brain.

The hyper-self-conscious aspect of this photographic scene also recalls nineteenth-century debates about photography and its relationship with art. In Victorian times, art historian and literary critic Lady Elizabeth Eastlake argues that true art requires some kind of imaginative input or expression from the artist. Photography, she argues, is simply too mechanistic for such purposes. The camera is a technology of exact reproduction, not creative insight or individual expression. Hence, the camera reduces the artist to a mere slave of the machine – the means of mechanical reproduction. It is for this reason, Eastlake contends, that photography is a science and not an art form: "For everything for which Art, so-called, has hitherto been the means but not the end, photography is the allotted agent – for all that requires mere manual correctness, and mere manual slavery, without any employment of the artistic feeling, she is the proper and therefore the perfect medium."[49] Photography is the means to, but not the ends of, "Art." As the means, it is thus closer to a science. Photography's job as a science, she maintains, is to record the facts or to mechanically reproduce an image. By contrast, real art (the "ends") depends upon the artist's own creative contribution, or his/her individuality. Only the latter can rightfully be called art in that only it delivers those insights or "truths which should accompany the further finish."[50]

Lady Eastlake therefore disagreed with photographers such as Sir William Newton who used techniques, not as a means to reproduce a scene, but rather as a means to record the artist's experience of looking.

Newton argued that the somewhat unfocused picture, "though less *chemically*, would be found more *artistically* beautiful."[51] Other photographers, such as Peter Henry Emerson, objected to highly stylized or composed images; even so, Emerson like Newton was interested in the experience of looking, and he would consequently take pictures out of focus. As Emerson reasoned, "nothing in nature has a hard outline, but everything is seen against something else, and its outlines fade gently into something else, often so subtly that you cannot distinguish clearly where one ends and the other begins."[52]

Emerson's 1886 photograph *Gathering Water Lilies* (figure 1.3), for example, is shot slightly out of focus, thus forcing the viewer to pay as much attention to how we see as to what we see.[53] We have visual input of a scene, but then we must filter these various details in order to map their relationships to one another and to the scene as a whole. The effect is repeated in other photographs such as his *Rowing Home the Schoof-Stuff* from the same year (figure 1.4). Emerson's photographs make us pay attention to seeing as an impressionistic experience – an experience that requires a self-reflexive approach to looking. This response reminds us very much of Simmel's own discussion of the urban gaze, with its emphasis on impressionistic experience and the mental life it awakens.

This emphasis on how – as opposed to what – one sees is central to late-Victorian urban photography. Improvements in technology had led to highly sensitive negatives that required a mere fraction of a second in exposure time, thus marking a radical change from the earlier daguerreotype (with its collotype and collodion plate), which required exposure times ranging from multiple seconds to even minutes. By the end of the century, improvements in camera lenses and shutters were permitting accurate exposures at $1/16$ of a second.[54] These new cameras were thus able to capture the rapid movement and electric energy of the city. For example, Paul Martin's 1890s *Magazine Seller, Ludgate Circus* depicts not only the rather downtrodden-looking magazine seller but also, in the background, a horse-drawn carriage as it rushes through the city street (figure 1.5). The slight blurring of the horse's front left hoof suggests the speed of this urban traffic.[55] Through this blurring, the viewer is reminded that in the city we not only see speed but also must therefore look and calculate quickly as the urban life rushes by or calls out to us.

Take, as another example from the 1890s, Martin's *Dancing to the Organ, Lambeth* (figure 1.6). Here the quick flash of the camera is able to capture the equally fast movement of the young girl dancing in the city street. The

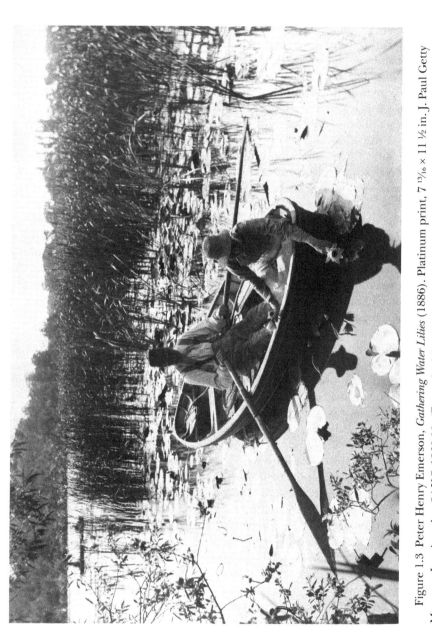

Figure 1.3 Peter Henry Emerson, *Gathering Water Lilies* (1886). Platinum print, 7 ¹³/₁₆ × 11 ½ in. J. Paul Getty Museum, Los Angeles. 84.XO.1268.10. (From the Metropolitan Museum of Art, New York, NY, Gilman Collection, Purchase, Mrs. Walter Annenberg and the Annenberg Foundation Gift, 2005.)

Figure 1.4 Peter Henry Emerson, *Rowing Home the Schoof-Stuff* (from *Life and Landscape in the Norfolk Broads* [1886], Plate XXI) (1886). Platinum print from glass negative. Image: 13.8 × 27.9 cm (5 7/16 × 11 in). Mount: 28.6 × 41 cm (11 1/4 × 16 1/8 in). Sheet (Interleaving Plate Sheet): 28.2 × 40.8 cm (11 1/8 × 16 1/16 in). (From the Metropolitan Museum of Art, New York, NY, Gilman Collection. Purchase, Mrs. Walter Annenberg and the Annenberg Foundation Gift, 2005.)

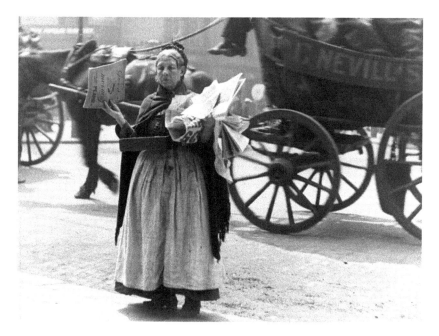

Figure 1.5 Paul Martin, *Magazine Seller, Ludgate Circus* (*c.* 1890s). Gelatin-silver
print. Victoria and Albert Museum, London, 1893–1936. (Digital Image
© The Museum of Modern Art / Licensed by SCALA / Art Resource,
NY. Gift of the artist to the museum.)

camera is so fast that we have little blurring of her feet, and only the pedes-
trian in the background is out of focus as he rushes past this urban scene
preoccupied with his own thoughts and business. Such a background
image reminds us that, as with "The Magazine Seller," urban space is not
only speeding by but also densely populated and full of random and/or
brief encounters; while one person is dancing or working, another one
passes by barely noticed, or photographed, in the background.

Inspired by the new technology, some fin-de-siècle photographers drew
direct comparisons between urban consumerism and visual consump-
tion. In Eugène Atget's photographs, for example, Paris is portrayed as a
space of consumerism, wherein the city and its wares elicit the spectator's
desires and need for quick choices and calculations. The camera, in turn,
acts as a mediator by representing the act of looking as an experience
of desire. In *Boulevard de Strasbourg, Corsets, Paris*, the photographic gaze
is arrested by a selection of women's undergarments in a shop window
(figure 1.7), and in the image of the female prostitute at Versailles, from

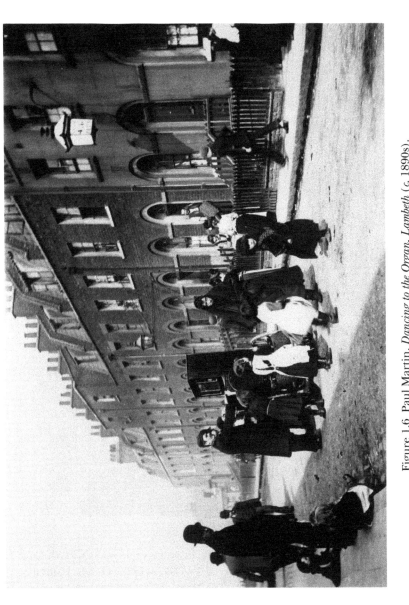

Figure 1.6 Paul Martin, *Dancing to the Organ, Lambeth* (*c.* 1890s).
(Photograph from V&A Images / Alamy Stock Photo.)

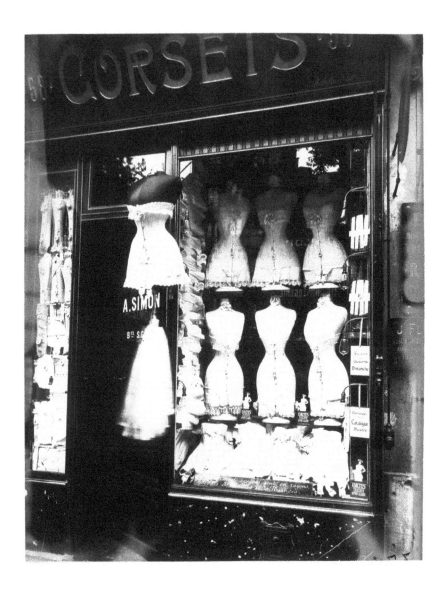

Figure 1.7 Eugène Atget, *Boulevard de Strasbourg, Corsets, Paris* (1912). Gelatin silver print from glass negative. Image: 22.4 × 17.5 cm (8 ¹³⁄₁₆ × 6 ⅞ in.) Mount: 36.7 × 28.7 cm (14 ⁷⁄₁₆ × 11 ⁵⁄₁₆ in.). (The Metropolitan Museum of Art, New York, NY Gilman Collection, Purchase, Ann Tenenbaum and Thomas H. Lee Gift, 2005.)

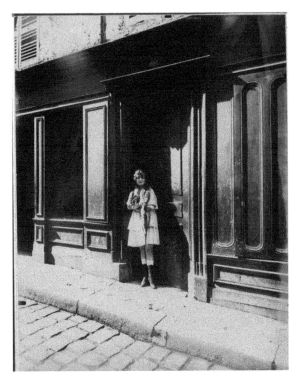

Figure 1.8 Eugène Atget, *Versailles, Maison Close, Petit Place* (1921).
Gelatin silver chloride printing-out paper print, 8 ⁹/₁₆ × 6 ⁷/₁₆ ins.
(Digital Image © The Museum of Modern Art / Licensed by
SCALA / Art Resource, NY. Abbott-Levy Collection.
Partial gift of Shirley C. Burden.)

1921, this seduction is made explicit as the camera pauses to contemplate her allure (figure 1.8).

In *The Romance of a Shop*, Gertrude's urban gaze clearly taps into this notion of photography as a medium for meditating on spectatorship. More important, however, is how her intense self-reflection begins to look like a kind of impressionistic construction of the self and consciousness, a move that is, again, in keeping with Victorian innovations in art and photographic theory. Marien explains how fin-de-siècle photographers such as George Davison (1854–1930) expanded on Emerson's

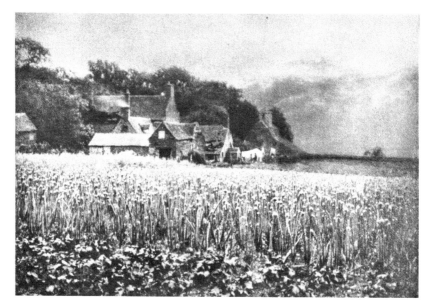

Figure 1.9 George Davison, *The Onion Field* (1890), from *Camera Work* 18
(1907). Photogravure (printed 1907). Image: 6 ⅛ × 8 ⅛ inches (15.5 × 20.6 cm).
Sheet: 7 ¹³⁄₁₆ × 11 ¹⁄₁₆ inches (19.8 × 28.1 cm). Accession number: 1966-205-
18(1). (From the Philadelphia Museum of Art.
Gift of Carl Zigrosser, 1966.)

model (much to the latter's annoyance) in order to create pictures that
were similar self-reflexive meditations on the manner in which one sees.
However, Davison pushed things further, making the move to impression-
ism. Davison used the photographic medium as a way to explore emo-
tional impressions, not just sensory ones. As Marien explains, "whereas
Impressionism, the French art movement of the 1870–80s, aimed at cap-
turing a momentary visual input of a scene, impressionistic photography
attempted to render a personal response to a subject."[56]

We have, for example, Davison's *The Onion Field* (figure 1.9), in which
the "entire surface ... is indistinct"; contrast this with Emerson's pho-
tography, where at least the "main subject was in focus."[57] As Marien
elaborates: "The blur in Davidson's image was produced using a pinhole
camera which softened edges and imparted a dreamy haze not neces-
sarily present at the time of exposure. Printed as a gravure, a technique

favored by Pictoralists because it suppressed detail, the image seems to have flowed into the fabric of the paper upon which it was printed."[58] Davison's blurred image resists focus and thus pushes us past the realm of sight into deeper probing questions of mental perception, consciousness, and emotion. The effect, as Marien points out, is a "dreamy haze" that forces us to think about consciousness and those deeper mental feelings. By ushering us into the realm of the abstract through deliberate manipulation of the technology, "Davison thus shifted the foundation of art photography from science to art."[59]

In Levy's remarkable novel, Gertrude's mind mimics the technology behind the impressionistic photograph as well as its intensely self-reflexive effects. For instance, early in the novel she is called upon to photograph the deceased Mrs. Watergate. Gertrude's mind jumps from a rapid catalogue to a final focused image, or photographic picture. Her eyes move across a surface, noting the elements and processing them in order of difference and distinction. Only through this process of data gathering can she make sense of her surroundings. More important, however, that final flash replicates the idea of how such images come to form a lasting impression. A stark opposition is established between her "overwrought consciousness" and the still frame that then "forms" upon her mind. It is as if those "dazzling" images have now slowed down and gathered themselves together into a single and stable form, a picture. In these final moments, then, Gertrude is jolted into consciousness by the photographic gaze.

Women, Photography, and the Urban Gaze

The most impressive consequence of Levy's exploration of the impressionistic photographic image is the novel's ingenious ability to rewrite gender roles – specifically, women's relationship with the urban gaze. We must not forget the other important aspect of the scene that represents the mutual gaze between Gertrude and Lord Watergate. We are, at this point, reminded of Di Bello's important inquiry into nineteenth-century albums. Di Bello traces the Victorian woman's interest in image-making and the self-conscious negotiation and reproduction of selfhood: "elite women started using informal amateur images or collage and mixed media techniques, to personalize their albums, visualize affective ties, and show-off personal connections"; "women's albums used these materials and techniques with conscious scepticism and

ambiguity to play elite games and make 'in' jokes about identity, familial and sexual relations."[60] These highly reflexive and mediated images – fragments pasted together through watercolour, collage, narrative, jokes, and so on – are not entirely different from the impressionistic photography of late Victorians like Davison. As with Di Bello's case studies, Gertrude uses the camera as an opportunity for both introspection and expression, seeing in a single moment not just the world around her but also how it affects her and "flashes" upon her consciousness.

Even more significant, however, is how Gertrude, like Di Bello's detailed examples, uses photography to imagine as well as project a new image of herself. At first, Gertrude is unable to look directly at Lord Watergate, for he has his back to her. But once she takes up her camera, he turns and looks at her with those sad grey eyes. He sees her, and she sees him. The camera thus mediates a new and mutual gaze between man and woman. Lord Watergate is compelled to look at Gertrude once she has the camera in hand; she is able to look back and, crucially, look him in the eye.

For Levy, this self-consciousness is a critical feature that differentiates the *flâneuse* from her male counterpart. As Gertrude drinks in the sights and energy of the city, her brain is jolted into consciousness as impressions or pictures flash upon her mind. She not only sees but also sees herself being seen. We need only focus on a later scene where Gertrude rides home "on the summit of a tall, green omnibus, her hair blowing gaily in the breeze" (99). At one point, she looks down and sees her friend and neighbour Frank on foot, "passing in painting-coat and sombrero" (99). Frank is a kind of New Man, one who readily accepts the empowered and urban Lorimer sisters. So it is no surprise that, upon seeing Gertrude so proud and "tall" atop the omnibus, he "plucked [the sombrero] from his head and waved it in exaggerated salute" (99). From Frank, Gertrude receives respect and even admiration for her bold claim to the city sights. The sexual radicalness of her position is figured not only in Gertrude's returned gaze but also in her hair blowing "gaily in the breeze." However, this quickly changes when she spots her conservative Aunt Caroline Pratt, "who to Gertrude's dismay, came dashing past in an open carriage, a look of speechless horror on her handsome, horselike countenance" (99). Her aunt's horror is a response to the modern *flâneuse*'s brash claim to public space and, worse yet, the urban male's gaze. Hence Gertrude quickly feels

herself shamed: "Now it is impossible to be dignified on the top of an omnibus, and Gertrude received her aunt's frozen stare of non-recognition with a humiliating consciousness of the disadvantages of her own position" (99–100).

This latter statement is important in two ways. First, we are given a narrative that appears objective but, on further investigation, shows us the inner workings of Gertrude's thoughts, her "consciousness" jolted into reflection upon seeing her aunt. This distinction is significant because, second, the omniscient mode suggests the power of Aunt Caroline's gaze over Gertrude's thoughts. Gertrude is suddenly thrust out of herself, her own subject position, and forced to see herself as "ridiculous" or "disadvantaged": these are clear references to her aunt's perspective and opinions. In other words, Gertrude immediately internalizes her aunt's gaze and the conservative gender roles it represents. All this is to say that Gertrude, as the *flâneuse*, is aware that others see her and, noticeably, of *how* they see her – as filtered through external gender norms. The point is that the *flâneuse* does not look at and consume the city sights from some "hidden" and even non-gendered subject position, "incognito" like Baudelaire's *flâneur*.

Returning, then, to that first encounter between Gertrude and Lord Watergate, we must consider how the mutual gaze is made possible by the former's status as an empowered but self-conscious photographer. At several points in *The Romance of a Shop*, the narrator observes how Gertrude feels a newfound sense of individual freedom and choice because of her work as a professional photographer: upon the success of the shop, "[Gertrude] was beginning, for the first time, to find her own level; to taste the sweets of genuine work and genuine social intercourse" (135). It is of course important that "genuine work" be followed immediately by "genuine intercourse," for her financial independence – which has been bought through her dedicated labour – means that she can choose her own friends, or "shop," so to speak, for her interactions. Her professional endeavours give her the power to decide what she wants, what is her "own level." And this same sense of social empowerment extends to the relationship between men and women. Gertrude now has the right to look back, for she – like the *flâneur* – has the exact same rights and purpose in the city. The only difference, of course, is that her access is guaranteed by her economic independence, her profession, and not by her sex.

With this newfound individual empowerment, Gertrude is also able to look back at and even stare down the most intimidating men,

including Sidney Darrell, the quintessential *flâneur*. Before I explain the showdown of the gazes between the *flâneur* and the *flâneuse*, I need to recapitulate Gertrude's history with Darrell. When Gertrude first meets him, she immediately senses his contemptuous dismissal of her and her "type": "Gertrude found herself rather cowed by the man and his indifferent politeness, through which she seemed to detect the lurking contempt; and as his glance of cold irony fell upon her from time to time, from beneath heavy lids, she found herself beginning to take part not only against herself but also against the type of woman to which she belonged" (108). It is vital to note the reference to Darrell's "heavy lids." Like a true *flâneur*, Darrell likes to look, and he clearly experiences looking as an act of leisurely, visual consumption. He need not even exert the effort to open his eyes fully; instead he looks out through half-open eyes, as if unconscious. With the added phrases "lurking contempt" and "glance of cold irony," those heavy lids take on another meaning. It is as if he refuses to pay Gertrude the honour of his gaze, denying her his full and respectful engagement. Yet Gertrude is not so "cowed" into submission that she misses the real reason for his contempt: as she well knows, he dislikes her "type" because she thwarts his expectation of what a woman should be. In her later report to her sisters, she characterizes Darrell as "the sort of man; – if a women were talking to him of – of the motion of the heavenly bodies, he would be thinking all the time of the shape of her ankles" (110). He is not interested in engaging with women as equals, intellectual or otherwise, so it is no surprise that he would perceive Gertrude, the empowered woman, as offensive.

Gertrude, however, eventually succeeds in demanding Darrell's respect. Later, she discovers that he has seduced her sister Phyllis. The problem is that Darrell is already married, so Gertrude races over to his flat to save her sister. Once she arrives, Darrell tries to fight Gertrude off with his intimidating gaze. But Gertrude rises to the challenge:

> His face was livid with passion; his prominent eyes, for once wide open, glared at her in rage and hatred.
>
> Gertrude met his glance with eyes that glowed with a passion yet fiercer than his own.
>
> Elements, long smoldering, had blazed forth at last. Face to face they stood; face to face, while the silent battle raged between them.

> Then with a curious elation, a mighty throb of what was almost joy, Gertrude knew that she, not he, the man of whom she had once been afraid, was the stronger of the two. For one brief moment some fierce instinct in her heart rejoiced [...] a moment and Darrell had dropped his eyes. (172)

Words such as "passion" and "smouldering" immediately signal the intensity of this "battle." Yet this time Darrell is forced to look closely at Gertrude, to engage her with his eyes "wide open." He must meet her "face to face" in this "fierce" test of wills and strength. Gertrude, in turn, is ready to stand up to this man "of whom she was once afraid," whose gazed formerly made her "cow" in self-loathing. And on this occasion, she is the stronger one. She feels this victory intensely, with a "curious elation," a "mighty throb of what was almost joy." Looking, for Gertrude, has now become not only an intense sensation but also a visceral feeling of power. She forces the *flâneur* to "drop his eyes" in submission to *her* authority. In claiming victory, Gertrude then takes Phyllis away.

Yet Gertrude's victory is short-lived, and the novel concludes with a rather ambivalent picture of the empowered *flâneuse*. At the close, the sisters' careers have changed. It has been a few years since Gertrude's confrontation with Darrell. Her sister Phyllis has since passed away. Fanny and Lucy have both married, though the latter still practises photography – entering her pictures of industrial children into competitions. Meanwhile, Gertrude has married Lord Watergate and chosen to pursue literary rather than photographic arts. For critics like Stephanie Russo and Lee O'Brien, this conclusion and, in particular, Phyllis's death signal the limits of Levy's feminism as well as its conservative influence upon subsequent New Woman literature: "For all its radicalism on a number of fronts, New Woman fiction as it develops after Levy was not at ease with female sexuality, especially the adulterous, antisocial passion (as Gertrude and Lord Watergate fear it to be when they rescue her) of Phyllis."[61] Indeed, the final encounter between Gertrude and her nemesis, Darrell, would seem to suggest that Phyllis died for nothing and that traditional gendered roles have been reinstated following the conclusion's shift to the marriage plot. By a sheer stroke of fate, Gertrude spots Darrell at a dinner party one evening. She "turned pale when she saw him, losing the thread of her discourse, and her appetite, despite her husband's reassuring glances down the table" (194). Darrell, in turn,

"went on eating his dinner and looking into his neighbor's eyes, in apparent unconsciousness of, or unconcern at, the Watergates' proximity" (194). Readers might be tempted to assume that things have returned to their old ways: Darrell is indifferent to the woman's demand for respect, and Gertrude is intimidated (she turns "pale") by this dismissive treatment. There is, however, a notable difference in Gertrude's response: she does not "cow" in submission, nor does she challenge the *flâneur* to a one-on-one stand-off. Instead, she turns to her husband for support, for his "reassuring glances." Gertrude has exchanged her status as a professional woman – trading her work as a photographer and subsequent economic independence – for marriage and a life of domesticity. Through this exchange, she has lost her power, her right to look at and stand on equal footing with the *flâneur*.

This ending might strike us as sad or defeatist, but it remains important to think about Gertrude's struggle in a larger context of photography and women's urban mobility. Many subsequent feminist aesthetes and gender radicals – including Charlotte Mew (in "Passed" [1894]), Ella Hepworth Dixon (in *The Story of a Modern Woman* [1894]), and George Egerton (in *The Wheel of God* [1898]) – would take up this question of women's right to the city, its opportunities and its pleasures.[62] Mew's short story recounts the female aesthete's queer encounter with a fallen woman during an evening stroll, while Egerton's and Dixon's New Woman novels show how new professions (like journalism) underwrote women's access to the city (and its sexual secrets). Levy's novel marks an important contribution to this long struggle for equal rights to the urban gaze. As *The Romance of a Shop* reveals, photography played a crucial role in this history. By 1888, any individual with money enough to afford the new portable Kodak camera could turn themselves into an amateur photographer.[63] At the same time, and in a brilliant marketing strategy, Kodak gave consumers the opportunity to take "snapshots" without the burden of developing film: "Instead of processing photographs in the home darkroom, users sent the camera and film to Kodak, which developed and printed the image."[64] In a testament to the gendered possibilities attached to this new marketing strategy, Kodak ran a series of advertisements featuring the "Kodak Girl" and slogan "You push the button – We do the rest" (figure 1.10).[65] Gertrude's success is brief, but it is because of stories like hers that women will later assume equal access to professions such photography and, with it, rights to the city and its pleasures.

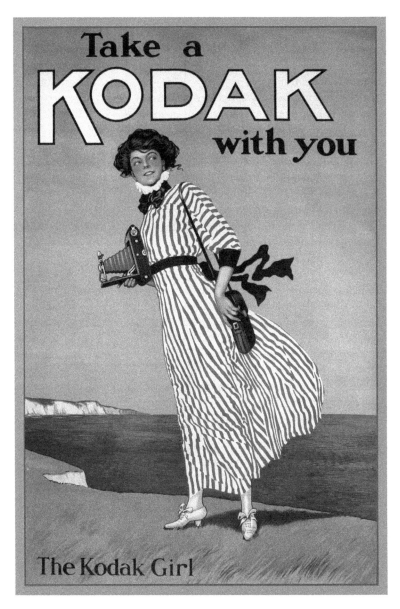

Figure 1.10 Artists unknown, *Kodak Girl, Australasian Photographic Review*, 23 January 1911. (Photograph from Shawshots/Alamy Stock Photo.)

NOTES

1 Amy Levy, *The Romance of a Shop* [1988], ed. Susan David Bernstein (Peterborough: Broadview Press, 2006), 55; further page references appear in parentheses.

2 See Nancy Armstrong, *Fiction in the Age of Photography: The Legacy of British Realism* (Cambridge, MA: Harvard University Press, 1999); Patrizia Di Bello, *Women's Albums and Photography in Victorian England: Ladies, Mothers, and Flirts* (Burlington: Ashgate, 2007); Jennifer Green-Lewis, *Framing the Victorians: Photography and the Culture of Realism* (Ithaca: Cornell University Press, 1996); and Daniel Novak, *Realism, Photography, and Nineteenth-Century Fiction* (Cambridge: Cambridge University Press, 2008).

3 Green-Lewis, *Framing the Victorians*, 6.

4 This then anticipates the emergence of photography as a way to document – frame – visual information.

5 Novak, *Realism, Photography, and Nineteenth-Century Fiction*, 6.

6 Novak, 7.

7 Di Bello, *Women's Albums and Photography in Victorian England*, 154.

8 Anne-Marie Richardson, "'The Consenting Silence': Chaperoning the Orphan Sisterhood of Levy's *The Romance of a Shop*," *Victoriographies* 9, no. 2 (2019): 147–64. For more on female urban flânerie in Levy's poetry, see also See Ana Parejo Vadillo, *Women Poets and Urban Aestheticism: Passengers of Modernity* (Basingstoke: Palgrave, 2005),

9 Deborah Epstein Nord, *Walking the Victorian Streets: Women, Representation, and the City* (Ithaca: Cornell University Press, 1995).

10 Nord, *Walking the Victorian Streets*, 182.

11 Nord, 201.

12 Kate Flint, "The '*hour of pink twilight*': Lesbian Poetics and Queer Encounters on the Fin-de-Siècle Street," *Victorian Studies* 51, no. 4 (2009): 687–712.

13 David Wanczyk, "Framing Gertrude: Photographic Narration and the Subjectivity of the Artist-Observer in Levy's *The Romance of a Shop*," *Victorian Literature and Culture* 43 (2015): 131–48.

14 Elizabeth F. Evans, "'We Are Photographers, Not Mountebanks!': Spectacle, Commercial Space, and the Public New Woman," in *Amy Levy: Critical Essays*, ed. Naomi Hetherington and Nadia Valman (Athens: Ohio University Press, 2010), 41.

15 Kate Flint, "Photographic Memory," *Romanticism and Victorianism on the Net* 53 (2009): 6.

16 Di Bello, *Women's Albums and Photography in Victorian England*, 151.

17 Bernstein, "Introduction," in Levy, *The Romance of a Shop*, 28.

18 Bernstein, "Introduction," 28.

19 Charles Baudelaire, *The Painter of Modern Life and Other Essays* (London: Phaidon Press, 1965), 9.

20 Janet Wolff, *Feminine Sentences: Essays on Women and Culture* (Berkeley: University of California Press, 1990), 45.

21 Wolff, *Feminine Sentences*, 41.

22 Wolff, 47.

23 See Erika Rappaport, *Shopping for Pleasure: Women in the Making of London's West End* (Princeton: Princeton University Press, 2001); Rachel Bowlby, *Carried Away: The Invention of Modern Shopping* (New York: Columbia University Press, 2001); and Krista Lysack, *Come Buy, Come Buy: Shopping and the Culture of Consumption in Victorian Women's Writing* (Athens: Ohio University Press, 2008).

24 Lise Shapiro Sanders, *Consuming Fantasies: Labor, Leisure, and the London Shop Girl, 1880–1920* (Columbus: Ohio State University Press, 2006).

25 Patricia Marks, *Bicycles, Bangs, and Bloomers: The New Woman in the Popular Press* (Lexington: The University Press of Kentucky, 1990).

26 Helena Wojtczak, *Women of Victorian Sussex: Their Status, Occupations, and Dealings with the Law 1830–1870* (Hastings: Hastings Press, 2003).

27 This scene, detailing Gertrude's healthy – indeed, flourishing – love of the city, anticipates Levy's later collection of poems, *A London Plane-Tree*. See Vadillo's *Women Poets and Urban Aestheticism: Passengers of Modernity* (2005, 54–77) for an excellent analysis of these poems (particularly "A London Plane-Tree" and "Ballade of an Omnibus") and the New Woman *flâneuse*.

28 See "The New Age of Photography," in *The Broadview Anthology of British Literature*, ed. Joseph Black et al., 6 vols. (Peterborough: Broadview Press, 2009–12), 5:376. For more on the rise of the professional photographer, see Grace Seiberling and Carolyn Bloore, "The Rise of the Professional," in *Amateurs, Photography, and the Invention of the Mid-Victorian Imagination* (Chicago: University of Chicago Press, 1986), 68–90. As Seiberling and Bloore explain, "the photograph, in 1850, was a novelty, a marvel, the product of an artscience practiced by a few practitioners. By 1860, it had become a commodity, produced by professionals for a new mass public" (68).

29 For more on the history of the amateur female photographer, see Mary Warner Marien, "Women Behind the Camera: Women as Amateurs," in Marien, *Photography: A Cultural History*, 3rd ed. (London: Lawrence King, 2002), 92–7.

30 Marien, *Photography: A Cultural History*, 97. See also Mike Weaver's chapters 12 and 13 on Lady Hawarden and Cameron, respectively, in *British Photography in the Nineteenth Century: The Fine Art Tradition* (Cambridge: Cambridge University Press, 1989), 141–61.

31 Marien, *Photography: A Cultural History*, 97.

32 Di Bello, *Women's Albums and Photography in Victorian England*, 19.

33 Di Bello, 19.

34 Di Bello, 21.

35 Nord, *Walking the Victorian Streets*, 201.

36 Nord, 201–2.

37 Evans, "'We Are Photographers, Not Mountebanks!,'" 35.

38 Evans, 41.

39 Evans, 25.

40 Evans, 25.

41 Georg Simmel, "The Metropolis and Mental Life," in *Simmel On Culture: Selected Writings*, ed. David Frisby and Mike Featherstone (London: Sage, 1997), 175.

42 See also Bernstein, "Introduction."

43 Bernstein, "Introduction," 11.

44 Michael Kramp moves from this scene to a discussion of Lord Watergate's next meeting with the Lorimers and his "paternalistic" attitude towards Phyllis, as if to imply that both women are victims of the "avarice of male sight." Kramp, "Exposing Visual Discipline: Amy Levy's *The Romance of a Shop*, the Decay of Paternalistic Masculinity, and the Powers of Female Sight," *Victorians Institute Journal* 40 (2012): 120.

45 Kate Flint, *Flash! Photography, Writing, & Surprising Illumination* (Oxford: Oxford University Press, 2017), 60.

46 Green-Lewis, *Framing the Victorians*, 91.

47 Novak, *Realism, Photography, and Nineteenth-Century Fiction*, 6.

48 Novak, 6.

49 Lady Elizabeth Eastlake, "Photography" (1857), in *The Romance of a Shop*, ed. Bernstein, 265–6.

50 Eastlake, "Photography," 264.

51 Quoted in Eastlake, 265. As Eastlake notes, these comments by Newton caused quite the scandal in the photographic society.

52 "The New Age of Photography," quoted in *The Broadview Anthology of British Literature*, 5:375.

53 See *The Broadview Anthology of British* Literature, 5:374–6. For more on this debate on photography as art or science, see Beaumont Newhall's *The History of Photography: From 1839 to the Present*, rev. ed. (New York: Museum of Modern Art, 1982).

54 For more on this history of the invention of these fast camera technologies, see Beaumont Newhall's chapter "The Conquest of Action" in *The History of Photography*, 117–36.

55 It is, of course, fascinating to note that while the horse's leg is blurred, the carriage wheel is not. This, again, suggests the fantastic advances in

photographic technology that were able to capture, without blurring, the fast pace of the modern city.

56 Marien, *Photography: A Cultural History*, 173. See also Helmut Gernsheim's chapter, "Impressionistic Photography," in *Creative Photography: Aesthetic Trends, 1839–1960* (New York: Dover Publications, 1962), 122–30, which discusses work by George Davison (122–6), as well as B. Gay Wilkinson (123–4), Heinrich Kühn (124–6), and Robert Demachy (125–7), to name but a few.

57 Marien, 173.

58 Marien, 173.

59 Marien, 173.

60 Di Bello, *Women's Albums and Photography in Victorian England*, 155.

61 Stephanie Russo and Lee O'Brien, "Sex, Sisters and Work: Mary Robinson's *The Natural Daughter* and Amy Levy's *The Romance of a Shop*," *Women's Writing* 28, no. 1 (2021): 52.

62 For more on this history, see also my book chapters on Levy and Egerton in *Critical Alliances: Economics and Feminism in English Women's Writing, 1880–1914* (Toronto: University of Toronto Press, 2020).

63 For more on the rise of the late Victorian amateur photographer, see Grace Seiberling and Carolyn Bloore, "Epilogue: The Amateur in the Later Nineteenth Century," in *Amateurs, Photography, and the Invention of the Mid-Victorian Imagination*, 106–16. As Seiberling and Bloore write, "Men or women who had no interest in photography as a craft or a phenomenon and who wanted only to make pictures began to photograph in increasing numbers. The democratization of photography, which had begun in the later 1850s, was fully realized between the late 1880s, when the Kodak was introduced – 'You push the button and we do the rest' – and the early 1900s, when the Brownie – an inexpensive camera for children – appeared on the market. Anyone with a relatively small amount of disposable income could become a photographer, and many did" (107).

64 Marien, *Photography: A Cultural History*, 163. Marien's book section "Part Three: Photography and Modernity, 1880–1918," 162–201, is particularly illuminating regarding the development of popular camera technologies and the rise of amateur and urban photography (esp. 168–9). See also Martin W. Sandler, *Photography, an Illustrated History* (Oxford: Oxford University Press, 2002). Sandler talks, in particular, about George Eastman's development of flexible film, which paved the way for the Brownie and the portable Kodak camera (20–1).

65 See also Marien, 162–3, 189.

The Decay of Marriage in Ella D'Arcy's Decadent New Woman Fiction

KATE KRUEGER

Ella D'Arcy's literary reputation has long been a matter of critical contention. She was one of the select coterie of women short story writers discovered and promoted by *The Yellow Book*. Published from 1894 to 1897, this quarterly journal marketed itself as the pre-eminent model of the "modern"; it was "charming," "daring," and "distinguished," and it had abandoned the "bad old traditions" of periodical literature, including, implicitly, happy endings.[1] *The Yellow Book* placed Decadents alongside New Woman writers, in this way deliberately positioning itself as a player in the social debates of the time. Because of her central place in *The Yellow Book* canon, some critics have viewed D'Arcy as a New Woman writer, even while others have labelled her an aesthete participant-critic or a Decadent anti-feminist.

Decadent, Aestheticist, and New Woman fiction rejected the idea of the "natural" relations between the sexes, and all three types of fiction were considered "modern" and a threat to the social and artistic status quo. However, these strains of literature diverged both in formal techniques and in their overarching goals. Decadence was a term used earlier in the century to critique artworks that emphasized artificiality; it was then popularized in 1893 by Arthur Symons, who defined it as an intensely self-conscious aesthetic movement characterized by a "spiritual and moral perversity."[2] Though Symons and others were articulating a particular doctrine, Aestheticism rapidly became part of common parlance, associated more broadly in British culture with notions of decay and disintegration. Dennis Denisoff explains the complex association between Aestheticism and Decadence: the terms were used almost interchangeably by critics at the end of the century to "condemn almost any artwork that displayed innovations in aesthetic philosophy, subject, or

style," yet "one of the cornerstone paradoxes of decadence was that the greatest beauty was seen to arise at the cusp of a society's destruction."[3] In Decadent literature, disasters were not meant to teach society a lesson – morality, or the future of society as a whole, was irrelevant. Immediate experience was privileged, and there was no greater reformist impulse to writers' critiques.

By contrast, the New Woman writer, as Teresa Mangum eloquently states, developed an "ethical aesthetics,"[4] writing cautionary tales and critiques of the immoral and unnatural treatment of women embedded in Britain's social fabric in an attempt to spur reform. The New Woman – a term coined in 1894 by the novelist Sarah Grand – rejected the traditional role of the woman-at-home and demanded equality in education, professional opportunities, and more enlightened social relations. New Woman writers tended to argue for greater freedom for women through narratives that often ended in tragedy. Like the Decadents, they disturbed social norms in order to promote an alternative version of social relations.

Margaret Stetz points out an overlap between women aesthetes and New Woman writers. Aestheticism is interested in the beauty of the object, the pleasure of the moment, and the refusal to moralize. Stetz observes that many female participant-critics were committed to revising the practice of art for art's sake as a means to counter the objectification of women embedded in the act of "appreciation": "Their goal was to rescue the worship of beauty, so prominent in aesthetic doctrine, from its association with the exploitation of women as nothing more than beautiful 'occasions' for masculine discovery, theorizing, and reverie."[5] One of the most famous examples of this kind of objectification is Oscar Wilde's titular Dorian Gray's obsession with the actress Sibyl Vane, which only extends to her as long as she performs as an actress and an object of beauty on stage. Similarly, Ella D'Arcy's stories regularly depict the dire circumstances brought about by men who objectify women to their mutual detriment.

However, while D'Arcy occasionally includes depictions of male aesthetes, her work should be considered more Decadent than Aestheticist. D'Arcy's fiction espouses what Ian Fletcher describes as the Decadent "aesthetic of failure,"[6] focusing on passive figures condemned to misunderstanding and disaster, even as she mounts a radical critique of marriage that aligns her work with the social concerns of New Woman fiction. Decadent writers tended to celebrate moments of decay as a breakdown of norms, exploring the realm of failure as a new mode of experience.

It is in this broader sense that Ella D'Arcy's work can be considered Decadent.

D'Arcy's literary reputation rests largely on the short stories she wrote for *The Yellow Book* and two subsequent short story collections in the "Keynotes" series, *Monochromes* (1895) and *Modern Instances* (1898). The "Keynotes" series was closely affiliated with *The Yellow Book* (which John Lane also published) and often became a second site of publication for *The Yellow Book* authors.[7] D'Arcy's contribution to the inaugural volume of *The Yellow Book*, "Irremediable," about a man's unfolding regret that he married an ill-suited woman, had been rejected by the reputable periodical *Blackwood's* on the grounds that "the sacrament of marriage could not be so summarily dealt with."[8] But, of course, the profanity of such a critique of marriage was exactly what attracted *The Yellow Book* editor Henry Harland, who was delighted to publish her work and continued to include her stories regularly over *The Yellow Book's* three-year run. Harland considered her fiction "remarkable" and used her work as a yardstick for measuring the talents of other women contributors.[9] D'Arcy became the most frequent contributor to *The Yellow Book* except for Harland himself, publishing eleven stories besides serving as subeditor for two years. Though D'Arcy was not well-known before her publication in *The Yellow Book*, through it she achieved a reputation as a "courageous modern" and a master of the short story.[10] In D'Arcy's stories, marriage is not simply a bad idea, it is life-threatening. Osbert Burdett goes so far as to state that "her lovers are sent to the altar as if ... their blood was to be shed."[11] Her biting depictions drew a positive response during the fin de siècle: her name cropped up repeatedly as a *Yellow Book* contributor worthy of praise owing to her "brilliant analysis of character," her "power and passion," and her "satire of poor humankind." Her work even reminded one reviewer of Emily Brontë.[12]

It was not until the twentieth century that D'Arcy earned a reputation for anti-feminism. For instance, in 1942 William Frierson repeated a claim he had first made in 1928 that, for D'Arcy, the "New Woman" did not exist because she showed "her sisters to be vain and tyrannical creatures"; indeed, "criticism of her sex [was] her only vital literary motive."[13] Her adoption of a male narrative perspective and her depictions of women as less than perfect are today the basis of D'Arcy's subsequent reputation as an anti-feminist. Such misreadings have shadowed and sometimes completely obscured the content of her stories. The current field of D'Arcy criticism is littered with assessments of destructive female characters and male victims; these women are described as "low-minded" and

"scheming" in their attempts to trap "decent, sensitive" men with their "feminine wiles."[14] "Miss D'Arcy," Katherine Lyon Mix succinctly states, "showed the superior and well-intentioned man caught in the snare of a designing or stupid woman. For all that was wrong in these marriages the blame rested on the heroine's drooping shoulders."[15] Carolyn Christensen Nelson, who includes one of D'Arcy's stories in her *New Woman Reader*, acknowledges this perceived anti-feminism. She points out that D'Arcy's choice of male narrators indicts negative attitudes towards women; yet she too describes D'Arcy's female characters as "ignorant and destructive," stating that they "tyrannize" men, who consequently become their victims.[16] Much of this critical assessment of D'Arcy's fiction fails to take into account the way in which she uses the Decadent language of failure and decay to mount a proto-feminist critique of the institution of marriage. D'Arcy may be the perfect example of an in-between writer whose texts adeptly meld elements of both Decadence and New Woman literature.[17] D'Arcy's fiction confounds distinctions between New Woman and Decadent fiction in part because her short stories embrace elements of both strains of writing to create a set of narratives that are uniquely disturbing.

Regenia Gagnier contends that a "necessary component" of Decadence was "reflection, obsession, or critique."[18] The ruinous power of Decadence's obsessive reflection could, in fact, lead to a kind of opening for transcendence, and that transformative potential echoed much more closely the reformist ethical impulse of New Woman fiction than either camp, in their respective milieux of the 1890s, seemed willing to admit.[19] When we place Decadence and New Woman literature along a spectrum of social and aesthetic engagement instead of casting these subgenres of the 1890s as a hostile binary, we may in fact be able to understand what was so very dangerous about both subgenres as well as their potential for social transformation. Decadence, in its discursive play, its engagement of fantasy and irreverence, and its dismantling of expected behaviour, when twinned with New Woman literature's politics of representation, offered more radical possibilities for upheaval than either aesthetic did on its own. D'Arcy's fiction uses irreverent dystopian depictions of unravelling courtships and marriages to unseat contemporary discourses about gender. While she is not as overtly didactic as some New Woman reformist writers, her lessons are inescapable.

In her depictions of unsavoury and ill-suited courtships, D'Arcy lays the blame squarely on the pretensions of men, courtship procedures that encourage mésalliance due to ignorance of one's partner, and the

institution of marriage itself. D'Arcy, in fact, parallels the critiques of feminist anti-marriage advocates, who regularly pointed out that the social constraints that prevent unguarded interactions between the sexes are ultimately more damaging to the social fabric than the spectre of impropriety. This was one reason why, in 1888, feminist activist Mona Caird denounced courtship and marriage rites: "the false sentiments induced by our present system [are] so many and so subtle, that it is the hardest thing in the world for either sex to learn the truth concerning the real thoughts and feelings of the other."[20] Caird's essay on marriage generated immense controversy: when the *Daily Telegraph*, inspired by Caird's commentary, launched a letter column inviting readers to write in their responses to the question "Is marriage a failure?," it received 27,000 letters.[21] Critiques of courtship and marriage, as captured by Caird, became a prominent theme in literature of the period. D'Arcy's name appears regularly in lists of writers of "bad marriage" stories of the fin de siècle, along with George Egerton, Netta Syrett, and Hubert Crackenthorpe.[22] Women in stories such as those of George Egerton suffer visibly. In "Virgin Soil," collected in *Discords* in 1894,[23] a woman returns home to upbraid her mother for pushing her into an appalling marriage to an older man, who has abused her and engaged in multiple affairs and whom she has decided to leave. Egerton's bad marriage stories are tragic (or at times liberatory); D'Arcy's bad marriage stories take a more mocking tone.

D'Arcy's vivid and macabre twist endings show a mastery of the short-story form while also driving home a Decadent message. Those endings reflect a prominent trend in short story writing at the turn of the century – the plotted short story. Dominic Head notes that Maupassant was an exemplar of this type of story, which is set against the "less well structured, often psychological story; the 'slice of life' Chekhovian tradition."[24] Maupassant was known for his powerful twist endings, especially in enduringly famous works such as "The Necklace" (1884). D'Arcy admired Maupassant,[25] and indeed, she embraced that short story structure and made it her own. D'Arcy's twist endings are shocking and sometimes darkly ironic in their exposure of raw truths.

In D'Arcy's stories, marriages are unfailingly disastrous for all parties. She takes on both male aesthetes who objectify women and bourgeois men who expect their fiancées or wives to serve as home ornaments. Her brilliant stories for *The Yellow Book* capitalize on the popularity of both these recognizable figures, portraying destructive courtships and marriages motivated by delusions (whether those ideas stem from the

dilettantism of a would-be aesthete or the presumptions harboured by an upper-middle-class man). Her endings drive home shocking revelations and confrontations that strip away these masculine pretensions.

In "At Twickenham," D'Arcy's suitor manages a rare escape, deciding to violate social mores and break his engagement rather than marry a woman he does not love. The suitor, Dr. Matheson, places the blame on his own shoulders, excusing his uninteresting ex-fiancée: "She is a victim of her upbringing ... She says the things she is taught to say, that other women say. You've got to get engaged to a woman in England it seems, if you're ever to know anything about her."[26] Matheson's language uncannily echoes Mona Caird's feminist polemic against marriage. D'Arcy crafts characters who become fictive mouthpieces for a radical feminist position. The closure of this story lays out the consequences of such decisions: this rare hero chooses wisely, leaving behind him a friend whose married life is a plague of boredom because his wife does not "even ... affect some show of interest in his views and pursuits."[27] D'Arcy illustrates how men and women perform the choreography of courtship without learning anything authentic about their partners. If, as Judith Butler claims, we presume a common set of idealizations through which we "seek to order ourselves in relation to one another and a common future,"[28] and ultimately this is how social order is given its coherence, the breakdown of such presumptions is not just a dismantling of social actions (a happy marriage), it is more radically a confrontation with a way of thinking. In this story, one man questions certain social presumptions in such a way that the reader is called to question the entire social order. One can only prevent a failed marriage by not marrying at all. Unfortunately, that choice is a rare one.

D'Arcy's reputation as a male sympathizer is belied by her occasional inclusion of female victims of the courtship ritual. The misrepresentation that courtship requires has devastating consequences for naive girls. In "An Engagement," the young Agnes is led to believe that her suitor, the nefarious Dr. Owen, is marrying her for love and not for her inheritance. Agnes, "of course, had always supposed that she should some day marry. Everyone did."[29] When Dr. Owen encounters a more advantageous match, he breaks his engagement. Because Agnes receives the formalities of his visits as evidence of his authentic affection, she cannot accept his lack of true devotion until he offers a public social sign. Agnes dies of heatstroke wandering on a country road after he snubs her "in broad daylight, openly, before witnesses," thus crushing her last hope of his affection for her.[30] Here, D'Arcy illustrates the severity of the consequences

for a woman who misjudges the sincerity of her suitor. A reliance on expectations of what courtship and marriage should mean leaves romantic partners vulnerable to critical misjudgments. D'Arcy pushes this to an extreme: the young woman dies because of it.

D'Arcy's *The Yellow Book* short stories also anatomize the damage that misguided partners can inflict on each other after marriage. In her focus on romantic entanglements from first blush to final breath, D'Arcy embraces a narrative innovation of New Woman fiction. Sally Ledger notes that by placing the marriage early in the narrative, New Woman writers were able to dissect rather than celebrate the institution.[31] Marriage thus served as a catalyst for conflict rather than closure. In "Irremediable," the gentleman suitor, Willoughby, chooses an unconventional partner based upon his "mistaken chivalry and flattered vanity,"[32] but he does not repent of his choice soon enough to avoid a disastrous marriage. The tenor of their interaction reveals the ways in which Willoughby's self-delusion creates the means of his downfall. When Willoughby, a young bank clerk on holiday in the country, encounters Esther, an East End factory girl recuperating from overwork and illness, he gives way "to a movement of friendliness to this working daughter of the people" because he "had dabbled a little in Socialism" and had at "one time wandered among the dispossessed." She considers him a "gentleman" and wishes she were a "lady" who wouldn't have to work; he enjoys "talking nonsense" with a girl who is "natural" and "simple-minded."[33]

Benjamin Franklin Fisher IV writes that Willoughby has a winning sensitivity, adding that D'Arcy elicits sympathy for him in "all respects."[34] Yet D'Arcy makes it clear from the start that Willoughby is overly self-satisfied and is attracted to Esther precisely *because* he feels himself above her both in class and in intellect. It is this inequity, and his enjoyment of patronizing her, that drives his idealization of her simplicity and his fascination with her as a romantic partner. When he avoids her for several days, she weeps upon seeing him again, and when she confesses that her father beats her, Willoughby is driven to propose to "justify his kisses, rescue her from her father's brutality, [and] bring back the smiles to her face."[35]

D'Arcy's subsequent depiction of Willoughby and Esther's unhappy marriage dramatizes a central tenet of anti-marriage propaganda. Marriage, in late-Victorian society, was often framed as a restrictive force upon men. Bachelors' time, at work and at home, was their own, and their spaces were entirely male. Upon marriage, they surrendered that liberty – the ability to come and go as they chose, to associate with whom they wished, and to run their domestic lives without interference.

Women, in turn, gained a legitimate household but were trapped there, reliant upon their husbands for company and expected to cater to their husbands' visions of perfect housekeeping. Anti-marriage rhetoric proclaimed that the bond of marriage "chafes the flesh, if it does not make a serious wound."[36] Willoughby's abject misery in his married life, only three months later, is not due to Esther's deliberate misrepresentation of herself – after all, she has been honest and forthright about her background, her character, and her desires. Willoughby's frustration is due to the fact that he now has a wife "completely dependent upon him not only for food, clothes, and lodging, but for her present happiness; her whole future life." It is the "sense of care inseparable" from the institution of marriage that ages him.[37]

Legal institutions such as marriage not only restrict action but also help define the ideal of what the roles within those institutions should be. In the many letters received by the *Daily Telegraph* offering answers to the question "Is Marriage a Failure?," some of the most intriguing pointed not to behaviours within marriage but to the detrimental effects of the marriage vows that preceded it. One young woman suggested "[cutting] out all that about 'obey and serve him, as I don't think a wife is exactly the same as a servant,"[38] while another argued that the marriage service "publicly humiliates a woman" by lowering the wife and placing the husband on a pedestal, "filling him with notions of marital supremacy." This writer asked, "What wonder that when a man hears himself described as his wife's god … he should consider her in the light of his dog, or his horse, or anything that is his?"[39] In this sense, the expectations a man had of marriage were shaped by the repeatedly reinforced ideal of what a husband and a wife should be. D'Arcy plays out the consequences of insubordination when those idealized norms are altered by her miserable couple in ways that break down every presupposition that this new husband has regarding expected behaviours and the ways in which his wife is supposed to fulfil a certain ideal.

Of course, it does not help that Willoughby and his wife are grossly ill-suited to each other. He attempts to educate her, but she resists.[40] His supposedly charitable reformist impulse actually reflects his attempt to reduce her to the type of wife he finds most acceptable. Her resistance to his reconstruction of her identity heightens his disgust for her, which extends beyond her bad habits and ignorance to "her manner of standing, of walking, of sitting in a chair, of folding her hands." In the end, he realizes that the obsessive passion he feels has never been love: it is hatred. Nevertheless, Willoughby will be bound to her for decades,

"he and she face to face, soul to soul."[41] In England during the Victorian period, one could not divorce one's spouse simply due to personal revulsion. The Matrimonial Causes Act of 1857 had first begun to grant divorce on a limited basis if a woman committed adultery; as of 1923 divorce could also be granted to a woman if a man had been unfaithful. By 1937, desertion, cruelty, and insanity had been added to the list of grounds for divorce. Not until 1973 did English law permit divorce due to personal differences. According to English law in the fin de siècle, Willoughby's marriage to Esther was, without a doubt, "Irremediable." This is one of D'Arcy's most lauded stories because of the power of its conclusion. D'Arcy utilizes the narrative weight of the short story, tilted towards its ending, to offer revelations such as these. Yet D'Arcy's shocking twists do not provide closure, only a devastating clarity. Elke D'hoker and Stephanie Eggermont observe that while the "story-with-a-twist" creates surprise while also neatly rounding out the plot, D'Arcy's story replaces plot-based closure with "a more psychological moment of revelation" that anticipates Joycean epiphany.[42] D'Arcy's masterful short stories infuse the generic potential of the plotted twist ending with Decadent aesthetics to explore the psychological ramifications for her characters of their failures, misreadings, and delusions because they ignore female agency and subjectivity.

Yet in reality, for women there were undeniable advantages to binding oneself in an irreversible legal contract and complying with normative expectations of femininity. A woman's desire for legitimacy was a contributing factor to "mercenary marriage." Mona Caird observed that the reasons women sought such marriages were understandable: "However degrading they may be ... a glance at the position of affairs shows that there is no reasonable alternative. We cannot ask every woman to be a heroine and choose a hard and thorny path when a comparatively smooth one, (as it seems), offers itself, and when the pressure of public opinion urges strongly in that position."[43] The dearth of alternatives for women compelled many to seek respectability above all else. Without it, women were severely vulnerable, economically and socially.

In "A Marriage," D'Arcy illustrates what can happen when a marriage becomes a means to an end. This story, which has most often been labelled anti-feminist, is particularly notable for its depiction of a tyrannous wife. But to focus solely on her accession to power is to ignore her original position of abject powerlessness. The massive power reversal that develops before and after marriage indicates the inherent destructiveness of a relationship defined from the outset by inequity. When a

woman embraces the play-acting that men are so eager to believe, she can manipulate their objectification of her in order to secure her position; the relentless use of women by men for their own ends suggests that this may in fact be her best option.

The marital disaster in this story is precipitated by the boyish Catterson's desire to make amends to his mistress and illegitimate child, whom he is hiding under assumed names in riverside lodgings while he lives as a bachelor "within the respectable circles of British middle-class society." Convinced that "in marriage lay the only reparation," Catterson is soothed by the litany of ideal qualities Nettie evinces: she is gentle, domestic, "unselfish," and a "devoted mother" to the baby girl, even though "scarcely more than a child herself."[44] When Catterson introduces his fiancée to his friend West, she attends to both men "as Catterson had taught her to do" and asks to accompany them "exactly as a child asks permission of parent or master." These ministrations and her absolute submission disturb his friend, yet Catterson is deeply proud of her docility: "It's always my wishes that guide her … I don't know how a man could have a better wife."[45] Nettie's allure seems to be rooted solely in her total dependence upon Catterson. She apparently has no identifiable personality of her own: she is no more than a mirror, a reflection of Catterson's habits and desires. But this pliability masks that she is expertly performing a set of expected actions that "occlude the ways they are performatively established."[46] She is so adept at seeming to be exactly what Catterson wishes her to be that he fails to recognize how accomplished her performance is. Nettie is a consummate actress, a self-aware cipher of Catterson's projections. While Catterson is blissfully ignorant of that artificiality, the narrator and, by extension, the reader are made uneasy by her perfect enactment of the role of subservient object of his affections. She is literally too good to be true. Ironically, this is exactly the kind of performance that Aestheticist art seems to praise: beauty for its own sake, an artificial performance as an expression of artistic perfection. D'Arcy here is underscoring the dangerous naivety of men who aestheticize women. In this story, the bourgeois man viewing his mistress as a potential wife commits a similar erasure of the woman, to his detriment.

If Nettie is nothing but a ghost before their marriage, Catterson becomes one after it. As soon as Nettie achieves legitimacy through marriage, she begins to assert an independent will, and Catterson learns to cater to her whims and desires above all else. He contracts a lingering illness after Nettie makes him go out in the rain. He complies with her demands because "there was no price too high to pay for the purchase of

domestic peace."[47] When West visits Catterson at his sickbed, Catterson can do nothing but marvel at the complete reversal of Nettie's character and bitterly conclude: "Women require to be kept under, to be afraid of you, to live in a condition of insecurity; to know their good fortune is dependent upon their good conduct … Marriage is the metamorphosis of women."[48] Nettie first had to conform to Catterson's ideal in order to achieve legitimacy. Had Catterson decided not to "make amends" and eventually discard her, she would have had no recourse. She is one of those women who seems to have married for "the sake of freedom and a place in life; for the sake of bread and butter."[49] Once she has these, she can shed her absolute docility and begin making demands upon her husband. This, above all, seems to be what will eventually kill Catterson. And this, of course, is the danger of the coercive nature of gender norms. While on the surface this may be a depiction of a mercenary marriage, it is also disturbingly clear that one cannot take one's partner at face value – a realization that has much wider consequences for all who are engaged in courtship and committed to the notion of marriage as a desirable social institution.

"A Marriage" is not just, as summarized by critic Winnie Chan, a story about an "ambitious, emasculating woman who dominates her sensitive, sympathetic husband to death."[50] To paint Catterson as an innocent is to ignore D'Arcy's inclusion of his original sin: his double life, his wilful enjoyment of keeping a mistress in absolute dependence upon him, and his assumption that her adherence to a normative ideal of submissiveness reflects a natural set of behaviours. There is an implicit doubt that the life he had with Nettie before their marriage, notwithstanding his words to the contrary, could be considered remotely ideal. Sarah Maier astutely points out that D'Arcy's stories illustrate the ways in which women are "judged according to their ability to live up to or project the image which men desire."[51] According to Maier, D'Arcy professes a radical feminism: she subverts conventions by establishing an ideal of femininity through the eyes of male narrators and then demonstrating the detrimental effects such ideals had on Victorian women. Maier's critique focuses entirely on the victimization of women; yet in these stories, it is not just women who suffer under this system. Each partner is victimized through these socially constructed false idealizations of masculinity and femininity so assiduously promoted in the routines of courtship and marriage.

And in fact, D'Arcy is doing something more radical than positing a proto-feminist vein of marital reform: she is calling into question the most basic societal assumptions about the gender norms of the time

and telling us they are neither natural, nor ideal, nor remotely reliable. Her Decadent reformist vision is fundamentally destabilizing. D'Arcy's troupe of disillusioned young men and their disappointing wives demonstrate the decay of romantic relationships patterned on social contracts that encourage exploitation and insincerity. Each of the men considers himself enlightened in terms of his attitude towards class or sexuality, yet they all fall back on conventional assumptions about women as objects of their discernment and affection. The disasters are predicated not on women who behave badly but rather on men who always seem to have the wrong idea.

It may seem that D'Arcy adheres so closely to an aesthetic of failure that any relationship in her fiction is doomed. But in fact, her story "The Pleasure-Pilgrim" does offer an implicit model for romantic reform. In it, D'Arcy explores the equality and pleasure that a man could gain through a relationship with a modern, unconventional woman. But this woman has shed the restrictive roles that dictate traditional relations between the sexes, and the male protagonist is unable to quash his own prejudices. She thus fails to adhere to her suitor's construction of her, and he doubts her sincerity, which drives her to extraordinary lengths to try to win his trust and approval. This relationship's ultimate failure is acutely painful precisely because it is easy to see how it might have worked had the suitor been able to change his romantic practices and expectations.

Lulie Thayer's unconventionality is what first attracts the suitor Campbell, and he congratulates himself as "superior" because he is able to recognize her unique qualities: "It seemed to him that he was the discoverer of her possibilities."[52] However, when Campbell's friend Mayne tells him that many men have sampled her possibilities because she is generous with her affections, Campbell is scandalized. Campbell has a fear of "being fooled" – since he cannot create her in the image he desires, he is no longer the manipulator of their relationship, and subsequently he fears becoming the manipulated.[53] Margaret Stetz argues that in this story, D'Arcy "revisits the territory of Henry James ... as a backdrop for her assault on the aesthetic practices of a male fiction writer" whose spectatorship of women reveals itself as "narcissism."[54] Sally Ledger argues effectively that this is a complex critique of male aesthetes: "Campbell the well-known author and Mayne the sometime artist," both of whom attempt to "contain and define Lulie Thayer." She exists as a beautiful object only when mediated through Campbell's "aestheticizing connoisseur's gaze," but he retreats from her when she takes on a life of her own

as a "romantic adventurer."[55] Though Campbell's fascination with Lulie does stem from his own narcissistic tendencies, his inability to conventionalize the images of masculinity and femininity within their romantic relationship also frustrates him. It is a sentimental as well as an aesthetic conflict. Campbell will not fully enter into an alternative pattern of heterosexual relations with a woman who has already redefined herself. He consequently refuses to meet her as an equal partner and to take her at face value.

Because Campbell has heard about the litany of skills and experiences she has gained as a pleasure-pilgrim, from cycling to shooting to kissing, he feels she cannot fulfil his ideal of the fresh innocent whom he first imagines her to be.[56] A major objection to the New Woman was her abandonment of modesty, one of the "exquisite graces" of womanhood destroyed by public pursuits. Anti-feminist Ouida commented: "Nothing tends so to destroy modesty as the publicity and promiscuity of schools, of hotels, of railway stations and sea voyages. True modesty shrinks from the … coarser gaze of a man."[57] All of Lulie's pursuits, including international travel, the acquisition of masculine skills like shooting, and her unfettered access to men have in the end sullied her. Campbell thus will not take Lulie at her word when she eventually professes her love for him. He instead chooses to do nothing – neither abandoning her nor advancing their courtship. Mayne, in turn, encourages his friend's self-doubt by labelling Lulie the "newest development of the New Woman," theorizing that she is nothing but an actress.[58] Lulie's repeated signs of devotion simply aggravate Campbell because he cannot forgive her for these experiences.

Yet he also recognizes that his prejudice, not her past, is the true barrier to domestic bliss. If he "could only blot out her record, forget it, accept her for what she chose to appear, a more endearing companion no man could desire."[59] Campbell is hounded by the idea that she is not what he has imagined her to be. In a heated argument, he declares that she cannot "really" love him, because "the mere idea that you could not come to your lover fresh, pure, untouched, as a young girl should … would fill you with such horror for yourself … [that] you would take up that pistol there, and blow your brains out!" In response, Lulie simply asks, "And suppose I were to [do it] … would you believe me then?"[60] When Campbell declares nothing short of that would convince him, she immediately shoots herself. In the end, Campbell's self-doubt drives this unique, "endearing companion" to a pointless suicide.

Campbell's final refusal to accept her sincerity gives him a pyrrhic victory. His lasting doubt finally and indisputably rewrites her actions as ambiguous at best, since even after her death Campbell is still unable to "convince himself that Lulie had really loved him." Campbell's obvious control over the definition of who Lulie *is* calls attention to his indisputable ontological power. That is, he gets to decide "who or what is considered real or true" and is thus acting as a coercive agent of gender normativity.[61] It is *his* knowledge and *his* definitional impulse that guides both of them. All her actions, from her declarations of affection to her irreversible final act, are stripped of meaning because she has failed to fit into Campbell's projection of the beautiful and innocent object of his affection, and by extension, what a girl is at its essence. Despite his knowledge of her skill with pistols (hinting at the unlikelihood that she accidentally shot herself) and her own final question, he cannot fully reject his friend's theory that she was a "consummate actress" performing a "sensational finale."[62] Ironically, because she refuses to play the part of the chaste maiden, Lulie is labelled an actress whose affections must be nothing but a performance. Despite the opportunities at hand to create an equal, accepting, and nonjudgmental relationship, the modern gentleman seems to fear, above all, being made a fool by a woman. Like the men in D'Arcy's previous stories, this suitor is led astray by his unwavering commitment to outdated ideals of femininity and by his own desire to control women as the objects of his gaze.

D'Arcy's illustration of the false dichotomy between the "natural" Victorian girl of the past and the "artificial" New Woman of the present contributed to a collection of satirical pieces in *The Yellow Book*. In Max Beerbohm's satirical Decadent essay, "The Defence of Cosmetics," he points out that women earlier in the century "appear to have been in those days utterly natural in their conduct – flighty, gushing, blushing, fainting, giggling, and shaking their curls." Women of the fin de siècle have seized on make-up and the manipulation of their appearance as part of their newfound rights, which "justifies the painted mask that Artifice bids them wear."[63] While Beerbohm seems to mock the seriousness of anyone who makes claims about the rights and roles of Woman, he does so by pointing out the similarity between the naturally and the artificially feminine. *The Yellow Book* writing tended to delight in the collapse of such categories.

D'Arcy's *The Yellow Book* stories brought this sensibility to a proto-feminist cause. She, too, is an equal opportunity satirist. In her fiction there are no martyrs and plenty of villains. Her characters give voice to radical critiques of the institution of marriage and gender norms that align closely

with the polemical critiques of other feminist New Woman writers. Yet her stories have been situated uneasily in the canon of New Woman literature in part because in them the relationships men find themselves in, and the women to whom they become bound, are often dangerous and downright horrid. D'Arcy enjoyed mocking folly through her stories, and the marriage plot at this time was ripe for ridicule. D'Arcy's depictions of masculine disillusionment offer a nuanced critique of the damage both partners inflict on each other in the toxic routines of courtship and marriage. D'Arcy offers instead socially transformative fiction in that, with delightful wickedness, she exposes false expectations and unstable norms.

D'Arcy's "bad marriage" stories repeatedly depict obtuse gentlemen and would-be aesthetes gripped by despair or disillusionment after they become disabused of their unrealistic notions of the women whom they have objectified, courted, and sometimes married. Through such blinded and foolish perspectives, D'Arcy charts their gradual disenchantment with the institution of marriage and the performance of gender norms, which ultimately seem to benefit no one. In the five stories examined here, one woman dies of heatstroke, another woman shoots herself, and a man will assuredly soon die of a chronic cold. Those who survive do not seem to fare much better. They are bound for life to unavailing remorse and, in the case of one man, to a woman he thoroughly detests. D'Arcy's disillusioning narratives seem to ask which romantic fate is worse. Marriage, in the fin de siècle, is intrinsically unhealthy – the behavioural patterns and ideals upon which partners base their expectations are not simply false – they are also undeniably dangerous. In the Decadent New Woman fiction of D'Arcy, such diseased partnerships can only produce mutual exploitation, the decay of affections, and an untimely, sometimes welcome death.

NOTES

1 "Announcement," *The Yellow Book* 1 (April 1894), 2–3.
2 Quoted in Dennis Denisoff, "Decadence and Aestheticism," in *The Cambridge Companion to the Fin de Siècle*, ed. Gail Marshall (Cambridge: Cambridge University Press, 2007), 38. Denisoff explains that Decadence was first coined as an aesthetic term in 1834 by Désiré Nisard to critique artworks that emphasized artificiality, and later turned into a compliment by Théophile Gautier when he praised Charles Baudelaire's poetry in 1868.

3 Denisoff, "Decadence and Aestheticism," 31, 33.

4 Teresa Mangum, "Style Wars of the 1890s: The New Woman and the Decadent," in *Transforming Genres: New Approaches to British Fiction of the 1890s*, ed. Nikki Lee Manos and Meri-Jane Rochelson (New York: St. Martin's Press, 1994), 49.

5 Margaret Stetz, "Debating Aestheticism from a Feminist Perspective," in *Women and British Aestheticism*, ed. Talia Schaffer and Kathy Alexis Psomiades (Charlottesville: University of Virginia Press, 1999), 31.

6 Ian Fletcher, "Decadence and the Little Magazines," in *Decadence and the 1890s* (New York: Holmes and Meier, 1979), 195.

7 *Monochromes*, published in 1895, collected "Irremediable" and a slightly expanded version of "The Pleasure-Pilgrim." These were comfortably situated alongside some of her other macabre stories, several of which were set in the Channel Islands, including "Poor Cousin Louis." First published in the second volume of *The Yellow Book*, in this story a lonely and infirm older man is effectively trapped in his own home, abused, and exploited by his servants, who are given advice from a doctor regarding how to prolong his life in order to continue living off his wealth. D'Arcy skilfully crafted short stories to make the most of the psychological impact of their endings, often highlighting the suffering that people inflict upon one another. Her stories offer revelation but resist closure, regularly condemning her characters to death or entrapment. See Ella D'Arcy, "Poor Cousin Louis," *The Yellow Book* 2 (July 1894), 34–59; *Monochromes* (London: John Lane at The Bodley Head, 1895); and *Modern Instances* (London: John Lane at The Bodley Head, 1898).

8 Derek Stanford, *Short Stories of the 'Nineties: A Biographical Anthology* (London: John Baker, 1968), 63.

9 Henry Harland in Karl Beckson and Mark Samuels Lasner, eds., "*The Yellow Book* and Beyond: Selected Letters of Henry Harland to John Lane," *English Literature in Transition 1880–1920* 42, no. 4 (1999): 401–32.

10 "The Rambler," *Book Buyer* 11 (May 1894), 191.

11 Osbert Burdett, *The Beardsley Period: An Essay in Perspective* (London: John Lane, The Bodley Head, 1925), 235.

12 These reviews are drawn from the following sources, respectively: N.O.B., "Novels and Novelists," *Echo* (1 July 1895), 1; Israel Zangwill, "Without Prejudice," *Pall Mall Magazine* 10 (November 1896), 452; O.O., "Modern Instances," *Sketch* (14 September 1898), 340; and "The Yellow Book," *The Queen, The Lady's Newspaper and Court Chronicle* (21 July 1894), 130.

13 William C. Frierson, *The English Novel in Transition, 1885–1940* (Norman: University of Oklahoma Press, 1942), 57–8. Frierson published the same

comments in an earlier article titled "Realism in the Eighteen-Nineties and the Maupassant School in England," *French Quarterly* 10 (March 1928): 31–41.

14 Benjamin Franklin Fisher IV, "Ella D'Arcy: A Commentary with a Primary and Annotated Secondary Bibliography," *English Literature in Transition 1880–1920* 35, no. 2 (1992): 184.

15 Katherine Lyon Mix, *A Study in Yellow: The Yellow Book and Its Contributors* (Lawrence: University Press of Kansas, 1960), 234.

16 See Carolyn Christensen Nelson, ed., *A New Woman Reader* (Peterborough: Broadview Press, 2001), 109.

17 Elke D'hoker and Stephanie Eggermont also discuss the ways in which the turn-of-the-century short story demonstrates a kind of hybridity of influences. Arguing that the two literary movements most important for the British short story were Aestheticism and New Realism, they note that D'Arcy is uncomfortably associated with both – she is realist in her style but also connected to Aestheticism due to her publication in *The Yellow Book*. While I similarly note a hybridity, I argue that her publication venue is not enough to associate her with Aestheticism. Her work more clearly blends Decadence and New Woman writing. See Elke D'hoker and Stephanie Eggermont, "Fin-de-Siècle Women Writers and the Modern Short Story," *English Literature in Transition* 58, no. 3 (2015): 296.

18 Regenia Gagnier, "The Victorian fin de siècle and Decadence," in Laura Marcus and Peter Nicholls, eds., *The Cambridge History of Twentieth-Century English Literature* (Cambridge: Cambridge University Press, 2004), 32.

19 Critics have charted hostility between New Woman and Decadent writers. Kirsten MacLeod indicates that the practitioners of New Woman writing saw a distinct difference between their respective doctrines, most obviously in their belief that "literature ought to serve an ethical function – whether moralistic or didactic." Sally Ledger faults the strain of social purity feminism most notable in the works of Sarah Grand as a contributor to the perceived polarity between Decadents and New Woman writers. In turn, MacLeod notes that the primarily male Decadents often dismissed New Woman writing out of hand as both crassly commercial and sullied with the "missionary zeal of the social reformer or moralist rather than as [aesthetically purist]." See Kirsten MacLeod, *Fictions of British Decadence: High Art, Popular Writing, and the Fin de Siècle* (New York: Palgrave Macmillan, 2006), 44; and Sally Ledger, "Wilde Women and *The Yellow Book*: The Sexual Politics of Aestheticism and Decadence," *English Literature in Transition, 1880–1920* 50, no. 1 (2007): 7. Ledger also acknowledges that there was a resonance between Decadence and New Woman writing, a more eclectic field than is sometimes allowed.

20 Mona Caird, "Marriage" (1894), in *A New Woman Reader*, ed. Christensen Nelson (Peterborough: Broadview Press, 2001), 186.

21 Christensen Nelson, ed., *A New Woman Reader*, 184.

22 See D'hoker and Eggermont, "Fin-de-Siècle Women Writers," 307; and David Malcolm, "Hubert Crackanthorpe and The Albermarle: A Study of Contexts," in *The Modern Short Story and Magazine Culture, 1880–1950*, ed. Elke D'hoker and Chris Mourant (Edinburgh: Edinburgh University Press, 2021), 71–2.

23 George Egerton, *Discords* (London: John Lane at The Bodley Head, 1894).

24 Dominic Head, *The Modernist Short Story* (Cambridge: Cambridge University Press, 1992), 16.

25 Stephanie Forward, "Introduction," in *Dreams, Visions, and Realities: An Anthology of Short Stories by Turn-of-the-Century Women Writers*, ed. Stephanie Forward (Birmingham: Birmingham University Press, 2003), xii.

26 Ella D'Arcy, "At Twickenham," *The Yellow Book* 12 (January 1897), 330.

27 D'Arcy, "At Twickenham," 318.

28 Judith Butler, *Undoing Gender* (New York: Routledge, 2004), 220.

29 Ella D'Arcy, "An Engagement," *The Yellow Book* 8 (January 1896), 394.

30 D'Arcy, "An Engagement," 405.

31 Sally Ledger, "The New Woman and Feminist Fictions," in Marshall, ed., *The Cambridge Companion to the Fin de Siècle*, 165.

32 Ella D'Arcy, "Irremediable," *The Yellow Book* 1 (April 1894), 107.

33 D'Arcy, "Irremediable," 89–91.

34 Benjamin Franklin Fisher IV, "Ella D'Arcy, First Lady of the Decadents," *University of Mississippi Studies in English New Series* 10 (1992): 243.

35 D'Arcy, "Irremediable," 98.

36 Caird, "Marriage," 195.

37 D'Arcy, "Irremediable," 100.

38 Harry Quilter, ed., *Is Marriage a Failure?* (London: Swan Sonnenschein, 1888), 66–7.

39 Quilter, *Is Marriage a Failure?*, 165.

40 D'Arcy, "Irremediable," 101, 106.

41 D'Arcy, 107–8.

42 D'hoker and Eggermont, "Fin-de-Siècle Women Writers," 303.

43 Caird, "Marriage," 193.

44 Ella D'Arcy, "A Marriage," *The Yellow Book* 11 (October 1896), 311, 314.

45 D'Arcy, "A Marriage," 319.

46 Butler, *Undoing Gender*, 209.

47 D'Arcy, "A Marriage," 332.

48 D'Arcy, 338.

49 Caird, "Marriage," 196–7.

50 Winnie Chan, "Morbidity, Masculinity, and the Misadventures of the New Woman in *The Yellow Book's* Short Stories," *Nineteenth-Century Feminisms* 4 (Spring–Summer 2001): 42.

51 Sarah E. Maier, "Subverting the Ideal: The New Woman and the Battle of the Sexes in the Short Fiction of Ella D'Arcy," *Victorian Review* 20, no. 1 (Summer 1994): 36.

52 Ella D'Arcy, "The Pleasure-Pilgrim," *The Yellow Book* 5 (April 1895), 40.

53 See Stetz, "Debating Aestheticism," 37.

54 Stetz, 37.

55 Ledger, "Wilde Women and *The Yellow Book*," 19.

56 D'Arcy, "The Pleasure-Pilgrim," 43.

57 Ouida, "The New Woman," 1894, in Christensen Nelson, ed., *A New Woman Reader*, 158.

58 D'Arcy, "The Pleasure-Pilgrim," 46.

59 D'Arcy, 60.

60 D'Arcy, 65.

61 Butler, *Undoing Gender*, 215.

62 D'Arcy, "The Pleasure-Pilgrim," 66–7.

63 Max Beerbohm, "A Defence of Cosmetics," *The Yellow Book* 1 (April 1894), 68–70.

Mabel Dearmer's Decadent Way

DIANA MALTZ

The term Decadent, as it is popularly used by modern literary critics, carries rather unsavoury associations: the dissipated poet's indulgence in absinthe and opium, the tawdriness of the music hall, exploitative and illicit sexual relations – all somehow epitomized by Aubrey Beardsley's visual representations of iniquitous dwarves and dangerous courtesans. Yet any reader of *The Yellow Book* recognizes that the journal's contents are distinguished by their diversity, and Beardsley can hardly be used to define the work of his fellow contributors. Stories by Ella D'Arcy and Charlotte Mew are characterized by their narrators' preoccupation with social obligations to the poor and to strangers. Such entries compel us to re-evaluate and interrogate the usefulness of Decadence as a critical category.

Historically, Decadence has been a notoriously amorphous, problematic term to define. In 1967, Karl Beckson defined British Decadence simply by anthologizing those writers who espoused a delight in decay, a fascination with perversity, and a celebration of artifice.[1] Yet looking to the movement's French forebearers in 1995, David Weir found more paradoxes than consistencies among Decadence's own theorists: "Decadence seems to emerge as both an extension of and a reaction to romanticism; as both a languorous and a rebellious state of mind; as both a decorative, superficial art and a pioneering, profound aesthetic."[2] The social project of decadence particularly remains a slippery entity. Also in the mid-1990s, Regenia Gagnier offered a social critique of Decadence as an ethical practice: she said that, whereas aestheticism tends towards the beautification of daily life for everyone, Decadence in art and life amounts to an exploitation of others in order to achieve escape from them.[3] By contrast, in developing Linda

Dowling's emphasis on style and language, Dennis Denisoff argued in 2006 that Decadence deliberately transgresses normative logic in order to confound the reader: "Rather than positioning itself against some sort of indescribable ideal or reality, the Decadent object maintains its position as one link in a tangled chain of representations."[4] Most recently, feminist critics have pulled further away from an ethical definition of Decadence by repudiating the stereotype of the 1890s poet as male, aristocratic, dissipated, and languorous; if we include Michael Field (the co-authors Katharine Bradley and Edith Cooper), Rosamund Marriott Watson, and Alice Meynell among the Decadents, we can see how they challenge that paradigm.[5] Decadence has been characterized as an artistic form, a social milieu, and a debauched lifestyle. Can it be one or two without being all three?

One means of arriving at a sharper definition of Decadence, or, more precisely, identifying the strands that contribute to it, is to examine a writer and artist whose work embodied its contradictions. The illustrator Jessie Mabel White Dearmer (best known as Mabel Dearmer) was famed for adopting a style characterized by a Japanese-influenced asymmetry, bold colour-blocking (redolent of Beardsley's poster art), and heavy use of outline. Yet for the most part, her images themselves were fairly benign ones used in the service of children's literature. Can an image be *formally* Decadent while remaining morally palatable?

At the height of her engagement with *The Yellow Book* set, Dearmer illustrated two children's books by her friend Evelyn Sharp, *Wymps, and Other Fairy Tales* (1897) and *All the Way to Fairyland* (1898), both published by Jane Lane at The Bodley Head. Examining their images alongside her semi-autobiographical novel *The Difficult Way* (1905), we can perceive the variability of Decadence and of the motives of those who deployed its tropes. In her novel, Dearmer grapples with the implications of living an authentically aesthetic life while also an ethically good one: generally, her characters are swayed by the beautiful, an art that inspires and elevates instead of corrupting and enervating. If we perceive *The Difficult Way* as a contextual source framing Dearmer's earlier visual arts productions, we can suggest two conclusions: first, it expunged any public association between her work and Beardsleyan salaciousness; second, and more likely, it affirmed that her children's book illustrations had simply been daring experiments in form all along – if "Decadent," then divested of any Beardsleyan desire to *épater le bourgeois*.

Mabel Dearmer's Career

After studying at Hubert Herkomer's art school in Bushey in her teens, Mabel Dearmer lived and worked at the heart of the 1890s vanguard. In addition to children's books, she designed bookplates, bindings, and posters. The years 1896 and 1897 were the height of her productivity in Decadent circles: she contributed images to *The Yellow Book, The Savoy*, and *The Studio*, and following Beardsley's departure as editor in April 1896, she was the first woman to create a cover for *The Yellow Book*.[6] A trained elocutionist, she offered public readings in 1894 of Henrik Ibsen's *Brand*, a play whose plot seems to have influenced her own fictions (she also produced the promotional poster herself [see figure 3.6]). She delighted in verses by the Symbolist Paul Verlaine, appropriating them in her novels, and was the dedicatee of a poem by Richard Le Gallienne. Her friendships with artists and aesthetes were more than mere acquaintanceships.[7] She and her husband, Percy Dearmer, went on multiple holidays with Netta Syrett, Evelyn Sharp, Laurence Housman, and Stephen Gwynn.[8] Close friends with *The Yellow Book*'s literary editor Henry Harland (for whom she designed the binding of his *Comedies of Errors*, published by The Bodley Head in 1898), she hosted a salon for the magazine's insiders, which Evelyn Sharp called "Mabel's lurid Mondays."[9]

Today few scholars of the fin de siècle are acquainted with her art.[10] She is better known for her death in 1915 from enteric fever while volunteering as a nurse in Serbia. Copies of her posthumously published *Letters from a Field Hospital* (1915) are far more obtainable than her illustrated books, which, given the propensities of their young owners, had an understandably short shelf life.

Mabel Dearmer's husband Percy Dearmer is far better remembered, not perhaps by scholars of literature, but certainly by historians of the Anglican Church. A respected Christian Socialist minister and liturgist, he was influential in promoting the standardization of Anglo-Catholic practices throughout Britain through his volume, *The Parson's Handbook* (1899), which ultimately ran to thirteen editions. By the 1890s his brand of High Churchmanship had become mainstream and did not carry the scandalous cachet that crossing over to Rome still did. Happily occupying the world of her husband and organizing parish activities,[11] Mabel Dearmer departed from socially iconoclastic New Women such as George Egerton (Mary Chavelita Dunne Bright) and Ella D'Arcy. She seems to have juggled her artistic predilections and ethical considerations successfully, perfecting a daring formalist style as a visual artist while also

pursuing Christian themes in her written work, particularly dramas for children and novels for adults.

Reflecting on her career and social circles, her friend Laurence Housman wrote in his 1937 memoir that after her husband's appointment as minister to St. Mary's, Primrose Hill in 1901, Mabel's character altered:

> [H]ow or why it came about, I don't know; but all at once she began to take herself seriously; ceasing to write funny books for children, she turned to somber novel-writing, and then to things of a mildly mystical character; and as her writing changed, she changed also; she became "good"; and it did not improve her, for it diminished her sense of humour, and still more the unconscious comedy of her behaviour. We remained good friends, but we saw less of each other as time went on; and when she began producing her plays by the aid of committees including archbishops and bishops, I was not of the company.[12]

Housman characterizes Dearmer's career by contrasting her early lightness to her later solemnity and religiosity, the latter epitomized by her production of mystery plays "by the aid of committees including archbishops and bishops."[13] It is indeed tempting to view Dearmer's art and life in terms of a transition from carefree Decadence to moral earnestness. But to claim this would be reductive. At sixteen, she was already an avowed socialist, pacifist, and suffragist. (Her belief that women would not gain the vote until they had proven themselves through service to the state was part of her later incentive to volunteer as a nurse in Serbia.) At seventeen, while still unmarried, she joined Percy Dearmer in London's East End, providing meals at the Christ Church Mission to dock workers' families during the 1889 Dock Strike.[14] In 1896 and 1897, the years she contributed to *The Yellow Book* and *The Savoy*, she was also illustrating Christian Socialist periodicals such as *Goodwill* and *Commonwealth*, the first jointly edited by Percy Dearmer's fellow Anglo-Catholic clergy, Henry Scott Holland and J.G. Adderly, and the second edited by Dearmer, Holland, Adderly and G.H. Davies.[15]

It is important here not to dichotomize the religious life against the aesthetic one. In earlier scholarship, I traced the paradigm of a Christian missionary–Aesthetic marriage in the union of Rev. Hugh Reginald Haweis and Mary Eliza Joy Haweis in the 1870s and 1880s.[16] Advancing the musical and decorative enhancement of church worship, Haweis had married a woman with artistic leanings, and the two became a recognizable force within British Aesthetic culture, associating with leading painters and heading *conversazioni* and salons. (They even purchased

the former home of Dante Gabriel Rossetti at the height of their success and maintained it as he had known it, out of homage to him.) The Rev. Haweis published treatises on church ceremonial; as an expert in campanology, this socialist priest also promoted Concerts for the People. Mrs. Haweis, in addition to her aesthetic guides, *The Art of Beauty* (1878) and *The Art of Decoration* (1881), produced pretty didactic books for children.

To some extent, in the 1890s the Dearmers followed this paradigm. While a young clergyman, Percy Dearmer was taken under the wing of the most vocal, innovative clergy of his day, men who merged their socialism with their ritualism: Holland, Adderly, Conrad Noel, and Stewart Headlam.[17] As a member of the Alcuin Club (established in 1897 to implement Tractarian guidelines for worship) and founder of the Warham Guild (established in 1912 for the design of ecclesiastical ornaments), Dearmer advised on materials from vestments to altar frontals.[18] Ritualism had created a specialized venue for British arts and crafts.[19] In 1900, Dearmer founded and chaired the S. Dunstan Society, which ensured that embroidered copes, surplices, and hoods would be solicited only from unexploited workers.[20]

Dearmer was far from a puritanical enemy of art. He had adorned his rooms at Oxford with Morris textiles, William De Morgan ceramics, and Edward Burne-Jones engravings.[21] He strengthened Mabel's aesthetic alliances: she initially befriended Richard Le Gallienne through him, and as his interest in hymnology grew, Percy consulted with Evelyn Sharp's brother, Cecil, the collector of folk ballads, on the road to his crowning work in indexing Anglican hymns with Ralph Vaughan Williams.[22] Together, he and Williams produced *The English Hymnal* (1906), *Songs of Praise* (1926), and *The Oxford Book of Carols* (1928). Percy Dearmer was a socialist, a feminist and supporter of suffrage, a scholar, and an aesthetic priest.

As a writer, Mabel Dearmer continued the thread of didactic children's literature begun by Mary Eliza Haweis. Mrs. Haweis had published *Chaucer for Children* (1877); Dearmer composed *A Child's Life of Christ* (1906) and founded the Morality Play Society in 1911 as a means of producing her drama *The Soul of the World, a Mystery Play of the Nativity and the Passion* (1911).[23] But where Mabel Dearmer departs from her forebearer is exactly the distinction in style between 1870s and early 1880s "greenery-yallery" Aestheticism and 1890s Decadence.

Readers of her children's books of the late 1890s detected Beardsley's influence on her visual style; her friend Stephen Gwynn called the designs "charming but mannered."[24] Reviewer H.D. Traill wrote in *The Graphic* in

1896 that she had illustrated Evelyn Sharp's *Wymps, and Other Fairy Tales* "comically enough, though sometimes with a 'Decadent' touch."[25] *The Graphic*'s later column that year on Christmas gifts for children included a dubious recommendation of Dearmer's next effort: "The illustrations are rather wonderful and fearful, Mrs. Pearcy Dearmer having evidently studied in the Aubrey Beardsley school and being addicted to harmonies – or discords – in the brightest yellow."[26] This flippant allusion to George Egerton aside, was it merely Dearmer's choice of a primary-colour palette that prompted reviewers to brand her a Decadent, or were wider choices of content to blame? In 1900, a reporter questioned the appropriateness of her *Book of Penny Toys* (1899) for children: "We notice that objection has been taken up in some quarters, and we think rightly, for serving up a tragedy like that in 'The Story of Pierrette' for children's consumption." The reviewer concluded: "The modern child is naturally precocious, and too much of the illustrated literature provided for it is calculated to intensify what from every point of view is an undesirable characteristic."[27] (The story is an unrequited romance that ends with the Pierrette dying for love.)

The attribution of Decadence to 1890s children's literature is nothing new. Caroline Sumpter's chapter on the little magazines at the fin de siècle demonstrates how fairy tales positioned the child as a symbol of a pre-industrial innocence and morality on the one hand, but as a representative of a pre-socialized, unconstrained individualism on the other.[28] Furthermore, tales by Oscar Wilde and illustrations by Laurence Housman and others served as vehicles for expressing and coding a gay sensibility and homoeroticism.[29] Dearmer did illustrate Evelyn Sharp's story in *Wymps*, "The Boy Who Looked Like a Girl"; but despite its promisingly queer title, the only quality that makes the boy effeminate in the tale is his smock, whose buttons up the back prevent him from casting it off. Posing the boy with his back to the viewer, Dearmer focused on his clothes rather than his face; in this regard, she was loyal to Sharp's tale. Not exactly gender-bending, neither the story nor the illustration were ultimately that radical. Generally, Dearmer's stories, rhymes, and accompanying illustrations seem tame in terms of content.

Mabel Dearmer's Art

With an eye to form, let us review some traits that Dearmer's work shared with Beardsley's. For instance, in the frontispiece to *Wymps, and Other Fairy Tales* (figure 3.1), she employs shading and line in ways that seem

Figure 3.1 Mabel Dearmer, frontispiece titled *Wymps* for Evelyn Sharp,
Wymps, and Other Fairy Tales (London: John Lane, 1897). (Reproduced by
kind permission of the Mark Samuels Lasner Collection, University of
Delaware Library, Museums and Press.)

evocative of his black-and-white engravings. The middle-right section
of this illustration, while not the focus of the drawing, mirrors Beards-
ley's characteristic use of stippling – that is, his use of a speckled texture
against patches of solid black and white. We see this quality in his *Cul de
Lampe* from Ernest Dowson's "The Pierrot of the Minute" (1905) and
in *The Eyes of Herod* from Oscar Wilde's *Salome* (1894) (figures 3.2 and
3.3). The landscape of the *Salome* picture anticipates the technique in
Dearmer's more simple drawing.

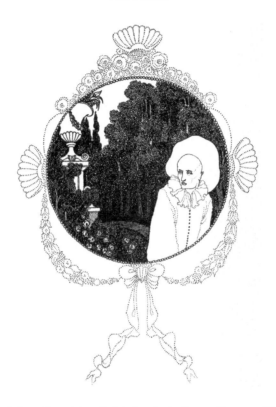

Figure 3.2 Aubrey Beardsley, *Cul de Lampe*, in Ernest Dowson, *The Pierrot of the Minute: A Dramatic Phantasy in One Act* (London: Leonard Smithers, 1897), 44. (Reproduced by kind permission of the Mark Samuels Lasner Collection, University of Delaware Library, Museums and Press.)

In 1915, Dearmer's friend, the Irish Member of Parliament, journalist, and poet Stephen Gwynn, recalled her innovation in fusing genres: "in making the pictures for *Wymps* [she] applied the methods of the poster to book illustration."[30] A compelling resonance exists between Dearmer's illustrations and Beardsley's colour-block posters. Beginning with Beardsley's poster for *A Comedy of Sighs* on the left, viewers have noted the sly way in which Beardsley's yellow dotted panels present the illusion of sheer, polka-dotted screens through which we see

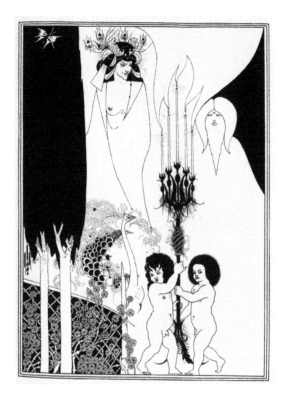

Figure 3.3 Aubrey Beardsley, *The Eyes of Herod*, in *Salome*, translated from
the French of Oscar Wilde (London: Elkin Mathews and
John Lane, 1894), opp. 32. (Reproduced by kind permission
of the Mark Samuels Lasner Collection, University of
Delaware Library, Museums and Press.)

the female figure (figure 3.4). Although Dearmer does not achieve this
effect, Beardsley's vertical panels are repeated in her broad horizontal
ones, the yellow being accentuated by regular dots in green (figure 3.5).
Notice on the left the way that Beardsley draws the figure's hair simply
by introducing a white parting and outline into the blue background; so
too does Dearmer pursue this technique with her standing female, using
white on black.

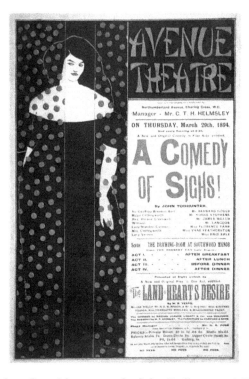

Figure 3.4 Aubrey Beardsley, poster for John Todhunter, *A Comedy of Sighs*,
and W.B. Yeats, *The Land of Heart's Desire*, Avenue Theatre, 29 March 1894.
(Reproduced by kind permission of the Mark Samuels Lasner Collection,
University of Delaware Library, Museums and Press.)

Although we have no letters or notes by Dearmer attesting to her
conscious borrowing from Beardsley's poster art, arguably the images
speak for themselves. Consider, on the left, the poster she produced
for her public recitation from Ibsen's *Brand* and Sheridan's *School
for Scandal* (figure 3.6). The white newspaper forms pointy angles
against the black background; now, on the right, see the ways that
these evoke the sharp angles in Beardsley's poster for *The Pseudonym
and Autonym Libraries* of his woman's shoulder, her hat brim, and her
hat ribbon (figure 3.7). The long skirts of both women occupy most
of the space in the left-hand panel, and in both posters the words are

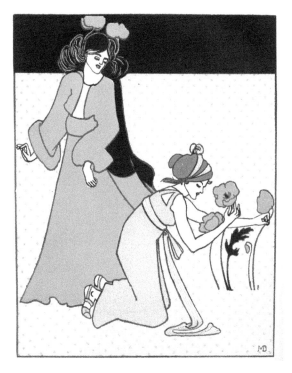

Figure 3.5 Mabel Dearmer, "The Soft-Hearted Prince," illustration, in
Evelyn Sharp, *Wymps, and Other Fairy Tales* (London: John Lane, 1897), 166.
(Reproduced by kind permission of the Mark Samuels Lasner Collection,
University of Delaware Library, Museums and Press.)

set off in right-hand panels that take up only one third of the whole
image. This similarity of word panels is even more pronounced when
we view Dearmer's poster against Beardsley's for the "Keynotes"
series that Elkin Mathews and John Lane published in the mid-1890s
(figure 3.8). Both word panels are inset in white against the coloured
or black background. The sharp angles of the newspaper again echo
the woman's mutton sleeves and hat in Beardsley, but there is even
more. Notice the use of sock and buskin, the masks of comedy and
tragedy, in each.

And finally, it is worthwhile to consider the Pierrot in Beardsley's
piece. A stock character from eighteenth-century Italian pantomime,

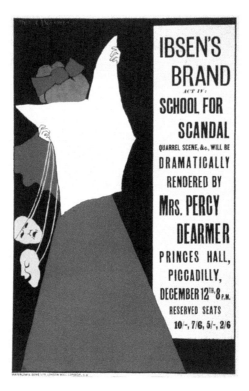

Figure 3.6 Mabel Dearmer, lithograph poster advertising her public recitation from Henrik Ibsen's *Brand*, act 4, and Richard Brinsley Sheridan's *School for Scandal*, Princes Hall, Piccadilly, 12 December 1895. (Reproduced by kind permission of the Mark Samuels Lasner Collection, University of Delaware Library, Museums and Press.)

the Pierrot, a sad, foolish clown pining for the woman he cannot have, was a favorite motif among English Decadents, and he occurs repeatedly in Beardsley's work, as in this design for a library series in 1896. The eighteenth-century painter Jean-Antoine Watteau, who had completed several images of the Pierrot, fascinated late Victorians such as Vernon Lee (Violet Paget) and Michael Field. Stephen Gwynn recalled that his friends of the 1890s "had the desire to express their emotions and their philosophies through fables, the more childish in form the better; to

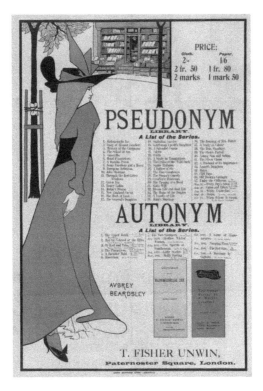

Figure 3.7 Aubrey Beardsley, advertising poster for *The Pseudonym and Autonym Libraries* (London: T. Fisher Unwin, 1894). (Reproduced by kind permission of the Mark Samuels Lasner Collection, University of Delaware Library, Museums and Press.)

charge a toy with meaning and load Pierrot with all the melancholy of the world."[31] The Pierrot does indeed seem ubiquitous. Dearmer published her own Pierrot illustration (figure 3.9); moreover, in her novel *The Difficult Way*, a painter completes an advertising poster that makes use of this figure.[32]

Returning from Dearmer's self-promotional poster to her illustrations in children's literature, I feel obliged to say that amid the more experimental and, as we will see, potentially disturbing examples from her body of

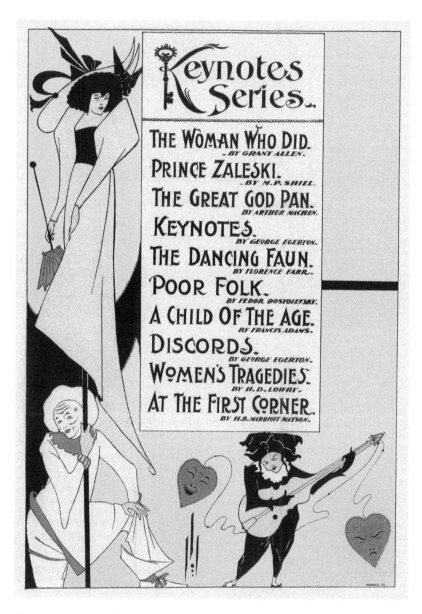

Figure 3.8 Aubrey Beardsley, poster for the "Keynotes" series (London: John Lane, 1897). (Reproduced by kind permission of the Mark Samuels Lasner Collection, University of Delaware Library, Museums and Press.)

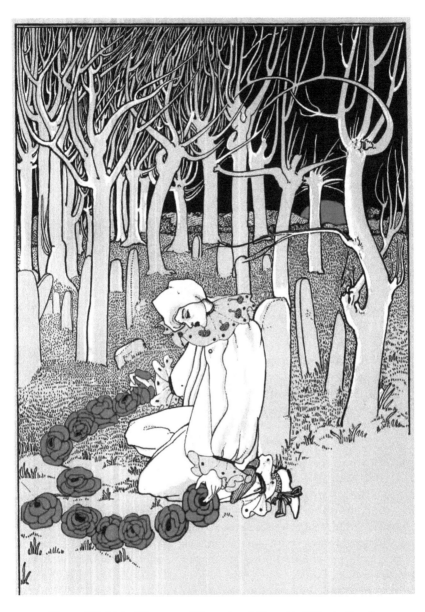

Figure 3.9 Mabel Dearmer, "Pierrot and Pierrette," illustration in
The Studio 11 (1897): 263. (Reproduced by kind permission of
Southern Regional Library Facility, University of California.)

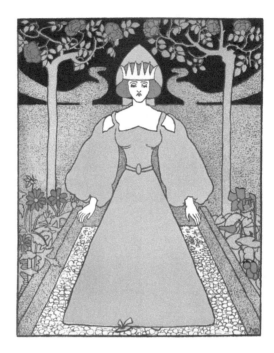

Figure 3.10 Mabel Dearmer, "The Princess in Her Garden," illustration, in
Evelyn Sharp, *Wymps, and Other Fairy Tales* (1897), 92. (Reproduced by kind
permission of the Mark Samuels Lasner Collection, University
of Delaware Library, Museums and Press.)

work, Dearmer also produced many images that were traditional, uncon-
troversial, and reminiscent of Walter Crane's or even Mrs. Haweis's –
pretty busy images of princesses, rocking horses, and sleeping dragons.
The more revolutionary qualities when they appear are really design-
oriented, such as her ability (in the frontispiece to *All the Way to Fairy-
land*) to capture speed through the juxtaposition of cloud shapes against
a flying princess's hair (this image seems to anticipate twentieth-century
action comics). Equally innovative is her flattening of a picture through
the use of symmetry and doubles, which impart a sense of decorative
pattern more like Walter Crane's wallpaper than his books for children;
"The Princess in Her Garden" and the cover designs for *Wymps* and *All the
Way to Fairyland* exemplify this method (figures 3.10–3.12). One can also

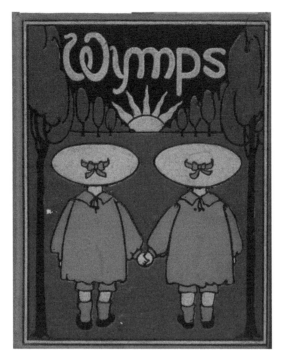

Figure 3.11 Mabel Dearmer, cover image, in Evelyn Sharp, *Wymps, and Other Fairy Tales* (London: John Lane, 1897). (Reproduced by kind permission of the Mark Samuels Lasner Collection, University of Delaware Library, Museums and Press.)

find a Japanese influence in images such as "Will you come and play with me, Little Wisdom," with its asymmetry, cherry blossoms, and parasoled figure (figure 3.13).

The condition of the prince in the picture points to another dimension. If we want to see morbidity in her work, it may be best found in her evocations of powerlessness and begging. Certainly, episodes of subjugation have been the stuff of children's literature from the Brothers Grimm on, and Sharon Marcus's chapter in *Between Women* reminds us of how doll play is an arena for enacting power,[33] as this illustration – "The Lady Emmelina Is Always Kept in Her Proper Place Now" – confirms

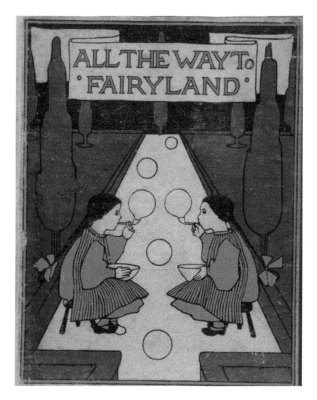

Figure 3.12 Mabel Dearmer, cover image, in Evelyn Sharp, *All the Way to Fairyland* (London: John Lane, 1898). (Reproduced by kind permission of the Mark Samuels Lasner Collection, University of Delaware Library, Museums and Press.)

(figure 3.14). Many of Dearmer's drawings represent scenes of pleading or kneeling, and they loosely parallel the inherent culture of dominance and submission in Beardsley's work. One does find an eeriness in the illustration "In a Sea-Green Country," whose artistry is not merely in its colouring but also in the details like the gulls overhead and the witch's positioning beside the vertical rocks on the left (figure 3.15). There is a desolation to this scene, and to "The Little Witch of the Plain," its sister from another story in *Wymps*, a bleakness that seems unusual for its time, especially when we consider that Dearmer published this only five years before Arthur Rackham's first efforts and ten before Edmund Dulac's.

Figure 3.13 Mabel Dearmer, "Will You Come and Play with Me, Little Wisdom?," illustration, in Evelyn Sharp, *All the Way to Fairyland* (London: John Lane, 1898), 179. (Reproduced by kind permission of the Mark Samuels Lasner Collection, University of Delaware Library, Museums and Press.)

Mabel Dearmer and Decadence

In contrast to the two volumes that she illustrated for Evelyn Sharp, whose images have been the focus here, Dearmer's own works for children such as *Round About Rhymes* (1898) and *A Book of Penny Toys* (1899) feature many of the same visual effects, but in a simple format, such as an alphabet book written for a younger child. Sharp's stories about the malevolent, childish, flighty, practical-joke-playing fairies, the Wymps, are far more unsettling than Dearmer's independent work, and it is to Dearmer's credit as an illustrator that she picked up on their tone and

Figure 3.14 Mabel Dearmer, "The Lady Emmelina Is Always Kept in Her Proper
Place Now," illustration, in Evelyn Sharp, *All the Way to Fairyland* (London: John
Lane, 1898), 145. (Reproduced by kind permission of the Mark Samuels Lasner
Collection, University of Delaware Library, Museums and Press.)

ran with it. Without question, "The Wymps Say That Queer Began It" is
the eeriest of Dearmer's pictures (figure 3.16), anticipating the other-
worldliness and obsessive repetition of faces in works by the twentieth-
century mentally ill Chicago recluse Henry Darger.[34]

Dearmer's reviewers perceived her work as Decadent, yet the public
continued to see her as a producer of popular, innocuous children's
books. There is no evidence that her style of draftsmanship or her alli-
ances with *The Yellow Book* circle threatened her husband's reputation as
a cleric or her own as a cleric's wife. But then, by the Edwardian era, the
public also knew her as a novelist concerned to reconcile art with ethics.
Her novel *The Difficult Way* presents a defence of aesthetic feeling in the
midst of a treatise about genuine Christian faith and love. It follows the

Figure 3.15 Mabel Dearmer, "In a Sea-Green Country," illustration, in Evelyn Sharp, *Wymps, and Other Fairy Tales* (London: John Lane, 1897), 22. (Reproduced by kind permission of the Mark Samuels Lasner Collection, University of Delaware Library, Museums and Press.)

minister John Pilgrim's growing discomfort with his wife's "pagan" love of beauty and the art-student culture she has only recently left behind, and it depicts the tragic consequences of her growing reticence and his distrust.

John Pilgrim's parish, in an unspecified, ugly district of South London, seems closely modelled on Lambeth, where Percy Dearmer had his first church in the starting years of the Dearmers' marriage.[35] In the novel, the young and spirited Nan Pilgrim is careless of the expectations placed on her as a minister's wife; it is difficult to credit this as autobiographical, since we have no record of Mabel Dearmer shirking her role, though she may have resented ladies' guilds in the early days of her marriage. Also a departure from biography, John Pilgrim

Figure 3.16 Mabel Dearmer, "The Wymps Say That Queer Began It,"
illustration, in Evelyn Sharp, *All the Way to Fairyland* (London: John Lane,
1898), 21. (Reproduced by kind permission of the Mark Samuels Lasner
Collection, University of Delaware Library, Museums and Press.)

is represented as austere by nature; his marrying a beautiful lively girl
has not squelched his earlier dogma of renunciation. Fretting that she
has not discovered God's spirit, he urges Nan in his old belief in the
virtue of self-denial.

Meanwhile, Nan's concerns are far more pragmatic and urgent. As
a household manager, she is shamed and harassed by their debts: John
Pilgrim's earnings do not cover the costs of their maintenance, however
simply they live, and she cannot bring herself to tell him how serious
the problem is. When she does, he thoughtlessly chides her for extrava-
gance. Yet she loves him enough not to quarrel. In order to afford good
food and wine so as to ameliorate his growing cough, she secretly models

for pay in the studio of her old art-school friend Roger Wentworth. This solution allays the Pilgrims' money problems but fosters Nan's distance and John Pilgrim's distrust at her absences. By the end of the book, Nan adopts his stance, confessing that for every material item she has bought to strengthen his body, she has chiselled away at his faith, his soul, through her deceptions.[36] By the end of the story, Nan's faith is her beauty.

A great irony of the novel is that John Pilgrim repeatedly blames Nan's elegant friend Selina for corrupting her. Sensible enough to know she does not have a talent as a painter, Selina has returned from Paris a successful milliner, and John assumes that Nan has been spending her afternoons at her luxurious shop in the city. Selina, while as much an unbeliever as Nan, worries over the visible dissolution of the Pilgrims' marriage and cultivates a friendship with Pilgrim's spiritual mentor, Father Peter. If Selina is wrongly accused of amoral decadence, then the real villain of the novel is Pilgrim's scheming parishioner Mrs. Stamp, who gloats over and gossips about Nan's alleged infidelity. Interestingly, Mrs. Stamp lives at 66A Mikado Road, hangs Japanese hangings in her hallway, wears tea gowns, and burns joss sticks from Liberty's, imagining herself "some veiled woman of the East" while the fumes "[cover] even the remembrance of the beef-steak pudding" (111). She is an unconvincing aesthete: her attempts at mystery and style are rendered comic by her "waddling," "bulky" person and her conventionalities and petty ethics regarding volunteer work in other scenes of the book (111, 119, 64).

If there is any Decadent aspect to Nan's character, it is that she is tightly wound, a bit like Max Nordau's representations in *Degeneration* (1892) of overcultivated degenerates past the physical prime of their race. "She was the sport of passions that carried her beyond herself" (49). Even before the conflict is introduced in the story, in bed at night, Pilgrim must soothe Nan from nightly terrors that spur her to cry out and sob in her sleep. Nan simply feels intensely. She suffers a war inside her between guilt, anger, and her physical passion for John – which is itself represented quite vividly (49). Likewise, one of the heroines of the book, Miss Gillespie, responds to the rumours of Nan's sin with hypersensitive, visceral shame and terror. Another novelist might dismiss her as a hysteric, but Dearmer justifies and applauds such strong sensations as genuine. Later in the novel, Nan's intensity of feeling is legitimized and given purpose when she is called on to nurse Pilgrim and telepathically shares his thrill at God's presence as he dies.

Although Nan's love of beauty, like all else, triggers immoderate emotions in her, it is not a love of decay or artifice or lassitude. In a key speech to Pilgrim, she excitedly refutes him.

> "The lust of the eye!" *What* does it mean? It's nonsense! Does it mean a longing for beauty? Beauty was our religion at Landsbury [art college]. Beauty was a holy thing. We were wild – mad – drunk – with the beauty of life. Life – and you talk of the *pride of life* as though it were a sin! Oh John, what *is* life, if you are not to be proud of it? [...] Beautiful, glorious, wonderful life – palpitating and beating, and burning in everything – here it is all slipping away, and we shall never, never, *never* have another! (47–8)

This statement, life-affirming as it is, disturbs John because of the Paterian anxieties of loss undergirding it; he is appalled that she has not envisioned an eternal life that will surpass the joys of this one (48). Indeed, the novel is threaded with knowing allusions to Walter Pater, and elsewhere, Wilde, as when Roger the artist lectures: "To realise oneself through a sitter isn't a mark of the charlatan. The great painter invariably sees himself" (51). Selina's description of a scene by the docks clearly draws on James Whistler's nocturnes (132), and Roger Wentworth's skills as a portraitist are weighed against John Singer Sargent's (287). A minor character boasts that she has studied at "Bastien's," a reference to Jules Bastien-LePage's Paris atelier, frequented by female English art students and by the realist painter and tubercular diarist beloved of the Decadents, Marie Bashkirtseff (to whom Dearmer's Nan actually refers) (185). Still, for all its sophisticated allusions, artists in the novel credit their work with the kind of socially regenerative potential found in John Ruskin's and William Morris's writings, not in Arthur Symons's and Max Beerbohm's respective defences of artifice. Roger anticipates that his portrait of Nan (as Elaine, that Pre-Raphaelite standby) will inspire and purify its viewers. He tenderly touches the painted face: "Because of you men shall pause in the midst of struggling, sordid lives, and become wishful for the unseen. Because of you shall their hearts fill with the wild longing for something – they know not what – something beyond the cradle of imagined things" (103–4).

Like Roger's, Nan's ideal of art is fortifying rather than enervating, and she sees beauty as a social necessity. Repeatedly, when she tries to explain her revulsion at the ugliness of South London ("There is no beauty, no sunshine, no laughter in this place [...] We live here together shut out in the blackness, full of anxiety for the morrow. We seem to see nothing but

the sores of the world" [67]), John responds by trying to undermine her thinking, translating the issue from an aesthetic into a moral one. He hopes to divert her focus from physical squalour to the unseen spiritual world and praises quotidian sacrifice as a price one pays for heaven. But Nan resists his sermonizing and protests that her environment ought to be sustaining, "It is this religion – this religion of pain – this religion that would turn life, beautiful life – into a crucifixion – that is between us. I won't be crucified – willingly. I hate pain. I hate discomfort. I see nothing noble in unnecessary suffering" (71–2). If we consider how slum Ritualists sought to beautify church services for the poor and to ease their everyday burdens through social activism, then it is clear that Nan's justification for physical beauty in daily life echoes that of Percy Dearmer and like-minded ministers.

But beauty alone is not enough without faith. Just as John is too puritanical, Nan is too childish and simple. For most of the novel, both persist in seeing aesthetics and trust in God as antithetical. The end of the book, however, finds Nan widowed, wiser, and transformed, still in decrepit South London, but cultivating, along with her garden, a nursery for her son and the children of the streets. Nan's aestheticism has found an avenue in service, and through this, she conquers the restlessness of her earlier days. Such a conclusion marks the novel as Christian Socialist and aesthetic, but not Decadent.

But what of its formal qualities? If we move away from the classification of Decadence as an immoral, self-serving lifestyle, are there effects in the novel that seem to test our logicality, where, in Barbara Spackman's phrase, "the logic of diversity functions to contaminate and introduce an asymmetry into the logic of absolute difference"?[37] Perhaps. When Nan ultimately explains the purpose of her existence and the reason for her peace, Dearmer's terms are mystifyingly general. Nan, who had celebrated life as an aesthete, now insists that "life" is all, that life is "the only key to the mystery of sorrow" (265). Presumably, this is not the same argument that she was making earlier, nor is she claiming, as Wilde did in *De Profundis*, that sorrow is the secret to life. Her lack of clarity does leave the reader in a state of perplexity. Again, we wonder if Dearmer is experimenting with a Decadent style in order to convey a socially responsible story.

The question "Was Dearmer a Decadent?" seems quite futile when we admit the elusiveness and variability of the term Decadence. We cannot simplify Decadence and hinge it on her resemblance to a single figure, a Beardsley or a Wilde. While Dearmer's visual illustrations are redolent of some

of Beardsley's poster work, they nevertheless also attest to her originality as a designer, particularly in her use of colour. Looking to the pictures' formal qualities, and hearkening back to earlier moral condemnations of Decadence, we might claim that some images, such as "The Princess in Her Garden" and "The Wymps Say That Queer Began It," emanate a sinister feeling. But we are more likely to call her Decadent because of the circles with whom she associated and the venues in which she published.

Perhaps more significant, Dearmer demonstrates how a single individual could occupy a point of intersection between coexisting cultures of formal Decadence and Christian Socialist aestheticism. Today we find these cultures oppositional and assume that she struggled to reconcile them. But it may be that, as a multifaceted personality (and a good-humoured one), she experienced them seamlessly and without conflict. Beardsley had deployed Decadence with an eye to titillating and scandalizing his viewers; Dearmer's visual Decadence instead appears grounded in the playful rather than the pornographic. Working through various formal challenges at her drafting table, she toyed with prevalent tropes such as the Pierrot and adopted the arrangements of popular poster art. Likewise, her moralistic novel features its own resolution of a puzzle, but through avenues that are not always clear to the reader. Hence, in its own manner, *The Difficult Way* is perhaps formally decadent in its "difficulty."

NOTES

I am grateful to Mark Samuels Lasner and Margaret D. Stetz for introducing me to the work of Mabel Dearmer.

1 Karl Beckson, *Aesthetes and Decadents of the 1890s: An Anthology of British Poetry and Prose* (Chicago: Academy Chicago, 1981).
2 David Weir, *Decadence and the Making of Modernism* (Amherst: University of Massachusetts Press, 1995), 10.
3 Regenia Gagnier, "A Critique of Practical Aesthetics," in *Aesthetics and Ideology*, ed. George Levine (New Brunswick: Rutgers University Press, 1994), 270.
4 Dennis Denisoff, "Vernon Lee, Decadent Contamination and the Productivist Ethos," in *Vernon Lee: Decadence, Ethics, Aesthetics*, ed. Catherine Maxwell and Patricia Pulham (Basingstoke: Palgrave Macmillan, 2006), 80.
5 Joseph Bristow, "Introduction," in *The Fin-de-Siècle Poem: English Literary Culture and the 1890s*, ed. Bristow (Athens: Ohio University Press, 2005),

3–5, 36–7; in the same volume, Jerusha McCormack, "Engendering Tragedy: Toward a Definition of 1890s Poetry," 47–9.

6 Jill Shefrin, "'Dearmerest Mrs. Dearmer': A Lecture Given at the Osborne Collection in Lillian H. Smith Branch, April 22, 1999" (Toronto: Friends of the Osborne and Lillian H. Smith Collections at the Toronto Public Library, 1999), 19. Out of print, this essay has been digitized and is available online at http://www.teetotum.ca/DearmerestMrsDearmer.pdf. More recently, Mabel Dearmer and her work have been acknowledged in Heather Marcovitch, "The Yellow Book: Reshaping the Fin de Siècle," *Literature Compass* 13, no. 2 (2016): 79–87 at 81, 82. In a short memoir, Ella D'Arcy recalled Mabel and Percy Dearmer attending open houses at Henry Harland's home: see Ella D'Arcy, "*Yellow Book* Celebrities," *English Literature in Transition, 1880–1920* 37, no. 1 (1994): 33–7 at 34.

7 Stephen Gwynn, "Memoir," in Mabel Dearmer, *Letters from a Field Hospital* (London: Macmillan, 1915), 8.

8 Shefrin, "'Dearmerest Mrs. Dearmer,'" 14–15.

9 Stephen Gwynn, *Experiences of a Literary Man* (London: T. Butterworth, 1926), 138.

10 Margaret D. Stetz offers a lively summary of Dearmer's political and artistic pursuits in *Gender and the London Theatre, 1880–1920* (High Wycombe: Rivendale Press, 2004), 53. Dearmer is listed in Sandra Kemp, Charlotte Mitchell, and David Trotter, eds., *Edwardian Fiction: An Oxford Companion* (Oxford: Oxford University Press, 1997), 93.

11 Gwynn, "Memoir," 14–15.

12 Laurence Housman, *The Unexpected Years* (London: Jonathan Cape, 1937), 129.

13 Housman, *The Unexpected Years*, 129.

14 Shefrin, "'Dearmerest Mrs. Dearmer,'" 11.

15 Shefrin, 14.

16 Diana Maltz, *British Aestheticism and the Urban Working Classes, 1870–1900: Beauty for the People* (Basingstoke: Palgrave Macmillan, 2006), 127–9.

17 Nan Dearmer, *The Life of Percy Dearmer* (London: The Book Club, 1941), 35–6, 39, 91.

18 Nan Dearmer, *The Life of Percy Dearmer*, 174, 177.

19 Christine Bayles Kortsch, *Dress Culture in Late Victorian Women's Fiction: Literacy, Textiles, and Activism* (Burlington: Ashgate, 2009), 159.

20 Nan Dearmer, *The Life of Percy Dearmer*, 114.

21 Shefrin, "'Dearmerest Mrs. Dearmer,'" 17.

22 Dearmer, *The Life of Percy Dearmer*, 99, 178.

23 By all accounts, Dearmer's discovery of the mystery play as a medium in 1910 and her facility at writing and directing such dramas were the creative

apex of her life. Gwynn claims that had she not died in 1915, she would have eventually founded her own private theatre ("Memoir," 8).

24 Gwynn, "Memoir," 8.

25 H.D. Traill, "The World of Letters," *The Graphic*, 12 December 1896, 743.

26 "The Christmas Bookshelf," *The Graphic*, 18 December 1897, 802.

27 "New Children's Books," *Birmingham Daily Post*, 6 January 1900.

28 Caroline Sumpter, *The Victorian Press and the Fairy Tale* (Basingstoke: Palgrave Macmillan, 2008), 140, 144.

29 Sumpter, *The Victorian Press and the Fairy Tale*, 156–74.

30 Gwynn, "Memoir," 8.

31 Gwynn, *Experiences*, 141–2.

32 Mabel Dearmer, *The Difficult Way* (London: Smith, Elder, 1905), 101. Dearmer also published the image "Pierrot and Pierrette," in *The Studio* 11 (1897), 263.

33 See Sharon Marcus, *Between Women: Friendship, Desire, and Marriage in Victorian England* (Princeton: Princeton University Press, 2007), 149–66.

34 On Darger, see John MacGregor, *Henry Darger: In the Realms of the Unreal* (New York: Delano Greenridge Editions, 2002).

35 Gwynn, "Memoir," 7.

36 Dearmer, *The Difficult Way*, 264; further page references appear in parentheses.

37 Barbara Spackman, "Interversions," in Liz Constable, Dennis Denisoff, and Matthew Potolsky, eds., *Perennial Decay: On the Aesthetics and Politics of Decadence* (Philadelphia: University of Pennsylvania Press, 1998), 41.

PART II

FEMININITY, MASCULINITY, AND FIN-DE-SIÈCLE AESTHETICS

"So much too little": Alice Meynell, Walter Pater, and the Question of Influence

BETH NEWMAN

For most of the twentieth century, Alice Meynell's work was regarded as too retrograde to matter. It was too traditional, too conventional, too decorous, in short, too "Victorian," even though she made her mark in the decade of the Decadents and lived into the ferment of high modernism. Feminist critics began recovering her in the 1980s, and since the turn of our own century, she has been reclaimed as a poet, essayist, and journalist who exemplified women's participation in fin-de-siècle aestheticism. The publication by Pickering and Chatto of *The Women Aesthetes: British Writers, 1870–1900* (2013), in which Meynell is one of the twenty or so writers represented, makes it likely that scholars will continue to engage with her as they seek to understand the last three decades of the nineteenth century. So too does the attention given to Meynell by Marion Thain in her monograph *The Lyric Poem and Aestheticism: Forms of Modernity* (2016) and by Isobel Armstrong in the second edition of her magisterial *Victorian Poetry: Poetry, Poetics, and Politics* (2019). But there is a recurrent problem in these efforts at recovery: Meynell's aesthetic conservatism, which distinguishes her from most of the other writers being grouped with her. It seems responsible for her neglect, determining the ways in which she quickly came to be viewed as not of her own time. How has this conservatism determined the ways in which she quickly came to seem out of step?

Critics have addressed this problem in different ways. Talia Schaffer, focusing on Meynell's essays, compellingly constructs her as the "Angel in Hyde Park" in whom aspects of the New Woman merged with those of traditional femininity – though at the expense of her reception in the generation of Virginia Woolf.[1] Meredith Martin, writing about the poetry, argues that Meynell anticipated her own eclipsing by the modernists,

fearing that her commitment to meter would make her unpalatable
to an audience indifferent to the "laws of verse" she held dear.[2] For F.
Elizabeth Gray, who recuperates her as a religious (specifically Roman
Catholic) writer, the problem is not Meynell's at all, but arises rather in
the "periodizing effort" itself, or in a secularist bias that regards her reli-
giosity as inherently regressive.[3] More recent scholarship about the fin de
siècle, which works to complicate the "periodizing" narrative of a break
between Victorian and modernist poetics, does not dismiss the problem
of Meynell's conservatism; it reformulates it. Rather than accepting the
high modernists' depreciation of the recent past, contemporary scholars
read turn-of-the-century writing more pluralistically and less apologeti-
cally. Thain, for example, characterizes Meynell's poetry as a deliberate
"theorisation of the phenomenology of the poetic page" that illuminates
the poetry of her more canonical contemporary, Thomas Hardy.[4] Arm-
strong, grouping her with other poets who represent "alternative *fins de
siècle*," locates in Meynell's work a critique of Decadence, in part through
a eucharistic reading of materiality.[5] My reading here similarly reads
Meynell as a critic of Decadence, but I focus on her conception of time as
the sign of her problematic relationship to the time in which she wrote.
I also seek to complicate the account often provided of her relationship
to her Aestheticist precursors.

 In the introduction to the section devoted to Meynell in *The Women
Aesthetes*, the editors assert that Meynell's writing "reflected the influ-
ence of Walter Pater and John Ruskin."[6] Here they are likely follow-
ing Schaffer, who established the existence of the "female aesthete"
and presented Meynell as a paradigmatic example. Schaffer invokes
the importance of both Pater and Ruskin to Meynell's aestheticism,
though emphasizing Pater: "When she discourses on the significance
of a particular cloud or reed, Meynell is following Pater's advice that
'art comes to you proposing frankly to give nothing but the highest
quality to your moments as they pass, and simply for those moments'
sake.'"[7] The source of the "advice" Schaffer quotes is the "Conclusion"
to Pater's *Studies in the History of the Renaissance* (1873), which is widely
considered the manifesto of the Aesthetic Movement, with Pater as its
chief theorist.[8] Ana Parejo Vadillo, characterizing Meynell's response to
the modern city as "impressionist," similarly invokes the famous "Con-
clusion" and draws an analogy between Meynell and Pater.[9] She notes
that both convey the impressions of an avowedly subjective observer in
carefully chosen language, producing that are late nineteenth-century
prose equivalents of the lyric poem.

But Meynell herself disavowed Pater's influence. More precisely, she consistently claimed she had not even read him. In a letter to her mother about the reviews of *Ceres' Runaway* (1909), one of her several essay collections, she writes: "I send you the *Morning Post* notice which is clever and cold and quite amusing. When the reviewer calls me a writer in Pater's manner, he makes a curious blunder; I am the only literary person now alive who has never read Pater at all."[10] Nor was this the first time she claimed a lack of familiarity with Pater. In 1896, Edmund Gosse sent her a collection of Pater's essays, probably the posthumously published *Miscellaneous Studies* (1895). In her letter of thanks, she noted: "I know so much too little of his writings, and these will interest me," adding that the poet Coventry Patmore had given her a copy of Pater's *The Child in the House*. But she did not indicate whether she had liked it or even that she had read it. Her silence suggests that she had not, but it may also have been dictated by the fact Patmore died exactly two weeks earlier, an event to which the rest of her short letter alludes.[11] Meynell's deep friendship with Patmore, cemented by their shared Roman Catholicism, their passion for poetry, their interest in poetic metre, and mutual admiration, flourished for four years despite their diametrically opposed political views. Eventually it grew too warm for comfort, and she broke with him. Defying the changing winds of opinion, she nevertheless continued to extol him in print after his poetry fell from grace.

Meynell defied those winds again when she published a full-length monograph about Ruskin in Blackwood's Modern English Writers series the year Ruskin died (1900). Her allegiance to Ruskin, too, was qualified, though when she expressed her criticism of him she did so with her characteristic mixture of obliqueness and defiance. She pays him ambivalent homage in a poem she first called "The Two Childhoods" but later renamed "Two Boyhoods." The revised title announces that Meynell is commenting on *Modern Painters*, the source of an essay ("The Two Boyhoods") that had, by the late nineteenth century, become a free-standing anthology piece. But whereas Ruskin had contrasted the boyhoods of two painters, Giorgione and J.M.W. Turner, Meynell pairs the boyhoods of two poets, William Wordsworth and Dante Alighieri, extolling both as the fathers to the most noble passions "in the heart of man."[12] She thereby corrects two of Ruskin's judgments in *Modern Painters*: (1) that in the course of the nineteenth century the poet will become less important to human expression than the painter, whose art better conveys the sudden, momentary experience of wonder; and (2) that Wordsworth is a poet

merely of the second order. Meynell simultaneously affirms poetry's centrality to "modern passion" and makes Wordsworth the peer of Ruskin's exemplary first-order poet, Dante.[13]

Meynell's quarrel with Ruskin about the future of poetry is no mere special pleading for her own chosen art form. Her preference for the revelatory power of temporal, sequential expression over the static character of pictorial representation is consistent with her attitude towards time, which I discuss below. But her general allegiance to Ruskin otherwise illuminates the specific character of her Aestheticism while also showing why, for most of the twentieth century, her work was regarded as too retrograde to matter, too mired in the Victorian sensibilities she outlived. Ruskin's writings won her assent because his ideas about art were inseparable from his criticism of laissez-faire economics, which she, as a socialist, also rejected; and because his economic views joined with his anti-utilitarian insistence on beauty to form part of a larger moral vision that she admired. Meynell frames her book as a defence of a major Victorian sage already deemed old-fashioned and irrelevant and whose teaching was being "effectually rejected."[14] Things had been different eighteen years earlier, when Walter Hamilton devoted an entire chapter to Ruskin in *The Aesthetic Movement in England* (1882) without even mentioning Pater. But it is impossible to imagine W.B. Yeats including a selection from Ruskin's writing in *The Oxford Book of Modern Verse, 1892–1935,* which famously begins with an excerpt from the chapter on Leonardo da Vinci in *The Renaissance* rendered into lines of poetry. As Rachel Teukolsky has observed, the name of Ruskin is "never far from the linked term Victorianism," often in its most disparaging acceptations. Yet Meynell preferred Ruskin for his insistence on the necessary relationship between beauty and morality and for his dissatisfaction with market capitalism. Above all, she preferred his theocentric vision, which made it possible for her to align him with Dante despite his early anti-Catholicism. At the close of her Ruskin volume, she observes that one of Ruskin's final works, *Praeterita: Outlines of Scenes and Thoughts Perhaps Worthy of Memory in My Past Life* (1885–9), "end[s], in Dante's way, with 'the stars.'"[15]

Yet there is something odd in Meynell's remark that she read "so much too little" of Pater. Had she simply ignored him? They shared many interests (art; the cultivation of their readers' taste; a love of Italy). Patmore had recommended him. They even lived in the same London neighbourhood, as Vadillo notes.[16] Is her strange oxymoron an embarrassed cover for the complete ignorance she later boasted of to her mother? Or could it be an unwitting acknowledgment that though she knows so little, it is

already too much – more than she cares to know? Similarly, what should we make of her reference to Pater in her 1906 tribute to Coventry Patmore, who died ten years earlier? In an unconvincing defence of his work, she declares: "Together with Love, Patmore's subject was the Child in the House, before ever Pater had so varied Patmore's title."[17] Here she is seeking to bolster Patmore's waning reputation by giving him both temporal and imaginative priority over the more highly regarded Pater, who becomes derivative – and whom she accuses of having pilfered both a title and a subject from her late friend. Is she revealing some kind animus against Pater?

I will argue here that contrary to what she claimed in her letter, Meynell read at least the famous "Conclusion" to Pater's *The Renaissance* and was provoked to refute it powerfully but obliquely in her own best-known essay, "The Rhythm of Life," first published in 1889. There is no direct evidence that Meynell actually read any part of *The Renaissance*. But even if she did not, the differences between these two short statements are worth considering for what they reveal about the dense interplay of aesthetics, politics, and religion in fin-de-siècle writing. The differences between Meynell's essay and Pater's "Conclusion" are political, doctrinal, and temperamental. They arise in Meynell's commitments to feminism, socialism, and insistent belief in God; and they reflect her tendencies towards ritual, discipline, and restraint.

Meynell contra Pater

In 1896, a few months before she thanked Gosse for sending her Pater's essays, Meynell contributed a brief commentary to the magazine *Woman*, which ran a series of six short pieces by six different woman writers on the topic "My Faith and My Work." Of her religious faith, Meynell says nothing, construing the word *faith,* as most of the other writers do, in secular terms – as a matter of the beliefs about life and work that guide them as professional women. Meynell ends her essay with a direct statement about her political beliefs, in the midst of which comes a sentence whose first half seems to paraphrase a much longer one from the "Conclusion" to *The Renaissance*. "Men," she writes, "are separated from each other by *an unalterable boundary of personality*."[18] Pater had written, with more resonant bleakness: "Experience, already reduced to a group of impressions, is ringed round for each one of us by that *thick wall of personality* through which no real voice has ever pierced on its way to us, or from us to that which we can only conjecture to be without."[19] Personality separates us

from one another; on this much they agree. But for Meynell, the unalterable boundary separating us becomes a reason to embrace political activity and human creativity as something shared, not a reason to retreat into private ecstatic experience. Earlier in the same paragraph, she declares herself "rather inclined towards Socialism than towards Individualism."[20] The sentence that begins by echoing Pater thus swerves in a direction altogether different from his. She concludes, "let [men] nonetheless live in order and in relation to one another; that relation is civilization and political vitality."[21] Her short statement thus ends with an exhortation to a shared life regulated by "order."[22]

A respect for order governs "The Rhythm of Life" as well. This short essay, one of Meynell's best-known now as in her own day, was much admired in its time. W.E. Henley, who published it in the *Scots Observer* on 16 March 1889, called it "one of the best things it has so far been my privilege to print."[23] This was no small praise. The *Scots Observer*, a short-lived weekly, counted among its contributors such fin-de-siècle luminaries as Edmund Gosse, Robert Louis Stevenson, W.B. Yeats, and Stéphane Mallarmé, along with other writers now being recovered by contemporary scholars. Meynell acknowledged her own fondness for the "The Rhythm of Life" by bestowing its title upon her first collection of essays, published by Elkin Mathews and John Lane in 1893, and placing it first in the volume. The date of its original publication is significant, for Pater had brought out the third edition of *The Renaissance* in 1888. This is the edition to which he restored the controversial "Conclusion," after withdrawing it from the second edition (1877) in deference to John Wordsworth, Oriel Professor of the Interpretation of Holy Scripture, and other theologically conservative colleagues at Oxford.[24] Though it is likely that Meynell was unaware of the essay's suppression, its restoration was newsworthy enough to be reported in the "Literary Gossip" section of *The Athenæum*.[25]

Meynell's publication of *The Rhythm of Life* under Mathews and Lane's The Bodley Head imprint has given the volume the "aesthetic" stamp for contemporary critics. Its original readers would have responded the same way, for, as Margaret D. Stetz has shown, John Lane cannily exploited the vogue of the "Aesthetic School" as a marketing strategy.[26] Nevertheless, the volume also shows Meynell rejecting the Aestheticism represented by two iconic aesthetes, James McNeill Whistler and Oscar Wilde. In an essay titled "The Unit of the World," she attacks their habit of championing art by denigrating nature or seeking to supplant it altogether. Her response is no simple reversal. Rather, she avoids the puerile "quarrel

of Art with Nature" by giving each one its due and by suggesting – first through a reference to St. Peter's Basilica and then through biblical allusion – that both serve another maker.[27] Man's "eyes have seen [Nature] and his ears have heard, but it would never have entered into his heart to conceive her. His is not the fancy that could have achieved these woods, this little flush of summer from the innumerable flowering of grasses, the cyclic recreation of seasons."[28] Her last phrase, as we shall see, echoes the point of view in "The Rhythm of Life." Despite the readiness of her contemporaries and ours to trace her Aestheticism to both Pater and Ruskin, here she sounds much more like the latter. Compare a famous sentence from the first volume of *Modern Painters*: "Nature is so immeasurably superior to all that the human mind can conceive, that every departure is a fall beneath her."[29]

"The Rhythm of Life" is now regarded in the growing body of scholarship on Meynell's work as an important articulation of her world view and a justification for the hiatus in her own poetic career. It espouses a theory of periodicity in which poets are "approached, and touched, and forsaken" by the muse, as she was when she turned from poetry to journalism and editorial work while rearing seven children.[30] Vanessa Furse Jackson argues that the essay is a "crucial" one for understanding her poetry and for showing that "personal restraint" – an aspect of her writing and her embodied self-presentation alike – was for Meynell "not just a social nicety … but an absolute essential for the survival of her soul."[31] Yopie Prins, reading the essay alongside Patmore's important essay "English Metrical Critics" (1857; 1878), constructs a prosodic theory underlying Meynell's poetic practice that both adapts and revises Patmore's.[32] Christina Richieri Griffin, contextualizing "Rhythm" in nineteenth-century discourses about gestation and fetal life, traces an evolution in Meynell's thinking in which periodicity acquires a dark, "tyrannical" aspect from which pregnancy offers at least temporary respite.[33] Like Prins, I read the essay as a feminist response to an important essay by a male precursor, and like both Prins and Griffin I consider that response as linked in part to female embodiment. I emphasize, however, the very different understandings of temporality that distinguish Meynell's thinking from Pater's as represented in the famous "Conclusion" to *The Renaissance*.

Like the "Conclusion," "The Rhythm of Life" is a brief, lyrical, carefully crafted *ars vivendi*, and, like the "Conclusion," it is concerned more directly with precepts to live by than with art proper. Both are about the mind. Both insistently link human life to forces at once corporeal and cosmic: Pater refers to the phosphorous and lime that are present not

only in the body but also scattered throughout the universe; Meynell locates periodicity in the revolutions of the sun, the elliptical or parabolic orbits of celestial bodies, and the "rhythmic pangs of maternity" (6). Most crucially, the two essays agree upon a conception of life as essentially rhythmic, as Meynell's title announces. The individual life, for Pater, comprises a "counted number of pulses" (188). Meynell's opening sentence seems to agree: "If life is not always poetical it is at least metrical" (1). Even that concession seems to echo one in Pater's essay: "This *at least* of flame-like our life has, that it is but the occurrence, renewed from moment to moment, of forces parting sooner or later on their ways" (187, emphasis added).

But here a striking difference of view arises. Pater, focusing on individual moments of perception and experience, derives his sense of the rhythm of life from the emerging psychology of aesthetics. The "pulses" represent "the passage and dissolution of impressions, images, sensations ... that continual vanishing away, that strange, perpetual weaving and unweaving of ourselves" in the gap between an experience and our apprehension of it (188). Meynell, by contrast, derives her vital rhythms from a sense of the inherent periodicity of the natural world – not only of seasons and of tides, but also of the phenomena best known to astronomers. These impersonal but transcendent forces provide the pattern on which the mind or "interior world" is structured, though "the Kepler of such cycles" has not yet come to light (2). The marked incompatibility between Pater's and Meynell's perspectives shows even more clearly in the way each responds to the pattern of waxing and waning that Meynell calls the "law of periodicity" (3). In famously ecstatic prose, Pater exhorts his reader to achieve "success in life" by seeking "to burn always with [the] hard, gem-like flame" he calls "ecstasy" (*The Renaissance*, 189); the goal is to "pass swiftly from point to point" (188), or pulsation to pulsation, and so paradoxically maintain this ecstasy, this being outside of *stasis*, as a steady state.[34] Meynell issues a warning that seems aimed squarely at this definition of "success in life." "To live in constant efforts after an equal life," she claims, in an infinitive phrase that recalls Pater's grammatical construction, "whether the equality be sought in mental production, or in spiritual sweetness, or in the joy of the senses, is to live without either rest or full activity" (3–4). To do so, she claims, is to engage in an "artificial violence" that "throws life out of metre" (2).

Rather than insisting on the need to make every moment extraordinary, then, Meynell's *ars vivendi* takes a view at once more restrained and more expansive. She bows to "the law that commands all things" (6)

because paradoxically it frees us, releasing us from the constant effort of restless seeking. The "law of periodicity" is thus an ordering principle, not a prohibitory force. She invokes in defence of her view the prohibition-defying words "Eppur si muove" (And yet it moves), words Galileo is supposed to have said *sotto voce* to the officers of the Inquisition, reading them as an insistence upon "the liberty and law of the universal movement" (3). This law determines "the coming of the moment of delight" but also its "inexorable flight" (2). The cultivation of continual ecstasy, delight, or even mental production, Meynell argues, distorts life by wrenching it out of a pattern of necessary though not wholly predictable alternation.

Meynell's insistence on the need to alternate between activity and rest is surely also a response to the intensity and velocity of life in modernizing fin-de-siècle London, the metropolis that threatens to come barrelling down on the woman riding the bicycle in her essay "The Woman in Grey."[35] Her appeal to rest recalls Patmore's "The Comparison," a poem from *The Angel in the House* that identifies frenzied and largely futile activity with the male half of the heteronormative couple, and effortless efficacy and rest with the idealized female half:

> And therefore in herself she stands
> Adorn'd with undeficient grace,
> Her happy virtues taking hands,
> Each smiling in another's face.
> So dancing round the Tree of Life,
> They make an Eden in her breast,
> While his, disjointed and at strife,
> Proud-thoughted, do not bring him rest.[36]

Meynell accepts the centrality of the opposition of work and rest to everyday life, but, perhaps because she was herself a working woman, not its gendering.

"The Rhythm of Life" differs most strongly from Pater's "Conclusion" to *The Renaissance* in this insistence on the alternation of intensity and its relaxation, rather than on the ecstatic moment, as its own defining principle. Pater, urging his reader to sustain that moment "always," clearly invokes an ideal unrealizable in practice. Modernists such as Virginia Woolf and James Joyce adapted that ideal to practical reality by recasting the "moment" as the meaningful part of the everyday. Meynell takes a different path, one that anticipates some gestures of the *écriture feminine* of

the 1970s. In a discussion of the meanings of the sun and the moon, she attaches greater privilege to the latter, to which she refers with the conventional feminine pronoun. The moon's phases become "the symbol of the order of recurrence" that most human beings do not understand (5). "Man," she says in a sentence that flirts with, but does not quite settle on, that noun's gendered acceptation – "is hardly aware of periodicity" (5). "The individual man," she continues, dropping the equivocation, "either never learns it fully, or learns it late" (5). The resonance of the word "periodicity," which Griffin identifies as "a nineteenth-century term for menstruation," and the narrowing of focus to the "individual man," subtly suggest that women learn more readily than men what their menstrual cycles teach them.[37] "If they would be wise," she concludes, the pronoun referring now unambiguously to all human beings, "they must wake and rest in its phases, knowing that they are ruled by the law that commands all things – a sun's revolutions and the rhythmic pangs of maternity" (6). This memorable final sentence posits the maternal body as the one on which the union of body and cosmos depends. More generally, the entire final paragraph elevates the female body to the norm. I hope I can be pardoned if I suggest that the essay's closing makes the whole seem like Mater's rejoinder to Pater.

Unmomentous Moments

Meynell's protégé Francis Thompson observed that her poems express the "spiritual perception of ... the blossom in the bud and the precedent bud in the blossom."[38] He was expressing her sense of herself as a "child of process," for whom the truth and the life are precisely the *way* – as she makes clear in a pair of poems titled "'I am the Way'" and "Via, et Veritas, et Vita."[39] Both assert the value of "Access, [and] Approach" over "goal" or attainment. Repeatedly, she eschews the meaning-full moment and calls attention to duration over the fullness of time. Temporality, as a preoccupation of Meynell's, clearly antedates "The Rhythm of Life," running through her first volume of poems, *Preludes,* published in 1875 when she was twenty-eight. In the remaining part of my discussion, I explore the anti-momentous temporality of two poems that appeared in *Preludes* and that she republished in her 1893 volume *Poems,* and then more briefly some of the poems that appeared later in her career. These works make clear that the conception of time she expresses in "The Rhythm of Life" is itself of long duration but does not govern her poetry in the same way across her career.

"An Unmarked Festival" commemorates a "feast undated yet" – the day when the poem's speaker and an unnamed significant other first met:

> Day of days! Unmarked it rose,
> In whose hours we were to meet;
> And forgotten passed. Who knows,
> Was earth cold or sunny, Sweet,
> At the coming of your feet?[40]

The paradox of the poem's title depends on the idea of periodicity – a festival being the calendrically regular celebration of a feast, which is, in turn, a "religious anniversary appointed to be observed with rejoicing" (*OED*). An unmarked festival cannot be observed – it is unmarked because unremarked. This one is unremarked because the event it would observe, if it could, was unremarkable: the relationship it celebrates was no sudden, cataclysmic love at first sight. What retrospectively became an exclamation-pointed "Day of days!" thus yearly passes "forgotten" because it was never known, being imperceptibly ordinary like the unmomentous moment when a flower "struck root and grew / Underground, and no one knew."[41] Yet this absence retroactively inspires poetry, a point underscored by the quiet pun on the word *feet*.

The value of a festival is that it marks out the metrical aspect of life, but the existence of festivals also reveals a human need for the ecstatic. "An Unmarked Festival" acknowledges some fundamental lack in the ordinariness of the everyday, expressing it with a regret not audible in the greater austerities of "The Rhythm of Life." The speaker laments: "Now, how dearly would we treasure / Something from its fields, its rills, / And its memorable hills."[42] That "something," if it existed, would provide the missing mark of the unmarked event: "Oh, to keep that day of ours / By one relic of its flowers!"[43] Yet the lack here belongs not to the un-ecstatic past, but rather to the present, during which the subject cannot re-experience the earlier time in the more muted and distanced form it would take in the memory. If an "equal life" were attainable, its counted pulses blending into a single ecstatic moment, then the writing of poetry would be impossible: there would be no moment of tranquility in which to recollect strong feeling, no time to "sing" one's "exaltation by remembering," as she wrote of Wordsworth in "Two Boyhoods" (*The Poems of Alice Meynell*, 70). For the production of art as opposed to its consumption, for the expression and articulation of passion rather than the kind of appreciation Pater enjoined upon the reader of *The Renaissance*, such a life is

not only impossible: it is, for Meynell, undesirable. The lack of a "relic" by which to remember the missing ecstatic moment, paradoxically, can for her provide an occasion for a poem – which then becomes that relic.

The word *relic* marks the theological underpinnings of Meynell's perspective, as do the words *festival* (in the title) and *feast*, its near synonym (in the poem's first line). Roman Catholic feast days or "holy days" commemorate some sacred mystery, person, or event; they serve "to excite the spiritual life by reminding us of the event[s]" they commemorate.[44] They punctuate the flow of everyday life by building into the calendar some regular pause for spiritual renewal. The modernist moment of being that looks back to Pater's moments "of highest quality" is likewise compensatory, but in a different way: as an aspect of a modernist aesthetic, the "moment" is frequently understood as a way of finding meaning in the ordinary when the belief systems that traditionally conferred meaning have been disavowed. James Joyce's "epiphany," the iconic example, secularizes a Roman Catholic feast day in precisely this way. The compensation he and others sought in incandescent moments Meynell found in feasts that provide something flame-like on a regularly recurring basis, and in connection with ritual and the sacred.

"Meditation" (later retitled "Advent Meditation"), also from the 1893 *Poems*, shows how Meynell's anti-momentous temporality works. This devotional poem makes explicit its basis in ritual and in the liturgical calendar. It is preceded by an epigraph from the Vulgate text of Isaiah 45:8, which is traditionally sung during the weeks of Advent (the *coming to*) that lead to the Feast of the Epiphany. The body of the poem constructs the original coming of Christ as a slow, continuous, even rhythmical process unfolding over time, the opposite of an intense moment:

> No sudden thing of glory and fear
> Was the Lord's coming; but the dear
> Slow Nature's days followed each other
> To form the Saviour from His Mother
> – One of the children of the year. (*The Poems of Alice Meynell*, 37)

This poem manifests Meynell's attentiveness to meter and her commitment to its contribution to meaning. It begins by negating, both literally and metrically, the suddenness it invokes, its opening iamb easing our entry into the entire poem – and also into the sentence that announces, but defers, its own ostensible subject: "the Lord's coming." By comparison, the opening trochee of the second line shows us what a

sudden blow at the beginning of a poem might have sounded like, and the spondee that begins the third lingers on the "Slow Nature's days," which are "dear" in their very slowness. In the remaining two stanzas that coming is imagined as a process requiring the passage of seasons: "Sweet summer and the winter wild, / These brought him forth, the Undefiled" (37). Nor do the pangs of Mary's maternity mark a sudden end to this process, which still requires the constant renewal of many "Springs" to provide "[t]he food and raiment of the Child" (37). Miracle and mystery are here subordinated to, or made consonant with, natural processes that unfold in a distinctly terrestrial, seasonal time, with its alternations of "sweet" summers and "wild" winters. The original Advent here does not end in an epiphanic showing forth or even a feast; merely "the daily bread" and "growing grain" that provide humble food and raiment (37).

Instead of epiphanies, both poems offer climactic moments hollowed out – negative epiphanies that can be remarked only retrospectively if at all, from a moment of belated integration. Ecstatic recognition is replaced by a matter-of-fact observation of non-*ekstasis*. Meynell's attentiveness to meter elsewhere enhances each poem's thematic claims. The extremely regular trochaic catalectic lines of "An Unmarked Festival" fittingly produce, in the stressed first and final syllables that strongly sever the lines one from another, a sensation of activity punctuated by rest, of measured units marked off one from another, much as "the measure / Of such days the year fulfils" (that is, the totality of such days fills out the year). Similarly, "Advent Meditation" enacts its own negation of the ecstatic moment through its fittingly ordinary opening line, one whose elided fourth foot smooths over what might otherwise seem unmetrical. But the second and the final lines of the first stanza begin with out-of-meter suddenness – that is, with trochees – despite the iambic meter that establishes itself in due course. Suddenness and intensity are thus at once articulated, enacted, and negated, so that they can be abandoned by the end of the stanza. The poem achieves in its second stanza the metrical regularity of the long sequence of days required "To form the Saviour" – a progression only faintly interrupted for the creation of man at its end ("Who **makes** / **man** from / the fertile dust") (*The Poems of Alice Meynell*, 37).

As Meynell begins to pursue a more compressed poetics after the turn of the century, her poems are less marked by the hollowing out of the meaningful moment, or the absence of that moment from the speaker's experience. Compression impels poetry towards the flash of

the momentous, as it does in a short poem written around 1912 titled simply "Maternity":

> One wept whose only child was dead,
> New-born, ten years go.
> "Weep not; he is in bliss," they said.
> She answered, "Even so,
>
> "Ten years ago was born in pain
> A child, not now forlorn.
> But oh, ten years ago, in vain,
> A mother, a mother was born." (*The Poems of Alice Meynell*, 85)

The poem's compression creates ambiguities. Was the child stillborn – "dead" when "new-born"; or has he, who was "New-born ten years ago," died since (85)? Whose pain accompanies the birth – is it the mother's birth pangs only, or was the child born in the pain of some illness that killed him sooner or later? From the poem's point of view, the result is the same, for the momentous event is not the death of the child but the birth of a mother – who remains a mother regardless of her ultimate childlessness. Yet however compressed in length, this poem looks backward prosodically, its two stanzas recalling not the austerities of modernist verse but the ballad stanza familiar from, among other precursors, Wordsworth's "Lucy" poems. The briefest and most compressed of those, "A Slumber Did My Spirit Seal," is also a mere eight lines long and also commemorates an untimely death, but it compresses its grief into a single stanza that follows a momentous white space. Here, by contrast, grief – specifically, maternal grief – begins in the first line and overflows the space of that stanza, filling the white space as well as the final four lines. At the same time, the grief is set at a distance from the speaker, whose relationship to the mother in question is unspecified. In the context of Meynell's other poems, one senses that this birthday commemoration is part of a ritual grieving, marked by the calendar and repeated yearly.

An even more striking example is a 1901 poem titled "The Two Poets." This poem is all about suddenness. It celebrates the moment when the wind strikes a beech tree, releasing arboreal music from the silence. Aesthetic experience – here an experience of poetic inspiration and utterance – is expressed in Romantic rather than avowedly Aestheticist terms:

> Whose is the speech
> That moves the voices of this lonely beech?
> Out of the long west did this wild wind come— (*The Poems of Alice Meynell*, 52)

Tree and wind are metaphors for the poet and her muse. The latter, given equal dignity as another poet, is figured not as the conventionally elusive female figure but as the "wild wind" that comes, like Shelley's, out of the west. (Shelley, as it happens, is one of her exemplars in "The Rhythm of Life" of the rare person who understands "the law of recurrence"; his rhetorical "If winter comes, can spring be far behind" expresses the periodicity of "onset and retreat" [3].) Meynell's poem insists at once on the separateness and sameness of the two voices in the moment of inspiration:

> Two memories,
> Two powers, two promises, two silences
> Closed in this cry, closed in these thousand leaves
> Articulate. This sudden hour retrieves
> The purpose of the past,
> Separate, apart – embraced, embraced at last. (52)

The momentousness of this moment is underscored by the poem's insistence on simultaneity: "Whose is the word? / Is it I that spake? Is it thou? Is it I that I heard?" (52). The moment of inspiration brings past and present together. It "retrieves" the past, making it meaningful. But here again Meynell's characteristic temporality expresses itself, for the poem is as much about waiting as it is about the suddenness that reveals the purpose of that waiting, a season during which "the tree was dumb, / Ready and dumb, until / The dumb gale struck it" (52). And the moment of the strike is not really a moment at all, being lengthened to a paradoxically "sudden hour." The wind remains a "visitant" – likely to leave, though perhaps also to return (52). The poem provides only an impersonal, restrained perspective on the ecstatic moment it imagines, corralling the lyric "I" in quotation marks that keep it at a distance – the same gesture that we have seen in "Maternity."

Other later poems continue to project the past into the present or the future and the reverse. Like the earlier ones I have discussed, they emphasize the imperceptible melting of one into the other rather than isolating the moment in which they come together. They emphasize *chronos*, or "one damned thing after another," in Frank Kermode's formulation, rather than *kairos*, an apocalyptic time outside time.[45] Or rather, they mediate between these modes, holding them in tension through what Julie Wise has called Meynell's "self-haunting poetic voice."[46] In "Time's Reversals: A Daughter's Paradox," which appeared in *Last Poems*, Meynell returns to a paradox like the one in the early "A Letter from a Girl to her

Own Old Age" (originally published in *Preludes*), a poem in which the
youthful speaker imagines her older self, holding the page on which she
now writes. On this occasion, though, the past meets the future as the
speaker lives to surpass her father's age at his death. Again, she bends
the future around to meet the past through touch: "Memory has not
died; it leaves me so – / Leaning a fading brow on your unfaded hand"
(118). But neither this poem, nor the earlier "Letter from a Girl to Her
Own Old Age," enacts the significant moment it imagines, or recounts
it as a heightened experience. Both merely *anticipate* that moment in a
peculiar *futur antérieur*. The actual moment is absent from the frame of
the poem's utterance.

"The Unexpected Peril," collected in *Later Poems* (1902), sombrely jus-
tifies Thompson's remark about "the blossom in the bud and the prec-
edent bud in the blossom." The speaker looks back on her youth as a
time when she anticipated death as potentially imminent – when, in her
mind's eye,

> My shroud was in the flocks; the hill
> Within its quarry locked my stone;
> My bier grew in the woods ... (*The Poems of Alice Meynell,* 90)

Now comfort and ease have supervened, and the unexpected peril
is the danger to the soul of complaisance, of ceasing to fear, ceasing
to expect. Meynell's speaker here desires an epiphanic moment, for
which she pleads with a masochistic self-aggrandizement reminiscent
of John Donne's "Holy Sonnet, 14" ("Batter my heart, three-personed
God"):

> How am I left, at last, alive,
> To make a stranger of a tear?
> What did I do one day to drive
> From me the vigilant angel, Fear?
>
> The diligent angel, Labour? Ay,
> The inexorable angel, Pain?
> Menace me, lest indeed I die,
> Sloth! Turn; crush, teach me fear again! (91)

But the epiphanic moment does not come, and it is only as a chastise-
ment that she can permit herself to plead for it at all.

This resistance to the different temporality of the modernist moment, which owes so much to Pater, is characteristic of the aesthetic conservatism that runs through Meynell's work and thought. Patmore told G.K. Chesterton that she was "a Radical in her opinions and a Tory in taste."[47] Given the conservatism of Patmore's sexual politics, from his perspective her radicalism surely included her feminism, which we have seen expressed subtly in "The Rhythm of Life." To Patmore, she complained more bluntly that some passages in his work get "no interior assent from me at all" – the ones "about women."[48] She noted on another occasion that among her many points of disagreement with him were "Democracy, Land Laws, [and] State Socialism."[49] Unlike her contemporary Mary ("Mrs. Humphry") Ward, who shared Meynell's fate of outliving what seemed too "Victorian" in her work, she supported woman suffrage, defending it in a fiery letter in 1912 to John George Snead-Cox, the editor of *The Tablet*, a liberal Catholic weekly, when a correspondent asserted that it was anti-Christian; she then denounced an article by a priest who declared feminism "evil."[50] Patmore was right, though, about the conservatism of her taste. She values the restraint of emotion and language through form – including the "Dear Laws" she celebrates in her poem "The Laws of Verse," which (as Prins suggests) contains a silent tribute to Patmore even though she obeys his "laws" on her own terms. Whether or not June Badeni is correct to attribute her yearning for restraining forms to her fear of the violence of her emotions, a love of such forms is what drew her to convert to Catholicism at nineteen, independently of her parents and her sister Elizabeth (later Lady Butler, the renowned war painter).[51] It motivates her embrace of other forms of "law, including the "law of periodicity," which governs (as we have seen) the ecclesiastical calendar with its feasts, festivals, and seasons, but also the cosmic forces of planetary motion and the more atomistic "tides of the mind." The value she places on restraint affects even her conception of socialism: "I do not understand why there is so much fear of outward control," she writes in "My Faith and Work": "I do not love political liberty much. The State is welcome to order my affairs far more closely than it has ever done yet, for the good of the majority, and especially for the good of the unfortunate."[52]

Such an attitude towards the benefits of restraint suggests that Meynell might reject ecstasy itself, the sought-after heightened experience that Pater's "Conclusion" advocates. One might indeed assume that ecstasy would trouble a Victorian lady who so willingly bowed to the dictates of propriety. After all, she changed an essay title from "The Leg" to

"Unstable Equilibrium" when Patmore objected to her original title as "improper."[53] But Catholic tradition allowed Meynell to embrace ecstasy as the positive pole of experience, as she does in "The Rhythm of Life." In contrast to Pater, though, she insists that it can be neither sustained nor actively cultivated, for, as "certain of the saints" knew, it is subject to the law of periodicity: "Ecstasy and desolation visited them by seasons" ("The Rhythm of Life," 4). Above all, she conceives of ecstasy in spiritual rather than sensory or even aesthetic terms. And here we come to the central governing difference between her representation of time and Pater's. Both are dealing with change, mutability, or impermanence, but in profoundly different ways. In Pater's "Conclusion," the epigraph from Plato's *Cratylus* reads (translated into English): "Heraclitus says, 'All things give way; nothing remaineth"; the body of the essay reminds us that we are all "under the sentence of death" (see *The Renaissance*, 186). As John Wordsworth complained, one dangerous implication of the "Conclusion" and the whole of *The Renaissance* was "that probably or certainly the soul dissolves at death into elements which are destined never to reunite."[54] Or, as a twentieth-century critic restated the case more sympathetically, "Pater's purpose in *The Renaissance* is to make wholly secular knowledge spiritually powerful, to contribute to a 'renaissance of the spirit' of individuals and of the age."[55] Meynell was writing for a secular audience upon which she did not urge immortality of the soul or other specific points of doctrine. But instead of the Heraclitean stream into which we cannot step twice, she adopts as a guiding metaphor for life the recurrence of oceanic tides and planetary cycles. "The flux is equal to the reflux"; "what is just upon its flight of farewell is already on the long path of return" ("The Rhythm of Life," 3).

Did Walter Pater influence Alice Meynell? I have been proposing for an answer her own uneasy assertion about how much of him she had read: "so much too little." He influenced her so much that she responded powerfully in one short piece of writing, and then considered herself acquitted of the need to read him further. But perhaps also too little, for that short piece is one of her best. Influence, we know, is complicated. Pater was widely recognized by his contemporaries as "a dangerous – which is to say, seductive – influence" – "poisonous," in George Eliot's opinion.[56] Part of the danger lay in the homoeroticism discernible in his writing, of which Meynell, to judge from her response to Oscar Wilde's conviction of "gross indecency," would have disapproved.[57] Then there is the threat of being taken over by the influence of another, which Wilde depicted in *The Picture of Dorian Gray* (1890, revised 1891). Pater himself told Edmund

Gosse that he refrained from reading his contemporaries – specifically (strange to say) Rudyard Kipling and Robert Louis Stevenson – because from hearsay he feared that they were "strong" and might "come between me and my page the next time I sat down to write."[58] Such anxiety calls to mind the theory of influence articulated by Harold Bloom, who would be unlikely to read Meynell at all, let alone as a strong poet engaged in an agonistic misprision of a precursor.[59] But "The Rhythm of Life" might be understood as a (mis)reading of Pater's text that "swerves away" from its precursor to suggest what a "correct" version, one aligned with her social, moral, and religious perspective, would be. Sustained engagement with more of his work might have won some assent, or provoked her to repudiation, or both. She might then have written prose or verse that was harder for the twentieth century to dismiss.

NOTES

An early, short version of this essay, which was given at the North American Victorian Studies Association meeting in 2010, appeared as "Alice Meynell, Walter Pater, and Aestheticist Temporality," *Victorian Studies* 53, no. 3 (2011): 495–505. I would like to thank Joseph Bristow for introducing Meynell's work to me in his National Endowment for the Humanities summer seminar 2009 titled "The Decadent 1890s," and for his suggestions regarding the current version of the essay.

1 Talia Schaffer, *The Forgotten Female Aesthetes: Literary Culture in Late-Victorian England* (Charlottesville: University of Virginia Press, 2000), 159–96.
2 Meredith Martin, "Alice Meynell, Again and Again," in *The Oxford Handbook of Victorian Poetry*, ed. Matthew Bevis (New York: Oxford University Press, 2013), 585. Meynell's poem, "The Laws of Verse," which she composed in 1921, appeared posthumously in *The Last Poems of Alice Meynell* (London: Burns, Oates and Washbourne, 1923). In the poem, her speaker repeatedly addresses her "Dear laws" (30).
3 F. Elizabeth Gray, "Making Christ: Alice Meynell, Poetry, and the Eucharist," *Christianity and Literature* 52, no. 2 (2003): 160. See also Ashley Faulkner, "Christ among the Doctors: Pedagogy, Pediatrics, and Divinity in Alice Meynell's Criticism," *Victorians Institute Journal* 40 (2012): 175.
4 Marion Thain, *The Lyric Poem and Aestheticism: Forms of Modernity* (Edinburgh: Edinburgh University Press), 160.
5 Isobel Armstrong, *Victorian Poetry: Poetry, Poetics and Politics*, 2nd ed. (London: Routledge), 219.

6 Jane Spirit et al., "Alice Meynell [née Thompson]," in Maroula Jannou and Claire Nicholson, headnote to "A.C. Thompson (1847–1922) [Alice Meynell]," *The Women Aesthetes: British Writers, 1870–1900*, ed. Jane Spirit, 3 vols. (London: Pickering and Chatto, 2013), 1:70.

7 Schaffer, *The Forgotten Female Aesthetes*, 176. Schaffer is quoting from Walter Pater, "Conclusion," in *Studies in the History of the Renaissance* (1873), later revised in successive editions as *The Renaissance: Studies in Art and Poetry* (1877, 1888, and 1893). Pater's famous statement appears in *The Renaissance: Studies in Art and Poetry – the 1893 Text*, ed. Donald L. Hill (Berkeley: University of California Press, 1980), 190. I discuss Pater's "Conclusion" in greater detail below.

8 Schaffer, *The Forgotten Female Aesthetes*, 176.

9 Ana Parejo Vadillo, *Women Poets and Urban Aestheticism: Passengers of Modernity* (Basingstoke: Palgrave Macmillan, 2005), 103. See also Rachel Teukolsky, "Walter Pater's *Renaissance* (1873) and the British Aesthetic Movement," in *BRANCH: Britain, Representation and Nineteenth-Century History*, ed. Dino Franco Felluga, Extension of Romanticism and Victorianism on the Net, https://www.branchcollective.org/?ps _articles=rachel-teukolsky-walter-paters-renaissance-1873-and-the-british -aesthetic-movement. The idea of aestheticism as a "movement" goes back to Walter Hamilton's *The Aesthetic Movement in England* (London: Reeves and Turner, 1882), which gave this name to the Pre-Raphaelites, Ruskin, Wilde, and others in response to parodies of them or their followers in the satirical magazine *Punch* and on the popular stage.

10 Alice Meynell, "To Christiana Thompson," 22 December 1899, in *The Selected Letters of Alice Meynell*, ed. Damian Atkinson (Newcastle upon Tyne: Cambridge Scholars, 2013), 265.

11 Alice Meynell, "To Edmund Gosse," 10 December 1896, in *The Selected Letters of Alice Meynell*, 102. Atkinson's footnote provides a date of 1894 and gives Oxford as the place of publication of Pater's "The Child in the House," which implies that she was referring to the 1894 Daniel Press edition of *An Imaginary Portrait*. This small book contained only "A Child in the House," which was originally published in *Macmillan's Magazine* in 1878, but which Pater did not include in *Imaginary Portraits* when he published the volume in 1887.

12 Alice Meynell, "Two Boyhoods," in *The Poems of Alice Meynell*, complete edition (London: Burns, Oates, and Washbourne, 1923), 71; subsequent page references to *The Poems of Alice Meynell* appear in the main text. The poem was originally published in *The Monthly Review* in November 1903 with the title "The Two Childhoods"; the changed title, first appearing

when the poem was printed in the 1913 *Poems*, makes more explicit its status as an homage to and critique of Ruskin.

13 John Ruskin, *Modern Painters*, in *The Works of John Ruskin*, 30 vols., ed. E.T. Cook and Alexander Wedderburn (London: George Allen, 1903–12), 3.

14 Alice Meynell, *John Ruskin* (Edinburgh: William Blackwood, 1900), 4.

15 Rachel Teukolsky, "Modernist Ruskin, Victorian Baudelaire: Revisioning Nineteenth-Century Aesthetics," *PMLA* 122, no. 3 (2007): 712.

16 See Vadillo, *Women Poets and Urban Aestheticism*, 84, 91.

17 Meynell, "Coventry Patmore," *Second Person Singular* (London: Oxford University Press, 1922), 106. The essay was originally published in 1906.

18 Alice Meynell, "My Faith and Work," *Woman*, 12 August 1896, 8.

19 Pater, *The Renaissance*, ed. Hill, 187 (emphasis added); subsequent page references appear in the main text.

20 Meynell, "My Faith and Work," 8.

21 Meynell, 8.

22 Meynell, 8.

23 W.E. Henley, "To Alice Meynell," 19 March 1889, in *The Selected Letters of W.E. Henley*, ed. Damian Atkinson (Aldershot: Ashgate, 1999), 185.

24 See Wordsworth, "To Walter Pater," 17 March 1873, in Edward W. Watson, *Life of Bishop John Wordsworth* (London: Longmans, Green, 1915), 89–91.

25 See "Literary Gossip," *The Athenæum*, 7 April 1888, 437–8.

26 Margaret Diane Stetz, "Sex, Lies, and Printed Cloth: Bookselling at the Bodley Head in the Eighteen-Nineties," *Victorian Studies* 35, no. 1 (1991): 77.

27 Alice Meynell, "The Unit of the World," in Meynell, *The Rhythm of Life, and Other Essays* (Elkin Mathews and John Lane, 1893), 29.

28 Meynell, "The Unit of the World," 33–4. Cf. 1 Corinthians 2:9 (KJV): "But as it is written, Eye hath not seen, nor ear heard, neither have entered into the heart of man, the things which God hath prepared for them that love him."

29 John Ruskin, *Modern Painters*, 3:137.

30 Meynell, "The Rhythm of Life," in *The Rhythm of Life*, 4; subsequent page references appear in the main text.

31 Vanessa Furse Jackson, "'Tides of the Mind': Restraint and Renunciation in the Poetry of Alice Meynell," *Victorian Poetry* 36, no. 4 (1998): 449.

32 See Yopie Prins, "Patmore's Law, Meynell's Rhythm," in *The Fin-de-Siècle Poem*, ed. Bristow, 261–84. Patmore's essay first appeared as "English Metrical Critics," *North British Review* 27 (1857), 127–61, and he revised it slightly before publishing it as "Prefatory Study on English Metrical Law," in *Amelia, Tamerton Church Tower, Etc.* (London: George Bell, 1878), 4–85, and in *Poems*, 4 vols. (London: George Bell, 1886), 1:3–85.

33 See Cristina Richieri Griffin, "Writing the Rhythms of the Womb: Alice Meynell's Poetics of Pregnancy," *Modern Philology* 112, no. 1 (2014): 226–48.

34 Thain discusses the challenges, for the Aestheticist poet, of "writing within a genre characterized by a Romantic aspiration to an eternal moment" (5) in *The Lyric Poem and Aestheticism*, pt. 1 ("Time"). Her discussion of Meynell comes under pt. 2, which is devoted to space; but much of what she says about meter and temporality in pt. 1 is relevant also to Meynell.

35 Schaffer calls attention to this essay in *The Forgotten Female Aesthetes*, 179–82.

36 Coventry Patmore, "The Comparison," in *The Angel in the House*, in *Poems*, ed. Basil Champneys (London: G. Bell, 1921), 30.

37 Griffin, "Writing the Rhythms of the Womb," 230.

38 Francis Thompson, "Mrs. Meynell's 'Poems,'" *The Tablet*, 21 January 1893, 89.

39 Meynell's phrase appears in "'I Am the Way'" in *Later Poems* (London: John Lane, 1902), 11, reprinted in *The Poems of Alice Meynell*, complete edition, 64. Cf. "Via, et Veritas, et Vita," in *Later Poems*, 12, reprinted in *The Poems of Alice Meynell*, 65; subsequent page references to *The Poems of Alice Meynell* appear in the main text.

40 Alice Meynell, "An Unmarked Festival," in *Poems* (London: Elkin Mathews and John Lane, 1893), 57. The poem first appeared in A.C. Thompson, *Preludes* (London: Henry S. King, 1875), 64–5. Both the 1875 and 1893 texts have six stanzas, though only the first five appear in *Poems* (London: Burns and Oates, 1913), 19–20; and *The Poems of Alice Meynell* (1923), 7.

41 Meynell, "An Unmarked Festival," in *Poems*, 56.

42 Meynell, "An Unmarked Festival," 57.

43 Meynell, 57.

44 New Advent, s.v. "Ecclesiastical Feasts," in *The Catholic Encyclopedia*, vol. 6 (New York: Robert Appleton, 1909), accessed 26 November 2022, https://www.newadvent.org/cathen/06021b.htm.

45 Frank Kermode, *The Sense of an Ending: Studies in the Theory of Fiction* (New York: Oxford University Press, 1967), 128.

46 Julie Wise, "Alice Meynell's Doubled Voices," *English Literature in Transition, 1880–1920* 61, no. 3 (2018): 300.

47 G.K. Chesterton, "Alice Meynell," *Dublin Review* 172 (1923), 7.

48 Meynell, "To Coventry Patmore," quoted in June Badeni, *The Slender Tree: A Life of Alice Meynell* (Padstow: Tabb House, 1981), 95. Badeni, who does not provide a date for this document, states that the correspondence is among the Greatham MSS.

49 Quoted in Badeni, 95; these letters do not appear in *The Selected Letters*.

50 Meynell, "To the Editor of *The Tablet*," 2 November 1912, in *The Selected Letters*, 323.

51 See Badeni, *The Slender Tree*, 35–6.

52 Meynell, "My Faith and Works," 8.

53 Meynell records Patmore's remark in "To John Lane," September 1892, *The Selected Letters*, 50.

54 Wordsworth, "To Walter Pater," 17 March 1873, 90.

55 William E. Buckler, "Introduction: Walter Pater and the Art of Criticism," in *Walter Pater: Three Major Texts*, ed. Buckler (New York: NYU Press, 1986), 11.

56 George Eliot [Mary Ann Evans], "To John Blackwood," 5 November 1873, in *The George Eliot Letters*, ed. Gordon S. Haight, 9 vols. (New Haven: Yale University Press, 1955–78), 5:455.

57 See James Eli Adams, "Transparencies of Desire: An Introduction," in *Walter Pater: Transparencies of Desire*, ed. Laurel Brake, Lesley Higgins, and Carolyn Williams (Greensboro: ELT Press, 2002), 2–3.

58 Edmund Gosse, "Walter Pater," *Critical Kit-Kats* (New York: Dodd, Mead, 1896), 265.

59 See Harold Bloom, *The Anxiety of Influence: A Theory of Poetry*, 2nd ed. (New York: Oxford University Press, 1997), 12.

Richard Le Gallienne and the Rhymers: Masculine Minority in the 1890s

EMILY HARRINGTON

W.B. Yeats's 1922 account of the founding of the Rhymers' Club, an all-male association of poets who met to read and discuss works-in-progress at the Cheshire Cheese pub in London in the early 1890s, portrays a group of young poets anxious to consolidate their poetic reputations through membership in a group. In the late 1880s, Yeats wrote to his fellow Rhymer Ernest Rhys: "I am growing jealous of other poets and we will all grow jealous of each other unless we know each other and so feel a share in each other's triumph."[1] Yeats's confession to Rhys, which comes from his *Autobiography* written in the 1930s, bespeaks both an anxiety about inferiority and a desire for dominance, an impulse towards community but also a fear that none of these poets might "triumph" on their own. The group that Yeats, Rhys, and by some accounts T.W. Rolleston formed, but by no means led, aimed for that triumph with the publication of *The Book of the Rhymers' Club* (1892), the first of two collections that the group published together, interspersing works by different authors and printing the poet's name at the end, rather than at the top, of each selection. Although, as Nicholas Frankel has noted, those choices highlight the collectivity of the group, privileging poetry over the poet, the reputation of the group has rested largely on individuals within it, thanks in part to Yeats's account.[2] Yeats often uses the word "dissipated" to describe the talented Rhymers Lionel Johnson and Ernest Dowson, both of whom died young, lived in some despair, and struggled with substance abuse. Based largely on the reputations of Dowson and Johnson, as well as Arthur Symons, all three of whose poetry variously dealt with forbidden desires and sexualities, music-hall eroticism, and being "desolate and sick of an old passion," an association of the Rhymers' Club with Decadence was firmly entrenched by the early twentieth century

and persisted in the scholarly discourse about the Rhymers; even those who disavow a strict relationship between the Rhymers and Decadence seem compelled to acknowledge the association.[3]

Yet there were thirteen Rhymers who, in addition to meeting regularly, published their works in *The Book of the Rhymers' Club* and *The Second Book of the Rhymers' Club* (1894). Many of their names are now forgotten to literary history. One such Rhymer, Richard Le Gallienne, declared in his own retrospective memoir that the Rhymers "lacked any common fusing artistic ideal" and had "nothing in common but a publisher."[4] Le Gallienne was born into a working-class family but, determined to be a poet and critic, insinuated himself into the centre of fin-de-siècle literary circles and became a reader for the very publisher the Rhymers had in common when he was still in his twenties. The Bodley Head, led by John Lane and Elkin Mathews until they dissolved their partnership in 1894, was responsible for several of the most striking and emblematic works of the 1890s. Especially important in this context were the thirty-three volumes in the "Keynotes" series, inaugurated by New Woman author George Egerton with a collection of the same name, which featured work by other up-and-coming writers, including Arthur Machen (*The Great God Pan* [1894]), M.P. Shiel (*Prince Zaleski* [1895]), Ella D'Arcy (*Monochromes* [1895]), and Grant Allen (*The British Barbarians* [1895]). The Bodley Head in April 1894 began publishing the hardbound quarterly *The Yellow Book*, which startled some quarters of the literary world. Although, like the first *Book of the Rhymers' Club, The Yellow Book* included a diverse set of works both progressive and conservative, it earned its controversial reputation through printing the poetry of Arthur Symons (whose male speaker, in "Stella Maris," recalls an encounter with a prostitute), the critical prose of Max Beerbohm (whose "Defence of Cosmetics" celebrates the idea that "Artifice ... has returned among us"), and the fiction of George Egerton.[5] Symons, Beerbohm, and Egerton were emergent rather than established writers, and in this opening issue Le Gallienne counted among their company, with a poem called "Tree-Worship," in which his speaker exhorts a tree to lend him some of its power: "Fill full with sap and buds this shrunken life of mine."[6] According to Le Gallienne, it was through such ventures that The Bodley Head "removed the stigma" from the minor author, a figure that had previously been the butt of "newspaper mockery."[7]

This point is especially true of the two anthologies the Rhymers published. Although he is not quite explicit about it, Le Gallienne asserts that what the Rhymers did have in common was their status as minor

poets, a status that poets could begin to claim with some pride in the 1890s. A survey of the poems the Rhymers published together bears out Le Gallienne's assertion of their variety. By taking these forgotten poets into account and viewing the Rhymers through the lens of Le Gallienne rather than Yeats, who came into increasing prominence as a major poet after the turn of the century, we come away with an understanding not limited to the vision of a "Tragic Generation" that Yeats described in 1922; rather, we see a group of men deeply conflicted about the exercise of poetic ambition as well as profoundly anxious about what they perceived as the waning status of poetry. Their poems declare that they answer to a "*Muse degraded*" and are only "*crumbs from the feast*" and "a little tender rhyme."[8] Though their themes and responses to Decadence vary, the Rhymers share an anxiety about the end of poetry as they knew it and about their own poetic inadequacy. In the context of that anxiety, these poets embrace their status as minor poets, to the point of enfolding femininity and frailty into that concept of minority in an ironic move to reinforce their power and authority.

The closing poem of *The Book of the Rhymers' Club*, "Song of the Songsmiths" by G.A. Greene, takes an embattled stance:

> *Who is it jeers at our song?*
> *Scoffs at an art sublime?*
> *Who is it jeers at our song?*
> *We who know right from wrong*
> *Worship the godlike rhyme.*[9]

These lines reflect the poets' fear of being laughed at and dismissed, but also their pride in it, for it galvanizes them in defence of rhyme. That combination of pride and anxiety about dismissal exemplifies the way the Rhymers persistently claim a minority status. They define themselves variously against "jeering" majorities, one poet's jeering majority being another poet's embattled minority. They might identify against the English, as many were Irish, Welsh, or Scottish, or with them, against the *femme fatale* and with a nun, with an exotic music-hall dancer or against her, with the modern city or against it, with Romantic predecessors or against them. But the stance of the embattled minority, whatever it is defined against, emerges as a common thread, particularly in the poems *about* the collective. That common thread overlaps in fascinating ways with their other uniting feature: they were all men. If the Rhymers were not united by artistic purpose, they were united in their anxiety about what

it meant to be a poet, and many of them derived their sense of authority and aesthetic value from their masculinity. At the same time, their turn towards collectivity as a response to individual insecurity brings with it a whisper of anti-elitism that appropriates some feminine traits while also validating their artistic pride.

Promoting the Rhymers' new book in 1892, Yeats asserted that they had "gathered well nigh all the poets of the new generation who have public enough to get their works printed at the cost of the publisher, and some not less excellent, who cannot yet mount that first step of the ladder famewards."[10] It is impossible to say whether Yeats's use of the phrase "well-nigh all" deliberately excludes women poets of the same generation, like Alice Meynell, who was considered for the laureateship upon the death of Tennyson, or Dollie Radford, who was married to Ernest Radford, one of the Rhymers. None of the poets' statements about the group explicitly claim the Rhymers to be an all-male club, nor do they offer a rationale for their exclusion of women, but the very absence of the numerous successful women poets of the late 1880s and 1890s testifies to the Rhymers' gendered strategy.[11] Compare Yeats's "well-nigh all" to the assertion of Le Gallienne, in his 1894 article "Woman-Poets of the Day," that "Man, for the present, seems to be at a stand-still, if not actually retrograde; and the onward movement of the world to be embodied in women."[12] In the context of Le Gallienne's praise for women's progress and poetry, the exclusivity of the Rhymers looks like an attempt to draw on their masculinity to shore up their authority, and their appeal to a poetic past like a way to disavow the poetic prowess of women of the present. Le Gallienne's essay also points to a simultaneous and contradictory move that appears in his own poetry and in that of his fellow Rhymers: an attempt to co-opt the feminine to claim it for themselves. Le Gallienne asserts: "There is no sex in poetry. Poetry is not to be divided into two kinds, masculine and feminine."[13] This assertion liberates women poets from a feminine "seraglio," as Le Gallienne puts it, while also allowing men to lay claim to the feminine and in doing so paradoxically to erase women from it.[14]

Le Gallienne's *English Poems*: Masculine Modesty

In the early 1890s, Le Gallienne published his work with the Rhymers' Club, in *The Yellow Book*, and in his own collection *English Poems*, while also serving as the principal reader for The Bodley Head. Le Gallienne's career during these years is emblematic of the Rhymers'

sometimes contradictory approach to the minority status it embraced and as well as of a gendered approach that underscores their attempt to claim authority as well as minority. At first glance, Le Gallienne's *English Poems* seems to be in explicit conflict with his central position within the Rhymers and as a reader and author with The Bodley Head. He also reviewed for the periodical press the works of poetry he advocated for at The Bodley Head. Regarding the "Decadence" with which Rhymers were identified, even early on he was, as Linda Dowling aptly puts it, "both publicist and prosecutor, for at times he adopted aggressively 'Decadent' poetic themes, only to damn them later."[15] *English Poems* opens with "To the Reader," in which Le Gallienne inveighs against the art of his own time as "*a lazar-house of leprous men,*" bemoans French influence, and longs to return to an "*English song.*"[16] He does not claim to return that song to the fullness of its old glory with his own work, but only to admire it in his poetic practice. That determination to keep singing even when others might "jeer" at the song unites Le Gallienne with the Rhymers, even as some of them might be damned as belonging to the "lazar-house."

In encouraging readers to embrace "English" verse, he critiques those who turn away from the sentimentality of the images he invokes: "*Still English daisies up and down the grass, / Still English love for English lad and lass – / Yet youngsters blush to sing an English song!*"[17] This blush, we can assume, arises out of a modern embarrassment about the provincial, the small, and the sentimental along with a concomitant desire for the cosmopolitan. His full-throated call for nationalistic poetry concludes with an apology for the low quality of his own verse:

> *Forgive that 'neath the shadow of thy name,*
> *England, I bring a song of little fame;*
> *Not as one worthy but as loving thee*
> *Not as a singer, only as a child.*[18]

Whereas the other Rhymers claim their minor status as a hallmark of their artistic outsider status, Le Gallienne asks to be congratulated for his conservatism, for his devotion to a nation and its past, rather than for the poetry itself. *English Poems* shares with *The Book of the Rhymers Club* the sense that the old masters are out of reach, but whereas the Rhymers attempt to forge a way forward in their commitment to Rhyme, Le Gallienne places nationalism above his own poetic aptitude, situating what he views as true poetry in the inaccessible past.

Le Gallienne's modesty about the quality of his own poetry coincides with his ambivalence about selling poetry. His dedication of *English Poems* to his sister idealizes poetry not just as historical artefact but also as wholly inaccessible because it is immaterial in its "pure" state. Ironically, he fetishizes the material object of the book, contrasting the private, familial world of reading old books with the mercenary poetic marketplace. "*Dear Sister*" the dedication opens. "*You dream like mad, you love like tinder, you aspire like a star-struck moth – for what? That you may hive little lyrics, and sell to a publisher for thirty pieces of silver.*"[19] He goes on to compare publishers to beehives, whose colonies' promiscuous love of flowers produces "*sacred cells of gold*" only to be sold.[20] This critique of commericalism's taint on art resonates with Le Gallienne's other writings of the period, as in "Poets and Publishers." In that essay, he attempts to reconcile the aesthetic and commercial aspects of poetry:

> Ideally, a poem like any other beautiful thing is beyond price, but practically its value depends on the number of individuals who can be prevailed upon to purchase it. In its ethereal otherwise its unprinted state, it is only subject to the laws of the celestial ether – one of which is that it makes no money … The transactions of poetry and sale are on two different planes.[21]

Here he acknowledges that his ideal of ethereal poetry really cannot exist, or at least is practically impossible to circulate. In his view, the need for circulation is his defence for merging the two planes. The framing dedication of *English Poems* calls attention to the tension between the idealized immateriality of poetry and its printed state, leaving aside the question of whether sound and orality figure in the ether or in the material.

Yet even while demonizing publishing, Le Gallienne fetishizes it. The dedication goes on to invite readers into Le Gallienne's own family circle with this picture, addressed to his sister:

> *Can we ever forget those old mornings when we rose with the lark, and, while the earliest sunlight slanted through the sleeping house, stole to the little bookclad study to read – Heaven bless us! – you perhaps, Mary Wollstonecraft, and I, Livy, in a Froben folio of 1531.*
>
> *Will you accept these old verses in memory of those old mornings?*[22]

In this passage, he attempts to resolve the tension between the ethereal and the material by giving at least one publisher an ethereal patina of the past. Le Gallienne was still young when he wrote these words, and

his verses, of course, were even younger, so his reference to the poems in this volume as "old verses" seems like a clear attempt to paint himself as an elder man of letters or as writing in an outmoded style. Although he disparages publishers in the first two paragraphs, he elevates a publisher of the past with his reference to his own *Livy in a Froben folio of 1531*." This book, edited by Erasmus, was the first to contain the missing books of Livy's history of Rome, which were found in a fifth-century manuscript in a Benedictine abbey in 1526. Froben was a famous printer in the sixteenth century who made Basel the centre of the Swiss book trade. Froben's enterprise was a family business, and since the founder of the press died in 1527, it would have been his son who printed the 1531 Livy. This bit of characteristic Le Gallienne elevates the publisher alongside the author. Moreover, even as this dedication invites the reader into the author's private family circle, it misrepresents that circle, calling to mind a wealthy family with a well-curated library. In fact, the young Le Gallienne went into debt buying books and had to borrow money from his practical middle-class father, whose only reading was the Bible and theological texts.[23] This dedication thus points to the deeply conflicted feelings that Le Gallienne would always have about the economics of poetry. Le Gallienne complains about the commercialism of poetry, even though he is complicit in it, as an acquiring reader for a publisher and a reviewer of those same books for the periodical press. This ambivalence, in combination with his resolute minority status as a poet and his insistence on his own smallness, can be read as a desire to refuse not just the capitalist marketplace but the arbiters of literary value, of which he was one. He rejects the concept of monetary value as well as his own aesthetic value while also attempting to retain the moral value of acceptance and modesty.

English Poems is largely a collection of love poems that refute the very possibility of ideal fulfilment. The "English lad and lass" longed for in the opening poem, "To the Reader," are remarkably tepid, with an emphasis on faithfulness, a kiss happening in "a garden where one, / Only one, dear, may go."[24] The section dedicated to Le Gallienne's wife, "Cor Cordium," presents her as the good enough lover: a "[d]arling little woman," "a little maid" who keeps him from noticing the "fair women" he sees "all the day."[25] The acceptance implicit in finding a mate who is just good enough extends to a set of poems near the end addressing the difficulties of aging: "And the song has been sung / And the story been told."[26] Though Le Gallienne himself was not very old, twenty-six at the time, he was aware of being part of an aging era, struggling between retrenching

himself in the old order and attempting to find the new. His stance in love and in poetry is primarily one of retrenchment, but that very acceptance of diminishment offers new freedoms, ones liberated from the model of the solitary poetic genius. He wears his mediocrity as a poet almost proudly, as in the lines above about aging or when he suggests that a poet is not an elite master but one of many labourers: "Yea! and the weaver of a little rhyme / Is seen his worker in his own full time."[27] As we shall see, Le Gallienne shares this artisanal spirit with his fellow Rhymers. His repeated declaration of his smallness as a poet is of a piece with the modesty of his love poems and his distaste for commercialism. By putting himself as a poet second to the concept of art and poetry in general, he can advocate for the form without advocating for himself. Eschewing ambition both poetic and romantic gives heft to his distaste for economic ambition. Implicitly, this rationale allows him to play a central role in the publishing industry, which is condemned as a business practice even while elevated as an art form in itself.

Le Gallienne plants the fetishization of printing and publishing as art within the poems. "Cor Cordium" features a supplication to "MIGHTY Queen, our Lady of the fire," asking the "Lady" to bring the speaker "a maiden meet for love."[28] Though "Lady" is the only term of address in this poem, rather than "Mary" or "Virgin," a reader knowledgeable about the history of print will understand that "our Lady of the fire" refers to Forlì's fifteenth-century woodcut of the Virgin that is supposed to have survived a house fire, floating above the flames and drifting safely away from destruction.[29] With this reference, Le Gallienne pays homage not to a deity but to the miraculous power of the burgeoning technology of print. He thus endows print with powers of survival and, through his supplication, with the capacity to grant love, over and against the powers of poetry. Indeed, he apologizes to the Lady, and by extension to printing, for the mediocrity of his verse:

> Lady, I bear no high resounding lyre
> To hymn thy glory, and thy foes appal
> With thunderous splendour of my rhythmic ire;
> A little lute I lightly touch and small
> My skill thereon.[30]

That Le Gallienne would use the standard oral metaphors for poetry in order to call the miraculous powers of print to his aid speaks to the firmly entrenched notion in Victorian verse culture that print might be

able to represent the orality and aurality of poetry.[31] Yet for Le Gallienne, the printed artefact, Forli's *Our Lady of the Fire*, reigns supreme over the diminished capacities of the lyre and lute. Le Gallienne takes a modern view here, questioning any idea that print is a mere representation of fully authentic orality. Yet at the same time it is *his* music that can't properly praise the Lady of Fire, *his* skill that is small. Le Gallienne is like the Rhymers, embattled against an ill-defined but more powerful enemy. He proclaims the diminished powers of his "rhythmic ire" against the "thunderous splendor" of the Lady's (undefined) foes. That embattled stance, combined with his "small skill," forces him to forge an alliance with the more formidable power of print and, by extension, with publishing. In admitting defeat in his poetic talent, Le Gallienne substitutes the prowess of publishing.

Similarly, his realistic, even pessimistic, ambition as a poet matches his reconfiguration of Romantic aspiration. He asks not for a beauty for all other men to envy, but rather for "my heart's own She." Declaring that "I ask no maid for all men to admire, / Mere body's beauty hath me in no thrall," he refers to D.G. Rossetti's poem "Body's Beauty," whose "Lady Lilith" (1870) in a paired poem and painting ensnares men, leaving their "straight neck[s] bent." Margaret Stetz contends that the Pre-Raphaelite poet D.G. Rossetti is a key model for Le Gallienne because, like the Italian poet Dante Aligheri, whose Paolo and Francesca figure prominently in *English Poems*, he perfectly balances sensual and spiritual passion. In resisting body's beauty, Le Gallienne's speaker touts his own ability to privilege the subject of Rossetti's poem paired with "Body's Beauty," "Soul's Beauty." Le Gallienne wants no part of the "Body's Beauty" femme fatale who leaves men impotent and no part of a relational dynamic that attempts and fails at conquest. He implicitly suggests that true masculinity rests not in the sexual ambition to seduce a femme fatale but in the ability to resist the feminine erotic enticements to which the speaker of "Body's Beauty" succumbs. Unlike Lady Lilith, who narcissistically admires her reflection in both painting and poem, "subtly of herself contemplative,"[32] Le Gallienne's "maiden meet" possesses "Beauty beyond all glass's mirroring." Le Gallienne asserts that his love rests on substance rather than base materialism, on spirit rather than the body.[33] In Le Gallienne's case, however, that spirit and the speaker's masculinity both rest on lowered expectations, the acceptance of a modest "maiden meet," buttressed by a moral high ground. Masculinity, in this dynamic, is defined by and shored up by a romantic relationship with a woman. Recent work on Le Gallienne attempts to position him as at least feminist-adjacent. Sean O'Toole

argues for the feminism of George Meredith and Oscar Wilde in their witty female characters, and by association for that of Le Gallienne in his early admiring book on George Meredith.[34] Stetz notes Le Gallienne's doting address to his sister, whom he pictures reading Wollstonecraft in the introduction to *English Poems*, as well as his social interaction with and professional support of women writers like George Edgerton as a reader for The Bodley Head. But even Stetz has to concede that Le Gallienne's attitudes towards women in his poetry – in which they boost men's creativity without creating anything themselves – were "deeply retrogressive."[35] The individuality and modesty of Le Gallienne's not particularly beautiful "heart's own She" implicitly authorize his own imperfection and allow him to own his mediocrity.

Invoking John Keats's ode of the same name, Le Gallienne's poem "To Autumn" is one such attempt to own up to his inadequacy. But instead of celebrating the diminished music of that season, when for Keats "in a wailful choir the small gnats mourn / Among the river sallows," Le Gallienne emphasizes the irredeemable privation of "Autumn that finds not for a loss so dear / Solace in stack and garner hers too soon."[36] The consolations that Autumn provided to Keats are no longer available to Le Gallienne. The poem continues in the second and third stanzas:

> Autumn, a poet once so full of song,
> Wise in all rhymes of blossom and of bud,
> Hath lost the early magic of his tongue,
> And hath no passion in his failing blood.
> Hear ye no sound of sobbing in the air?
> 'Tis his, – low bending in a secret lane,
> Late blooms of second childhood in his hair,
> He tries old magic like a dotard mage;
> Tries spell and spell to weep and try again:
> Yet not a daisy hears, and everywhere
> The hedgerow rattles like an empty cage.
>
> He hath no pleasure in his silken skies,
> Nor delicate ardours of the yellow land;
> Yea! dead, for all its gold, the woodland lies,
> And all the throats of music filled with sand.
> Neither to him across the stubble field
> May stack or garner any comfort bring,
> Who loveth more this jasmine he hath made,

> The little tender rhyme he yet can sing,
> Than yesterday with all its pompous yield
> Or all its shaken laurels on his head.[37]

Autumn is a useful figure for the fin-de-siècle sense of winding down, but Le Gallienne takes that concept of devolution further by rejecting Autumn's harvest, marking the minor poet as unproductive. In contrast to Keats's celebration of the music of gnats, crickets, and robins, Le Gallienne's "Autumn" finds "the throats of music filled with sand." The poem repudiates the "full-throated ease" of Keats's nightingale and the surprising beauty of his "stubble plain" touched with "rosy hue."[38] Declaring Romantic poetry to be the "pompous yield" of "yesterday," Le Gallienne dismisses Keats's celebration of the "Season of mists and mellow fruitfulness" that "fill[s] all fruit with ripeness to the core," and by extension Romantic poetry itself, as grandiose.[39] Le Gallienne's figure for the minor fin-de-siècle poet is also explicitly masculine, personifying the season as male instead of as Keats's autumnal goddess, "sitting careless on a granary floor."[40] The impossibility of figuring the male minor poet of the present as fertile and productive signals that he is the last in his line. We see him trying the "old magic" in this poem, in its fixed form and iambic pentameter lines. The only hope for a poetry that is new and different is explicitly small, even feminine, and looks eastward. The "little tender rhyme he yet can sing" calls to mind the successful women's poetry of the 1890s, which was excluded from the Rhymers: Dollie Radford referred to her verses as "tender measures."[41] The jasmine flower in the minor poem that he "loveth more" than the work of Romantic giants recalls the *Japonisme* that flourished in the fin de siècle. Read within *The Book of the Rhymers' Club* instead of in *English Poems*, the jasmine flower situates the hope for a new fresh verse outside of English tradition altogether. Within *English Poems*, however, it seems in its own small way to question the very premise of the volume. Even as he critiques the pomposity of the Romantics, he beats Keats at his own game, prizing a still more diminished music. The effect is one of bitter, defensive pride, in that he vigorously excludes himself from the circle of Romanticism even while including himself in that circle, desiring a break with the past but fearing what comes after. When "To Autumn" appears in *English Poems* the same year, its love of the little jasmine and repudiation of Keats's stubble plain take a back seat to its nostalgia for "full-sailed summer," the "rhymes of blossom and of bud" and the "old magic."

The appearance of this poem in both collections speaks to its ambivalence about the place of poetry at the end of the nineteenth century; it implicitly offers a feminine, non-English, exoticized way forward while at the same time suggesting that that new way forward in no way compensates for the decidedly male, decidedly English, decidedly old poetic past.

Critics of *English Poems* agreed with its author that it was unexceptional. George Bernard Shaw's review savaged the verse as banal and unoriginal. This review appeared in *The Star*, the liberal evening newspaper for which Le Gallienne also wrote. Shaw said he was tempted to write a good review because Le Gallienne – a "professed logroller" – might be able to return the favour some day.[42] Nonetheless, he felt bound by his conscience and taste to declare the book ordinary. Stetz suggests that Theodore Wratislaw's "vitriolic" review in *The Artist*, which took a low blow at Le Gallienne's class origins, was motivated by jealousy and resentment, Le Gallienne having rejected two of his manuscripts for The Bodley Head.[43] Both Shaw and the critic for the conservative *St. James Gazette* found the book's vehement anti-Decadence misplaced. The *St. James Gazette* critic rightly noted that not many contemporary English poets were either influenced by the French or particularly part of "a lazar-house of leprous men."[44] The same critic asserted that Le Gallienne's screed was actually aimed at Arthur Symons, one of the better-known of the Rhymers, whose poems do fit a Decadent model much more than they embrace the literary minority I trace here.

Though panned by the critics, *English Poems* enjoyed robust sales and was sent to the printer for a second edition within a few months. Le Gallienne's pose as a defender of Englishness in poetry was very good at selling poetry; so was his implicit critique of the Rhymers. The quality of his poems may have been uneven at best, but if he was not a poetic success, he was at least (or at worst, as he might view it) a commercial one. Ultimately, Le Gallienne may have been so worried about commercializing poetry because he was so deeply engaged in that very process, reviewing books he had encouraged John Lane to publish. In *English Poems*, he may have idealized poetry of the past in an attempt to inject the ethereal into the material. His effort to elevate the ethereal over the material in both poetry and romance, to make the ethereal material by raising print to a sacred and aesthetic status, helped him compensate for the mediocrity of his poetry and present himself as a humble artistic worker.

The Rhymers' Club: A Confederacy of
Diminished Expectations

Especially in poems about themselves as a group, the Rhymers shared Le Gallienne's modesty about his own work. A sense of diminished possibility pervades the opening poem of the first *Book of the Rhymers' Club*, "At the Rhymers' Club: A Toast" by Ernest Rhys. They counter that diminishment with humour, male bonding, and a devotion to Rhyme. Their shared masculinity makes such collectivity possible, yet that collectivity is what justifies their minority status. Notwithstanding Yeats's assertion that "We Rhymers did not humour and cajole," this poem presents humour as one of the very elements of an early modern model of poetry that they hope to reclaim and casts humour as a collectivizing force:[45]

> *As once Rare Ben and Herrick*
> * Set older Fleet Street mad,*
> *With wit not esoteric*
> *And laughter that was lyric,*
> * And roistering rhymes and glad:*
>
> *As they, we drink defiance*
> * To-night to all but Rhyme,*
> *And most of all to Science,*
> *And all such skins of lions*
> * That hide the ass of time.*
>
> *Tonight to rhyme as they did*
> * Were well, – ah, were it ours,*
> *Who find the Muse degraded,*
> *And changed, I fear, and faded,*
> * Her laurel crown and flowers.*
>
> *Ah rhymers, for that sorrow*
> * The more o'ertakes delight,*
> *The more this madness borrow: –*
> *If care be king to-morrow,*
> * To toast Queen Rhyme to-night.*[46]

Through alliteration, the poem links poetry with playfulness; the "*laughter that was lyric*" and the "*roystering rhymes*" cast the versifying that unites these men as fun. Although this poem is by a single author, it envisions the

practice of poetry as collective – although wit might be enjoyed alone, no one much wants to imagine a poet's "*jolly folly*" or "*roistering*" as solitary. This poem calls to mind a kind of pleasure that can only be shared, and implicitly shared between men. Likewise, the defiance that accompanies the humour must be collective rather than a solitary sulk. This defiance highlights the difference between the poets' aspirational allegiances and their real ones. They may not collaborate with the long dead Ben Jonson and Robert Herrick, but they wish they could "*rhyme as they did.*"

Recent scholarship on rhyme attests that this formal device is associated with more than predictability and constraint.[47] The Rhymers often invoke rhyme and adhere to it in a way that underscores their idealization of a poetic past, as well as a poetic common denominator that has been consistent from the greats of the Elizabethan age to anonymous balladeers. It makes sense that they would identify with Herrick – whose reception history points to a poet variously considered both minor and major – given that they relish their status as minor poets with defiance even while aspiring to canonicity and collective "triumph." They might well have wanted to ally themselves with the work of the author of "To the Virgins to make much of Time" (1648) in order to share an emphasis on pleasure – male heterosexual pleasure in particular – while also participating in a lyric tradition that traffics in women. Yet while these poets believe they are following in a grand lyric tradition, they are also aware that they are working in its shadow. They resemble their predecessors in their devotion to poetry, but the "*degraded*" muse suggests disillusionment and discontent with a world that produces a verse less persuasive, less effective, and less potent. That discontent, both with the world and with their verse, leads to a renewed urgency to write and to rhyme. Although the muse is "*degraded*," the poets benefit from the energy and motivation of both their sorrow and their collective "*roistering.*"

This opening vision of playfulness, however much it contrasts with descriptions of the Rhymers' meetings as dull in multiple memoirs, is central to the way the volume presents masculine collaborations. It tempers and sanctions the very real anxieties in both this poem and in others about being among the last poets of an outworn age rather than an innovative new generation. The poetic greatness the Rhymers aspire to here requires coalescing around female figures more explicitly than in a nod to Herrick and his Virgins. As with Le Gallienne's invocation of the "lady of the Fire," the inspiration and the formal scaffolding of their verses are figured as female, and a female figure appears as an empowering force. This gendered figuration loosely aligns with Wayne

Koestenbaum's model of male collaboration, in which men write or edit
together in order to "separate homoeroticism from the sanctioned male
bonding that upholds patriarchy" and in which the "text they balance
between them" can be a "shared woman."[48] The Rhymers define them-
selves both as poets and as men around figures of women, yet they are
clearly aware that this strategy is falling apart. The figure of a degraded
muse suggests that poetic inspiration has perhaps been too promiscuous,
depriving these Rhymers of the originality they seek.

Despite the degradation of the muse, which signals both the libera-
tion of women sexually and poetically and an unsuccessful effort to find
new forms for poetry, the final line of the poem reinforces the strategy
of uniting poets as men around a female figure who is written rather
than one who writes; even if the muse is degraded, they must still turn to
"*Queen Rhyme.*" The way these male poets gather around female figures
of the poem itself dictates their exclusion of women writers. Recalling
that the 1890s were still much inspired by the Pre-Raphaelites – Dante
Gabriel Rossetti in particular, who could make a woman "the priestess of
her shrine," – Yeats is surprisingly explicit on the central, figurative place
for women to the Rhymers: "It could not be otherwise, for Johnson's
favourite phrase, that life is ritual, expressed something that was in some
degree in all our thoughts, and how could life be ritual if woman had not
her symbolical place?"[49]

I am somewhat loath to bring up the angel/whore dichotomy, by which
women are considered either saintly or sexually deviant, because it is as
trite and hackneyed now as it was in the 1890s, but in the same way that
Le Gallienne rejects "mere body's beauty" in favour of the "maiden meet,"
The Book of the Rhymers' Club bears out this gendered binary, just as its
opening poem does in its opposition of the "*Muse degraded*" and "*Queen
Rhyme.*" Even a brief look at a few poems demonstrates how the Rhymers,
committed to working within this dynamic, responded to the modernity
of the 1890s by continuing to cling firmly to the ideal of the writer as male
and the written as female. Within the collection, one finds a fascination
with female sexuality that often looks "*degraded.*" Thus, in Arthur Symons's
"Javanese Dancers: A Silhouette," the dancers' almost disembodied hands
and feet "undulate" while their eyes are still and their smiles are "inani-
mate."[50] Symons's dissection of the dancer is emblematic of the emphasis
on part over whole that Le Gallienne critiques in Decadent poetry. When
Le Gallienne takes up the femme fatale in "Beauty Accurst," he criticizes
a figure whose astonishing beauty draws away a poet "writing honey of his
dear" so that he leaves his poem incomplete.[51] His femme fatale makes

brides and grooms forget their own weddings and grinds economic activity to a halt. When she goes by, "All markets hush and traffickers forget."[52] For Le Gallienne, then, it is not only poetry that the femme fatale threatens but also the very domestic and economic engines of society. He feels ambivalent about women when it comes to publishing their poetry, and his own poetry expresses a clear anxiety about the effect the femme fatale might have on the commercial. Given Le Gallienne's poems are dedicated to his wife in *English Poems*, we might assume that he identifies with the man "writing honey of his dear"; the femme fatale is thus a threat to his ease, both domestic and economic. On the other end of the spectrum, Ernest Dowson's "Carmelite Nuns of the Perpetual Adoration" embodies an idealized, aestheticized ascetic life of fragrant incense behind an "impenetrable gate."[53] The nuns' rest, and escape from time, is the corollary to Decadent ennui. These poets may be fascinated or repulsed by the femme fatale, but they can identify with the figure of the nun.

Dowson's nuns are the only "angels" in the collection; the mid-Victorian domestic angel is no longer a possibility, given Ernest Rhys's "Quatrain: Les Bourgoises":

> Their health they to their horses give:
> They, dully blinking, ride behind,
> And yawn again, who do not live,
> But seek for life and never find.[54]

The figure that might once have resembled Coventry Patmore's *The Angel in the House* is here too bored for her own good, but she cannot respond to the ennui of the 1890s by embracing the contemplative rest of the nuns, nor by seeking out new sensations in the music halls as men do in Symons's poems. The only domestic angel in *The Book of the Rhymers' Club* appears immediately before "Les Bourgeoises," and it is a man. In Ernest Radford's ironic "Freedom in a Suburb," a man smokes a pipe "in perfect peace" inside his garden walls:

> He leaned upon the narrow wall
> That set the limit to his ground,
> And marvelled, thinking of it all,
> That he such happiness had found.[55]

Yet that peace is only supported by that which threatens it; every day he leaves his "heart" at home to take the "subterranean cars" of the Under-

ground into the "devil's din / Of London's damnèd money mart."[56] Echoing Le Gallienne's deep scepticism of commercialism, Ernest Radford's "Freedom in a Suburb" asks what the proper place is for a man and makes the home look like a much more appealing option than the marketplace. Yet as in the anthology of the Rhymers' Club as a whole, here the absent presence of women underwrites the man's choice of place and his options for self-definition. If he were tasked with managing the household, he might have less pipe-smoking, star-contemplating peace and London's money mart might sound much less like a devil's din. Yet these three examples – Dowson's "Carmelite Nuns," Rhys's "Les Bourgeoises," and Radford's "Freedom in a Suburb – allow the male Rhymers to identify with different types of feminine ennui. The latter two give them the opportunity to try out the position of the bored housewife, a figure that resembles the minor poet in her acceptance of diminished expectations.

Their nearly invisible traffic in women – excluded, and rendered symbolic rather than real – safeguarded the Rhymers against charges of effeminacy. It also allowed them implicitly to include sensitivity, weakness, and smallness in their definition of the male poet. In later years, Yeats's and Le Gallienne's retrospective accounts of the Rhymers' Club would dwell on Ernest Dowson and Lionel Johnson, both of whom converted to Roman Catholicism and died young. Both Yeats and Le Gallienne describe Johnson as looking like a child of fifteen. Le Gallienne describes Dowson as a "frail appealing figure, with an almost painfully sensitive face, delicate as a silverpoint, recalling at once Shelley and Keats, too worn for one so young."[57] The comparison of Dowson to a "silverpoint" recalls John Gray's famous 1893 volume of poetry *Silverpoints*, ushered into being by Oscar Wilde. Gray was rumoured to have been the inspiration for Dorian Gray, and was, like Lionel Johnson, gay. Le Gallienne's reference nods covertly to the homosexuality within and the homosociality of the Rhymers, all the while, as in Koestenbaum's theory of male collaboration, reaffirming the patriarchal masculinity of the group, which widens out here to include not just the Rhymers themselves but their similar Romantic forerunners, Shelley and Keats. Le Gallienne also refers to Johnson as a "fragile creature" who is "tiny" and "frail," so much so that "it was hard to believe such knowledge and such intellectual force could be housed in so delicate and boyish a frame."[58] Indirectly, Le Gallienne insists here that a mid-Victorian model of muscular Christianity is not necessary for intellectual potency. Because the "boyish" constituted a somewhat ambiguous gender in the 1890s, Le Gallienne argues

implicitly here that force can come just as well from what Martha Vici-
nus calls the "liminal creature" of the adolescent boy as from a "manly"
one.[59] In *The Romantic '90s*, Le Gallienne is eager to underscore his close
friendship with Johnson by referring to and including facsimiles of let-
ters he received from him. By doing so, he allies himself with the "force"
of the boy or the feminized man. Le Gallienne here both reinforces the
gendered system identified by James Eli Adams that calls "into question
the 'manliness' of intellectual labor"[60] and begins to forge a script for
the outgrowth of a new gendered type, defined by Johnson but also vis-
ible in certain poems from the Rhymers and in Le Gallienne's *English
Poems*: a man who revels in domestic tranquility, who fantasizes about
being a nun, who celebrates his just-good-enough wife in order to be
just-good-enough himself, who writes a hackneyed good-night poem for
his children.[61]

These connections between mediocre poetry, minor literary status,
and the male bonding of the Rhymers' collective endeavour strengthen
the "defiance" in the opening poem of the collection, shoring up an
idea of the Rhymers as a new, young, possibly avant-garde coterie whose
"defiance" embraces a minority status rather than seeking a new form of
dominance. Nicholas Frankel has argued persuasively that in its very title
The Book of the Rhymers' Club emphasizes not authors but the materiality of
the book and the poetry itself. Le Gallienne's bibliophilia, and his effort
to elevate printing and publishing to art forms in his invocations of the
Froben Folio and the "Lady of the Fire," certainly support Frankel's argu-
ment. Frankel asserts that the very collectivity of the Rhymers' two joint
volumes was an affront to the idea of author-as-master and constituted
a form of resistance, speaking for alienation and against sage culture.[62]
The rejection of the sage master in favour of a collectivity can only take
place within the authority of maleness, a deliberately weak and attenu-
ated maleness, and an incorporation of womanly positions and traits,
ironically made possible by the exclusion of women and by the contin-
ued invocation of the feminine as a figure, whether of rhyme itself or as
an object of fascination or enmity to rally around, as in Dowson's nuns,
Symons's dancers, and Le Gallienne's femme fatale and the "Lady of the
Fire."

Greene's closing poem ensures that *The Book of the Rhymers' Club* is
bookended by invocations of "*Queen Rhyme*":

Ours are the echoes at least
 That fell from that golden prime;

Ours are the echoes at least,
Ours are the crumbs from the feast
* At the feet of the queenly rhyme:*
Ours be the task to prolong
The joy and the sorrow of song
* In the mist of years that begrime;*
In the clinging mist of the years,
With reverent toil and with tears,
* To hammer the golden rhyme,*
* Hammer the ringing rhyme*
* Till the mad world hears.*[63]

With relative certainty, Greene declares their poetry to be of diminished quality, nothing but echoes and crumbs from a greater era. Yet it is their job to ensure that "*Queen Rhyme*" lives on. It is an artisanal rather than an industrial job, and here an explicitly masculine one figured as the rough physical labour of the blacksmith.

Alex Murray and Jason David Hall assert that a narrative of Decadence that casts it as a transition to modernism often overlooks "the central role of nostalgia and a general retrogressive tendency that can be seen in so many decadent writers."[64] Whether or not we consider the Rhymers to be Decadent, when we view them through the lens of Le Gallienne, their retrogressive tendencies become clearer. Their collectivity relied on an increasingly outmoded model of masculinity and even on an increasingly outmoded model of poetry – they swear their allegiance not to poetry or to verse, but to rhyme, whose formal importance would soon be on the wane. Yet their minor status as well as their approach to gender was neither entirely retrogressive nor entirely progressive. That embrace of minor status was retrogressive in its poetic nostalgia but also progressive in its rejection of solitary genius and an author-focused poetry. Likewise, their expansion of what it could mean to be a man can seem radical, yet their erasure of women in the process locks them at times into age-old sexist dynamics. That they can look both forward and backward at the same time attests to the variety of the Rhymers and of the decade of the 1890s.

NOTES

1 William Butler Yeats, *The Collected Works*, vol. 3: *Autobiographies*, ed. William H. O'Donnell and Douglas N. Archibald (New York: Scribner, 1999), 147.

2 Nicholas Frankel, "'A Wreath for the Brows of Time': The Books of the Rhymers' Club as Material Texts," in *The Fin-de-Siècle Poem: English Literary Culture and the 1890s*, ed. Joseph Bristow (Athens: Ohio University Press, 2005) 131–57.

3 Ernest Dowson, "Non sum quails eram bonae sub regno Cynarae," in *The Second Book of the Rhymers' Club* (London: The Bodley Head, 1894), 60. Murray Pittock declares the club to "stand in a symbolic relation to its age," *Spectrum of Decadence* (New York: Routledge, 1993), 129. John Reed cites Arthur Symons, and secondarily Ernest Dowson and Lionel Johnson, the most enduring of the Rhymers besides Yeats, as examples of decadent poets, though not so much so, he qualifies, as Beaudelaire or Swinburne, *Decadent Style* (Athens: Ohio University Press, 1985), 109–10. The sole book to be devoted to the Rhymers also takes its lead from Yeats, starting with its title: Norman Alford, *The Rhymers' Club: Poets of the Tragic Generation* (New York: St. Martin's Press, 1994).

4 Richard Le Gallienne, *The Romantic '90s* (New York: Doubleday, Page, 1926), 183, 163.

5 Arthur Symons, "Stella Maris"; Max Beerbohm, "A Defence of Cosmetics"; and George Egerton, "A Lost Masterpiece," *The Yellow Book: An Illustrated Quarterly* 1 (1894), 129–31, 82, 189–96.

6 Richard Le Gallienne, "Tree-Worship," *Yellow Book* 1 (1894), 59.

7 Le Gallienne, *The Romantic '90s*, 172, 174.

8 Ernest Rhys, "At the Rhymers' Club: The Toast"; G.A. Greene, "Song of the Songsmiths"; Richard Le Gallienne, "To Autumn," *The Book of the Rhymers' Club* (London: Elkin Matthews, 1892), 2, 93, 68. (Italics in the original.)

9 Greene, "Song of the Songsmiths," 92. (Italics in the original.)

10 W.B. Yeats, "The Rhymers' Club," *Boston Pilot* (23 April 1892), quoted in Alford, *The Rhymers' Club*, 143.

11 Mention of the Rhymers' exclusive masculinity does not arise directly in Le Gallienne's *The Romantic '90's*, Yeats's *Autobiographies*, or "Victor Plarr on 'The Rhymers' Club': An Unpublished Lecture," ed. George Mills Harper and Karl Beckson, *English Literature in Transition, 1880–1920* 45, no. 4 (2002): 379–401.

12 Richard Le Gallienne, "Woman-Poets of the Day," *English Illustrated Magazine* 11 (1894), 650.

13 Le Gallienne, "Woman-Poets of the Day," 650.

14 Le Gallienne, 650.

15 Linda Dowling, *Language and Decadence in the Victorian Fin-de-Siècle* (Princeton: Princeton University Press, 1986), 142.

16 Richard Le Gallienne, "To the Reader," in *English Poems* (London: Elkin Mathews and John Lane, 1892), 3. (Italics in the original.)

17 Le Gallienne, "To the Reader," 3. (Italics in the original.)
18 Le Gallienne, 3. (Italics in the original.)
19 Le Gallienne, "Epistle Dedicatory," in *English Poems*, vii. (Italics in the original.)
20 Le Gallienne, "Epistle Dedicatory," vii. (Italics in the original.)
21 Richard Le Gallienne, "Poets and Publishers," *Speaker* 8 (25 November 1893), 579.
22 Le Gallienne, *English Poems*, vii–viii. (Italics in the original.)
23 Richard Whittington-Egan and Geoffrey Smerdon, *The Quest of the Golden Boy: The Life and Letters of Richard Le Gallienne* (Barre: Barre Publishing, 1962), 46–7.
24 Le Gallienne, "Hesperides," in *English Poems*, 72.
25 Le Gallienne, "Cor Cordium. A Love Letter" and "Cor Cordium. The Constant Lover," in *English Poems*, 59, 61.
26 Le Gallienne, "An Old Man's Song," in *English Poems*, 77.
27 Le Gallienne, "Inscriptions," in *English Poems*, 105.
28 Le Gallienne, "Cor Cordium. The Destined Maid: A Prayer," in *English Poems*, 47.
29 The "Madonna of the Fire" was the first printed artifact to become a religious icon. It was also the first to have a monograph dedicated to it, some two hundred years after its presumed miraculous survival. Lisa Pon, in her book-length study, *A Printed Icon in Early Modern Italy: Forlì's Madonna of the Fire* (New York: Cambridge University Press, 2015), discusses how it "occupies the intersection of three potent categories of manufactured things: the nexus of aesthetics, technology and religion" (1–2).
30 Le Gallienne, "Cor Cordium. The Destined Maid: A Prayer," 48.
31 See Eric Griffiths, *The Printed Voice of Victorian Poetry* (Oxford: Clarendon Press, 1989).
32 Dante Gabriel Rossetti, "Body's Beauty," in *The Pre-Raphaelites and Their Circle*, ed. Cecil Y. Lang (Chicago: University of Chicago Press, 1975), 118.
33 Le Gallienne's attack on Decadence, which itself develops ideas and motifs central to Rossetti and the pre-Raphaelites, takes precisely this approach. In *The Religion of a Literary Man*, Le Gallienne critiques the "materialising" influence of Decadence and its exclusive focus on the senses. That materialism, he asserts, results in a lack of proportion, suffering from its attempts to isolate "things … from all their relations to other things and their dependence on the great laws of life" (London: Elkin Mathews and John Lane, 1893), 89–90.
34 Sean O'Toole, "'Writing in Lightning' in Meredith, Wilde, and Le Gallienne," *The Yearbook of English Studies* 49 (2019): 155–72.
35 Margaret D. Stetz, "Richard Le Gallienne and a Tale of Two Dantes," *Studies in Walter Pater and Aestheticism*, no. 3 (2018): 86.

36 John Keats, "To Autumn," in *John Keats: Complete Poems*, ed. Jack Stillinger (Cambridge, MA: Harvard University Press, 1982), 360–1; Le Gallienne, "Autumn," in *English Poems*, 85.

37 Le Gallienne, "Autumn," 85–6.

38 Keats, "To Autumn," 86.

39 Keats, 85.

40 Keats, 85.

41 Dollie Radford, *Songs and Other Verses* (London: Elkin Mathews, 1895), 34.

42 George Bernard Shaw, "Bassetto on Logroller," Review of Le Gallienne, *English Poems*, *The Star*, 27 November 1892, 4.

43 Stetz, "Richard Le Gallienne," 77–8.

44 [Anon.], "A Budget of Bad Verse," *St. James's Gazette*, 25 October 1892, 4.

45 Yeats, *Autobiographies*, 229.

46 Rhys, "At the Rhymers' Club: The Toast," 1–2. (The poem appears in italics in the original text.)

47 See Peter MacDonald, *Sound Intentions: The Workings of Rhyme in Nineteenth Century Poetry* (Oxford: Oxford University Press, 2013).

48 Wayne Koestenbaum, *Double Talk: The Erotics of Male Literary Collaboration* (London: Routledge, 1989), 3.

49 Yeats, *Autobiographies*, 234.

50 Arthur Symons, "Javanese Dancers: A Silhouette," in *The Book of the Rhymers' Club*, 57.

51 Richard Le Gallienne, "Beauty Accurst," in *The Book of the Rhymers' Club*, 28–9, and *English Poems*, 95.

52 Le Gallienne, "Beauty Accurst," in *The Book of the Rhymers' Club*, 28; and *English Poems*, 95.

53 Ernest Dowson, "Carmelite Nuns of the Perpetual Adoration," in *The Book of the Rhymers' Club*, 10.

54 Ernest Rhys, "Quatrain: Les Bourgeoises," in *The Book of the Rhymers' Club*, 81.

55 Ernest Radford, "Freedom in a Suburb," in *The First Book of the Rhymers' Club*, 80.

56 Radford, "Freedom in a Suburb," 80.

57 Le Gallienne, *The Romantic '90s*, 186.

58 LeGallienne, 187–91.

59 Martha Vicinus, "The Adolescent Boy: Fin-de-Siècle Femme Fatale?," in *Victorian Sexual Dissidence*, ed. Richard Dellamora (Chicago: University of Chicago Press, 1999), 83. Vicinus's conclusion might well describe the role that Johnson played for the Rhymers: "While the fin-de-siècle woman sucked life out of men, the fin-de-siècle boy died lest his love contaminate,

and the fin-de-siècle boyish androgyne was ridiculed. Seldom have heterosexual men been so vulnerable, and so well protected, in literature" (101).

60 James Eli Adams, *Dandies and Desert Saints* (Ithaca: Cornell University Press, 1995), 1.

61 In "Child's Evensong," *English Poems*, 93, Le Gallienne demonstrates that the tropes that inspired the recent popular parody for parents *Go the Fuck to Sleep* were already hackneyed in 1892. See Adam Mansbaugh, *Go the Fuck to Sleep*, illustrations by Ricardo Cortès (New York: Akashic Books, 2011).

62 See Frankel, "A Wreath for the Brows of Time."

63 Greene," "Song of the Songsmiths," in *The Book of the Rhymers' Club*, 93–4. (The entire poem appears in italics.)

64 Alex Murray and Jason David Hall, "Introduction," in *Decadent Poetics: Literature and Form at the British* Fin de Siècle, ed. Murray and Hall (Basingstoke: Palgrave Macmillan, 2013), 5.

Max Beerbohm's "Improved"
Intentions and the Aesthetics of *Cosmesis*

MEGAN BECKER-LECKRONE

The Greeks in their exquisite wisdom combined order and adornment in the same word, the art of adorning and that of ordering. "'Cosmos'" designates arrangement, harmony and law, the rightness of things: here is the world, earth and sky, but also decoration, embellishment or ornamentation. Nothing goes as deep as decoration [and] ornamentation is as vast as the world.
Michel Serres, *Les cinq sens* (*The Five Senses*, 1985)

There is a wealth of material that almost no one talks about when they talk about the works of Max Beerbohm, though its existence is well-known among scholars. Such material includes hundreds of drawings, handwritten added text, impersonations of dead authors in the form of false inscriptions and commentary, pasted illustrations, wry defacements, embellishments of printed illustrations, invented handwriting, forged typeset, and more – all added to books that had already been published, both his own and, more subversively, those of other writers. The books in Beerbohm's own library at the Villino Chiaro, Rapallo, Italy, were the prime canvasses for this complicated art, but others had a different provenance: dedication copies for both friends and strangers, for instance, or belated additions (e.g., a copy of *The Works of Max Beerbohm* [1896] apparently sent to a charity in London in 1931) expressly designed to add value for collectors.[1] The volume of this body of work is enormous, but because it resides primarily in disparate special collections libraries in Britain and the United States, it remains largely unpublished and has had a dormant posthumous existence.

For its sheer volume, this unpublished material radically, but generatively, challenges what we mean when we refer to "the complete works

of Max Beerbohm." It offers the raw materials, the starting point for a new criticism. Whatever may demand categorical adjustments, in the full accounting of Beerbohm's work, new definitions and revaluations also suggest critical opportunities: for scholars of the artist or his time, for studies of caricature and the fin de siècle and modern essay. This work places Beerbohm in cultural traditions of which he has not, thus far, been a part (book history, extra-illustration); and it situates him squarely within theoretical paradigms into which he has, thus far, only clumsily or partly seemed to fit (Gérard Genette's concepts of "paratext" and "palimpsest," textual materiality, theories of authorship).[2] The variety of techniques, the ingenuity, and the imagination evident in so much of this unpublished work makes clear that an authoritative understanding of Beerbohm's "complete" oeuvre will come about only once it is accounted for as a meaningful part of that whole. First, of course, this work simply needs to be seen. The uniquely embellished volumes that Beerbohm, fondly and suggestively, called his "improved" books were the product of a lifelong preoccupation. In this chapter I take that ironic name seriously enough to begin thinking of this work not just as a pastime or a decades-long practical joke on Beerbohm's part, but at his word and at its roots. My argument is that Beerbohm's "improvements" draw from the anti-mimetic aesthetic philosophy of fin-de-siècle Decadence and, in that regard, engage in what I call *cosmesis*: a type of critically astute ornamentation or embellishment that stands as an extra-illustrative art form in its own right.[3]

I will focus my discussion on one "improvement" in particular: the astonishing illustrations that Beerbohm inscribed into one of his copies of Oscar Wilde's *Intentions* (1891), the volume that brought together the brilliant critical essays – "The Truth of Masks," "Pen, Pencil, and Poison," "The Decay of Lying," and the two parts of "The Critic as Artist" – that Wilde published between 1885 and 1891 (figure 6.1). Beerbohm's "improved" *Intentions* is not only, arguably, the most ornately beautiful example of such work, but also among his earliest extant manifestations of it. The essays in *Intentions*, especially "The Decay of Lying" and "The Critic as Artist," offer Wilde's most explicit critical expression of *cosmesis* as an aesthetic theory, which renders Beerbohm's drawings in this volume suggestive in many ways. Most simply, however, they provide perhaps uniquely useful descriptions for what Beerbohm's "improvements" literally do. He, as "beholder" of the existing "beautiful thing," lends *Intentions* – to use Wilde's words – its "myriad meanings, and makes it marvelous for us, and sets it in some new relation," to himself, to each new viewer.[4] As a

Figure 6.1 Max Beerbohm, pen, ink, graphite, and gouache drawing on the verso of the front endpaper and title page of Oscar Wilde, *Intentions* (London: Osgood, McIlvaine, 1891), William Andrews Clark Memorial Library, University of California, Los Angeles. PR6003.E4Z95wi* (first of two "improved" copies). (© Estate of Max Beerbohm. Reproduced by kind permission of Berlin Associates.)

cosmetic creation, Beerbohm's "improved" *Intentions* acts out what "The Critic as Artist" calls "the highest kind" of creativity: "It treats the work of art simply as a starting point for a new creation."[5] Beerbohm, to adapt Wilde's own words, "does not confine [him]self ... to discovering the real intention of the artist and accepting that as final."[6] As a statement of sheer fact, this is what Beerbohm does: he takes the "real" *Intentions*, but he does not accept its binding and green cloth boards, nor its author's intentions, "as final." Materially, that object becomes the "starting point for a new creation." My interpretation considers it more than mere coincidence that Beerbohm places the most illustratively coherent "improvement" in the entire volume, expressive of precisely this aesthetic principle, on the facing page of "The Critic as Artist, Part I" (figure 6.2).

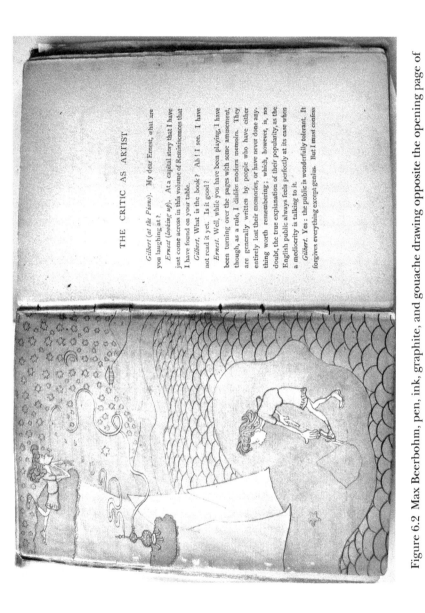

THE CRITIC AS ARTIST

Gilbert (*at the Piano*). My dear Ernest, what are you laughing at?

Ernest (*looking up*). At a capital story that I have just come across in this volume of Reminiscences that I have found on your table.

Gilbert. What is the book? Ah! I see. I have not read it yet. Is it good?

Ernest. Well, while you have been playing, I have been turning over the pages with some amusement, though, as a rule, I dislike modern memoirs. They are generally written by people who have either entirely lost their memories, or have never done anything worth remembering; which, however, is, no doubt, the true explanation of their popularity, as the English public always feels perfectly at its ease when a mediocrity is talking to it.

Gilbert. Yes: the public is wonderfully tolerant. It forgives everything except genius. But I must confess

Figure 6.2 Max Beerbohm, pen, ink, graphite, and gouache drawing opposite the opening page of Oscar Wilde, "The Critic as Artist," in Wilde, *Intentions* (London: Osgood, McIlvaine, 1891), William Andrews Clark Memorial Library, University of California, Los Angeles. PR6003.E4Z95wi* (first of two "improved" copies"). (© Estate of Max Beerbohm. Reproduced by kind permission of Berlin Associates.)

It is in this spirit of "new creation," perhaps, that critics such as Kristin Mahoney have sought to rescue Beerbohm from his reputation as a minor artist and stale relic of the fin de siècle. She instead reads that reputation as the shrewdly self-fashioned creation of an engaged, productive, and sophisticated twentieth-century artist, "increasingly interested in the political uses of the past" and sensitive to the social value of satire as a subtle counterweight to the horrors of the Great War, a way to revive certain elements of aestheticism in palatable relation to a new age.[7] I am confident that such subtle critical attention to Beerbohm's unpublished "improvements" will enhance our scholarly understanding of his full, long creative life. Sarah Davison's 2011 article "Max Beerbohm's Altered Books," for example, goes a long way towards not only making some of this work visible to contemporary scholars, but also taking it seriously as a legitimate object of critical analysis, and showing how other critics might as well.[8] Aside from the twelve illustrations that Davison reproduces in her essay, there are the more than thirty "title-page caricatures" that biographical critic N. John Hall reprints in his important 1984 article "A Genre of His Own: Max Beerbohm's Title-Page Caricatures."[9] But as both Davison and Hall acknowledge, hundreds more "improved" books exist, themselves often containing dozens of alterations that make clear Beerbohm devoted considerable artistic labour to this work. A two-day London auction at Sotheby & Co. (12–13 December 1960) listed 383 items for sale in the *Catalogue of the Library and Literary Manuscripts of the Late Sir Max Beerbohm, Removed from Rapallo*. As the catalogue's title page further outlines, the sale included "books 'improved' by Max Beerbohm by the addition of drawings, caricatures, or other decorations, notes and parodies, altered illustrations, and mock presentation inscriptions."[10] To date, the auction catalogue stands as the most exhaustive published record of this large area of Beerbohm's work.

Several of these auction items reside in the William Andrews Clark Memorial Library in Los Angeles, California, among the voluminous collections dedicated to the works and papers of Oscar Wilde, the age of Wilde, and other Wildeana. One volume in particular stands out: Sotheby's Lot 240, "WILDE (OSCAR) INTENTIONS, FIRST EDITION, elaborately decorated in pen and wash by Max Beerbohm in the Beardsley manner."[11] This specific volume of Wilde's *Intentions* contains no fewer than eighteen pages of such elaborate scope and detail that they well exceed the generic designations applied by both Hall and Davison, even though Hall includes the title and facing pages of Lot 240 in his inventory of "title-page caricatures."[12] For the meticulous, deliberate care with

which these eighteen pages of illustrations were drawn, but also their relative obscurity, they constitute a rich critical specimen for Beerbohm and Wilde scholars alike. As the Sotheby's auction catalogue affirms, the 1891 edition of Wilde's *Intentions* remained in Beerbohm's library his whole life.

To be sure, the existence of this volume is not unknown among scholars, but it is routinely judged a mere curiosity, one passed over for critical analysis in favour of other "improved" specimens in Beerbohm's library. S.N. Behrman, for example, recounts in *Conversation with Max* (1960) how Beerbohm treated him to a viewing of a savage reworking of Archibald Henderson's *George Bernard Shaw: His Life and Works*, among several other items.[13] More recently, Lawrence Danson reports that so profound was Beerbohm's devotion to *Intentions* that he referred to it simply as "The Book," his own copy "elaborately 'improved' with pen-and-ink drawings."[14] Yet Danson does not believe that Beerbohm's many drawings of Wilde are anything more than frivolous. He calls Beerbohm's later emulation of Wilde's writing in *The Works of Max Beerbohm* (1896) "parasitic," the drawings in the "improved" copy of *Intentions* "graffiti," and in particular the illustration prefacing "The Critic as Artist," cited above, as merely a "jolly cartoon" (see figure 6.2).[15] Meanwhile, David Cecil's 1964 biography *Max* takes greater care to describe several of Beerbohm's "improved" artefacts, and explains the process by which he produced them, even including the full text of a letter written by the (fictional) heroine of Beerbohm's only novel, *Zuleika Dobson* (1911):

> With a fine pen, meticulous care and so skillfully that it is hard often to distinguish Max's handiwork from the printed object, he would get to work on a real book[,] "improving" it, to use his own [term]. This meant altering the title-page, inserting or changing an illustration, interpolating imagined questions, appending absurd and invented press notices, writing a forged dedication or message from the author.[16]

Still, Cecil seems determined to subordinate these remarkable details to biographical portraiture, the "improvements" being merely inhabitants of Beerbohm's supposedly childlike "world of comic fantasy."[17] It is in this context that Cecil places the "copy of Oscar Wilde's *Intentions* … adorned all through in a mock-Beardsley style," a reference to the startling black-and-white pen drawings that shot the young illustrator Aubrey Beardsley to fame in *The Studio* in 1893.[18] Within months, Beardsley's eroticized art had become synonymous with an emergent Decadence. Cecil, who

clearly perceives that Beerbohm's art is secondary to Beardsley's, places the "improved" *Intentions* in the same category as Beerbohm "making an apple-pie bed[19] for his wife's young niece" – that is, as little more than evidence that his impish reputation for "making jokes" was lifelong.[20] Furthermore, Cecil gives that volume less attention than an improved Walter Pater volume he misidentifies as *The Renaissance: Studies in Art and Literature* (first published in 1873, and revised three times thereafter) rather than *Miscellaneous Studies* (1895), and deems it less "memorable" than Beerbohm's notoriously "improved" copies of Henderson's 1911 biography of Shaw, Queen Victoria's *More Leaves from the Journal of a Life in the Highlands* (1868), and Herbert Trench's long poem *Apollo and the Seaman* (1908), in which, "with a penknife ... Max scraped out all the aspirates in all the words beginning with 'h' said by the mariner and substituted an apostrophe," transforming the Seaman in the poem into a "modern Cockney."[21]

Beerbohm's "improved" *Intentions*, however, clearly engages critical complexities such as those identified by Davison in the focal point of her essay, the "improved" biography of George Bernard Shaw, even though she categorically identifies the practice as grangerism: a term dating from the 1780s that identifies the short-lived popular practice of cutting and pasting prints and other visual materials into James Granger's *Biographical History of England* (1769). The practice, which was initially reserved for the idle elite who could afford to destroy books, and eventually made available to the masses, was associated from its beginnings with an act of violence against the book, even while the endeavour aimed at adding personal value to the specimen itself. Book historians such as Lucy Peltz and Jeffrey Todd Knight show how old, vast, and complex is the broad range of practices like grangerism, which scholars more generally call extra-illustration.[22] Beerbohm was familiar with the term grangerism, at times using it himself, but the very fact that he called his own works in this vein "improved" books signals an equally broad engagement not only with the tradition of extra-illustration, unserious and otherwise, but also – which is more important – with the central tenets of fin-de-siècle Decadent aesthetics.

Cosmesis, Creativity, and Criticism

The notion that Beerbohm's private additions and amendments "improve" upon a finished, published work is in keeping with the leading critical idea expressed everywhere in Wilde's *Intentions*: the primary

function of art is to improve upon an imperfect nature, and the highest art looks not to real life for inspiration, but to other forms of art. On the first page of *Intentions*, in the dialogic essay "The Decay of Lying," we encounter Wilde's persona Vivian making this observation: "What Art really reveals to us is Nature's lack of design ... her absolutely unfinished condition. Nature has good intentions, of course, but ... she cannot carry them out.... Art is our spirited protest, our gallant attempt to teach Nature her proper place."[23] Here Vivian echoes Charles Baudelaire's "In Praise of Cosmetics" (1863), an essay that equates art with civilization, with "everything that is beautiful and noble," and that connects the cosmetic impulse with our "need to surpass Nature," not merely "imitate" it in the tradition of mimesis.[24]

In this context, Beerbohm's notorious essay "A Defence of Cosmetics," published in the controversial first issue of *The Yellow Book* in April 1894, reads as a cogent digest of what we might call Decadent anti-mimesis: a radical challenge to the long-standing assumption that art is or should be a reflection – an imitation, a representation – of real life. The essay recalls, for example, the provocations of Des Esseintes, the reclusive protagonist of Joris-Karl Huysmans's infamous 1884 anti-realist novel *À rebours* (*Against Nature*), who announces: "Nature ... has had her day ... There can be no shadow of doubt that ... the time has come for artifice to take her place whenever possible."[25] Beerbohm brings to this polemic an emphatic clarity: he claims that to privilege artifice, make-up, and cosmetics above some more "natural" state is not to remain aloof from real life, but rather to contest the pretence that any art (whether romantic or realist) functions "under the direct influence of Nature."[26] The earlier part of the nineteenth century was an age, he says, in which "all things were sacrificed to the fetish Nature."[27] In the era of Charles Dickens, Beerbohm writes, "we find that it is absolutely true. Women appear to have been in those days utterly natural in their conduct – flighty, gushing, blushing, fainting, giggling and shaking their curls."[28] The notion of "Nature" as a "fetish," an idol of our own creation, closely echoes Wilde's "The Decay of Lying," in which the main speaker Vivian claims that artists created the London fog and that "the whole of Japan is a pure invention."[29] Both of Vivian's outrageous statements serve his serious theoretical pronouncement: "Nature is no great mother who has borne us. She is our creation. It is in our brain that she quickens to life. Things are because we see them, and what we see, and how we see it, depends on the Arts that have influenced us."[30]

Decadent representation operates not according to the logic of *mimesis*, in other words, but according to that of *cosmesis*.[31] The term is

evocative for its multivalent etymology, which demonstrates, from the start, that the line between creating and merely copying, between the natural and what dresses nature up, has never been secure. Throughout *Intentions* – not just in "The Decay of Lying" but also in a longer essay, "The Critic as Artist," also a dialogue – Wilde asserts that art is not a reflection of life; rather, life is a reflection of art, and the "critical spirit" sees an existing work of art – as I suggested earlier in connection with Beerbohm's "improvements" – merely as "the starting point for a new creation." By contrast, and as Plato so decisively asserted in *Ion* and *The Republic*, the mimetic artist makes nothing; he holds a mirror up to the world and pretends he makes a world, but the creation of a world can only be credited to the one original creator who made the cosmos.[32]

The most consequential artists of the Decadence, however, do not so much reverse what comes with the mimetic assumption that "art is like a mirror" (rejecting the "real" in favour of the "artificial") as undo that opposition altogether.[33] A central feature of Decadent representation – both in its execution (rhetorical, thematical, formal, and stylistic) and in our understanding of it – is that it challenges the notion that "style" is supplementary to substance and that art is supplementary to nature. By invoking the trope of the "cosmetic," these artists remind us (as Michel Serres does in *The Five Senses*) that the Greek words *kosmos* and *kosmeo*, "combine ... order and adornment in the same word, the art of adorning and that of ordering."[34]

In his "improved" *Intentions*, Beerbohm's *cosmesis* occupies nearly every one of its unprinted pages, as well as the title and facing page, the fly title pages, and the page between the first and second parts of "The Critic as Artist." That last page is an illustration that the Clark Library possibly overlooked: it was not protected by tissue paper, leaving its ghostly image on the facing page, the first page of part II. Also, it would count as the eighteenth illustrated page, while the catalogue card lists only seventeen (figure 6.3). I have found no definitive reference to this page by either Beerbohm himself or his critics. To my mind, the two illustrations that face the two half-title pages of the two parts of this critical dialogue are the most exceptional in the book. In addition to being the most elaborate and colourful, they distinguish themselves from the collage-like "illuminations" or fantasias that occupy so many other pages – such as the green-tailed monster at the end of Wilde's "Pen, Pencil, and Poison" – in that they aim at being representational. As I stated earlier, the first of the two "improvements" to "The Critic as Artist" (figure 6.2) depicts

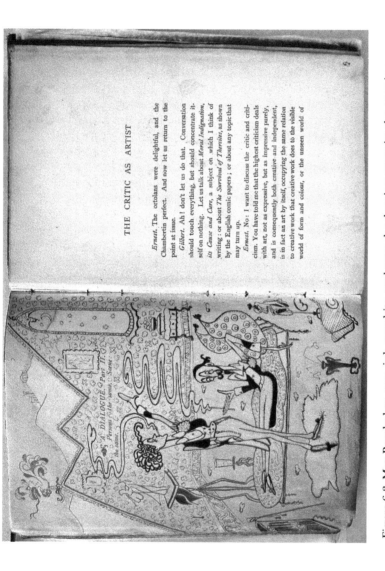

Figure 6.3 Max Beerbohm, pen, ink, graphite, and gouache drawing opposite the opening page of Oscar Wilde, "The Critic as Artist," in Wilde, *Intentions* (London: Osgood, McIlvaine, 1891), William Andrews Clark Memorial Library, University of California, Los Angeles. PR6003.E4Z95wi* (second of two "improved" copies"). (© Estate of Max Beerbohm. Reproduced by kind permission of Berlin Associates.)

the essay's strongest thesis: that the critical faculty is higher and more valuable than the creative. In staking this claim in "The Critic as Artist," the essay's Wildean Gilbert overturns the basis of Matthew Arnold's 1864 essay "The Function of Criticism at the Present Time," in which Arnold posits that the "critical effort [is] to see the object as in itself it really is."[35] Gilbert's earnest interlocutor, Ernest, who at times responds in a scandalized and uncomprehending manner to Gilbert's counter-intuitive assertions about the purpose of criticism, is shocked to learn from his friend that "the primary aim of the critic is to see the object as in itself it really is not."[36] Through this theoretical position, Gilbert affirms that the "critic" has total freedom on this point: "Criticism," Gilbert declares, "is itself an art [and] is really creative in the highest sense of the word. Criticism is, in fact, both creative and independent."[37] Beerbohm's *cosmesis* is "critical" in just this way, since it is literally, as Gilbert says, "a creation within a creation."[38]

In keeping with the brilliant critical/creative dialectic of Wilde's "The Critic as Artist" (in which the one term changes places with the other), it is clear that Beerbohm's art serves as an act of critical reading in its own right: it serves as a running commentary on Wilde's essays themselves, rather than an illustration of them per se. At times, Beerbohm's *cosmesis* appears complementary to Wilde's essays, while at other times it almost seems to compete – spatially and artistically – with the printed text. The drawing on title page, for example, practically obscures the printed word altogether. In several places in *Intentions*, his "improvements" bear no clear relation to the content of Wilde's essays. We see this non-relation in the many cats, dragons, smoking ducks, plumes and stars, and winged imaginary animals that appear, in utopic commingling, throughout the book (figures 6.4–6.7). A remarkable number of Beerbohm's figures have crossed limbs, stand on pedestals, or hold writing implements and books. At the same time, the genial likeness of Wilde pops up everywhere, and these are emphatically *not* the lurid, morbidly corpulent caricatures of Wilde that circulated widely at the time. (Beerbohm himself produced some very unflattering caricatures of this kind.[39]) Instead, the Wilde of Beerbohm's "improved" *Intentions* seems almost as fanciful and fairy-tale-like as the snaky-locked seraphim that populate these pages. His Wilde holds a wand at the end of the essay "The Truth of Masks," has wings, rides in a flying top hat, and floats away in a Hellenic setting at the end, where he resembles the Emperor Hadrian admiring the beautiful youth Antinous (figures 6.8 and 6.9).

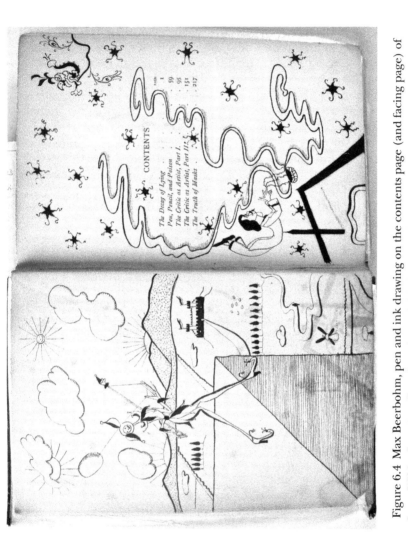

Figure 6.4 Max Beerbohm, pen and ink drawing on the contents page (and facing page) of Oscar Wilde, *Intentions* (London: Osgood, McIlvaine, 1891), William Andrews Clark Memorial Library, University of California, Los Angeles. PR6003.E4Z95wi* (second of two "improved" copies"). (© Estate of Max Beerbohm. Reproduced by kind permission of Berlin Associates.)

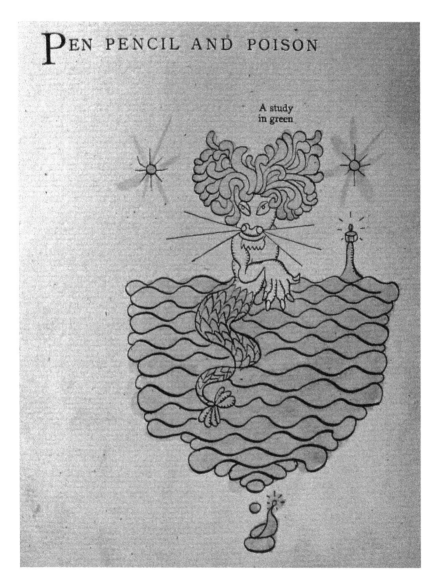

Figure 6.5 Max Beerbohm, pen and gouache drawing on the opening page of Oscar Wilde, "Pen, Pencil, and Poison," in Wilde, *Intentions* (London: Osgood, McIlvaine, 1891), William Andrews Clark Memorial Library, University of California, Los Angeles. PR6003.E4Z95wi* (second of two "improved" copies). (© Estate of Max Beerbohm. Reproduced by kind permission of Berlin Associates.)

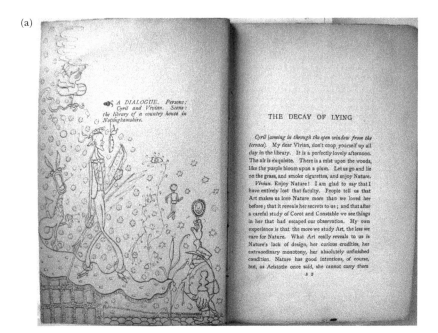

(a)

(b)

Figure 6.6 (a) Max Beerbohm, pen and ink drawing on the opening page and (b) zoomed-in detail of the drawing in Oscar Wilde, *Intentions* (London: Osgood, McIlvaine, 1891), William Andrews Clark Memorial Library, University of California, Los Angeles. PR6003. E4Z95wi* (second of two "improved" copies"). © Estate of Max Beerbohm. Reproduced by kind permission of Berlin Associates.)

Figure 6.7 Max Beerbohm, pen, ink, and gouache drawing in Oscar Wilde, *Intentions* (London: Osgood, McIlvaine, 1891), William Andrews Clark Memorial Library, University of California, Los Angeles. PR6003.E4Z95wi* (second of two "improved" copies"). (© Estate of Max Beerbohm. Reproduced by kind permission of Berlin Associates.)

Everywhere in Beerbohm's "improved" *Intentions*, fantastical creatures align with identifiably Wildean countenances, with fictional characters in dialogue, and with allegorical embodiments of the key concepts of that dialogue. The various figures indicate graphic correspondences from one to another: the undulating tail of the sea serpent repeats the ground upon which the "creator" figure labours, and matches the wavy hair of

Figure 6.8 Max Beerbohm, pen and ink drawing in Oscar Wilde, *Intentions* (London: Osgood, McIlvaine, 1891), William Andrews Clark Memorial Library, University of California, Los Angeles. PR6003.E4Z95wi* (second of two "improved" copies"). (© Estate of Max Beerbohm. Reproduced by kind permission of Berlin Associates.)

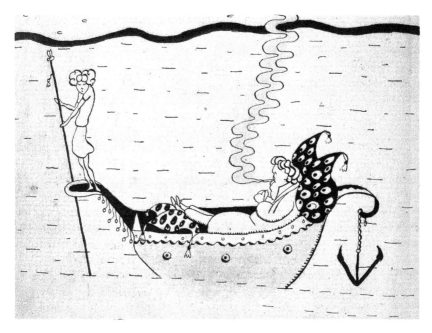

Figure 6.9 Max Beerbohm, pen and ink drawing in Oscar Wilde, *Intentions* (London: Osgood, McIlvaine, 1891), William Andrews Clark Memorial Library, University of California, Los Angeles, PR6003.E4Z95wi* (second of two "improved" copies"), detail from back endpapers. (© Estate of Max Beerbohm. Reproduced by kind permission of Berlin Associates.)

her and her counterpart, the "critic" in repose. Like the seraphim and the dragons, the drawing-room dandies have similar hair, and all of them find echoes in the trails of smoke from Gilbert's cigarette that repeat throughout the volume. Moreover, the plumes of smoke, like the many flying or groundless figures, and John Bull's errant arrow aiming at a high-flying, winged Wilde, emphasize a whimsical imagining of, perhaps, Decadent elevation, as extolled throughout *Intentions*, but also appear as a visual expression of the text's exuberant and relentless irony, and of Wilde's elusive deployment of it. Flying, floating, standing on a sturdy pedestal, peeking out from fences, and, in a final image, floating in full repose in a gondola surrounded by anachronistically classical scenery, the Wilde of Beerbohm's vibrant imagination here surely had not yet met the downfall that brought a hiatus to a very successful literary career.

Given other bits of graphic and bibliographic evidence, it is fair to place their date of composition well before 1895, and likely earlier, and in this sense they serve as material evidence of a deeply absorbed engagement with Wilde's criticism that shed new light on Beerbohm's best-known contributions to the fin de siècle.

Beerbohm's *Cosmesis* and the 1890s

At the Old Bailey on 25 May 1895, Wilde was sentenced to two years in solitary confinement with hard labour for committing acts of gross indecency with other men. In 1905, Beerbohm published a moving tribute to Wilde, sensitive to the dire circumstances in which Wilde met his end. Beerbohm's essay "A Lord of Language" is nominally a review of *De Profundis*, the document in which Wilde reflects on his two-year imprisonment (1895–7), which had been published in a carefully abridged form that year. Beerbohm expresses scepticism towards the widely held view that in *De Profundis* we see "at length … something [Wilde] really and truly felt," stripped of irony, "a heart-cry": an authentic outpouring of sincere and repentant grief that contrasts with the ironic, epigrammatic wit whose apparent superficiality made Wilde such an object of both criticism and acclaim during his heyday.[40] For Beerbohm, there was no way that Wilde, the artist, could have capitulated to vulgar self-abasement even during his cruel incarceration. "Even from the depths," he writes (echoing the Latin title that had been given to Wilde's letter), "Wilde's language soars."[41] It is this vision of Wilde that everywhere populates Beerbohm's "improved" *Intentions*. What Beerbohm's "improvements" inventively, even subversively, demonstrate is his own inventive creativity within the framework of a Decadent aesthetic that he himself was instrumental in promulgating in "The Defence of Cosmetics" and elsewhere. They are specimens of its privileged aesthetic practice, offering profound variations on the central premise of Decadent aesthetics, namely that art has neither secondary status to nor an obligation to represent "reality," "life," or "Nature." Beerbohm's paratextual additions offer vital examples of the Decadent aesthetic with which he most publicly associated himself; these "improvements" are the very living, enduring practice of a Decadent *cosmesis*.

In "A Peep Into the Past" (composed 1893), Beerbohm imagines a fictional (and much older) Oscar Wilde tucked away in "a life of quiet retirement in his little house … solacing himself with many a reminiscence of the friends of his youth," his modest fame a thing of the past,

eclipsed by his "better known brother," William.[42] For neither the first nor the only time, we can see how much more appropriately Beerbohm's words describe their author than their subject. The 1893 essay, written when Beerbohm was still an Oxford undergraduate and Wilde was at the height of his fame as a dramatist, would remain unpublished until 1923, and, even then, in an unauthorized edition. It opens up a critical question that Beerbohm's "improved" *Intentions* may help answer, namely, what was the nature of Beerbohm's understanding or admiration of Wilde, beyond what we can glean from what the relatively few published caricatures depict? Aubrey Beardsley's notorious illustrations of Wilde's *Salome* (1894) have such expressive, subversive power that they not only suggest a relation of that text to those images that critics ponder to this day, but also have acquired a life of their own, one that exists well past either Beardsley's or Wilde's own. In many ways, Beardsley's contributions to the English edition of Wilde's one-act biblical drama have to come to iconize the lurid vision of an entire brilliant but doomed aestheticism that met its fate in Beardsley's early death from tuberculosis in 1898 and Wilde's premature demise, from meningoencephalitis, in 1900. The unpleasantness of several of Beardsley's drawings, in which he depicts Wilde's rather flabby countenance in the figure of Herod, in the moon that presides over the stage, and in an American Indian cap, says much about the ill feeling that Beardsley cultivated towards Wilde. As Beardsley's much less famous "brother" of sorts, Beerbohm's artistic reputation (as far as most modern critics are concerned) similarly pales by comparison, eclipsed as the imaginary Oscar is by the imaginary William of "A Peep into the Past." Yet it is profitable to consider Beerbohm's "improved" *Intentions* as a comparison or counterpoint to Beardsley's *Salome*. Beerbohm's *cosmesis*, I maintain, is much more than a venture into "mock-Beardsley" illustration.

Holbrook Jackson's *The Eighteen Nineties: A Review of Art and Ideas at the Close of the Nineteenth Century* (1913) offers a good foundation for such speculation. Jackson looks back across the seemingly great divide of the twentieth century and the age of modernism to demand a re-evaluation of a Decadent aesthetic that exceeded its decade and lives on to this day. It "began with a dash for life," he asserts, "and ended in retreat – not defeat."[43] Decadent art and criticism, writes Jackson, "fought from a great variety of positions," of which Beerbohm, in writing or drawing, published or unpublished, was also a defining part. In Jackson's *All Manner of Folk* (1912), which contains "interpretations and studies" of mostly nineteenth-century writers and artists, Beerbohm stands as one among

many in as eclectic a group as the title suggests.[44] A year later, however, in *The Eighteen Nineties*, Jackson devotes a central chapter to Beerbohm, and he begins the book by quoting him. Jackson's book is dedicated to Beerbohm as well. In the 1922 and subsequent editions, this dedication noticeably displaces a portrait of Beardsley that originally faced the title page in the first edition.[45] These developments reveal that for Jackson it was Beerbohm, not Beardsley, who eventually best represented a decade whose legacy remained palpable through the 1920s.

Jackson draws attention to Beerbohm's lifelong pose as a has-been, a hanger-on, a quiet and minor voice among literary giants, and a trifling sketch-artist in an age of iconic art. As Jackson says, "Max Beerbohm gives the impression of having been born grown-up – that is to say, more or less ripe when others would be more or less raw and green."[46] "The ripeness of maturity having established itself so early," Jackson continues, "it is not surprising to find Max Beerbohm announcing his intention of settling down to cosy dotage at the great age of twenty-five."[47] Here Jackson has in mind Beerbohm's "Diminuendo" (1895),[48] the final essay in the ironically titled *The Works of Max Beerbohm* (1896), a collection of seven essays that John Lane published when Beerbohm was twenty-three. [49] "Once, under the delusion that Art, loving the recluse, would make his life happy," writes the young Beerbohm tongue in cheek, "I wrote for a yellow quarterly and had that *succès de fiasco* which is always given to a young writer of talent. But the stress of creation overwhelmed me. [I] shall write no more, I shall write no more. Already I feel myself to be a trifle outmoded. I belong to the Beardsley period."[50] Set in 1890, "Diminuendo" recounts a deflating, latter-day sighting of the aesthete Walter Pater on the streets of Oxford. (Pater, who died in 1894, was among the earliest English writers to advocate art for art's sake, and his writings – especially *The Renaissance* – left a deep impression on the aesthetes of Wilde's generation.) From the vantage point of 1895, Beerbohm looks back – almost as if a half century had passed – on "those more decadent days" when he was an Oxford undergraduate, suffused with the regret of someone who has arrived too late for everything, for life itself.[51] For Jackson in 1913, it was not "how whimsically and how ironically" Beerbohm cast his lot with Pater or Beardsley that mattered.[52] The resonance of Beerbohm's "Diminuendo" lies in the unintended dramatic irony of his statements. Beerbohm had the rest of a productive decade for his joke to reach its punch line, and several decades more to refine his witty self-presentation as relic of a bygone age. Precociously "outmoded" and at a distance from the era to which he belonged and to which he constantly referred

in his art and writings, Beerbohm claimed an aesthetic immunity from the fin de siècle that he would call upon repeatedly throughout a long career, one in which he outlived virtually all of his contemporaries, many of whom died before the Great War. Events conspired to bring Beardsley's contributions to *The Yellow Book* (including the first five of its iconic covers) to an abrupt end in 1895 – Wilde was reported to have left court with a copy of *The Yellow Book* under his arm; moreover, Beardsley's subsequent work, Jackson argues, was in twilight along with his health. Beardsley was twenty-five years old when he died. He was born, as Jackson observes, in the same week as Beerbohm in 1872; Beerbohm outlived Beardsley by sixty-two years. "Aubrey Beardsley," Jackson remarks, "actually abandoned his period in the evening of its brief day, and when he died, in 1898, the Beardsley period had almost become a memory."[53]

One might detect a tinge of cruelty in Jackson's idea that, by dying prematurely, Beardsley failed to live out "the Beardsley period" to which Beerbohm consigned himself two years prior to Beardsley's own death. Yet Jackson's critical re-evaluation is remarkably free of polemic. If anything, privileging Beerbohm at Beardsley's expense serves as Jackson's plea for critical pluralism, a counterpoint to the dominant, lurid, Beardsley-as-Decadent vision of the 1890s that characterizes other studies of the period. Beardsley, Jackson argues, was "but an incident of the Eighteen Nineties, and only a relatively significant one. He was but one expression of *fin de siècle* daring [among] the most vital movements of a decade which was singularly rich in ideas, personal genius and social will."[54] In 1913, with Decadence seemingly in full retreat, Beerbohm stood out because of the literal novelty that he was (unlike Beardsley, Wilde, and several other 1890s writers) still alive. Jackson's sly encomium in *All Manner of Folk* conjures the familiar tropes of "the Beardsley period," though with a difference:

> [Beerbohm] himself would not deny the charge of *poseur*, but his pose is as natural as anything really civilized can be natural. Civilization is the art of the human race: Max Beerbohm is a detail of that art, just as the column is the detail of architecture, or rhyme of lyric verse. He is the finishing touch, the ornament, one of the points at which Nature becomes self-conscious, contemplative, artistic ... He is, in short, a dandy.[55]

Jackson uses familiar Decadent tropes to revalue Beerbohm, whose "pose" is "as natural" as any "human" art, and a vague genitive ("his talk is the talk of the cultured") suspends any question of Beerbohm's verbal

authenticity with the assurance that his essays are "finely" made, his illustrations drafted "with a smile."[56] He asserts, too, that even if Beerbohm might appear to be a "*poseur*," the dandyism is neither "theatrical" nor involved in "personal display" but remains an "expression" of "urbane and civilised genius" – "a dandyism of the mind."[57] Yet what is notable about his descriptions of Beerbohm within the Decadent vocabulary of artifice is Jackson's canny variation upon that theme. Here, importantly, Beerbohm does not make secondary art – verbal parodies of the most audacious Decadent prose and visual caricatures of its most familiar practitioners – nor is he, by extension, a secondary or "minor" figure within Decadence. Beerbohm is *himself* ornamental in, or to, the golden age of ornament, its "finishing touch … one of the points at which Nature becomes self-conscious, contemplative, artistic." He is neither an accessory nor a relic of Decadence, but an exemplar of it. Jackson is rare among critics for writing about Beerbohm by writing *like* Beerbohm in a way that is genuinely "critical" in Wilde's strong sense of that term, and for maintaining a sustained interest in Beerbohm's work without the seemingly compulsory job of deciding how to take the joke, without stating for the critical record where he stood on the question of whether (and if so, where and when) Beerbohm "meant" what he wrote, or whether he had some other aim.

Beerbohm, *Cosmesis*, and Ironic Unseriousness

Beerbohm's repeated gesture of fashioning himself as a "voice from the past," as he did in his BBC broadcasts of the 1930s and 1940s (collected in *Mainly on the Air* [1946]), has intriguing things in common with the writings of Oxford speech-act philosopher J.L. Austin, who spent most of the early 1950s developing groundbreaking work on the power of the "performative utterance," most famously in his book *How to Do Things with Words* (1955).[58] Like Beerbohm, Austin was disarming and witty and chauvinistic, and, also like Beerbohm, he understood that words have force beyond their declarative or referential meaning: an observation that Austin made against the trend of his fellow philosophers, whose faith in the stability of linguistic meaning mirrored much the same faith in "ordinary language" as Beerbohm's critics have in the representational status of his work. For Austin, "I'm kidding" means far more than "please don't take seriously what I just wrote." It *does* more, it makes something happen; Austin knew that insincerity was not the mere opposite of "sincerity," no matter how much his fellow Oxford language philosophers

wished otherwise. Austin's book demonstrates those slippery rhetorical realities on every page, and Beerbohm's work does the same.

Beerbohm's "improved" *Intentions* serves as an especially rich artefact for highlighting the uncommon oddness of his selective resistance to being taken seriously. If the logic of this defence is that "serious" criticism or new-fangled theory ruins the fun, misses the joke, or forestalls Beerbohm's ironic unseriousness, why would critics of Oscar Wilde – an ironist of Olympian proportions – feel no similar compulsion whatsoever? Why such protective vehemence, such (anti-)critical devotion to the man whom Jackson (after Shaw) called "the incomparable Max," who lived in material comfort and high regard, affably and productively, his whole long life?[59] Wilde's was a life cut brutally short by prosecutors willing to reduce the artist's brilliant irony to an object of blunt force, literally to use his own words against him by conflating "the man" with his art, dismantling the literary apparatus that generates irony as such by treating the speech of his characters as nothing but veiled autobiography. What was it about Beerbohm that distinguished his dandyish humour from Wilde's?

A clue to Beerbohm's ironic unseriousness appears in his ostensibly baffled response to Henri Bergson's influential essay *Le Rire: essay sur la signification du comique* (1900), which was translated into English eleven years later as *Laughter: An Essay on the Meaning of the Comic.* Contrary to what critics have said, Beerbohm understands Bergson's *Laughter* perfectly well. Bergson's principled privileging of phenomenological (that is, actual) experience over philosophical generalizations about experience becomes, in Beerbohm's rendering, a distinctly Paterian objection to "weaving theories as to the ways of things in general."[60] As Pater says of "beauty" in his "Preface" to *The Renaissance*, Beerbohm uses the occasion of Bergson's "Laughter" to express what it (the essay and the concept) is *to him*.[61] It was for the sake of simple thinkers "as myself … that M. Bergson sat down and wrote about – Laughter."[62] He attests that he has "profited by [Bergson's] kindness no more than if he had been treating of the Cosmos," and what it elicits from him is "a coarse peal of – Laughter."[63] For Beerbohm, the "laughter that goes so far as to lose all touch with its motive, and to exist only … in itself. This is laughter at its best."[64] For its own sake and for what it is "to me," laughter is one of many modes of aesthetic experience, measured only "according to its intensity."[65] For all that, though, in its most meaningful intensity, laughter is more than the sensory manifestation of jollity or amusement. "I will wager that nine tenths of the world's best laughter is laughter *at*, not *with*," writes the

comedian, who "prefer[s] that laughter takes [him] unawares" (132, 131). As Bergson's essay stresses, laughter is a *social* activity, but that is not to say – as Beerbohm stresses – it is necessarily a *public* one. Beerbohm's "improvement" project draws this distinction into sharp focus. Go to "music halls and such places, [and] you may hear loud laughter," but laughter "at its greatest and best is not there" (131). As this wealth of material evidence suggests, it was "there" in these books, at Rapallo. Where Cecil sees an eternal child engaged in facile play, and Hall a clever man who chuckles to himself while doodling in the margins of his books, there is also room for another, more suggestive reading of this laughter with which Beerbohm's critics have not always come to terms.

Here Foucault's insights assist us in comprehending the critical edge to the laughter that results from Beerbohm's *cosmesis.* In his "Preface" to *The Order of Things* (1966), Michel Foucault says his book arose from an encounter with Jorge Luis Borges's whimsical, probably apocryphal "Chinese encyclopedia," which, with its fantastical classification of animals ("(a) belonging to the Emperor, (b) embalmed, (c) tame, (d) suckling pigs, (e) sirens, (f) fabulous, (g) stray dogs," etc.), reveals "another system of thought" that shows "the limitation of our own."[66] *The Order of Things* was forged, in other words, "out of the laughter that shattered, as I read the passage, all the familiar landmarks of my thought – *our* thought – breaking up all the ordered surfaces ... with which we are accustomed to tame the wild profusion of existing things, [which] disturb and threaten with collapse our age-old distinction between the Same and the Other."[67] Beerbohm's "improved" books similarly throw into question the tendentiously unserious posturing of Beerbohm's critics.

In the private pages of Beerbohm's strange and wonderful illuminated books, we can begin to read the images not as mere depictions of the text or, more important, of its author, but as a vital dialectic between these media, and aim to understand not just what, together, they might *mean,* but what they *do.* Beerbohm's published essays, stories, and novel are a record of what he *did* with words, his drawings what he *did* with images. His voluminous production of extra-illustration, however, offers a chance to see what he did with books. It is time we took a closer look at what he was doing all that time in his library in Rapallo, not just what he was publishing or supplying to biographers. From the perspective of his "improved" *Intentions,* the horizon of this critical work is extraordinary.

When Beerbohm died in 1956, he was far closer to the cut-out animation of Terry Gilliam's iconic *Monty Python's Flying Circus* (1969–74),

to the Blue Meanies of The Beatles' album *Yellow Submarine* (1968), or to the sixteen-track overdubbing of *Sgt. Pepper's Lonely Hearts Club Band* (1968) than he was to Wilde and Beardsley. Beerbohm's most successful legerdemain has been not just to create an enormous body of work, more than half a century's worth, that many are content to consider critic-proof even to this day. It is to have so successfully yoked himself to the past, as he does with tremendous aplomb, assisted by John Lane in both *The Yellow Book* and *The Works of Max Beerbohm*,[68] that no one dares associate him with a future that has given us the graphic novel and artists like Banksy. More consequentially, Beerbohm seems so much a creature of the Decadent 1890s that one tends to forget that he wrote for himself, in *The Works of Max Beerbohm*, a posthumous existence that in fact would endure for half a century of productive life. My hope is that the uncomfortable laughter elicited by Beerbohm's improved books encourages a newly generative, critical afterlife that has only just begun.

NOTES

1 Max Beerbohm, pencilled notes and amendations, pen and gouache drawings, dated, "in Max Beerbohm, *The Works of Max Beerbohm* (1896), William Andrews Clark Memorial Library, University of California, Los Angeles, PR 6003 E4A1, copy 2. Enclosed is a typescript ["Typescript of original ALS now in the manuscript files"], which reads as follows: "VILLINO CHIARO, RAPALLO, ITALY, August 1931. Dear Mr. Hastings – I send to you in a registered package that copy of my 'Works'. I had put a note on the fly-leaf of it, and a sketch on the first 'turn-over' page of it, and written something on the inside of the back-cover of it. And I have now completed a poem on the title-page – and also made a sketch on the turn-over pages of the essay entitled '1880'. And I hope these absurd little addenda may make the booklet more lucrative than it otherwise would be for your beneficent purpose. And I am very sincerely yours Max Beerbohm[.] PS. You might send me a postcard to say that the parcel has safely reached you."

2 Gérard Genette, *Palimpsestes : La Littérature au second degré* (1982, 1987), actually includes a brief discussion of Beerbohm's authorial strategies in his book *A Christmas Garland* (1912). *Paratexts: Thresholds of Interpretation*, trans. Jane E. Lewin (New York: Cambridge University Press, 1997), was published in French under the title *Seuils* (Paris: Editions du Seuil, 1987).

3 N. John Hall, "A Genre of His Own: Max Beerbohm's Title-Page Caricatures," in *English Literature in Transition 1880–1920* 27, no. 4 (1984): 270–88. While there is critical consensus that Beerbohm called these his "improved" books, I cannot find the source or genesis of the term in Beerbohm's own words. The Sotheby's auction catalogue calls them "improved," as do biographers such as David Cecil and J.G. Riewald, who report seeing some of this work first-hand, in Beerbohm's library in Rapallo. See *Catalogue of the Library and Literary Manuscripts of the Late Sir Max Beerbohm, Removed from Rapallo* (London: Sotheby's, 1960), 67–9; J.G. Riewald, *Max Beerbohm's Mischievous Wit: A Literary Entertainment* (Assen: Van Gorcum, 2000), 113; and David Cecil, *Max: A Biography* (London: Constable, 1964), 373.

4 Wilde, "The Critic as Artist: With Some Remarks upon the Importance of Doing Nothing – Part I," in *Intentions* (London: Osgood, McIlvaine, 1891), 143. Wilde published a slightly revised edition of *Intentions* in 1894.

5 Wilde, "The Critic as Artist," 142.

6 Wilde, 142.

7 Kristin Mahoney, *Literature and Politics of the Post-Victorian Decadence* (New York: Cambridge University Press, 2015), 39. Mahoney's reading, which also considers Beerbohm's complex relationship to Wilde's work, resonates with Wilde's celebration, in "The Critic as Artist, Part I," of the truly creative critic who perpetually "[shows] us the work of art in some new relation to our age" (127).

8 Sarah Davison, "Max Beerbohm's Altered Books," *Textual Culture* 6, no. 1 (2011): 48–75.

9 See Hall, "A Genre of His Own."

10 Sotheby and Company, *Catalogue of the Library and Literary Manuscripts of the Late Sir Max Beerbohm: Removed from Rapallo (Sold by the Order of the Administratix of the Estate of the Late Sir Max and Lady Beerbohm) 12–13 December 1960* (London: Sotheby's, 1960), 3.

11 Sotheby and Company, *Catalogue*, 67.

12 Hall, "A Genre of His Own," between 280 and 281.

13 See S.N. Behrman, "Conversation with Max, I – Compare Me," *The New Yorker*, 6 February 1960, 80–1, reprinted in Behrman, *Conversation with Max* (London: Hamish Hamilton, 1960), 22–6.

14 Lawrence Danson, *Max Beerbohm and the Scene of Writing* (Oxford: Oxford University Press, 1989), 43.

15 Danson, *Max Beerbohm and the Scene of Writing*, 63–4. That Danson's next monograph would be devoted entirely to Wilde's *Intentions* and other critical works makes this dismissal stranger still, for the latter book makes

scant reference to Beerbohm, despite using one of his "improvements" to *The Happy Prince* for his cover art. See Danson, *Wilde's Intentions: The Artist and His Criticism* (Oxford: Oxford University Press, 1997).

16 David Cecil, *Max: A Biography* (London: Constable, 1964), 372.

17 Cecil, *Max: A Biography* [1964 ed.], 375.

18 Cecil, 373.

19 Short-sheeting, that is.

20 Cecil, *Max: A Biography* [1964 ed.], 371.

21 Cecil, 373–6.

22 Lucy Peltz, "Facing the Text: The Amateur and Commercial Histories of Extra-Illustration, c. 1770–1840," in *Owners, Annotators, and the Signs of Reading*, ed. Robin Myers, Michael Harris, and Giles Mandelbrote (New Castle: Oak Knoll Press; London: British Library, 2005): 91–136. See also Jeffrey Todd Knight, "Furnished for Action: Renaissance Books as Furniture," *Book History* 12 (2009): 37–73; and see especially Peltz's account of Frederick Strong's ill-fated effort, in 1847, to capitalize on the public's waning interest in this specific kind of extra-illustration, whose selling point was "book-breaking" (91). She reproduces Strong's advertisement for a place he called "The Destruction Room," which promised to be "full of interesting Books, or at least when cut up will be so" (92–3).

23 Oscar Wilde, "The Decay of Lying," in *Intentions*, 1–2.

24 "Tout ce qui est beau et noble est le résultat de la raison et du calcul"; "du besoin de surpasser la nature." Charles Baudelaire, "XI : Éloge du maquillage" ("In Praise of Cosmetics") [1863], in *Le Peintre de la vie moderne* (Paris: Mille et une nuits, 2010), 62, 65.

25 Joris-Karl Huysmans, *Against Nature*, trans. Robert Baldick (New York: Penguin, 2003), 22–3.

26 Max Beerbohm, "A Defence of Cosmetics," *The Yellow Book* 1 (1894), 68.

27 Beerbohm, "A Defence of Cosmetics," 68.

28 Beerbohm, 68–9.

29 Wilde, "The Decay of Lying," 46.

30 Wilde, 40.

31 Grammatically, κόσμησις (*cosmēsis*) is the verbal noun for both "arranging" and "adorning." I borrow the theoretical sense of the term from critic Barbara Spackman, who coins it to describe the confounding referential logic at work in Des Esseintes's bizarre synesthetic adventures in home decorating in the aforementioned *Against Nature*. *Cosmesis* denotes for Spackman Des Esseintes's self-enclosed systems of correspondences – such as the "mouth organ" that produces a "symphony" by matching up the taste of certain liqueurs with the sounds of specific musical instruments.

Taste corresponds to sound because he decides it does, with no reference to any verifiable, conventional reality whatsoever. The real drops out of the referential system altogether. Des Esseintes does not merely reject some universal "standard of taste" (to use David Hume's phrase); it circumvents it altogether. See David Hume, "Of the Standard of Taste," in *The Philosophical Works of David Hume*, ed. T.H. Green and T.H. Grose, 4 vols. (London: Longman, Green, 1874–5), 3:266–84. It substitutes real experience not with an artificial one, but with substitution itself, with a world of sensations that is entirely self-made, where one sense refers to another sense, because Des Esseintes says it does. See Spackman, *Decadent Genealogies: The Rhetoric of Sickness from Baudelaire to D'Annunzio* (Ithaca: Cornell University Press, 1989), 33–104.

32 In his magisterial study of allegory, Angus Fletcher cites Plutarch (in his *Moralia*, bk. 2, ch. 1, "Of the World"), who says Pythagoras "was the first philosopher that gave the name of *kosmos* to the world, from the order and beauty of it; for so that word signifies." Fletcher, *Allegory: The Theory of a Symbolic Mode* (Ithaca: Cornell University Press, 1964), 110n.

33 See, for example, M.H. Abrams, "Imitation and the Mirror," in *The Mirror and the Lamp: Romantic Theory and the Critical Tradition* (Oxford: Oxford University Press, 1953), 30–46. I give a more thorough account of Oscar Wilde's place within the long-standing philosophical conception of art's *mimetic* function in "Oscar Wilde (1854–1900): Aesthetics and Criticism," in Julian Wolfreys, ed., *The Continuum Encyclopedia of Modern Theory and Criticism* (New York: Continuum, 2010), 658–65.

34 Michel Serres, *The Five Senses: A Philosophy of Mingled Bodies*, trans. Margaret Sankey and Peter Cowley (New York: Continuum, 2009), 32. Angus Fletcher identifies *kosmos* as the animating feature of "allegory" writ large, an originary *allos* (other) that "subvert[s] language itself," and produces the "peculiar doubleness of intention" of allegorical meaning, namely the "literal level that makes good enough sense all by itself" and the figurative/interpretive level by which the literal "becomes much richer and more interesting if given interpretation" (2, 7). He also stresses that "the etymological connections of *decorum* and *decoration*, *polite, police* ... *cosmic* and *cosmetic, costume* and *custom*, with all their minor variants ... all demonstrate the same fundamental duality" (109). It should be noted that Robert Viscusi's *Max Beerbohm, or, the Dandy Dante: Rereading with Mirrors* (Baltimore: Johns Hopkins University Press, 1986) not only makes this explicit connection between cosmos and cosmetic in relation to Beerbohm's work, but also cites Fletcher's same discussion in doing so.

35 In "The Function of Criticism at the Present Time" (1864), Matthew Arnold posits that the "critical effort [is] to see the object as in itself it really is." He also, though more equivocally than Wilde credits, affirms that "the critical power is of lower rank than the creative." Arnold, *Lectures and Essays in Criticism*, ed. R.H. Super, in *The Complete Prose Works*, 11 vols. (Ann Arbor: University of Michigan Press, 1960–77), 3:258–85.

36 Wilde, "The Critic as Artist," 139.

37 Wilde, 135–6.

38 Wilde, 137.

39 To cite just one paradigmatic example, N. John Hall, Lawrence Danson, and J. G. Riewald all note the remorse Beerbohm ultimately expressed over the poor timing of a lurid caricature of Wilde he published in September 1894 (in *Pick-Me-Up*, 22 September 1894 [no. 1779]). As Riewald explains, a year later, the caricature was "taken to the police station as evidence against him, after he had been arrested." Riewald, *Max Beerbohm's Mischievous Wit*, 110. In 1911, Beerbohm reflected: "When I did that [caricature], and even when it was first published, I hardly realized what a cruel thing it was: I only realized that after Oscar's tragedy and downfall" (quoted in Rupert Hart-Davis, *A Catalogue of the Caricatures of Max Beerbohm* [Cambridge, MA: Harvard University Press, 1972], 10). For Lawrence Danson, in *Max Beerbohm and the Scene of Writing*, Beerbohm's Wildean grotesques stand apart in their excess, even by the standards of caricature, and warrant close reading (73–6). Danson finds complex, meaningful distinctions between Beerbohm's whimsical, winged extra-illustrations of Wilde (for example, those in his copy of *The Happy Prince*, which closely mimic the winged Wilde of *Intentions*) and "the damning visual satire of the drawing in *Lady Windemere's Fan*," its front and back cover caricatures in "pinky-flesh tones and fleshy folds [and] grotesquely doubled chin" (73, 73–6).

40 Max Beerbohm, "A Lord of Language," *Vanity Fair*, 2 March 1905, 309, reprinted in Beerbohm, *A Peep into the Past and Other Prose Pieces*, ed. Rupert Hart-Davis (London: Heinemann, 1972), 38.

41 Beerbohm, "A Lord of Language," in *A Peep into the Past*, 37–8.

42 Beerbohm, "A Peep into the Past," in *A Peep into the Past*, 3.

43 Holbrook Jackson, *The Eighteen Nineties: A Review of Art and Ideas at the Close of the Nineteenth Century* (London: Grant Richards, 1913), 12.

44 See Holbrook Jackson, "Max Beerbohm," in *All Manner of Folk: Interpretations and Studies* (London: Grant Richards, 1912), 78–83. Jackson's other chapters focus on such figures as Edward Carpenter, William Morris, John Millington Synge, and Walt Whitman.

45 The textual history of this dedication itself participates in Beerbohm's inventive blurring of the line between real and imaginary, criticism and fiction. A curious intertextuality with Jackson's emerges with Beerbohm's own invocation of Jackson's *Eighteen Nineties* in the first paragraph of "Enoch Soames" (1919), in which the fictional writer goes looking for his name in the index of Jackson's book: "He was not there. But everybody else was. Many writers whom I had quite forgotten, or remembered but faintly lived again for me ... in Mr. Holbrook Jackson's pages. The book was as thorough as it was brilliantly written. And thus the omission found by me was an all the deadlier record of poor Soames's failure to impress himself on his decade." Max Beerbohm, "Enoch Soames," in *Seven Men* (London: Heinemann, 1922), 3.

46 Jackson, *The Eighteen Nineties*, 143.

47 Jackson, 143.

48 Beerbohm's "Diminuendo" first appeared as "Be It Cosiness," *Pageant*, Christmas 1895, 330–55. "Diminuendo" is set in 1890 and centres around an undergraduate Beerbohm's deflating experience of seeing the famous Walter Pater on the streets of Oxford. Despite eagerly telling his tutor that he hopes to study with Pater, the encounter makes clear he has arrived too late, an insight that becomes the occasion for grander musings, largely in the key of Pater, on belatedness as such, one of Pater's own great themes.

49 Publisher John Lane was happy to conspire with Beerbohm on the ridiculous conceit of publishing *The Works of Max Beerbohm* in the first place, and assuming authorship of its bibliography. Lane's first entry reads: "A Letter to the Editor. *The Carthusian*, Dec. 1886, signed Diogenes. A bitter cry of complaint against the dulness [*sic*] of the school paper. Not reprinted."

50 Beerbohm, "Diminuendo," in *The Works of Max Beerbohm* (London: John Lane, 1896), 159.

51 Beerbohm, "Diminuendo," 149.

52 Jackson, *The Eighteen Nineties*, 17.

53 Jackson, 17.

54 Jackson, 17.

55 Jackson, *All Manner of Folk*, 81.

56 Jackson, 81.

57 Jackson, 83, 82.

58 See a 1947 Heinemann publication, *Mainly on the Air*, a collection of the six Beerbohm broadcasts on the BBC from 1935 to 1945. In 1955, J.L. Austin's book was published posthumously, and collated by his students from the

series of lectures, of the same title (*How to Do Things with Words*), that he gave at Harvard University from 1952 to 1954.

59 In *The Eighteen Nineties*, Jackson titles his chapter on Beerbohm "The Incomparable Max" (141–51). The phrase, as Jackson acknowledges, comes from George Bernard Shaw, "Valedictory," *Saturday Review* 85 (1898): 683.

60 Max Beerbohm, "Laughter," *North American Review* 214 (1921): 39.

61 Pater writes in the "Preface": "Many attempts have been made by writers on art and poetry to define beauty in the abstract, to express it in the most general terms ... To define beauty, not in the most abstract, but in the most concrete terms possible, to find, not its universal formula, but the formula which expresses this or that special manifestation of it, is the true aim of aesthetics ... What is this song or picture, this engaging personality presented in life or in a book, to *me*? What effect does it really produce on me?" Pater, *The Renaissance: Studies in Art and Poetry – The 1893 Text*, ed. Donald L. Hill (Berkeley: University of California Press, 1980), xix–xx.

62 Beerbohm, "Laughter," 40.

63 Beerbohm, 40.

64 Beerbohm, 41.

65 Beerbohm, 42. Here, Beerbohm's appeal to "intensity" obviously invokes the critical spirit of Pater's *The Renaissance*, which first appeared in 1873, but also Henri Bergson's own fin-de-siècle masterpieces, *Essai sur les données de la conscience* (1889) and *Matière et mémoire* (1896).

66 Michel Foucault, *The Order of Things*, trans. Anon. (New York: Vintage Books, 1973), xv. Foucault's study was originally published in French as *Les mots et les choses : une archéologie des sciences humaines* (1966).

67 Foucault, *The Order of Things*, xv.

68 John Lane, after all, published not just the infamous *The Yellow Book* but also the even more infamous *Blast I* (1914) and *Blast II* (1915).

PART III

WOMEN, BABIES, MOONS – 1890S POETICS

Dollie Radford and the Case of the Disappearing Babies

JULIE WISE

When the greeting-card company Marcus Ward published a calendar in 1897 featuring images of twelve modern poets, Dollie Radford appeared among its pantheon. Here, she joins the company of other widely read poets from the 1890s, including Algernon Charles Swinburne, Alice Meynell, and William Morris.[1] Writing about this "Modern Poets" calendar, Linda Peterson observes that this ephemeral object in fact "testif[ies]" to the status achieved by the poets it includes.[2] In her calendar photograph, Radford looks every bit the poet, as she gazes with thoughtful intensity at the camera, leaning forward in her seat as though glancing up from her work (figure 7.1). Its edges blurred, the portrait conveys an otherworldly effect, as though finding the poet emerging from the mists of her imagination.

The original version of this photograph, however, tells a very different story. In the original – a small photograph tucked away in the Radford archive at the William Andrews Clark Library alongside a copy of the "Modern Poets" calendar – Radford bends not over any verse but now clearly over an infant, nestled in draping blankets (figure 7.2). She looks towards the viewer as though presenting her baby. This photograph's crisp, clear edges reveal the mother's arms carefully cradling her child.

This curious instance of photo-manipulation invites exploration, not only because it conveys an important image of Radford as a poet but also because it renders the baby's absence significant to this image. It may be impossible to pin down the reasons why this image appeared in this way; after all, in the absence of archival documentation, these reasons may inevitably remain elusive. Yet these paired images serve as a metonym for a distinct phenomenon in Radford's poetry from the period. In her lyrics

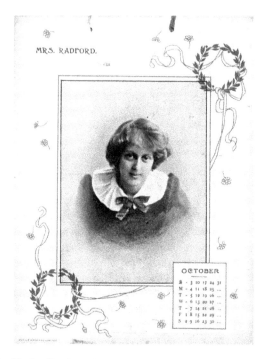

Figure 7.1 Dollie Radford, in *Modern Poets: Calendar for 1897* (Belfast: Marcus
Ward, 1897). (Dollie Radford Papers, 1880–1920, box 3. William Andrews
Clark Memorial Library, University of California, Los Angeles.)

from *A Light Load* (1891, reissued in 1897), children tend to become
apparent as much for their absence as for their presence. The curious
presence of absent children in Radford's work enables her to define and
delimit the authority of her lyric voice.

A close look at these two images of Radford, as they appeared in the
Marcus Ward calendar and in her family photograph, can provide insight
into the ways Radford defined her lyric authority. Together with the
poems from *A Light Load*, in fact, they suggest that Radford uses the fig-
ure of the absent child to establish the scope of her work as a poet, a spe-
cifically minor poet engaging with a nineteenth-century lyric tradition.
By looking at these texts, and the curious presence of absent children in
Radford's work, I hope to illuminate some of the complexity of her work
as a poet who to this day has received little critical attention. I also hope

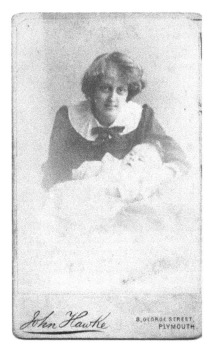

Figure 7.2 John Hawke, photograph of Dollie Radford and infant (n.d.).
(Dollie Radford Papers, 1880–1920, box 3. William Andrews Clark Memorial
Library, University of California, Los Angeles.)

to call attention to the complex ways in which writers consciously framed
the significance of their own work during the fin de siècle.

An Image of a Minor Poet: Radford in
the Modern Poets Calendar

Although Radford's name may remain "all but absent from contempo-
rary literary history," as LeeAnne Richardson observes, "from 1891 to
1912, her poems appeared in such magazines as *The Athenæum, The
Nation, McClure's Magazine,* and *The Yellow Book*"; in addition, "she wrote
well-reviewed books of poetry for both adults and children."[3] Radford's
very appearance in the "Modern Poets" calendar points to her promi-
nence as a poet in 1897, six short years after her publication of *A Light
Load* and two years after *Songs and Other Verses* appeared. In this calendar,

she joins the recently appointed poet laureate, Alfred Austin, along with the handful of other poets who had received consideration for the position.[4] Writing about the appearance here of Alice Meynell (one such potential laureate), Peterson argues that the calendar served a specific purpose for that poet: "to garner prestige, bid for permanence, and establish its author as part of a 'high' culture and the literary canon."[5] Radford, to be sure, occupied a slightly different position than Meynell, one without the same degree of prestige as her fellow poet.[6] Yet Radford's appearance in this calendar likewise makes visible the reputation she had already earned as a poet while also revealing the distinctive ways in which she, too, continued to bid for permanence. Namely, I suggest, the image reveals Radford's critical awareness of the role of the minor poet and her effort to modify that role for her circumstances as a woman poet.

On its cover, the calendar describes itself simply as "Modern Poets Calendar for 1897," offering then a series of twelve portraits, each framed by aesthetic flourishes, including drawings of laurel wreaths and ribbons that loop among delicate flowers.[7] Several of the portraits likewise feature aesthetic embellishments, but notably only in the six photographs of women poets. The men who appear in the calendar dress in unassuming suits and sit in standard, head-and-shoulders poses. By contrast, the women poets represent a variety of aesthetic costumes, props, and postures. Meynell appears elaborately dressed in pearls, ribbons, and silk, gazing downward at her stylish fan. Margaret Woods, in mutton-leg sleeves, appears busy arranging flowers, while Katharine Tynan, her hair cropped close in modern, New Woman style, looks engaged in active philosophical debate. Edith Nesbit glances coyly over the shoulder of her stylishly ruffled dress, while Jean Ingelow, in an old-fashioned Victorian gown with a cameo at her neck, peers through her glasses at the book she holds on her lap. This notable difference in presentation here makes clear the extent to which the female poets stand out as marked by comparison to their male counterparts. Talia Schaffer observes that "female aesthetes were constantly trying to reconcile competing notions of identity," including the challenge of "being female yet being aesthetic."[8] The portraits of women poets in this calendar stage some of the ways in which they sought such reconciliation in their self-definitions, whether as a pensive dreamer, a vibrant intellectual, or a knowing matriarch. Among this group, Radford's image stands out for the particular version of Aestheticism it signals.

By 1897, Radford had established a reputation for writing Aestheticist poetry and for her commitment to Aestheticism, which she combined

with socialist political beliefs. During the 1880s, she had developed close friendships with other Aestheticist or Decadent women writers including Amy Levy and Olive Schreiner, with whom she spent time at the British Museum Reading Room. It was at the Reading Room that she met her husband, the Rhymers' Club poet Ernest Radford, subsequently establishing a household with him nearby in Bloomsbury. The couple exchanged visits and participated in reading groups with other fin-de-siècle poets and Aestheticists, including Levy and Michael Field, and with other members of the Rhymers' Club.[9] The two shared a commitment to socialist politics, visible in Radford's intimacy with Eleanor Marx and in her friendship with the sisters Clementina, Constance, and Grace Black. The Radfords deeply admired William Morris, moving to Hammersmith in 1887 in order to participate in the Hammersmith Socialist League, which he led.[10] As Ruth Livesey and LeeAnne Richardson show, Radford's poetry typically unites her commitments to Aestheticism with her socialist views.

Against the other portraits in the 1897 calendar, Radford's stands out by virtue of its stark simplicity. With her unadorned dress tied at her neck like an artist's smock, and with her nimbus of hair framing her face, Radford appears the image of a modest aspiring poet. She resembles less her fellow poets and more a young Rembrandt in one of his early self-portraits. Like the young painter, Radford presents herself as pursuing an inward artistic inspiration, an impression emphasized by the portrait's heavily blurred edges. Indeed, her short hair and simple dress reinforce a rather androgynous look. With this presentation of herself, Radford contributes another key way for a woman writer to define herself as an Aestheticist poet: as a minor poet.

During the fin de siècle, the minor poet was a distinct category of writer. Holbrook Jackson explores this figure in his monumental study of the 1890s, explaining that critics began using the term "to distinguish the younger generation of poets."[11] Jackson identifies Radford as one such minor poet of the 1890s, noting that "some sort of permanence is assured of their work in special fanes of poesy, if not in the broader avenues of popular acceptance."[12] He points out that although the label "minor poet" initially conveyed disparagement, Richard Le Gallienne among others demonstrated the significance of the minor poet to the fin-de-siècle literary scene. Radford's friend Amy Levy scrutinized the idea of the minor poet, using that term for the title poem of her collection, *A Minor Poet and Other Poems* (1884).[13]

Joseph Bristow writes that as an "Anglo-Jewish feminist writer," Levy shows critical awareness of the term "minor poet" by "transvaluing, on

her own terms, the meaning of a far from complimentary label." He argues that Levy's work

> suggests that the "minor" study of poets might have its own distinction. This "minor" distinction was the result of structural exclusions from a literary establishment that esteemed gentile orthodoxies, heterosexual desire, and the male sex during a decade when the privileged value of each was to some degree in doubt ... Openly embracing the position of a "minor poet," Levy ... sought to transform what it meant to belong to those banished streams.[14]

Bristow then explores the ways in which Levy defines a modern emblem of poetic creativity in the figure of the minor poet, an outsider whose affinities belong with "the feminists, sexual dissidents, Jewish people, and freethinkers" who people her urban world. For Levy, the minor poet almost inevitably suffers, but "in that suffering," according to Bristow, "such men would tell the truth of an art that was decisively 'minor.'"[15]

Like Levy, Radford acknowledges and even embraces her status as a minor poet, finding the role to be "its own distinction." Upon publishing *A Light Load*, Radford expresses pride in her work, calling it "a very nice little book. I think I should be quite pleased with it if I met it unaware." Yet she also expresses some ambivalence about its substance: "I wish it were not *so* small. What shall I hear about it? It is no matter."[16] Indeed, when Symons reviews the collection, he emphasizes its smallness, calling it "a tiny, fragile load ... indeed, but not less exquisite than it is unsubstantial."[17] The suffering Levy emphasizes in the minor poet thus becomes for Radford a needling dismay as she awaits critical responses to her work. Her portrait in the 1897 calendar suggests, however, that she has come to embrace her identity as a minor poet, transvaluing it in her own terms by transvaluing her own portrait.[18]

In the original version of the photograph, of course, the baby's presence altogether changes the meaning of the portrait and of Radford as its central figure. Most immediately, the baby in Radford's arms figures her in clearly gendered terms as a young mother. Thus, she wears here not an artist's smock but the loose-fitting garment of a new mother, tied at the neck with a bow not in bohemian fashion but in the diminutive style of a maternity gown. Her hair floats around her face not as the halo of a visionary artist but as the sensible style of a busy mother. She emerges not from a misty frame but in crisp relief, glowing not with inward poetic inspiration but rather with a tired maternal pride as she presents her

healthy baby for the viewer to admire. And while the portrait in the "Modern Poets" calendar includes no attribution, the original version clearly names a family photographer, John Hawke, and the address of his studio in Plymouth, a place where Radford had family connections through her husband, Ernest Radford.

This portrait thus appears to be an unusual choice for a publicity calendar featuring an elite company of poets. Only Radford's portrait and one other, Edith Nesbit's, lack attribution; the others indicate the work of well-known London photographers like Elliott and Fry (Swinburne, William Morris) or Enrico Resta (Meynell).[19] In addition, this photograph appears to be somewhat dated for the 1897 calendar, given that Radford's three children arrived in 1884, 1887, and 1889. If in fact one of them appears here as the infant in Radford's arms – as her maternal pose gives little reason to doubt – the photograph cannot date from any later than 1889 or 1890. Thus, by the time the doctored version of this photograph came out in the "Modern Poets" calendar, the original was at least six or seven years old.[20]

Radford had other options, to be sure. In an 1895 letter to her husband, for instance, she mentions receiving proofs of family photographs: "one of mine is rather nice," she reports, "but rather affected looking [and] fancy."[21] Instead, she chose an image from an earlier moment in her career, before she had established herself professionally – while she began publishing her poems as early as 1883 (as "C. M.," for Caroline Maitland, in the radical journal *Progress*), her book collections did not appear until the 1890s. Thus, it represents a moment when Radford truly was a minor poet, confirming this impression of her as part of her lasting public image.

One might then quickly explain away the editing that changed this family photograph into a formal portrait simply as evidence of Radford's desire to represent herself professionally as a minor poet instead of as a mother. Yet I suggest that the "Modern Poets" portrait of Radford remains a compelling image of her as a poet not despite its photo-manipulation but because of it. After all, the doctoring of this photograph remains imperfect and incomplete: to the careful eye, the ghostly outline of an infant remains visible in Radford's arms. Look once, and the professional poet returns the gaze. Look again, but with an eye to the rounded blur near the crook of her arm, and the poet becomes something else, challenging categorical distinctions. For this reason, Radford's representation of herself as a minor poet is as radical in its own way as Levy's. While Levy associates her minor poet with the marginalized figures who haunt

urban landscapes – "the feminists, sexual dissidents, Jewish people, and freethinkers" – his professional status as a poet never comes into question.[22] By contrast, Radford offers a minor poet whose very labours place her at the margin of the fin-de-siècle literary world itself, insofar as she occupies a space between professional and domestic spheres, performing both modes of labour. The authority of her minor poet derives from her paradoxical position, of being all at once a poet and not a poet, a mother and not a mother – of simultaneously holding a baby in her arms and holding no baby at all. By representing Radford in this way, this image calls into question some of the arbitrary distinctions that determine who qualifies as a poet – what work this person performs, what experiences this person represents – and who does not. Belonging to neither world fixedly, Radford unsettles both.

The Presence of Absent Children in *A Light Load*

Radford's first volume, *A Light Load*, immediately signals the liminal position of the poet in its frontispiece, an illustration of a mother with a baby in her lap and an older child standing by her side, looking out a window towards the night sky. Analysing this image, Emily Harrington observes: "The scene juxtaposes the intimacy of its domestic setting with the grandeur of the cosmos, suggesting that the mother's load extends beyond the care of her children." From this image, Harrington concludes: "the illustration in conjunction with the title asserts that both the burdens of caring for children and of contemplating the universe are bearable."[23] But this image also shows that both loads belong simultaneously to the maternal figure seated by the window. Located in the space where the domestic interior meets the universe at large, holding a baby in her lap, the poet has given her body over to her children while allowing her mind to range elsewhere. While this frontispiece represents the poet's mind as momentarily absent, elsewhere in *A Light Load* it is the children rather than the poet who go missing temporarily. The presence of absent children in these poems complicates the lyric authority of their speakers, especially given the more fixed role children tend to play in the nineteenth-century lyric tradition. By relocating children in her poetry, sending them into suspended absences, Radford redefines their role within lyric and thereby revises the terms of aesthetic lyric expression.

While Radford represents herself as a minor poet, occupying a liminal position as both a writer and a caregiver, her work has drawn attention for its representative qualities as Aesthetic poetry. Marion Thain proposes

Radford's poems as "the quintessential lyrical utterance of the period" for both the aesthetic qualities they enact – their lyric motifs of "birdsong, lost love, tears, and nature" as well as their "metrical ease" – and the commentary they offer on the nature of lyric itself.[24] Certainly, many of the pieces in Radford's collection *A Light Load* reflect on the aims of the Aesthetic lyric poem. In her short poem "Violets," for instance, she identifies with the lyric tradition, albeit recognizing the relatively small scale of her own lyric aims:

> Violets, sweet violets,
> I can find the fairest,
> In a little ferny glen
> Blossom all the rarest,
> I can reach the leafy beds
> Where they hide their dewy heads.
> From the mossy stones and rocks
> Where the pools are deepest,
> I can leap across the stream
> Where the banks are steepest,
> And beneath the hawthorn get
> Many a scented violet.[25]

Seeking the shy domestic violet, a relatively common flower in the English countryside, Radford's lyric speaker pursues a humble aim. Yet the violet also symbolizes immortality. And to locate them requires not just a keen eye to "find the fairest" where "they hide their leafy heads" but also a certain dexterity to "leap across the stream / Where the banks are steepest."[26] Moreover, in naming the shy, modest violet as her aim, the lyric speaker invokes the spirit of Wordsworth's Lucy, whom Wordsworth compares to a "violet by a mossy stone / Half hidden from the eye" in "She Dwelt among the Untrodden Ways" (1800).[27] In this way, the speaker identifies her project with the lyrical legacy of the earlier poet. Although writing within a smaller, more sentimental register than Wordsworth, Radford here affirms the significance of her efforts, seeing them as a distinct contribution to an English tradition of lyric poetry: the modest contribution of a minor poet.[28]

Elsewhere, Radford more searchingly explores her marginal position as a poet, locating herself between lyric landscapes and domestic spaces. Thus, the poem that opens *A Light Load* – one of several in the collection simply titled "Song" – begins by posing this question: "Why am I singing

all alone, / Outside your window here?"[29] Like the frontispiece illustration, this poem situates the lyric speaker next to a window. Unlike in the frontispiece, however, here she is "singing all alone" from outside the window, without the company of children, who presumably are inside.[30] The remainder of the poem then offers a series of answers to her initial question:

> Because the roses are all blown
> And all the sky is clear
> Because the glen I passed was fair,
> And fresh with morning dew,
> Because the gold shines in your hair,
> Because your eyes are blue.
> Because for many a sunny mile
> The hills stretch out, and furled
> Is every cloud: because God's smile
> Is shining through the world.[31]

With this short ballad, Radford again identifies her poetic vocation with the nineteenth-century lyric tradition, and specifically with the Wordsworthian lyrical ballad, insofar as her experience of nature – the blooming roses, the clear sky, the morning dew – elicits from her reason to sing.

To be sure, this lyric poet experiences nature as more beautiful than sublime. This lyric poet grapples not with the majesty of Mont Blanc or even with the stark power of nature that Wordsworth confronts in his Lucy poems, such as in "A Slumber Did My Spirit Seal" (1800), in which he imagines the girl returned to the earth in death, "Rolled round in earth's diurnal course, / With rocks, and stones, and trees."[32] Instead, Radford summons a picturesque landscape, with clear skies and a fair glen between sunny hills, with roses – a domesticated flower – in full bloom. Strangely, this speaker never quite makes explicit the connection between her initial question – "Why am I singing all alone?" – and the catalogue of natural beauty she names in response. Indeed, the form her response takes as a list has the effect of foreclosing rather than furthering any explanation. Also peculiar, while the speaker identifies a listener, she also implies that her song will not reach this audience – she stands outside the listener's window, singing all alone. For these reasons, this "Song" represents a failure of communication, a phenomenon that Harrington observes in Radford's poetry, whereby her lyrics never quite reach their intended audiences or do so only imperfectly.

Yet even as a failure of communication, this "Song" enables Radford to survey her domain as a lyric poet. When addressing the question of why she sings, the speaker first looks outward towards the picturesque landscape beyond her addressee's window, with its blooming roses, clear skies, and dew-drenched glen. But she then turns her gaze inward, imagining the blue eyes and golden hair of her addressee, who belongs to the space on the other side of the window. Demonstrating her access to both of these spaces, she concludes by turning her gaze outward again to the broader expanse of hills and sky. Doing so, she observes that this larger space remains yet unwritten, insofar as the clouds are "furled," not determined by text. This movement thus enables her to lay claim to the space, filling it with her song.

Like several other poems in the collection, this "Song" implies the presence of children without placing them specifically in the poem. Here, the speaker identifies a golden-haired, blue-eyed listener, suggesting the features of a child, while also drawing from the sing-song language of a children's song, ending with the reassurance of "God's smile / … shining through the world."[33] This uncertain position of children in this poem calls attention to the more fixed role children tend to play in the nineteenth-century lyric tradition with which Radford engages. Perhaps most notably, Wordsworth's lyrical ballads regularly feature children. But almost as regularly his poems feature their demise.[34] In a number of Wordsworth's poems – the Lucy poems most conspicuously as well as "The Thorn" (1798), and even in some ways "Ode: Intimations of Immortality" (1807) – the loss of a child enables the voice of the lyric speaker. Thus, he lingers on the departed Lucy in "She Dwelt among the Untrodden Ways," a "violet by a mossy stone / Half hidden from the eye!"; since "she is in her grave," he exclaims, "oh, / The difference to me!"[35] Likewise, in "Three Years She Grew" he observes that

> She died, and left to me
> This heath, this calm and quiet scene;
> The memory of what has been,
> And never more will be.[36]

Her death serves as a sacrifice that permits his lyric voice to sing.

In her measured representations of children, Radford departs conspicuously from Wordsworth's lyric tradition. Most notably, she allows the children in her lyrics to survive. But their presence – their needs, their songs, and their rhymes – complicates her understanding of

herself as a poet. Her poem "What Song Shall I Sing" explores poetic vocation directly, and specifically the vocation of a poet who both writes lyric and provides care for children. Managing these two roles, she faces the challenge of achieving lyric originality as sings the repetitive songs and rhymes of childhood over the course of the day.[37] She explains that although there are many new singers, songs, writers, and "books to understand," "I can sing, these evening times, / Only the children's songs and rhymes":

> All the day they play with me,
> My heart grows full of their looks,
> All their prattle stays with me,
> And I have no mind for books,
> Nor care for any other tune
> Than they have sung this golden June.[38]

This stanza in particular makes clear Radford's frustration at finding her mind full of children's rhymes, crowding out, it would seem, her own lyrics.

This poem thus makes for a compelling study of the challenges posed by the effort to balance creative work and family life. Yet it also makes available another, slier reading: the songs the speaker sings to her children also energize her efforts as a poet. The speaker here is asking herself not *how* she will manage to sing after a long day of tending children, or even *why* she should bother singing, but rather *what* she will sing to her seemingly inert listener, who requires songs or books to stimulate him. And while many nameless and numberless singers and writers might satisfy this need, the speaker stands out as distinct from both groups. Unlike this proliferation of singers and writers, she has unique access to the abundance of children's verse (it's possible to read the "only" in line twelve as an enjambed modifier of the "I" of line eleven). At the very least, unlike her passive listener, who depends upon someone else to bring him music or books, the active speaker finds inspiration in this wealth of material with which her heart has grown full. When she observes that she has "no mind for books" nor "care for any other tune," it's possible to read these lines as statements of defeat. She can no longer keep up her reading or pay attention to current music. But it is also possible to read these lines as expressions of liberation: she need not mind, care, or worry over this seemingly endless proliferation of indistinguishable, dead, and deadening texts.

A later poem in the collection, "In the Woods," again pairs an active speaker with a passive reader who suffers from the stultifying effects of his studies. Watching him read, the speaker likens his activity to a slow entombment, asking "Are your grave eyes graver growing?" She implores him to set aside his books: "Come into the woods and see / Where I find my posies." Her lyrics, her "posies," derive not from the traces left by a "buried singer" like the one her listener reads but directly from her experience of nature. Moreover, this very "buried singer" had "found his music / Where I find my flowers." In this poem, Radford's speaker finds a continuity between herself and this earlier poet – between herself and the lyric tradition that has made its way onto the printed page – not because she studies his written texts but because she finds inspiration from the same living landscapes, the "the mighty woods and river" that also "[t]aught him how to sing."[39] Taken together, these poems highlight the tension in Radford's poetry between lyric as an aural form and its instantiation in print.[40] But they also render the activity of the lyric poet as compatible with the pursuits of caregiving – both for small children and for infirm scholars.

Radford thus finds continuity between her commitments as a caregiver and her vocation as a poet. Of course, "What Song Shall I Sing" stands out from the collection in this respect: it's one of the few poems in which Radford mentions children explicitly or reflects on the experience of maternity directly. Children more often haunt the margins of her poems as her implied listeners or even as her implied readers, given the sing-song quality of many of her rhymes, but seldom do they materialize as figures within her poems. Even in "What Song Shall I Sing," the children strangely disappear by the end. Indeed, in an earlier draft, Radford had made their presence more exact. In editing the poem, Radford cut from it a concluding stanza. Whereas the published version of the poem ends with the speaker remarking that she has no "care for any other tune" than those her children "have sung this golden June" (17, 18), the earlier draft resolves with an image of the children safely at rest:

Come with me and rest awhile,
By this old river-wall,
I will tell you, though you smile,
That this is best of all:
To sit by you with the stars o'erhead,
And the wee ones safe with their dreams in bed.[41]

This concluding, unpublished stanza shifts the poem's meaning, turn-
ing it into a poem not about lyric vocation but rather about domestic
harmony (Figures 7.3a and 7.3b). Moreover, it resolves the speaker's
ambivalence about parenting. By leaving out this stanza, Radford pre-
serves the poem's indeterminate meaning. But she also preserves the
indeterminacy of the meaning of the children. While the lyric opens by
locating them "safe with their dreams in bed," figuratively they remain
singing out and about in the golden June, where the shortened poem
leaves them.

 In preserving the indeterminacy of the children's meaning in this poem
and elsewhere in her work, Radford makes an even more thoroughgoing
departure from the lyric tradition of Wordsworth and rewrites the role
of children in lyric. For Wordsworth, children almost inevitably figure as
emblems of nostalgia, of a past no longer accessible even as it continues
to shape the present. Lucy is dead. The baby in "The Thorn" remains
in her grave. The absent brothers and sisters from "We Are Seven" in
"the church-yard lie." Recollections of childhood may tease the speakers
of "Tintern Abbey" and "Ode: Intimations of Immortality," reminding
each of his early intimacy with nature, but this version of himself as a
child also remains lost, never to return, in exchange for the grown-up's
philosophic mind. By contrast, the children for Radford consistently
resist such containment within the lyric poem. They figure no loss for
which lyric must compensate. Rather, they serve as emblems of the lim-
its of lyric, that is, of that which lies beyond the scope of lyric. In her
study of the Aestheticist lyric poem, Thain suggests that towards the end
of the nineteenth century, "the 'totalisation' of lyric in print somewhat
paradoxically served to highlight a key location of meaning outside of
lyric's own language" (41). Thain focuses on the "audacious" character
of Michael Field's Sapphic lyrics and the ways these lyrics call attention
to the limits of what printed lyric might capture. She also argues that
"femininity might usefully represent for poets the tension characteristic
of the totalized print lyric between containment and excess" (45).[42] For
Radford, children serve much the same purpose, introducing into her
lyric poems figures of that which escapes the lyric speaker's purview, that
which the lyric may acknowledge but not encompass.

 Children serve this purpose in "What Song Shall I Sing" insofar as
they remain not tucked away and sleeping at the poem's conclusion but
rather continue to intrude upon the speaker's ears with the echoes of
their prattle and singing. The subsequent two poems in *A Light Load* also
feature children, among the few that appear directly in the volume, here

(a)

(b)

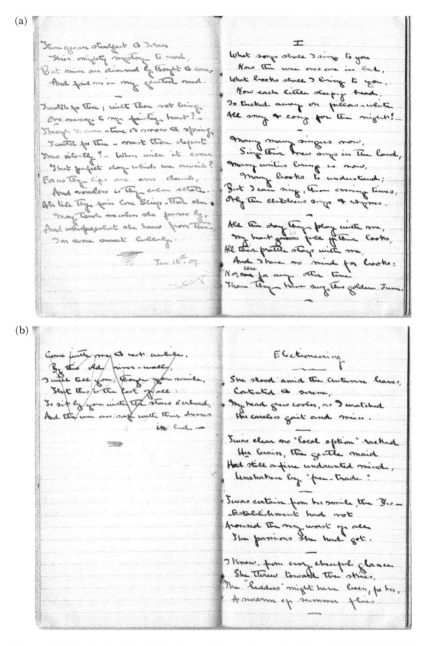

Figures 7.3 Dollie Radford, Notebook: Poems, fos. (a) 150[r] and (b) 150[v]. (Dollie Radford Papers, 1880–1920, box 3. William Andrews Clark Memorial Library, University of California, Los Angeles.)

also curiously uncontained. The first of these poems, "On the Moor," describes a pastoral scene:

> OUT on the moor the sun is bright,
> And the gorse is yellow,
> The sky is blue and the air is light,
> And a little fellow
> May walk for miles in the grassy way
> On a holiday.

The poem offers no explanation about why "a little fellow" might "walk for miles" across this moor, seemingly alone, nor does it specify a destination for his holiday. Hereafter, the "little fellow" disappears into the poem's landscape. While the speaker returns in the second stanza to describing the bees and fresh heather of the moors, she also notices the pathways that children have carved through the brush ("through the bracken the young have slips").[43] Unseen by the speaker, these children have left behind only the traces of their activity, their own inscriptions on the landscape, visible but not fully legible to the lyric speaker.

By contrast, the central child appearing in the next poem, "Little Maiden," remains squarely within the speaker's sight and within the frame of the poem, but her thoughts elude the lyric speaker. The speaker engages the girl by asking a series of questions:

> LITTLE maiden are you lonely,
> Standing there beside the sea,
> Are your blue eyes sad or only
> Filled with dreams too fair for me.
> Are the summer breezes making
> Fairy music on the sand,
> And the quiet ripples breaking,
> From some sea-girt fairy-land.

Focusing on this interaction between a lyric speaker and solitary "little maiden," the poem resembles Wordsworth's "We Are Seven." But Wordsworth's speaker demands a response from the little maid he encounters, who obliges by explaining her siblings' fates, the lyric dramatizing their contrasting perspectives. Radford's speaker elicits no reply from the girl she observes, however. Instead, her lyric speaker merely speculates about

the dreams or fairy visions occupying the girl's mind and expresses hope for their continuation, independent of her grown-up influence:

Ah, the fragrant flowers never
Fade in that sweet sunny air,
And the fairy people ever
Send you dreams and fancies rare.
Little maiden, you must only
Keep your blue eyes clear and free,
And you never will be lonely,
Standing there beside the sea.[44]

The lyric speaker leaves the little maiden as she has found her, at the margin of the sea, wrapped up in "dreams and fancies" inaccessible to the speaker and enjoying the company of the fairy people.

"Little Maiden" concludes with the speaker offering the girl something of a benediction, that the girl may continue to keep company with the "dreams and fancies" of the fairies and with her own thoughts, engaging in a creative vitality beyond the ken of the speaker, beyond this moment of observation, and outside the scope of her lyric. The poem thus calls attention to its own limits while also gesturing at an excess creative energy outside these bounds. In this way, it gives expression to the view of lyric that the first edition of *A Light Load* introduces in its very frontispiece, an image of a mother looking towards a child gazing pensively out the window. This frontispiece also suggests that the dreams of the children motivate the lyric expression of their mother but not because she shares in them. Her own gaze unreturned, the mother finds herself alienated from her child's visions. This inevitable alienation, a loss not of the child but of the poet's continuity and synchronicity with the child, motivates her lyric expression. In other words, children appear in Radford's lyrics not as reminders of a past to which the poet will never return but as intimations of a present the poet does not share and a future to which she will not belong.

Conclusion

The 1897 "Modern Poets" calendar, an ephemeral object devoted to marking time, serves as a surprisingly appropriate emblem of Radford's work insofar as it represents her efforts at fashioning a role for herself as a lyric poet and aesthete. It makes visible her understanding of her role

as a minor poet, writing from the margin where professionalism and
domesticity meet. It also offers a visual account of the elusive children
in her lyrics, figures by which her poetry scrutinizes the bounds of what
lyric may or may not contain. But this single calendar page also marks a
particular moment in time and implies a particular role for lyric poetry
in marking its passage. The calendar itself suggests that each of its pages,
each of its poets, will inevitably pass on to the next as each month suc-
ceeds the last. By way of conclusion, then, I suggest that Radford's image
ultimately pushes against this very logic of calendar time. After all, her
author's portrait, with its misty traces of a sleeping baby, conflates several
moments in time, holding them together in a single image. Likewise do
her lyrics manage to unite the concerns of late-century Aestheticism, in
which she finds promise and abundance, with an ongoing lyric tradition.

NOTES

1 The full list in order of appearance is Algernon Charles Swinburne (cover–
January), Alice Meynell, William Morris, Margaret Woods, Lewis Morris,
Edith Nesbit, William Watson, Katharine Tynan, Richard Le Gallienne,
Dollie Radford, Alfred Austin, and Jean Ingelow.

2 Linda Peterson, "Presenting Alice Meynell: The Book, the Photograph,
and the Calendar," in *Women Writers and the Artifacts of Celebrity in the Long
Nineteenth Century*, ed. Ann R. Hawkins and Maura Ives (Burlington:
Ashgate, 2012), 187.

3 LeeAnne M. Richardson, "Naturally Radical: The Subversive Poetics of
Dollie Radford," *Victorian Poetry* 38, no. 1 (2000): 109. Richardson shows
that Radford's contemporaries tended to misunderstand her work, a
problem that contributed to the neglect she received from later critics.
Addressing this critical neglect, Livesey argues that the "tepid enthusiasm
shown for Radford's works" by Modernist critics like D.H. Lawrence "can
be read as representative of the erasure of nineteenth-century women's
poetry from the twentieth century's acts of literary remembrance" more
broadly. See Ruth Livesey, "Dollie Radford and the Ethical Aesthetics of
'Fin-de-Siècle' Poetry," *Victorian Literature and Culture* 34 (2006): 495–6.
Like Richardson, Harrington suggests that Radford's immediate reviewers
misunderstood her work, specifically her critical approach to lyric form,
but she also points out that Radford defined her audiences in a limited
way, circulating her books only "in small numbers presumably among a
literary upper class." See Emily Harrington, "'So I Can Wait and Sing:

Dollie Radford's Poetics of Waiting,'" in *Second Person Singular: Late Victorian Women Poets and the Bonds of Verse* (Charlottesville: University of Virginia Press, 2014): 161.

4 See Peterson, who notes that Austin's appointment most likely did not reflect his strength as a poet. She argues that the "Modern Poets" calendar responds to this appointment in its ordering of poets. The calendar "acknowledges the Queen's choice, Alfred Austin, with the label 'poet laureate' beneath his name," she observes, "but, by virtue of its monthly assignments, it 'ranks' the contenders by putting Swinburne, Meynell, and William Morris at the forefront of modern poets." Peterson, "Presenting Alice Meynell," 186.

5 Peterson, 182.

6 Holbrook Jackson classifies Meynell among the poets who have "won something like the indisputableness of classics," while identifying Radford as among those poets who still elicit only "a lively interest." Jackson, *The Eighteen Nineties: A Review Art and Ideas at the Close of the Nineteenth Century* (London: Grant Richards, 1913), 162, 163.

7 The calendar itself represents an effort at burnishing a reputation. As a company, Marcus Ward had been in business since 1802, when it was founded as a paper mill in Belfast. During the company's mid-nineteenth-century heyday, it gained renown for the quality of its designs from artists like Kate Greenaway and Walter Crane. By the end of the 1890s, however, new technologies had begun to crowd Marcus Ward out of the marketplace. The company strained to keep up with the demand for photography in particular before finally going out of business in 1899. This calendar reflects its struggle with this effort in that it joins photography with the decorative elements for which the company had been widely known, associating both with the cultural capital of poetry and aestheticism in particular. For more on Marcus Ward, see Gillian McIntosh, "Marcus Ward & Co. of Belfast," in *The Oxford History of the Irish Book*, vol. 4: *The Irish Book in English, 1800–1891*, ed. James H. Murphy (Oxford: Oxford University Press, 2011), 129–36.

8 Talia Schaffer, *The Forgotten Female Aesthetes: Literary Culture in Late-Victorian England* (Charlottesville: University of Virginia Press, 2000) 4–5.

9 Harrington places Radford "at the center of elite literary circles of the 1890s" alongside her husband, observing their intimacy with figures such as Arthur Symons and Michael Field, among others, *Second Person Singular*, 140.

10 See Livesey, "Dollie Radford, 496.

11 Jackson, *The Eighteen Nineties*, 161.

12 Jackson, 163.

13 Linda Hunt Beckman writes about the friendship Radford shared with Levy in *Amy Levy: Her Life and Letters* (Athens: Ohio University Press, 2000). Ann MacEwen also mentions this friendship in "The Radfords, William Morris and the Socialist League," *Journal of the William Morris Studies* 17, no. 3 (2007): 30–49.

14 Joseph Bristow, "'All Out of Tune in This World's Instrument': The 'Minor' Poetry of Amy Levy," *Journal of Victorian Culture* 4 (1999): 76, 80.

15 Bristow, "'All Out of Tune,'" 80, 97.

16 Dollie Radford, 14 April 1891, Diary Entry, Dollie Radford Papers, 1880–1920, William Andrews Clark Memorial Library.

17 Arthur Symons, Review of *A Light Load* by Dollie Radford, *Academy*, 13 June 1891, 39.

18 Bristow, "'All Out of Tune,'" 80.

19 The use of this photograph is all the more peculiar, insofar as images of women writers during the fin de siècle served as important elements of their publicity. Peterson observes: "*Fin-de-siècle* authors used the visual image to increase their popularity and book sales, and publishers of mass-market women novelists virtually required their authors to have photographs taken by a celebrity photographer … for frontispieces that would reveal the author to her reader." Peterson, "Presenting Alice Meynell," 176. Neither Elkin Mathews nor The Bodley Head, publishers of *A Light Load* and *Songs and Other Verses*, used such frontispieces, of course, decorating their title pages with illustrations instead.

20 This photograph most likely dates from 1887, insofar as it probably features Radford with her daughter Hester, from whom the William Andrews Clark Memorial Library received its Radford archive. Ann MacEwen, Dollie Radford's granddaughter and Hester Radford's niece, describes the dispersal of the family papers in "Ernest Radford and the First Arts and Crafts Exhibition, 1888," *Journal of William Morris Studies* 17, no. 1 (Winter 2006): 27–38. Dollie Radford and Hester Radford quite likely sat for this portrait during a family visit to Plymouth in the summer of 1887, when Hester was four or five months old. MacEwen mentions this visit in "The Radfords, William Morris and the Socialist League."

21 Dollie Radford, "To Ernest Radford," 2 December 1895, Radford Archive, British Library, Add MS 89029.

22 Bristow, "'All Out of Tune,'" 80.

23 Harrington, *Second Person Singular*, 169.

24 Marion Thain, *The Lyric Poem and Aestheticism: Forms of Modernity* (Edinburgh: Edinburgh University Press, 2016), 19, 20.

25 Dollie Radford, "Violets," in *A Light Load* (London: Elkin Mathews, 1891), 16.

26 Radford, "Violets," 16.
27 William Wordsworth, "She Dwelt among the Untrodden Ways," in *William Wordsworth: The Major Works*, ed. Stephen Gill (London: Oxford University Press, 2008), 147.
28 I am grateful to Joseph Bristow and my fellow participants in the NEH seminar on "The Decadent 1890s" for this reading of "Violets," which we developed together as a group.
29 Dollie Radford, "Song," in *A Light Load*, 2.
30 Harrington demonstrates Radford's interest in the failure of the song as a form, insofar as many of Radford's poems titled "Song" feature a failure of communication between the song's singer and listener.
31 Radford, "Song," in *A Light Load*, 2.
32 Wordsworth, "A Slumber Did My Spirit Seal," in *William Wordsworth: The Major Works*, ed. Stephen Gill (London: Oxford University Press, 2008), 147.
33 Radford, "Song," in *A Light Load*, 11–12.
34 Wordsworth's poetry contributes to the significant body count of children in eighteenth- and nineteenth-century literature, from Swift's "A Modest Proposal" to Eliot's *Adam Bede*, Elizabeth Barrett Browning's "The Runaway Slave at Pilgrim's Point" (1847), and the unnamed, murdered child of the unfortunately named Wragg in Arnold's "The Function of Criticism at the Present Time" (1864). A number of critics have noticed this trend. Laura C. Berry, for instance, argues that the victimized child in nineteenth-century literature serves as an emblem of the nineteenth-century liberal self; "representations of the victimized child," argues Berry, "become an important means of articulating an autonomous and socially indebted self, bound but self-determined." Berry, *The Child, the State, and the Victorian Novel* (Charlottesville: University of Virginia Press, 1999), 19.
35 Wordsworth, "She Dwelt among the Untrodden Ways," in *William Wordsworth: The Major Poems*, 147.
36 Wordsworth, "Three Years She Grew," in *William Wordsworth: The Major Poems*, 154–5.
37 Richardson observes that this poem addresses a "meta-poetic concern: the difficulty of combining the work of the poet with the work of a mother." "Naturally Radical," 112.
38 Radford, "What Song Shall I Sing," in *A Light Load*, 23–4.
39 Radford, "In the Woods," in *A Light Load*, 47–8.
40 See Thain, who explores this tension, as well as Elizabeth Helsinger's study of the relationship between nineteenth-century poetry and song, *Poetry and the Thought of Song in Nineteenth-Century Britain* (Charlottesville: University of Virginia Press, 2015).

41 Dollie Radford, Draft of "What Song Shall I Sing," Diary Entry, Dollie
 Radford Papers, 1880–1920, William Andrews Clark Memorial Library.
42 Dollie Radford, Draft of "What Song Shall I Sing," 41, 45.
43 Radford, "Out on the Moor," in *A Light Load*, 25, lines 1–6, 9.
44 Radford, "Little Maiden," in *A Light Load*, 25.

"She hath no air":
Mary Coleridge's Moon

KASEY BASS

I would not be the Moon, the sickly thing,
To summon owls and bats upon the wing;
For when the noble Sun is gone away,
She turns his night into a pallid day.

She hath no air, no radiance of her own,
That world unmusical of earth and stone.
She wakes her dim, uncoloured, voiceless hosts.
Ghost of the Sun, herself the sun of ghosts.

The mortal eyes that gaze too long on her
Of Reason's piercing ray defrauded are.
Light in itself doth feed the living brain;
That light, reflected, but makes darkness plain.

Mary Coleridge, "In Dispraise of the Moon" (1896)[1]

In 1896, Mary Coleridge – a writer whose considerable achievements have become clearer through the recent rediscovery of several gifted fin-de-siècle women poets – composed one of her greatest lyrics, "In Dispraise of the Moon," which appeared in the first volume of her poetry to bear her name, published posthumously in 1908, one year after her death. That same year, she published her first book of poetry, *Fancy's Following*, signing herself with the Greek pseudonym Ἄνοδος ("Anodos"). Coleridge's slim first volume came out from the Daniel Press, named after the Rev. Henry Daniel, whose fine letterpress editions were issued from Worcester College, Oxford. *Fancy's Following* joined a stable of well-known poets who were mainly linked with Oxford. Such writers included

Robert Bridges, Richard Watson Dixon, Margaret L. Woods, and Laurence Binyon.

The year after, a further group of lyrics by "Anodos" appeared in *Fancy's Guerdon*, which Elkin Mathews – a well-known London publisher of fin-de-siècle contemporary poets such as Michael Field – brought out in 1897. It was not until 1908 that her collected lyrics appeared under her own name in the posthumous *Poems*. By the time of her early death from appendicitis at the age of forty-five, Coleridge's expert lyrics formed part of a very large oeuvre featuring several novels, a study of the Pre-Raphaelite painter William Holman Hunt, and an edition of Dixon's poetry. In this chapter, I explore the complexity of "In Dispraise of the Moon" to show the ways in which Coleridge's art encodes her close relations with a little-studied circle of highly educated women who forged their own distinctive aesthetic culture. As this lyric reveals, Coleridge's art draws into question several conventional assumptions linked with the moon – a powerful icon of femininity, especially in classical mythology. I begin by examining Coleridge's resonant pseudonym before turning to the doubts that her lyric casts upon the moon. Thereafter, I situate the poem within the close-knit emotional bonds that existed among Coleridge's intimate women friends. As we will see, "In Dispraise of the Moon" guides us towards a broader understanding of why "Anodos" keeps rethinking the gendered manner in which both ancient and modern cultures conjure lunar imagery.

The Resonances of "Anodos"

Coleridge's pseudonym is a striking one that deserves some scrutiny before we turn to the fascinating "I" that gives voice to her equally compelling lyric that – for reasons that need careful explanation – dispraises the moon. The name "Anodos" emerged from Coleridge's contemplation of a suitable professional identity, one that both included her autobiographical sense of self and stretched well beyond that self. Coleridge ostensibly adopted the name from the male narrator of George MacDonald's fables about fairyland, *Phantastes* (1850). Yet MacDonald's stories are not her only point of reference. As she knew from her classical education, "Anodos" resonates with different meanings in a range of Greek texts. On the one hand, it signifies "having no road" or proving "impassable," while on the other, it carries the Platonic sense of an "upward path" towards enlightenment.[2] It is significant that she decided upon "Anodos" after previously calling herself "Vespertilio" (a type of bat)

in the notebooks that led up to *Fancy's Following*. (The original title of *Fancy's Following* was *Verses by Vespertilio*.[3]) With "Vespertilio," she created a nocturnal alter ego that was linked to the supernatural and the occult. With "Anodos," however, she broadened her pseudonymous identity to follow an implicitly arduous or difficult male path that pursues higher knowledge.

In Coleridge's letters and diaries, she absorbs these definitions of "Anodos" into her understanding of her subjectivity, especially when she describes moments of enlightenment that encourage her to view her daily life from a new perspective. In an entry from 1888, she alludes to herself as "Anodos" in order to describe how Mozart's *The Marriage of Figaro* has stayed with her, unlocking differently gendered emotions that she cannot put into words:

> "*Dove sono i bei momenti?*" Sometimes we lose the Present Tense of life alto-gether. For Anodos this morning is last night. Last night he was up in the Gallery at Covent Garden, happy as a god, listening to *Figaro*, and tho' he has been to bed in the interval, there he still is, and there he is likely to remain … Perfect comedy is almost too beautiful to laugh at, as perfect tragedy is "too deep for tears."[4]

"Anodos" can evidently remain in this space in spirit through reference to Wordsworth's "Ode: Intimations of Immortality" (1807); the phrase "too deep for tears" keeps "Anodos" in a state of God-like suspension. While Coleridge may need to rise in the morning and go about her day, "Anodos" retains the freedom to stay at the Royal Opera House in Covent Garden, where he relishes the famous aria from Act III.

It was also in 1888 that Coleridge described how "Anodos" has more spiritual liberty than she herself can enjoy:

> Talk of myriad-minded Shakespeare. Why, the commonest man breath-ing has many, many more than a myriad minds. I am a different person every twelve hours. I go to bed as feminine as Ophelia, fiery, enthusiastic, ready to go to the stake for some righteous cause. I get up the very next morning, almost as masculine as Falstaff, grumbling at Family Prayers. Is it possible for me to believe that I am really the hero of the night before? Personal identity? People are fools that doubt it? Upon my word, I think we are much greater fools to believe in it. It is only the stupid transitory flesh in which we walk about that makes us. We believe it for others, not for ourselves.

Anodos has over and over again been conscious, both for good and evil, that he was being rented by a spirit not his own, and when his body goes to sleep, he is in all probability animating another one at the Antipodes. Of course, he cannot be found out in this Box and Cox arrangement; he cannot even find out himself … Nature is ever economical, and souls are her very dearest commodity. It probably takes her as long to manufacture even a baby's soul, as it does to turn out ten elephants.[5]

These extracts make it clear that through poetry Coleridge undergoes a remarkable transformation when she becomes "Anodos": a voice unbound by gendered expectations and free to experience pure inspiration. More than that, through "Anodos" she can eschew a singular identity altogether. This eschewal has much to do with her resistance to complying with society's gendered binaries, which she overturns when feeling "as feminine" as Shakespeare's otherwise suicidal Ophelia, who will "go to the stake for righteous cause" in the evening, and "as masculine" as the otherwise cocksure Falstaff, who is left muttering while saying his "Family Prayers." Ophelia is obedient to her father, loyal to Hamlet, and, ultimately, long-suffering and kind, despite Hamlet's cruelty. Falstaff, by contrast, is drunken, fat, and sceptical about social conventions. In their original forms, these Shakespearean characters seem fairly stereotypical. Coleridge takes interpretive licence in this passage to re-envision Ophelia's suicide as a rebellion against Hamlet's infidelity to love. While Ophelia will die of heartbreak, going to a "stake" of her own making for the righteous cause of love, Falstaff does not want to go into battle for honour and questions the very concept of honour.[6] She humorously chooses Falstaff to sit in her place at Family Prayers, implying that she, too, sometimes grumbles at these sorts of social conventions. Coleridge finds freedom in upsetting gendered norms, imagining herself as part male and part female through reimagining these iconic characters. Furthermore, she begins this passage with a quotation from her great-great-uncle, Samuel Taylor Coleridge, a quotation that she immediately questions and undermines. Samuel Taylor Coleridge may laud "myriad-minded Shakespeare," but Coleridge questions the stability of a coherent "personal identity," and "Anodos" experiences the schisms lying beneath its performance. Like Falstaff grumbling about the fact that honour is a word – it is just "air,"[7] through "Anodos" she reveals that personal identity, particularly gendered personal identity, is a mere cultural performance. As I demonstrate in this chapter, these passages cast into relief a similar resistance that is evident in Coleridge's lyrics. In

particular, I wish to show how the poetic voice of "Anodos" ingeniously redefines the conventional sexual assumptions that have for centuries been associated with a powerful literary icon: the moon.

"In Dispraise of the Moon" – which presents an airless and lifeless sphere that looks undesirable – presents an initially inscrutable response to Coleridge's cultural position as a woman poet during the 1890s. Why would a woman writer repudiate the moon in such forceful terms of "dispraise"? If we read Coleridge's lyric voice as an expression of her own subjectivity, we can begin to see that there is another aspect to the "sickly" disposition of the moon. As the lines unfold, the poetic "I" sounds as if she is refusing to permit her writing to be a negative object, one that depends on the sun for her reflected illumination. We can already glimpse that "Anodos" does not wish to reflect any male literary light associated with "Reason's piercing ray." Instead, she wants to be a rather different kind of moon, a moon whose phantasmal existence is not dependent on the solar source. The lyric develops the idea that her poetic moon could transform, in a single line, from the "Ghost of the sun" into the "sun of ghosts" – from a vicarious reflection to a spectral source of energy. In this way, Coleridge was decisively shifting the literary conventions that had traditionally treated the moon as a figure of feminine inferiority to the masculine "noble Sun."

It takes, however, several lines before we can grasp this radical transformation. "I would not be the Moon, the sickly thing," the poem begins, with this "sick[ness]" linked to the calling of Gothic "owls and bats." The speaker then concentrates on what happens when the solar light disappears from the lunar surface: "For when the noble Sun is gone away, / She turns his night into a pallid day." This opening shows that Coleridge layers the poem with the gendered binaries that usually attend poetic representations of the sun and moon. She insinuates that the solar is connected with a masculine form of illuminating "Reason," while the lunar is associated with a femininity that the sun alone lights up. The colourless, reflective quality of the "Moon"'s "day" continues through aural metaphors in the next stanza:

> She hath no air, no radiance of her own,
> That world unmusical of earth and stone.
> She wakes her dim, uncoloured, voiceless hosts,
> Ghost of the Sun, herself the sun of ghosts.

As we can see here, the stanza moves back and forth between the speaker's description of the power of the "Moon" on the earth and the

description of the "Moon" herself, a "world unmusical of earth and stone.'" If this is a reference to the music of the spheres, this satellite is definitely out of key.

Yet even if the "Moon" is an airless "Ghost of the Sun," she still has had the power to "wake" figures that are variously "dim," "uncoloured," and "voiceless." As the poem progresses, Coleridge's lyric voice begins to deepen the emphasis on the strength rather than the weakness that the "Moon" derives from her traditionally secondary position:

> The mortal eyes that gaze too long on her
> Of Reason's piercing ray defrauded are.
> Light in itself doth feed the living brain;
> That light, reflected, but makes darkness plain.

In these lines, the "mortal eyes" that contemplate the lunar sphere, once they peer "long" enough upon her, witness something decidedly unconventional about the "Moon." The "Moon," it appears, has the power to defy "Reason" and, finally, to "make darkness plain." Thus, the "mortal" gaze initiates a recognition of the moon's power to exist independently from the light emitted by solar "Reason." To be sure, given that "Reason" can "pierce" and "feed" its object, the "Moon," since she "reflect[s]" the rays of the "Sun," cannot offer her own light. Still, the "Moon" reveals something else: the ever-present darkness, one obscured by the blinding light of "Reason" and the "noble Sun."

Once we mull over this counter-intuitive approach to the lunar surface, we might want to question who this "I" is – an "I" that "would not be the Moon," even though this voice also observes that the "sickly" sphere has the power to summon "voiceless hosts." That the poem intimates that the "I" harbours some dissatisfaction with the sexual binaries linked with the "Sun" and "Moon" is borne out in Virginia Blain's shrewd commentary: "The speaker is partly reacting against the traditional poetic association of the moon with a woman."[8] Yet the poetic "I" is arguably not just reacting to the traditional literary associations of the moon with femininity. The lyric repudiation of the moon as a "sickly thing" is an implicitly sharp critique of sensitive cultural coding. The moon, after all, has long defined femininity because of a prevailing belief that the cycles of the moon control women's fertility, just as it does the tides. It is worth remembering that in the nineteenth century a debate raged about the function and effects of menstruation, with some medical authorities positing that the supposed monthly damage to the uterus left women unfit for higher education or for professional employment.[9]

Since Coleridge's moon possesses an active "wak[ing]" power in this lyric (it is certainly an entity that does more than simply reflect the sun), we might want to look again at the memorable first statement in the poem: "I would not be the Moon, the sickly thing." *Who*, we might wonder, "would not be the Moon"? The opening line therefore encourages us to determine whether we will accept the speaker's claims for "Reason" and the "nob[ility]" of the "Sun" or whether we will notice the ability of the "Moon" to gather "voiceless hosts," together with the swarming owls and bats, as well as create the darkness pulsing and surrounding the "ray" of "Reason." If we approach the poem this way, we can see how Coleridge is hinting that the "Moon" and even the poetic "I" are literary devices, ones laden with the weight of cultural assumptions that one might want to question and even reimagine.

Coleridge, Literary History, and Women's Friendship

There were specific reasons why Coleridge decided to "dispraise" the moon in such critical terms, and they relate to her immediate family circumstances and the unusual social circles in which she moved. As her family name suggests, she certainly had the background to understand what it meant for a female author to refigure the meaning of the moon in English lyric. Her father was Arthur Duke Coleridge, the great-nephew of the Romantic writer Samuel Taylor Coleridge. He was an accomplished singer, performing with the London Bach Choir and the "Swedish nightingale" Jenny Lind; he was also, in his day job, Clerk of the Assize on the Midland Circuit. The Coleridge household welcomed some of the most influential artists and writers of the time, such as the Pre-Raphaelite painters John Everett Millais and William Holman Hunt, the actress Fanny Kemble, the poet laureate Alfred Lord Tennyson, and the venerated Robert Browning. Her mother, Mary Ann Jameson, was also an accomplished musician, though she chose not to pursue performance. Besides her daughter Mary, Jameson had Florence, who was three years younger. The sisters shared a room and also shared a resistance to being too attentive to their appearance. Theresa Whistler explains that the sisters did not conform to traditional ideals of middle-class Victorian femininity: "[Florence's] disregard for her appearance was equal to Mary's, but for characteristically different reasons; for while she felt it wrong to give thought to one's raiment, Mary simply could not be bothered."[10] While Mary and Florence enjoyed the same literary-inspired childhood, acting out Walter Scott's Waverley novels every

Saturday with a group of friends, with Mary as "a rapt and lanky Ivanhoe behind a dishcover shield."[11] Mary alone joined a group of girls interested in learning Greek. The circle constituted an ambitious coterie of friends who consolidated their belief that they could take their place as artists and thinkers with the same accomplishments as the men of their own and preceding generations.

As Coleridge's private correspondence reveals, she employs the moon image to symbolize her relationship with this close-knit female milieu who called themselves the Quintette: Margaret Duckworth, Helen Duckworth, Ella Coltman, Lucy Violet Hodgkin, and Coleridge herself.[12] By any account, this was a remarkable circle of young women with distinguished pedigrees. And, perhaps for this reason, they were able to forge exceptionally close personal and professional bonds with one another. Susan Chitty has provided detailed insights into this circle.[13] Margaret Duckworth and Helen Duckworth were sisters, the daughters of Reverend Arthur Duckworth and Edina Duckworth, the youngest daughter of Lord Campbell. Margaret Duckworth went on to marry the popular imperialist poet Henry Newbolt, who became editor of *The Monthly Review* in 1900, while maintaining her close relationship to her cousin, Ella Coltman, the daughter of a lawyer and granddaughter of one of the Duke of Wellington's generals. Many years later, Margaret Newbolt published, in memory of her husband, *The Later Life and Letters of Sir Henry Newbolt* (1942). Meanwhile, Ella Coltman, who had been conducting an affair with Margaret Duckworth, also developed an intimate relationship with Henry Newbolt, a relationship that transformed his marriage into a *ménage à trois*. In her role as his subeditor, Coltman carried the weight of the magazine's correspondence; she handled submissions, a task that led to the discovery of the writer Walter de la Mare. By comparison, in 1896 Helen Duckworth married Bernard Holland, the son of Francis James Holland, Canon Residentiary at Canterbury Cathedral. Bernard Holland served as Private Secretary to the Secretary of State, Colonies, from 1903 to 1908.[14] The fourth member, Lucy Violet Hodgkin – one of Coleridge's closest friends – introduced the future poet laureate Robert Bridges to Coleridge's work, by leaving out a notebook of her poetry when he was visiting. (It was Bridges who arranged for the publication of *Fancy's Following*, with the Daniel Press in Oxford.) Hodgkin was the daughter of the Quaker historian Dr. Thomas Hodgkin.[15] In 1922, she married John Holdsworth and subsequently wrote histories for adults and children, such as *A Book of Quaker Saints* (1917) and *Gulielma: Wife of William Penn* (1947). Although not officially part of the Quintette, Paula

Schuster was an important correspondent and (with her mother) a benefactor of Octavia Hill's housing for the working poor.[16]

The Quintette developed from a previous group that styled themselves the Grecians: a club of young women learning Greek under the tutelage of William Johnson Cory. When she was thirteen, Coleridge's family visited Cory's home at Hampstead. Cory, who was known until 1872 as William Johnson, previously taught Classics at Eton College, until he was removed from his post after writing an indiscreet letter to a pupil. As Whistler observes: "His regard for his pupils had been emotional, and he did not express himself discreetly. Like Socrates, he adored the beauty of youth, which filled him with a protective yearning, at times sentimental. A letter to a boy is said to have been brought to the attention of the headmaster, who decided that the safest – or simplest – course was to let Johnson go."[17] To escape scandal, he left England for Madeira. Ten years later, he returned as a married man and settled in North London. After making Coleridge's acquaintance, Cory became her eager and inspiring mentor. Over the course of the next decade, his influence broadened both her reading and her approach to learning, as she became proficient in German, French, and Italian. When she was twenty-three, Cory began holding weekly classes on Greek literature for Coleridge and her friends. Besides herself, the group of "Grecian Ladies," as they styled themselves, consisted of Margaret Warre Cornish, Janet Bartrum, Violet Hodgkin, Ella Coltman, and Edith Sichel. Cornish was the daughter of the Provost of Eton. Bartrum became a governess.[18] Coltman introduced Coleridge to the Duckworth sisters.[19] Sichel introduced Coleridge's prose to a wider audience through her edition, *Gathered Leaves: From the Prose of Mary E. Coleridge*, which was published posthumously in 1910.

This circle led to the creation of one further network. Some of the Grecians formed a different group, the Settee, with only Coleridge, Margaret Duckworth, Coltman, and, occasionally, Henry Newbolt counting among its members.[20] His role in this tight circle reveals how much he learned from these female friends. Newbolt was instrumental in theorizing and developing English metrical verse in the 1890s and early 1900s. As Meredith Martin has observed, Coleridge enjoyed a mutually beneficial relationship with Newbolt: "Henry Newbolt learned a great deal about meter from Mary Coleridge."[21]

As Whistler points out, these friendships inspired and shaped Coleridge's writings: "Mary declared in the preface to [her novel, *The Shadow on the Wall* (1904)] that she did not write 'for those who hold that friendship is less romantic than love.'"[22] The Grecians, the Settee, and the Quintette supported her in discovering her emboldened lyric

voice. Her poems emerged from the hours spent discussing and corresponding with these gifted friends, ones whose close ties became evident in the secret language and secret names they devised for one another. Coltman was "Fidus Achates" (the "faithful friend" from Virgil's *Aeneid*), Arthur Coleridge was "Arcturus" (the brightest star) of the Boötes, constellation, and Florence was "Virgil," while Robert Bridges was "Ponte Vecchio" (the "old bridge," a name coined by Arthur with the famous Florentine passage across the Arno in mind). In Coleridge's case, she was either "Anon." or, more publicly, "Anodos" – the one without a name, the one without a path, yet possibly the one also ascending towards greater knowledge.

Coleridge's "Moon" and Poetic Tradition

At the time she published "In Dispraise of the Moon," Coleridge was thirty-five years old and had enjoyed success as a writer of fiction since *The Seven Sleepers of Ephesus* appeared in 1893. (Her works of prose fiction, noticeably, were signed "M.E. Coleridge.") As the 1890s progressed, she became an established author, writing essays for a range of different publications and seeing her books go into multiple editions. Her final novel, *The Lady on the Drawingroom Floor* (1906), received many plaudits. When she died after an attack of appendicitis in 1907, she was at the peak of her career. Immediately, Newbolt and Bridges rushed to put together obituaries and to plan the first collection of her poetry published not under the pseudonym "Anodos" but under her own name.

There have been different types of interest in Coleridge's substantial oeuvre since her death. Her *Poems* went into seven editions by 1918. A sure sign of the respect her work commanded lies in the fact that the leading composer Hubert Parry set to music seven of her lyrics, including "Armida's Garden" ("I have been there before, O my love!") and "The Maiden" ("Who was this that came by the way").[23] As late as 1921, editors routinely included her essays, poetry, and fiction in their anthologies. Whistler's scholarship revived Coleridge's reputation through the 1950s, noting that the poet's "brief verses … cast a shadow greater than themselves."[24] Especially significant in advancing our appreciation of Coleridge's lyrics was a foundational work of feminist literary scholarship, *The Madwoman in the Attic* (1979), by Sandra M. Gilbert and Susan Gubar. These co-authors drew attention to the powerful lyric "The Other Side of a Mirror" (1882), in which the poetic "I" confronts her reflected image, only to discern a "face bereft of loveliness" whose "lurid eyes" nonetheless defiantly shine with the "dying flame of life's desire."[25]

More recent critics – including Christine Battersby, Katharine McGowran, Virginia Blain, Angela Leighton, Alison Chapman, Vanessa Furse Jackson, and Adela Pinch – have broadened our appreciation by focusing on such topics as Coleridge's poetic relationship to Samuel Taylor Coleridge, her use of the Gothic, her poetics of female intimacy, her remarkable approach to poetic subjectivity, and her inventive prosody.[26] In 2010, Simon Avery published a selected edition of Coleridge's poetry, making her lyrics accessible once more to a new generation of readers.[27] Four years later, Emily Harrington included a fascinating analysis of Coleridge's lyrics alongside those of Christina Rossetti, Augusta Webster, Agnes Mary Frances Robinson, Alice Meynell, and Dollie Radford.[28] More recently, Heather Braun has published an edition of *The Lady on the Drawingroom Floor with Selected Poetry and Prose*.[29]

None of these inquiries, however, looks in depth at the extensive archive of Coleridge's papers housed at Eton College. My own research engages in particular with the poet's unpublished letters in order to determine the varied ways she herself understood what Angela Leighton terms "the company of women," what Chapman describes as her poetic "uncanniness and dislocation" as a result of her "close and intense female friendships [that] were erotic attachments," and what McGowran calls "awakening sexuality'" in such haunting poems such as "The Witch."[30] This wealth of documentation reveals the very close connections between her methods of composition and her correspondence.

It was in 1888 that Coleridge began to refer to the metaphorical power of the moon in her letters, particularly in male poetic representations of that sphere. She usually alludes to the moon using female pronouns. At this early point in her career, she often yearned for the ability to see through these male poets' eyes. For example, she writes to Hodgkin about the joy of envisioning "[Robert] Browning's moon":

Up on the cliff the other evening, I saw such a wonderful thing. It was just after sunset, & there were 2 great purple wings of cloud resting over the waves. It was exactly those 2 lines of [Dante Gabriel] Rossetti,

"The sky leans dumb on the sea,
A-weary with all its wings,
And O, the song the sea sings
Is dark everlastingly." You know?

It's so triumphant when Nature once in a way shows one what she showed a poet before. She has let me get a peep at [Robert] Browning's Moon once or twice, but she never let out Rossetti's clouds till then.[31]

Even if a female Nature ultimately controls Coleridge's vision in this passage, the moon belongs to one or more of Browning's poems featuring lunar imagery, just as the clouds derive from Rossetti's lyric "The Cloud Confines."[32] Although we can certainly hear the playfulness with which Coleridge writes to Hodgkin, we can also discern that she feels almost grateful to share in a vision she admires so greatly in these male precursors.

There are, however, moments in Coleridge's early correspondence when one can catch sight of her growing desire to see nature independently of these revered male writers. This impulse is clearest when she writes about Wordsworth's long autobiographical work, *The Prelude,* which had been published in 1850. As she writes to Hodgkin (also in 1888): "I've begun Wordsworth's 'Prelude.' You would like it, you couldn't help it. The descriptions of Nature are so exquisite, the blank verse is so fine & stately. 'Man alone is vile.' When he goes wearying on about himself, I hate him. But what eyes he had!"[33] In her response to Wordsworth's poetry, we can tell that she is focused on those instances when his self-awareness disrupts his "descriptions of Nature."

Eight years later, however, Coleridge began to judge Wordsworth less as a "stately" poet than as an almost comical figure, a man who – as the next letter shows – she found somewhat verbose. As she wrote to Helen Duckworth:

> I felt quite furious with Dorothy Wordsworth, the other day, because she said she was disappointed in Canterbury. What on earth – or in Heaven – did she expect? But I think she + Wordy. [i.e., Wordsworth] had a <u>rôle</u> of running down everything that wasn't a Lake or Skiddaw. Otherwise, she is perfect. Why, O why was she not my Aunt? Why, o why, did S. T. C. [Samuel Taylor Coleridge] meet that fatal [Sara] Fricker before he had seen her. Now + then she reminds me a little bit of you – not always. Her journal is the sweetest thing. When Wordy had to write a letter which bored him to death, he used to copy out bits of it. His own letters, when he did not have recourse to D., are as dull as ditch-water. They used to go to town with S. T. C. + when S. T. C. was overcome by the scenery, he went into public-houses, + wept.[34]

Given that she was the great-great-niece of S.T.C., her wry view of her own literary heritage is striking. Seeing the genius in Dorothy Wordsworth's journal and wishing to be related to her certainly unsettles a literary tradition that lauds Wordsworth's singular poetic achievement.

Coleridge was especially frustrated by the way that male writers had traditionally portrayed women. She admired Greek depictions of femininity but felt that modern representations boiled women down to "abstractions":

Woman with a big W bores me supremely. How γυνή [a woman] would have puzzled the beautiful concrete Greeks. It is a mere abstraction born of monks and the mists of the North. A woman I know, but what on earth is Woman? She has done her best to spoil history, poetry, novels, essays, and Sir Thomas Browne and Thoreau[35] are the only things safe from her; that's why I love them.[36]

While she values women who think and transgress norms, she seems concerned about what she describes as the fin-de-siècle woman:

I read some of Medea; it stiffens one's mind to do a bit of Greek … Medea is thoroughly *fin de siècle*, says she would rather go into battle three times than have a baby once, pitches into men like anything. But there's too much Whitechapel about her. How are you to be seriously interested in a woman who has murdered her mother and boiled her father-in-law before the play begins?[37]

Taking action, it seems, is double-edged. She evidently believed that women should act boldly and that literature should represent them as well-rounded people rather than as "abstractions," but she felt that modern women were at risk for becoming just a new type of caricature – a man-hating, warlike species that refused to marry or give birth. (As we shall see, she describes such a figure in the poem "The White Women," about a matriarchal society.)

Coleridge values representations of women that broke the mould of "abstractions," and she also desires to align herself with like-minded women of the past, such as Dorothy Wordsworth and medieval nuns:

I take a personal interest in the Anglo-Saxon nuns of the ninth century, because if I had happened to be born then instead of the in the nineteenth, I should have had to enter a convent from the impossibility of getting books anywhere else. They were obliged by their abbesses to read two hours a day, and they wore fringes (for the bishops had them up), and corresponded with St. Boniface, or any other saint they could find, in bad Latin, and went to Rome on pilgrimage whenever they were tired of one another, and were

dreadfully afraid of meeting Saracens there. Five hundred of them once danced for joy on the grave of a novice-mistress whom they hated, till the earth sank in half a foot, and the Abbess condemned them to fast three days on account of the hardness of their hearts. My opinion is that unmarried ladies had a high old time of it in those days.[38]

In this fascinating passage, she admires these women because they chose a life of learning, outside marriage, and they were willing to transgress conventional social expectations. These women learned Latin (albeit badly), travelled on pilgrimages, and danced on graves. This rebellious life would not have been possible had they been married. She desired the women she saw depicted in literature to have the same depth of perspective and learning that she claimed for herself. Coleridge would not be "Woman" just as she "would not be the Moon." She did not accept the images of "Woman" that had been handed down through generations and abstracted from lived experience, since any truth of representation had long since faded away.

"Met'er by Moonlight": Lunar Intimacy

Even as Coleridge was exploring the moon image to critique the vision of canonical male poets, she also frequently discussed the lunar sphere each time she described female intimacy. A good example occurs in another letter to Hodgkin, which she wrote soon after she had learned of Margaret Duckworth's engagement to Henry Newbolt:

F. [Florence or Coltman][39] & I walked up & down in the moondark (there wasn't any light at all to speak of) on Friday night, I almost felt as if we were engaged ourselves. Dear me, I wish I were going to marry a poet! It always seemed to me it would be the most delightful thing in the world, next to being Mrs. R. B. Browning yourself. I have had serious designs on [Algernon Charles] Swinburne before now, but alas! I have never yet manage[d] to meet him. When I have a cap, (which I mean to have one shortly,) I shall set it at him like any thing.[40]

The moon is noticeably invisible in this letter, just as a poet-partner is invisible in Coleridge's life. At the same time, however, this passage makes it plain that she has many intimate friends through the Quintette as well as through her desire to place herself in literary history – namely, by imagining that she was Browning's spouse, the poet Elizabeth

Barrett Browning, and by "set[ting]" her "cap" at Swinburne, whose highly sexual poetry remained a source of controversy through the end of the nineteenth century. One must conjecture that these desires involve both personal fantasies and poetic aspirations. As one reflects on the different types of relationships that she explores in this letter, it is apparent that it is the moon that connects these women, even when it remains obscured. In her comments to Hodgkin, Coleridge emphasizes that the lack of a moon creates an atmosphere that is "moondark": an inventive word that paradoxically gives the moon a special absent presence.

The moon recurs, with different implications, in Coleridge's correspondence with this member of the Quintette: "I believe it's the eclipse of the Moon that has made you ill. I knew you must be feeling it last night."[41] On this occasion, the moon has the power to heal, and the women feel its absence physically. Coleridge later wrote to the same dear friend: "I am in the depths of despair. No moon at all. I am better, but have a bad cold; spiritually this [here and elsewhere in the letter she inserts a visual symbol] = Stormy."[42] The hand-drawn symbols she presents to Hodgkin are versions of moons, ones based on her emotions, including what she describes as a three-mooned "tomoyé."[43] (This is a *tomoe*, a Japanese lotus symbol with three half-waning moons that meet in the middle, forming a wheel shape.[44]) Worried about her friend's well-being, Coleridge encourages Hodgkin to draw the moon above her handwriting when she composes her next reply: "You seemed to me to be utterly moonless when you last wrote. Next time I hope to see a little wee moon at the top of your paper."[45] Clearly, the moon has become a token of the two women's intimacy. Together, they cannot only make the moon shine; they can also share the moon between them through their exchange of letters.

On the same page, Coleridge thanks Hodgkin for making a gift of John Milton's works, and then makes a series of remarks that relate to her sense of her own unattractiveness and her increasing criticisms of male authors: "I would like so much to see him. Only I'm afraid he'd hate me. Boys always do. So do men."[46] On the next page, she jokes about her capacity to repulse others: "So do girls mostly. Sometimes very old ladies rather like me."[47] Later in the same document, she begins to describe her frustration with Ralph Waldo Emerson's work. In this case, she refers satirically to Emerson as "his serene highness" and labels him "an altogether odious person."[48] She particularly doubts Emerson's ability to judge friendship: "I understand now why I didn't care 2 straws for 'Representative Men' + never felt inclined to finish the Essay on Friendship. He knew what a friend was indeed! Why, he never had one or was one,

in his life."[49] As we look at these different parts of the correspondence, we can readily grasp that the moon, which Coleridge hopes Hodgkin will inscribe at the top of her next communication, holds a central place in her understanding of closeness between women, which she believes is innately separate from Emerson's (and, by extension, men's) concepts of friendship.

Hodgkin must have felt similarly about the moon's power to unite the women in their coterie. In 1891, she relates a humorous story to Coleridge that processes the interconnection of the moon and female intimacy:

> Miss Morenee Smith electrified us with it last night but she said it so demurely that we were quite ½ a minute before we saw that there was any joke to see. "What are the different kinds of metre?" "Well, there is long metre, + short metre, + common metre + peculiar metre + metre by moon-light alone." Helen + I looked, or rather did not dare to look at one another for we were guiltily conscious that we each had, as you might say, met'er[50] by moonlight alone not so very long before![51]

Two years later, Coleridge wrote to Hodgkin: "I knew you had to do with that Moon; you were in her, or else she was in you, or something. How dearly something or other always draws you & me together about this time!"[52] These moons evidently no longer belong to either Browning or Rossetti. Instead, Coleridge and her female circle have claimed them in the name of their intense sororal bonds.

Even though Hodgkin's "guilty" looks in the letter above imply a fear that women's intimacy will be coded as aberrant, Coleridge does not display this concern in her correspondence. To the contrary, she celebrates the transgressions involved in creating an intimate female community, as we can see in poems such as "The White Women" (1900). In this lyric, which draws its materials from one of Hugh Clifford's adoptions of Malay folk tales,[53] she describes a group of "wild white women folk" who are "mortal to man."[54] They hunt, fight, and procreate without men. Men may not look on them and survive or hear them and understand:

> Their words are not as ours. If man might go
> Among the waves of Ocean when they break
> And hear them – hear the language of the snow
> Falling on torrents – he might also know
> The tongue they speak.

In fact, the poem closes with the tale of a man who died from gazing on their terrible beauty: "One of our race, lost in an awful glade, / Saw with his human eyes a wild white maid, / And gazing, died." The "White Women," we discover, "have never sinned," but have through partheno-genesis given birth to their daughters by "fling[ing] their girdles to the Western wind, / Swept by desire." Not only are these women separate from the society of men and women of which the speaker is a part; they are also not bound by the cultural traditions that link desire with sin and strength with masculinity.

Equally invested in the female intimacy inscribed in the moon is "The Witches' Wood" (1895). Written five years before "The White Women," this lyric describes an enchanted forest in which the moon is trapped in a small pool. Coleridge uses a technique much like rack focus in filmmaking, in which the focus shifts between the fore-ground and the background. She brings our attention first to the enchanted trees, then, gradually, she shifts our gaze to the pool that traps the moon. She intensifies the contrast between these zones by making the forest and each tree bare and barren. By contrast, only the pool contains life of any kind, and, ironically, the life that exists there belongs to the moon, which eerily appears as a reflection of a reflection. Her descriptions of the trees echo this kind of haunting emptiness. She adopts gendered stereotypes, with masculine charac-teristics linked to commerce and feminine characteristics linked to appearance:

> Their roots were like the hands of men,
> Grown hard and brown with clutching gold.
> Their foliage women's tresses when
> The hair is withered, thin, and old.[55]

Much like the Victorian concept of gendered spheres put forth in poems such as Coventry Patmore's *The Angel in the House* (1854–62), the mascu-line sphere faces outward, to the public world of work and society, and the feminine sphere faces inward, to the privacy of the home. What is significant, however, is that both of these masculine and feminine char-acteristics reinforce the trees' diminished vitality.[56]

In an interesting reimagining of the ideas we see throughout "In Dispraise of the Moon," the witches have chased away the sun; they prefer to keep the moon with them at all times in a small pool. They do not, how-ever, "dispraise" the moon; instead, they control it. The speaker, while

seeming to display disgust at the witches' appearance and behaviour, nonetheless shares an insider's knowledge about this moon:

> And in the midst a pool there lay
> Of water white, as tho' a scare
> Had frightened off the eye of day
> And kept the Moon reflected there.

In contrast to the "Moon," the sun exists only metaphorically as an "eye." By comparison, "In Dispraise of the Moon" aligns the sun with "Reason." Taken together, these two lyrics suggest that the sun both sees and knows. Conversely, the moon feels and imagines. Where the sun projects, the moon reflects. Preferring the moon to the sun, the witches keep it trapped within their wood. Coleridge names and capitalizes the "Moon," establishing it as a character that reflects the witches' defiance. This "Moon" is certainly no "sickly thing." Instead, it is a power that the "witches" harness so that they can transgress and thus transform boundaries of nature and gender. Moreover, the "Moon" exerts a power harnessed by the poet: a lyric voice that creates (as it were) her own lyrical "pool" that both echoes the witches' transgressions and preserves "the Moon reflected there."

"My Extreme Singleness": Coleridge's "Moon"

In 1896, the year she wrote "In Dispraise of the Moon," Coleridge composed a letter in which she referred to the moon in order to speak of women's intimacy and to redefine the lunar image, while drawing attention to the fact that she was explicitly rewriting a passage from Shakespeare's *The Taming of the Shrew*. In her correspondence with Helen Duckworth (now known, through marriage, as Helen Holland), Coleridge describes a "wedding party" riding near her on the train.[57] At the end of this account – after she mentions her "extreme singleness" – she notes that the groom and best man were fast asleep, with their heads propped on the bride's shoulders.[58] At this moment, Coleridge reveals that "the bride's name is Kate."[59] Coleridge foresees the moment when Shakespeare's Kate will say, in glaring sunlight: "I know it is the moon."[60] In *The Taming of the Shrew*, this line reveals that Katherina has been "tamed" by Petruchio – a change that means she is now willing to accept his interpretation of the world, after having been kept from eating or sleeping through his efforts to "tame" her. In this scene, Petruchio demands that Kate agree,

even on a sunny day, that the moon shines above, in order to prove his dominion over her. The resonance of this episode is clear in Coleridge's letter. Immediately after naming the bride as Kate, Coleridge depicts the moon, which perhaps responds to the bride's impending betrayal. The implication is that all brides could potentially be Kate:

My Helen,

I reached home quite safely ... Nobody tried to murder me, nor stole so much as a blade of grass. My bones are all intact, + I have not lost 2 front teeth. I think it will be a relief to you + Bernard to hear this. There was a wedding party of course. A wedding party always accompanies me whenever I travel by rail. There's something about my extreme singleness that attracts them, I think. Their caresses were rather trying, but the beery bridegroom fell asleep at last with his head on his bride's shoulder, + likewise the best man. The bride's name is Kate. The Moon did several very odd things about Rochester. I don't believe she likes the place. If she didn't turn round on her other side, + squint, my initials are not

MEC.

Coleridge – given her outsider status as an unmarried woman disconnected from the bridal celebration – recalls seeing the moon and then voicing the moon's rejection of the setting (in this case, the city of Rochester, Kent) and, perhaps, the party itself. The moon, by squinting at the proceedings, views the place and the party from a fresh perspective that allows for scrutiny, judgment, and ultimately rejection. Squinting can communicate overt disapproval and covert messages.[61] These are two meanings that Coleridge embeds in her vision of the moon. If we read the reference to Kate as a critical allusion to Shakespeare's comedy, it is Coleridge herself who "squint[s]" with the moon. She further shares this alignment with the moon through the way she closes her letter. Coleridge frequently integrates her initials into the closing lines of her correspondence as she does here, but on this occasion this habit is particularly noticeable because it indicates that she explicitly wishes to integrate her identity into her declarations about the moon.[62] If, her letter suggests, the moon did not "squint," Coleridge would not be herself. In other words, Coleridge's identity is linked to her belief that she has interpreted the moon correctly and understood its repudiation of those, like Kate, who would deny the moon's power in the name of maintaining intimacy with a man.

There is further significance in the fact that Coleridge addressed this letter to Duckworth. In 1893, they had shared kisses in the schoolroom in Coleridge's house, talked frequently of literature and the theatre, and created with each other an intimate relationship. To describe their closeness, Coleridge and Duckworth frequently employed literary allusions to as well as metaphors of mother and child. Martha Vicinus describes the power of this metaphor in intimacy between women during this period: "The two most common models for the successful intimate friendship were fundamental to the heterosexual family: the wife-husband couple and the child-mother bond … Daughters turn into nurturing mothers, mothers into needy children, back and forth, requesting, demanding, coercing, then giving, bestowing, blessing."[63] This seems to be the case for the two women. Before her marriage, Helen told Coleridge: "There's something of the child & something of the mother in my love for you … I worship you, & I want to nurse you."[64] In 1894, when Duckworth was engaged to Bernard Holland, Coleridge was still corresponding with her friend, particularly to describe her adventures as a single woman.[65] In the 1896 letter, in particular, Coleridge describes her freedoms in a way that implicates Duckworth in what she may have seen as the oppression of marriage by linking her intimate friend to the bride named Kate.

Yet the yearning for closeness with another woman could and did lead to frustration in Coleridge's lyrics. In "Awake" (1897), she explores the moon's close connection with the lyric "I." This poem features a speaker who is a moon-like entity searching for a partner who will, she hopes, echo her feelings:

> The wailing wind doth not enough despair;
> The Sea, for all her sobbing, hath the Moon,
> I cannot find my heart's cry anywhere,
> Fain to complain alone.
> The whistle of the train that, like a dart,
> Pierces the darkness as it hurries by,
> Hath not enough of sadness, and my heart
> Is stifled for a cry.[66]

The "Sea" ensures that the "Moon" echoes her cries; the lyric voice, by contrast, cannot find a similar partner. The wind "doth not enough despair" and the train's whistle "[h]ath not enough of sadness." Here Coleridge's "extreme singleness" means that even though she must "complain," she does so without any "cry" that will echo back to her. This

is her plight because she has no "Moon." And, more distressing still, the "Moon" remains linked to the distraught "Sea."

The poem thus evokes the deepest despondency. To be "awake" in these lines means to look out over the night and recognize one's desperate isolation. The outsider's perspective here is one of silenced observation. Rather than connect the speaker to a female community, the "Moon" – positioned to rhyme jarringly with "alone" – can only moan. Even if, the speaker intimates, one finds a mate in this world, it is only to have one's cries echoed back, so that one can be grateful for isolation and the critical perspective it yields. The poem's two jolting trochaic feet ("Fain to" and "Pierces") noticeably disrupt the iambic rhythm and draw attention to the violence of the wailing wind and the grating whistle as well as to the estrangement the speaker finds through her very moon-like vantage point. While the speaker's asphyxiation at the end of the poem certainly silences her heart, it also brings relief, since it stifles her crying.

Coleridge continued to develop this notion of the moon as a distant observer in two further poems, "A Witness" (1897) and "The Song of Nightingales" (for which the date of composition remains unknown).[67] In "A Witness," the moon is a "sentinel" that should see everything.[68] If the moon does not watch over the world – does not stay "awake" – there is no justice. The potential witness explains:

> I did not see. How could I know?
> Down in the little wood
> He – and he – together stood,
> One above, one below.
> The face of heaven was overcast.
> The Moon among the driven clouds sailed fast.
>
> I did not see. I turned my eyes away;
> And the Moon did not look.
> If she – the sentinel – her post forsook,
> What was I then that I should stay?
> The face of heaven was overcast.
> The Moon among the driven clouds sailed fast.

The observing "Moon" would have provided a "witness" to the apparent murder. It would have provided some sort of sign of coming justice, when silent "heaven" does not provide enough motivation for the speaker to look at the crime and witness it herself.

By comparison, in "The Song of Nightingales," when the moon does not watch over the earth, the birds fill the void with their singing. The speaker claims these songs as her own:

> The song of nightingales
> When the moon fails
> Along the lake and down the grassy shore –
> This is not yours to hear, who often hear,
> But it is mine, my dear,
> Who heard it once and hear it evermore.[69]

In this case, the moon's "failure" is associated with women's victimization and silencing through the figure of Philomela: the raped and mutilated woman from Ovid's *Metamorphoses* who is traditionally associated with the nightingale. Philomela's brother-in-law, King Tereus, rapes her and then cuts out her tongue to prevent her from revealing his crime. She weaves her story, instead, into a tapestry, and her sister, Procne, kills and cooks her son and feeds him to his father, Tereus, to avenge her sister's suffering. (The gods turn all three into birds.) The loss of the moon is loss of physical security and loss of voice through sexual violence. In her letter to Duckworth, Coleridge of course playfully dismisses the very real threat of such violence as she travels on the train alone. Perhaps the moon in the letter also "squints" to keep a protective eye on Coleridge. The speaker in "The Song of Nightingales" assuredly knows about this loss, but her addressee – her "dear" – cannot and perhaps should not hear the evidence about it. Maybe the speaker can even protect the "dear" one, now that she has deemed that the song "is not yours to hear."

We can see further evidence of Coleridge's interest in the moon as a female guardian in an extract Sichel includes in the memoir she furnished for her 1910 selection of Coleridge's prose. Leighton draws our attention to the following passage in order to describe the way we can glimpse a "lesbian subtext" in Coleridge's writings:[70]

> Tonight there was a glorious sunset there, and it reminded me of what you said about Nature's gradual changes. Quite true – except as to the moon, and goodness gracious, can't she startle one every now and then, and gleam at one out of boughs in a white passion of rage, just when one least expects it! I don't feel sure of the sun, but there is not the faintest doubt that that moon

was once a woman, she is the most human thing in creation ... Haven't you sometimes felt inclined to run away anywhere out of reach of those dreadful eyes, with all of the expression frozen out of them? Somebody treated her very badly, depend upon it.[71]

Here, as well as in the previous examples I have cited, the moon takes a distinctly female form. As a guardian, the moon's failure precedes sexual violence. As a forced observer of human aggression, she "gleam[s] ... in a white passion of rage."[72] This passage confirms that Coleridge's moon has become not only an image of women's intimacy but also a female sentinel, one offering sorority and protection.

In the end, Coleridge guides us to reimagine the different moons of English literary history through her adept modification of lyric form. She encourages us to notice literary galaxies that expand beyond each earlier poetic work and to witness the ways her moons manoeuvre among them while also, perhaps, outmanoeuvring them. When studying "In Dispraise to the Moon," we notice that to question the hovering lyric "I" – to notice the emerging shapes in the darkness observed in the lines – is to join the "voiceless hosts." In this great lyric, Coleridge's moon exists outside traditional spaces – beyond "Reason" and beyond the "light.'" Her moon does not pretend to "feed." Instead, it only reveals what was always there. Such a moon has the power to call to those on the fringes of time, summoning a community of "voiceless hosts." This truly is Coleridge's own moon: the moon that women can create in order to evoke their own creative light in their correspondence. It is a moon that has the power to connect these female friends across geographical spaces as well as the social spaces that separate them through the institution of heterosexual marriage. As I hope to have shown here, when Coleridge's lyric voice declares "I would not be the Moon," that voice is also implying that there might be something else about the feminine ghostly sphere that warrants our attention. This possibility arose from her sense that "Anodos" could give voice to identities and desires that were not bound by conventions of space and time. Nor were her lyrics limited by precepts that dictated what was properly male or female. Ultimately, the moon she supposedly dispraises "hath no air." But that, it seems, is no disadvantage, since the lunar satellite also makes for Coleridge's female circle the "darkness plain": a shadowy universe of their own that thrives beyond the reach of masculine rays of light.

NOTES

I would like to thank Joseph Bristow and my colleagues at the NEH Summer Seminar, "The Decadent 1890s: English Literary Culture and the Fin de Siècle," for helping me to develop these ideas through their excellent questions and comments. My thanks also go to Michael Meredith and the staff members of the Eton College Library for their kind assistance with my research in the Coleridge archive. All quotations from the archive (MEC) are reproduced by kind permission of the Provost and Fellows of Eton College.

1 Mary E. Coleridge, "In Dispraise of the Moon," in *The Collected Poems of Mary Coleridge*, ed. Theresa Whistler (London: Rupert Hart-Davis, 1954), 189. The poem first appeared in Coleridge's posthumous collection, *Poems* (London: Elkin Mathews, 1908), 60. Whistler states that Coleridge composed the poem in 1896. She explains that she uses the dates provided by her mother Margaret Newbolt (*née* Duckworth), in notes that Margaret Newbolt took when she was using Coleridge's manuscripts while assisting her spouse Henry Newbolt when he was editing Coleridge's *Poems*. See Whistler, "Introduction – Mary Coleridge: Her Life and Personality," in *The Collected Poems of Mary Coleridge*, 15, 80. I have followed Whistler in the dating of Coleridge's poetry.

2 The meaning of *anodos* as "an ascent" appears in a range of Greek texts, including Plato's *The Republic*, bk. 7, 517b, where Socrates says to Glaucon: "τὴν δὲ ἄνω ἀνάβασιν καὶ θέαν τῶν ἄνω τὴν εἰς τὸν | νοητὸν τόπον τῆς ψυχῆς ἄνοδον τιθεὶς οὐχ ἁμαρτήσῃ τῆς γ᾽ ἐμῆς ἐλπίδος, ἐπειδὴ ταύτης ἐπιθυμεῖς ἀκούειν" (If you take the upward journey and the seeing of what is above as the upward journey of the soul to the intelligible realm, you will not mistake my intention, since you are keen to hear this). Plato, *The Republic*, ed. and trans. Chris Emlyn-Jones and William Preddy, 2 vols. (Cambridge, MA: Harvard University Press, 2013), 1:116–17.

3 For a further description of her writing process, see Kasey Bass Baker, "'Oh, Lift Me over the Threshold, and Let Me in at the Door!': Boundaries and Thresholds in Mary Coleridge's Poetry," *Victorian Poetry* 48, no. 2 (2010): 195–218.

4 Mary Coleridge, *Gathered Leaves: From the Prose of Mary E. Coleridge*, ed. Edith Sichel (London: Constable, 1910), 219–20. Coleridge is alluding to the Countess's aria in the third act of *The Marriage of Figaro*; the line in Italian translates as "Where are the lovely moments?" The phrase "too deep for tears" comes from the final line of William Wordsworth, "Ode: Intimations of Immortality from Recollections of Early Childhood," in *Poems, in Two*

Volumes, and Other Poems, 1800–1807, ed. Jared Curtis (Ithaca: Cornell University Press, 1983), 277.

5 Coleridge, *Gathered Leaves*, 221. The phrase "myriad-minded Shakespeare" comes from Samuel Taylor Coleridge, *Biographia Literaria: Or Biographical Sketches of My Literary Life and Opinions*, ed. James Engell and W. Jackson Bate, in *The Collected Works of Samuel Taylor Coleridge*, 16 vols. (Princeton: Princeton University Press, 1969–2002), 15.2:19. A "Box and Cox arrangement" is a reference to the comedic play *Box and Cox*, in which two men rent a room, one at night and the other during the day, both believing that each is the sole renter of his room. See John Maddison Morton, *Box and Cox: A Romance of Real Life* (New York: Douglas, 1848).

6 See, for example, Falstaff's "catechism" in Shakespeare, *Henry IV, Part 1*. When the Prince tells Falstaff that he "owest God a life," Falstaff does not want to pay:

> 'Tis not due yet. I would be loath to pay him before his day. What need I be so forward with him that calls not on me? Well, 'tis no matter; honour pricks me on. Yea, but how if honour prick me off when I come on? How then? Can honor set to a leg? No. Or an arm? No. Or take away the grief of a wound? No. Honour hath no skill in surgery, then? No. What is honour? A word. What is in that word "honour"? What is that "honour"? Air. A trim reckoning! Who hath it? He that died o'Wednesday. Doth he feel it? No. Doth he hear it? No. 'Tis insensible, then? Yea, to the dead. But will it not live with the living? No. Why? Detraction will not suffer it. Therefore I'll none of it. Honour is a mere scutcheon. And so ends my catechism.
>
> (ed. David Scott Kastan, Arden 3rd ser. [London: Thomson Learning, 2002], 5.1.127–40)

7 See the quotation in note 6.

8 Virginia Blain, ed., *Victorian Women Poets: A New Annotated Anthology* (New York: Longman, 2001), 295. Blain also contends that Coleridge is responding to the history of the moon's "associat[ion] with madness" and that the "voiceless hosts" are "the crowds of the dead in Hades," with the moon associated with Artemis or Diana (296).

9 On this debate, see Thomas Laqueur, *Making Sex: Body and Gender from the Greeks to Freud* (Cambridge, MA: Harvard University Press, 1990), 216–27.

10 Whistler, "Introduction," 30.

11 Whistler, 32.

12 Whistler, 39.

13 Susan Chitty, *Playing the Game: A Biography of Sir Henry Newbolt* (London: Quartet Books, 1997), 77–8. Chitty provides detailed information about the members of Coleridge's close-knit circle (77–80, 91, 126–7).

14 Derek Ryan, "Virginia Woolf and Canterbury," *Virginia Woolf Miscellany* 89 (2016): 31–3.

15 Ryan, "Virginia Woolf and Canterbury," 129.

16 This information appears in Caroline Morrell, "Housing and the Women's Movement, 1860–1914," PhD diss., Oxford Brookes University, 1999, 366; and in Chris Cook and Jeffrey Weeks, "Octavia Hill," in *Sources in British Political History, 1900–1951* (London: Macmillan, 1978), 97.

17 Whistler, "Introduction," 35–6.

18 Isobel Hurst, *Victorian Women Writers and the Classics: The Feminine of Homer* (New York: Oxford University Press, 2006), 69.

19 Chitty, *Playing the Game*, 81.

20 See Chitty, 94–5.

21 Meredith Martin, *The Rise and Fall of Meter: Poetry and English National Culture, 1860–1930* (Princeton: Princeton University Press, 2012), 199.

22 Whistler, "Introduction," 43; see also Coleridge, "A Letter to the Reader," in *The Shadow on the Wall: A Romance* (London: Edward Arnold, 1904), ix.

23 Coleridge, *The Collected Poems*, 155, 199. The other five lyrics that Parry set to music are "Three Aspects," "St. Andrew's," "The Witches' Wood," "Whether I Live," and "There."

24 Whistler, "Introduction," 21.

25 See Sandra M. Gilbert and Susan Gubar, *The Madwoman in the Attic: The Woman Writer and the Nineteenth-Century Imagination*, 2nd ed. (New Haven: Yale University Press, 2000), 15–16. Coleridge's "The Other Side of a Mirror" appears in *The Collected Poems*, 88–9.

26 See Christine Battersby, "Her Blood and His Mirror: Mary Coleridge, Luce Irigaray, and the Female Self," in *Beyond Representation: Philosophy and Poetic Imagination*, ed. Richard Eldridge (New York: Cambridge University Press, 1996), 249–72; Katharine McGowran, 'The Restless Wanderer at the Gates: Hosts, Guests, and Ghosts in the Poetry of Mary E. Coleridge," in *Victorian Women Poets: A Critical Reader*, ed. Angela Leighton (Cambridge: Blackwell, 1996), 186–97; Vanessa Furse Jackson, "Breaking the Quiet Surface: The Shorter Poems of Mary Coleridge," *ELT* 39, no. 1 (1996): 41–62; Angela Leighton, *Victorian Women Poets: A New Annotated Anthology*, ed. Virginia Blain (New York: Longman, 2001); and Alison Chapman, "Mary Elizabeth Coleridge and the Flight to the Lyric," *Yearbook of English Studies* 37, no. 1 (2007): 145–60. See also Chapman, "Mary Elizabeth Coleridge, Literary Influence, and Technologies of the Uncanny," in *Victorian Gothic: Literary*

and Cultural Manifestations in the Nineteenth Century, ed. Ruth Robbins and Julian Wolfreys (Basingstoke: Palgrave, 2000), 109–28; and Adela Pinch, "Rhyme's End," *Victorian Studies* 53, no. 3 (2011): 485–94.

27 See Mary Coleridge, *Mary Coleridge: Selected Poems*, ed. Simon Avery (Exeter: Shearsman, 2010).

28 See Emily Harrington, *Second Person Singular: Late Victorian Women Poets and the Bonds of Verse* (Charlottesville: University of Virginia Press, 2014).

29 See Mary E. Coleridge, *The Lady on the Drawingroom Floor with Selected Poetry and Prose*, ed. Heather Braun (Madison: Fairleigh Dickinson University Press, 2018).

30 Angela Leighton, "Mary E. Coleridge (1861–1907)," in *Victorian Women Poets: An Anthology*, ed. Angela Leighton and Margaret Reynolds (Oxford: Blackwell, 1991), 611; Chapman, "Mary Elizabeth Coleridge," 154; McGowran, "The Restless Wanderer," 188.

31 Coleridge, "To Lucy Violet Hodgkin," 22 April 1888, Eton College, MEC 43, f. 1c. The lines Coleridge quotes originate in Dante Gabriel Rossetti, "The Cloud Confines," in *The Collected Works of Dante Gabriel Rossetti*, ed. William M. Rossetti (London: Ellis and Scrutton, 1886), 317–18.

32 Examples of moons in Browning's poetry include "Caliban upon Setebos" (1864) ("Setebos, Setebos, and Setebos! / 'Thinketh, He dwelleth i' the cold o' the moon"); "Andrea del Sarto" (1855) ("My face, my moon, my everybody's moon, / Which everybody looks on and calls his"); "An Epistle Containing the Strange Medical Experience of Karshish, the Arab Physician" (1855) ("Out there came / A moon made like a face with certain spots / Multiform, manifold and menacing"); and "One Word More" (1855) ("This I say of me, but think of you, Love! / This to you – yourself my moon of poets!"); see Browning, *The Poems*, ed. John Pettigrew and Thomas J. Collins, 2 vols. (New Haven: Yale University Press, 1981), 1:805–12, 643–50, 565–73, and 737–43.

33 Coleridge, "To Lucy Violet Hodgkin," 19 August 1888, Eton College, MEC 54, f.2c.

34 Coleridge, "To Helen Holland (née Duckworth)," 19 August 1888, Eton College, MEC 586, f.1a–b.

35 Sir Thomas Browne, the seventeenth-century doctor and author of books on philosophy and medicine, is known especially for *Religio Medici* (1643). See Caoimhghín S. Breathnach, "Sir Thomas Browne," *Journal of the Royal Society of Medicine* 98, no. 1 (2005): 33–6. Henry David Thoreau, nineteenth-century American author, is known particularly for *Walden; or, Life in the Woods* (1854) and "Civil Disobedience" (1848).

36 Coleridge, *Gathered Leaves*, 234.

37 Coleridge, 235. Whitechapel refers to the area of East London linked with "Jack the Ripper," the infamous Victorian serial killer.

38 Coleridge, 236.

39 "F." might stand for Florence or for Ella Coltman, whom Coleridge called "Fidus Achates." See *The Collected Poems*, ed. Whistler, 49.

40 Coleridge, "To Lucy Violet Hodgkin," 19 August, 1888, Eton College, MEC 54, f.1a-b.

41 Coleridge, "To Lucy Violet Hodgkin," n.d., Eton College, MEC 38, f.1d.

42 Coleridge, "To Lucy Violet Hodgkin," n.d., Eton College, MEC 40, f.1a.

43 Coleridge, "To Lucy Violet Hodgkin," n.d., Eton College, MEC 40, f.1a.

44 Interestingly, *tomoe* (often translated as "whirlpool" or "swirl") is important in Japanese culture both as a lotus symbol, as Tarnai and Miyazaki note, and as the character name for the female warrior, Tomoe Gozen, from Heike *monogatari*, as Brown notes. See Tibor Tarnai and Koji Miyazaki, "Circle Packings and the Sacred Lotus," *Leonardo* 36, no. 2 (2003): 145–50; and Steven T. Brown, "From Woman Warrior to Peripatetic Entertainer: The Multiple Histories of Tomoe," *Harvard Journal of Asiatic Studies* 58, no. 1 (1998): 183–99. In Japan, *tomoe* is not directly linked to the moon.

45 Coleridge, "To Lucy Violet Hodgkin," n.d., Eton College, MEC 40, f.1b.

46 Coleridge, "To Lucy Violet Hodgkin," n.d., Eton College, MEC 40, f.1b.

47 Coleridge, "To Lucy Violet Hodgkin," n.d., Eton College, MEC 40, f.2a.

48 Coleridge, "To Lucy Violet Hodgkin," n.d., Eton College, MEC 40, f.3b.

49 Coleridge, "To Lucy Violet Hodgkin," n.d., Eton College, MEC 40, f.3b. Emerson's "Essay on Friendship" reads more like a philosophical treatise than a personal expression of emotion. For example, he writes: "The moment we indulge our affections, the earth is metamorphosed: there is no winter, and no night: all tragedies, all ennuis vanish, – all duties even; nothing fills the proceeding eternity but the forms all radiant of beloved persons." Emerson, "On Friendship" [1841], in *Essays: First Series*, ed. Joseph Slater, Alfred R. Ferguson, and Jean Ferguson Carr, in *The Collected Works of Ralph Waldo Emerson*, 10 vols. (Cambridge, MA: Harvard University Press, 1971–2013), 2:114.

50 In the contracted form of "met" and "her," "met'er" implies a moonlit rendezvous. Hodgkin may have had Shakespeare's *A Midsummer Night's Dream* in mind: "Ill met by moonlight, proud Titania" (ed. Sukanta Chaudhari, Arden Shakespeare, 3rd ser. [London: Bloomsbury Arden Shakespeare, 2017], 2.1.60. In the play, this line sets off a jealous argument between Oberon and Titania, culminating with Titania's explanation that Oberon's infidelity and the resulting discord have disrupted the natural world: "Therefore the moon, the governess of floods / Pale in her anger, washes all the air, / That rheumatic diseases do abound" (2.1.103–5). In the context of the joke that Hodgkin tells, the women's secret meeting

might make others jealous, resulting in the women's feelings of guilt. She brings Coleridge in on the moment when the public joke that hinges on wordplay becomes a private joke between the women. In the letter, she had previously explained the nightly meetings. She described the onerousness of constant visitation, then exclaimed, "why the nights can always be the best part of the days you know!" Similarly, the rest of the letter describes the gap between public and private behaviour in 1891. The letter itself is a rendezvous with its recipient, and an escape to allow two people to meet in privacy. Hodgkin left Orchardleigh, the Duckworth estate, which she was visiting, to allow Helen Duckworth and Herbert (whose surname was not mentioned) to meet in private. This, in turn, gave Hodgkin the time to write to Coleridge: "My M [Mary], I've been waiting for this for days, & I didn't think it would come to-day. In fact, it wouldn't have come if Herbert had not appeared at the door of Helen's [Duckworth] room with 'I want to find you alone' written so plainly all over him that there was nothing left for me but to vanish & pay you a visit at St. Andrews." As in the joke she relayed from Miss Smith, she found humour in the juxtaposition of public and private behaviour. She went on to describe a young Cecilia, Margaret and Henry Newbolt's daughter, who "ma[de] an old clergy man kiss her through the bannister" and lavished attention on unsuspecting people in the streets: "this morning she calmly went up to a shy Eton boy & threw her arms round him without any warming" ("To Mary Coleridge," 26 August, 1891, Eton College, MEC 200, 1c, 1a, 1d).

51 Hodgkin, "To Mary Coleridge," f.1d–2a.

52 Coleridge, "To Lucy Violet Hodgkin," 24 December 1893, Eton College, MEC 95, f.1b.

53 In "The Camp of the Semangs," Hugh Clifford recalls listening to an "aged patriarch" (177) who tells the story of a tribe of women who lived "in the broad forests towards the rising run, beyond the Kinta valley":

> These women know not men; but when the moon is at the full they dance naked … The Evening Wind is their only spouse, and through Him they conceive and bear children. Yearly are both to them offspring, mostly women-folk whom they cherish even as we do our young; but, of, perchance, they bear a manchild, the mother slays it ere it is well-nigh born … Woe to the man who meets these women, or dares to penetrate into the woods in which they dwell, for he will surely die unless the hosts give speed of his flight.
>
> (Clifford, *In Court and Kampong: Being Tales and Sketches of Native Life in Malay Peninsula* [London: Grant Richards, 1897], 177, 179)

54 Coleridge, "The White Women," in *The Collected Poems*, 212–13.

55 Coleridge, "The Witches' Wood," 174.

56 In *Gathered Leaves*, Coleridge writes: "I cannot think of souls that are not masculine or feminine ... but just as the negation of sex is inconceivable to me, so is its unification; I cannot think that we shall be men as well as women, and men women as well as men. If we do not retain sex I don't see how we can retain identity. Male and female we were created; it is of the very essence of our nature" (233). However, she later starts to see the divisions more flexibly. She writes of Henri Frédéric Amiel: "I have been reading Amiel all day ... He ought to have been a woman and married Thoreau. Thoreau is the masculine half of him" (234). Coleridge has most probably been reading Amiel's *Fragments d'un journal intime*, which was published in French in 1882 and translated into English as *Amiel's Journal* by Mrs. Humphry Ward [Mary Augusta Ward] in 1885.

57 Coleridge, "To Helen Holland," 19 July 1896, Eton College, MEC 585, f.1a–b.

58 Coleridge, "To Helen Holland."

59 Coleridge, "To Helen Holland."

60 William Shakespeare, *The Taming of the Shrew*, ed. Barbara Hodgson, Arden 3rd ser. (London: Methuen Drama, 2010), 4.5.17.

61 Definition 2c of the *Oxford English Dictionary* links "squinting" with taking a position of judgment: "To glance at, on, or upon (a person or thing) with dislike or disapproval, or by means of some covert allusion, hint, or suggestion."

62 In several of her publications, such as her novels, Coleridge presented her name as "M. E. Coleridge"; as a result, she appears to be – at least typographically – "ME Coleridge," the author Coleridge that is "me."

63 Martha Vicinus, *Intimate Friends: Women Who Loved Women, 1778–1928* (Chicago: University of Chicago Press, 2006), xxvi–xxix.

64 Coleridge, "To Lucy Violet Hodgkin," 21 March 1893, Eton College, MEC 87, 1d–2a. For more information about this relationship, see Bass Baker, "'Oh, lift me over the threshold.'"

65 See Coleridge's letters, Eton College, MEC 103–5.

66 Coleridge, "Awake," in *The Collected Poems*, 202.

67 In Coleridge's *Poems*, Newbolt numbered the poem "CXXXVII" (132). Since Whistler did not include this poem in her edition, the composition date of this poem is unknown.

68 Coleridge, "A Witness," in *The Collected Poems*, 193.

69 Coleridge, "The Song of the Nightingales," in *The Collected Poems*, 202.

70 Angela Leighton, "Mary E. Coleridge (1861–1907)," in *Victorian Women Poets: An Anthology* (Oxford: Blackwell, 1995), 612.

71 Edith Sichel, "Mary Coleridge," in *Gathered Leaves*, 9–10.

72 Sichel, "Mary Coleridge," 9–10.

.

PART IV

AESTHETICISM, DECADENCE, AND THE MODERN AGE

Radical Empathy in Dora Sigerson's *The Fairy Changeling* (1898) and Broadside Poems of 1916–1917

SO YOUNG PARK

In 1893, William Butler Yeats inscribed a copy of the first edition of *The Celtic Twilight: Men and Women, Dhouls and Faeries*, his collection of supernatural stories and Irish folklore, "To Dora and Hester Sigerson from WB Yeats, 1893, with all friendship and regard."[1] In the presentation copy, Yeats has gone through the trouble of correcting printer's errors in his own hand, gingerly crossing out and inserting words in pencil, for Dora Sigerson and her sister. A year later, in the April 1894 issue of *The Bookman*, Yeats's poem "The Song of the Old Mother" and Sigerson's poem "All Souls' Eve" were published on the same page.[2] In 1907, George Meredith wrote the introduction for Sigerson's *The Collected Poems*, and two years after her death, Thomas Hardy offered a preface for her collection of short stories called *A Dull Day in London* (1920).

Dora Sigerson published her first volume of poetry, *Verses*, in 1893.[3] Married in 1896 to Clement Shorter, an English journalist and the editor of popular periodicals like *The Illustrated London News* and *The Sphere*, Sigerson moved in London's key literary circles in the 1890s and the early decades of the twentieth century.[4] Her literary friends and connections included Dublin poets and writers like Yeats, Katharine Tynan, George Bernard Shaw, and George Moore; and, through Shorter, she had a wider network of literary contacts that included Thomas Hardy, George Meredith, Algernon Swinburne, Francis Thompson, Joseph Conrad, and Henry Fielding Dickens.

Despite Sigerson's significant role and participation in literary and publishing networks of the 1890s, however, very little is still known about her. This is surprising, given her many publications during the fin de siècle. In addition to *Verses*, Sigerson published three other volumes of poetry, including *The Fairy Changeling and Other Poems* (1898), *Ballads and*

Poems (1899), and *My Lady's Slipper, and Other Verses* (1899). Furthermore, from the 1890s to her death in January 1918 Sigerson was prolific, publishing more than eighteen volumes of poetry and poetry collections, some of which appeared posthumously. She also ventured into prose fiction that ranged from fairy tales and children's stories to short stories and novels. In addition, she wrote numerous war poems, such as "Comfort the Women, A Prayer in Time of War" (1915) and "An Old Proverb" (1916), printed privately by Clement Shorter.

Besides being prolific and well-known in London literary circles, especially near St. John's Wood, where she and Shorter lived, Sigerson was critically acclaimed by her contemporaries. After reading one of Sigerson's poems in an American journal, the New England author Sarah Orne Jewett praised her work and asked for a copy of *Verses.*[5] Louise Guiney, an American poet and editor of Irish poetry, described Sigerson's poems as "lark-lyrics."[6] Arthur Quiller-Couch, who later became King Edward VII Professor of English at Cambridge, not only included her work in the first edition of *The Oxford Book of English Verse* (1900) but also wrote to her to say her poems brought tears to his eyes.[7] Eliza Davis Aria, known as a society hostess and fashion columnist, considered Sigerson's work relevant and commercial enough to include in *May Book: In Aid of Charing Cross Hospital* (1901), whose list of contributors included the literary lights at the turn of the century: Henry James, Thomas Hardy, Sarah Grand, Max Beerbohm, and Marie Corelli.[8] And after her death, Sigerson's poems appeared in affordable pamphlet form in the series Augustan Books of Poetry, published by Ernest Benn in 1919. Once again, Sigerson's work was included with that of important Decadent, Georgian, and modern poets such as John Davidson, Lionel Johnson, W.E. Henley, Laurence Binyon, Edith Sitwell, and Vita Sackville-West.

Who was Dora Sigerson, and how did it come about that, despite having left so many literary traces, she has largely disappeared from literary history? Talia Schaffer in *The Forgotten Female Aesthetes* mentions Sigerson briefly alongside Tynan and identifies them both as part of the group of Catholic writers centred around Alice Meynell.[9] Also, Marion Thain includes Sigerson in a "Catholic network" of women writers of the 1890s.[10] Sigerson's work appears in anthologies devoted to the 1890s, especially of women's poetry, yet it remains understudied when we look at the recent scholarship on women writers such as Alice Meynell, Michael Field, Vernon Lee, Amy Levy, Ella D'Arcy, and Netta Syrett, to name just a few.[11]

Considering the life and work of Sigerson in the context of the Decadent 1890s offers an opportunity to puzzle over why she has almost

vanished from accounts of women's literary history of the era. A clue lies in her poetry of the 1890s, especially *The Fairy Changeling and Other Poems*, published by John Lane in the Belles Lettres series in 1898. The most effective poems in the collection rehearse the pain of misrecognition, diaspora, and alienation, at the same time exploring the idea of empathy, not as an interiorized, individual feeling but as a radical concern and identification with a wide array of subjects and subjectivities. In this chapter, I argue that Sigerson's empathy for birds, dogs, ghosts, spectral lovers, rejected wives, lost children, and forgotten stories radically unsettled both readers and critics. This inclusive empathy also made her work hard to categorize: Was it Decadent? Was it a translation of Irish folklore or poetic innovation? In what ways did it participate in the Irish Literary Revival, the renaissance in Irish poetry and letters that counted Yeats, Lionel Johnson, and Katharine Tynan among its many members?

The wide-ranging empathy of Sigerson's poetry resulted in an early critical dismissal of it as either undeveloped or dilettantish. In the preface to *A Dull Day in London,* Hardy wonders about her "constitutional impatience of sustained effort" and whether it "would always have prevented her building up her ideas on a broader artistic framework," had she lived.[12] Meredith coyly avoided assessing her work altogether, referring to Sigerson only in the final paragraph of his introduction to her *Collected Poems*, noting her "gentle sincerity" and that "[f]urther work, especially ballads, is to be expected from her, Irish or other."[13] Meredith's focus on Sigerson's poetic affect – "gentle sincerity" – and Hardy's diagnosis of "impatience" are echoed in later reception of her work as "sentimental" and "lacking in intensity and development."[14]

Long after Sigerson's death, her work continued to baffle her critics and friends alike. Clement Shorter, in a chapter of his *Autobiography* (1927) titled "Dora Sigerson," remembers a poet "who, publishing many books in prose and poetry, never achieved a success of any kind, or aught but slight recognition."[15] Sigerson's poetry deserves a second look, especially for its formulation of radical empathy, through which she attempted to connect the Decadent 1890s to the main currents of the Irish Literary Revival.

The Decadent 1890s: *The Fairy Changeling and Other Poems*

Holbrook Jackson in his survey of the 1890s reveals that *new* was the key word of the decade.[16] John Lane self-consciously emphasizes the novelty of *The Fairy Changeling and Other Poems* by inserting a note before the title

page announcing that "only one poem [has] appeared in book form" and that others have appeared prominently in *Longman's, Cassell's, The Pall Mall Magazine, The Bookman, The National Observer,* and several American periodicals.[17] *The Fairy Changeling* may not be new in terms of publication, but it is indeed new in its wide variety of themes and subjects, which include Irish folklore and mythology, female autonomy, sexual desire, religion, exile, and animal life.

On first look, two main themes inform the volume: New Women themes and Irish folklore and mythology. Critics including Laurel Brake, Linda K. Hughes, and Margaret D. Stetz have written on the gendered dynamic of fin-de-siècle poetry, especially in works by New Women writers.[18] Hughes names gender reversal and female "erotic agency" as two of the most "decadent" aspects of New Women writing.[19] These characteristics recur in Sigerson's poetry: in "The Lover," for instance, sexual desire for the missing lover is boldly declared: "I crouch alone, unsatisfied, / Mourning by winter's fireside" (28). Though the seasons change, the speaker feels no joy because of unrequited desire. Sigerson uses remarkably direct language to convey emotional and sexual longing for the beloved: "Must this be so? / No southern breezes come to bless, / So conscious of their emptiness / My lonely arms I spread in woe, / I want you so" (29). Even if nature were to compensate with the balm of "southern breezes," they would have no effect but to further compound the speaker's sense of "emptiness." This emptiness or lack in turn incites more lyric poetry. In the case of "An Eclipse," it leads to the poet's plangent plea to the beloved to release her from the chains of love: "Let there be an end ... Pass over, fair eclipse, / That hides the sun. / Dear face that shades the light / And shadows me, / Begone, and give me peace, / And set me free" (43). Sigerson's use of "fair eclipse" represents aptly both the unresponsiveness of the beloved and also the finality, the completeness of their indifference: the eclipse obliterates all light. In several poems in *The Fairy Changeling,* by contrast, there is no plangent plea for release, but a raw expression of desire. In "Love," the Decadent colour yellow signals desire:

Deep in the moving depths
Of yellow wine,
I swore I'd drown your face,
O love of mine;
All clad in yellow hue,
So fair to see

...
Within the hungry chase
I thought to kill
You, love, who haunted thus
Without my will. (36)

Desire is expressed through violence and the language of recrimination. In fact, the entire poem rehearses the speaker's repeated failures to forget the wayward beloved. Reading offers no consolation: "I could not see the words – / Saw only you" (36). Neither does fantasy: the speaker envisions the beloved drowning in "the liquid eyes" of a "maid" (37). But even in reverie, he escapes her control: he survives, only to laugh at her.

Likewise, the first poem of the collection, "The Fairy Changeling," expresses the desire to circumscribe a wandering love, but this time the love of a mother who has lost her boy and who has been given a fairy child in his place. Her husband, Dermod O'Byrne, insists that fairy folk have replaced his healthy boy with a "weakly, wizen thing" (1). This poem dramatizes love's potential to wander from so-called proper subjects (biological kin) to foreign "things" (a fairy changeling). The poem invites readers to consider how newfound empathy for the other – the estranged, foreign, unfamiliar, or even non-human – disturbs the dynamics of power in established affective relationships such as that between husband and wife. O'Byrne tries to circumscribe his wife's emotional agency by insisting that she reject the fairy changeling. However, she refuses: "'I love the weak, wee babe the best!'" (2). She refutes O'Byrne's command by claiming the "thing" as her own "wee babe"; indeed, she puts the new child above her husband in terms of family love and loyalty. The mourning wife-mother persists in her love for the foreign being that calls forth her radical empathy.

Sigerson's poems are at their most powerful when she explores human love and desire through the trope of wandering that initiates a decentring of the self, so to speak, which leads to new experiences of radical empathy. In "A Vagrant Heart," she focuses on the social constraints that limit women's freedom of movement: the speaker of the poem voices a familiar lament of New Women writers, "O to be a woman! to be left to pique and pine, / When the winds are out and calling to this vagrant heart of mine" (65). The poem rehearses the litany of house-bound activities through which women are exhorted to dissipate their precious time instead of venturing out on their own: to sew, to "chatter," to quibble about "little fashions," and to "sigh on the shore" (66). Furthermore, it questions the status quo: "The laws confused that man has made, have

reason not nor rhyme" (66). It rejects these laws by giving defiant voice
to the wild desire to wander and to follow "vagrant longings" (67), which
lead to a "world of passion," away from "a home that knows no riot" (67).

To help cut the ties that bind women to patriarchal Victorian codes of
obedience and silence, Sigerson deploys the figure of the bird to lift up,
as it were, their vision toward the sky and to new possibilities. She calls up
a "bird that fights the heavens," asking it a rhetorical question intended
to pique her readers: "Would you leave your flight and danger for a cage
to fight no more?" (66). The "cage" might allude here to social repres-
sion, among other things, which the poem counters by celebrating the
desire to move and to explore without predetermined ends. It praises
"the nomad's heart" (65), which revels in "vagrant" – that is, unfixed,
unbounded, free – "longings," a phrase whose ambiguity invites capa-
cious imagination. Most interestingly, Sigerson brings the figure of the
stranger or the nomad into the very centre, the metaphorical home, so
to speak, of the poem: at the beginning, the poet refers to "the nomad's
heart in me" (65), which by the third stanza has become, "this nomad
heart with you":

> Would I change my vagrant longings for a heart more full of quiet?
> No! – for all its dangers, there is joy in danger too:
> On, bird, and fight your tempests, and this nomad heart with you! (67)

Through the prism of reimagination made possible by poetry, someone
else's heart ("the nomad's heart") has been transformed figuratively into
my own heart ("this nomad heart"). What's more, the poet has given
readers a communal sense of journeying together by adding two very
simple words, "with you," thereby fostering more opportunities to experi-
ence empathy for others.

The celebration of wandering and the "nomad heart" takes on a spe-
cial significance in "A Bird from the West," which expresses an undying
longing for Ireland's urban and rural landscape. A bird sings to the poet
("Ireland! Ireland! Ireland!"), the poet climbs onto the bird's wings, and
they fly over Ulster, Connaught, Munster, and Leinster (30). The bird
and the poet's flying over the Irish landscape is paralleled visually by the
readers' eyes wandering over the stanzas of the poem. "A Bird from the
West" illustrates a striking feature of the poems that comprise *The Fairy
Changeling*: Sigerson represents New Woman themes of desire, auton-
omy, and freedom in the context of Irish folklore and mythology for an
English audience, inviting her English readers to wander, to decentre

themselves from their routine affections, and to empathize anew. The majority of the ballads in *The Fairy Changeling* use Irish locales, names, and folk tales; for instance, the motif of the sea, sea maidens, and the metamorphosis of the non-human into the human recur in "A Ballad of Marjorie" and "The Rape of the Baron's Wine." The occult, which Yeats connected closely with Irish folklore,[20] permeates "The Ballad of the Little Black Hound," in which the eponymous creature grants a man wealth in exchange for his firstborn son. When the black hound returns, the man forfeits his family, though he cannot remember how they met their deaths. The ballads mentioned retell traditional Irish tales, but what is new is their showcasing of strong women characters who resist capture, steal precious wine, or fight for their lives with haunting power.

But *The Fairy Changeling*'s most innovative poems are the "revenant" poems, in which a dead lover or beloved returns after a long absence or even death.[21] In "All Souls' Eve" a woman waits for the "sweet ghost" of her male lover, but her desire turns into dread during the night and she laments her cowardice as she waits another year for the return of All Souls' Eve (33). In "The Blow Returned," the speaker confesses, "I struck you once, I do remember well" (47). The beloved dies before reconciliation, but comes back as an estranged revenant: "The ghost returns the blow upon my heart" (47). "The Ballad of the Fairy Thorn-Tree" tells the story of a woman who calls on the devil to revive her dead lover. What these three poems share is their continuing engagement with the beloved despite the estrangement or defamiliarization brought on by death.

The revenant theme reinforces *The Fairy Changeling*'s intense interest in reanimation or revival. In fact, the collection establishes readers' contact not only with dead lovers and relatives and spectral figures but also with non-human life forms, like animals and plant life, that seem inert but are awakened in Sigerson's poetry. An oak tree speaks of spring, a robin dreams of rain, and sheep think of lambs "frolic[king] / 'Neath the sun" ("A New Year," 56). Sigerson refers to a blackbird in a loving tone: "This is my brave singer" and "my serenader / Hath a human love" ("An Irish Blackbird," 72). In just the first three lines of "The Kine of My Father," Sigerson animates a "young goat ... at mischief," a "Banshee keening," and cattle that "are straying" from her speaker's "keeping" (57). We can trace this concern with life forms of all kinds to Sigerson's first collection of poetry, *Verses* (1893). For example, in "A Cry in the World," she laments the way humans exploit animals. The poem's long, largely six-beat lines introduce the perspectives of "the sad-eyed kine," birds, and seals.[22] The cows witness their offspring being taken away: "[M]an has bereft us and

taken our young ones from us."[23] Similarly, the birds and seals experience enforced separation from their "nestlings" and "loved ones."[24] By giving voice to these creatures, Sigerson again expands readerly empathy beyond fellow humans to include animal life. Her poetry invites readers to experience a multiplicity of beings and their perspectives.

We may well read these examples as playful anthropomorphisms, or expressions of love for animals, feral or domesticated, and for other life forms. Both Tynan and Hardy attested to Sigerson's "passionate love for animals."[25] Louise Guiney once described Sigerson as "the greatest beast-lover" she had known.[26] In "Beware," Sigerson herself writes that killing a "moth or a worm" is tantamount to murder: their death calls up for her an image of "a bleeding human heart" and "a dying human soul" (77). This intense concern for animal welfare was not uncommon in fin-de-siècle literary culture: it was a subject that engaged writers as diverse as Florence Henniker and Thomas Hardy, who became close friends because of their opposition to vivisection and the maltreatment of circus animals.[27] Evelyn Sharp, the feminist folklorist and author of *At the Relton Arms*, published in John Lane's influential "Keynotes" series, and her husband, Henry Woodd Nevinson, used their journalist credentials to advocate animal rights.[28]

But a more resonant analysis emerges if we take these diverse examples of the revenant, reanimation, and revival as instances of Sigerson's radical empathy, which crosses boundaries between human and non-human, between one's home country and other nations. A case in point is "An Eastern God," a remarkable poem in which the poet addresses an unnamed marble-faced deity with many hands. By empathizing with the foreign deity's experience of alienation as a "[l]one exile" without priests or mourners in England, the poet reanimates the deity (61). The poet whispers into his "marble ear," and the marble deity reciprocates: "The painted lips they smiled at me" (62). An initial act of empathy revives the deity, turning marble to flesh, an act that initiates a dialogue that in turn inspires the speaker to pray to the Eastern god to "guard my love, where'er he be," thereby reviving the missing lover in the space of the revenant poem.

The revenant poems illustrate the key relation between empathy and revival at work throughout *The Fairy Changeling*. That is, the revenant poems of revival and reanimation dramatize the process of awakening empathy and its pivotal role in understanding foreign things and subjects. Sigerson's poems invite readers – specifically, her English readers – to experience a radical empathy needed to understand exiles, aliens,

and the non-human. More to the point, the key revenant in *The Fairy Changeling* is Ireland: Sigerson mobilizes radical empathy to revive feelings of communality for Ireland among her implicitly English audience. As Deborah Logan has observed, no other political issue was as important to Sigerson as Irish national independence.[29]

Given this political context, there is an eerie prescience about the poems in *The Fairy Changeling*. Although they were published eighteen years before the Easter Rising of 1916, the poems speak to the experience of political unrest, diaspora, and martyrdom. For instance, the revenant poem "All Souls' Eve" evokes poignantly the geographic proximity but perceived cultural and political distance, even estrangement, between England and Ireland: through the voice of a woman waiting for her lover to return, Sigerson seems to apostrophize Ireland: "We were too wide apart – / You in spirit land – / I knew not when you came, / I could not understand" (33). The longing expressed here turns into despair in poems of political revolution and disaster: in "An Imperfect Revolution," Sigerson describes an apocalyptic scene in which people weep and die after some unnamed disaster. The poem repeats the refrain "'God save us if no God there be,'" varying it from stanza to stanza (34). The *mise en abîme* of this phrase is stunning: the power of the utterance "God save us" has been evacuated by the idea that "no God there be." If, however, "no God there be," then the phrase "God save us" is reanimated by its return to the pure status of a performative speech act. The conundrum of this refrain reflects the political stalemate surrounding the issue of Irish Home Rule – Ireland's struggle to establish its own parliament in Dublin while maintaining "a federalized arrangement" with the United Kingdom – in the 1890s and beyond.[30]

In her poems, Sigerson often illustrates the human cost of political stalemate and strife through the figure of the beloved's body, be it dispersed or disintegrated. For example, in "The Kine of My Father," the speaker is haunted by visions of the beloved's body in foreign places that keep shifting: "on the prairie," in the desert by "coyote dogs," and on the waters (57). The note of helplessness is wrenching: "Somewhere you are dying, and nothing can I do" (57). In "Cean Duv Deelish," translated as "dear black head," the beloved's body is dispersed across multiple temporalities and spaces. The speaker addresses her beloved, whose body is lost at sea (19). The poem destabilizes the familiar trope of a woman mourning (on land) her beloved's death (at sea) by showcasing the turbulence of her emotions within a violent seascape that threatens to engulf her as well: "The riderless horses race to shore / With thundering hoofs

and shuddering, hoar" (19). Here, the breaking surf is animated into apocalyptic horses. In addition, the speaker visualizes the missing body in different, incompatible spaces: "[b]eyond the world" (the afterlife) and "beneath the sea" (physically out of reach). The restless searching for the missing body compels her to create a third, similarly impossible space and time, the subjunctive future, where a "woman, whoever she be," might "recover" the body from the sea (20). This complex layering of disjointed space and time points to a profound anxiety and helplessness over the missing bodies of loved ones, who still live on in our memories. In *The Fairy Changeling*, the missing body of the beloved undergoes a diasporic diffusion that haunts the living, transforming ordinary poems of longing into revenant poems.

These poems of impending disaster and diasporic diffusion are further politically enhanced by Sigerson's representations of women at war. "The Ballad of the Little Black Hound" describes a mother's struggles with a dark spirit for the life of her child. A variation on the same theme, "The Ballad of the Fairy Thorn-Tree," tells the story of a woman who forfeits her soul to save her beloved's soul from "anguish" (93). Throughout *The Fairy Changeling*, women threatened with loss and violence fight on, and sometimes martyr themselves, for their children, lovers, husbands, families, and home. In these ballads and narrative poems, we can trace a shift from the representation of personal tragedy to a collective, though as yet unnamed, one that foregrounds Sigerson's own aesthetic development: from a translator and purveyor of Irish folklore and mythology for English audiences to a political poet who promoted Irish culture and political independence for Ireland. This shift, an obscured portion of Sigerson's career, provides a vital clue to help address the question of her disappearance from the critical landscape despite her prolific writings and literary friendships.

The Irish Literary Revival

Sigerson's politics grew out of her participation in the Irish Literary Revival, a movement that had its origins in the 1840s and the Young Irelanders. As Gregory Castle has noted, the Young Irelanders developed a "form of Revivalism associated with the Gaelic League and [Irish] nationalism … culminat[ing] in the 1890s with writings that emphasized 'self-improvement and national education,' and that attempted 'to restore a belief in the essential poetry and nobility of the Irish people.'"[31] The 1890s saw an unprecedented flowering of work in Irish literature, folklore, and

history that included pioneering works such as Charles Gavan Duffy's *The Revival of Irish Literature* (1894) and Douglas Hyde's *The Love Songs of Connacht* (1894) and *A Literary History of Ireland* (1899).

Often mentioned with Duffy and Hyde, George Sigerson was one of the elder statesmen of the Irish Literary Revival and Dora Sigerson's father. A medical doctor by training, George Sigerson collected and translated Irish folklore, publishing books on Irish poetry and land reform. In 1892, he gave the inaugural lecture of the National Literary Society in Dublin, and three decades later he became one of the first senators of the Irish Free State. In late 1922, he attended the first Senate meeting, along with Governor General Healy and other senators, including Yeats.[32] By the 1890s, the Sigerson household on Clare Street in Dublin was a well-known literary salon that included guests such as the French medical specialist in hysteria Jean-Martin Charcot and the Irish political activist John O'Leary.[33] It was at the Clare Street house that Dora Sigerson met Yeats and Tynan as well as other writers who belonged to the Dublin and London literary circles of the Decadent 1890s.[34]

Dora Sigerson's Dublin ties were both social and literary. As I mentioned earlier, Yeats gave her a corrected copy of the first edition of *The Celtic Twilight*, perhaps the landmark text of the Irish Literary Revival. Although no biography yet exists of Sigerson's life and work, key details emerge from archival materials. She maintained, for instance, a long, though sporadic, correspondence with Yeats, helping him receive publishing and copyright advice from her husband, Clement Shorter.[35] Yeats reciprocated by reading and gently editing Sigerson's poems, even providing feedback from Augusta Gregory, his Anglo-Irish patron, friend, and co-founder of the Abbey Theatre in Dublin.[36] When the Yeats family encountered financial problems in London in the 1890s, Sigerson commissioned a portrait from John Butler Yeats, the painter and charismatic patriarch of the Yeats family.[37] It was through friendship with her that Yeats became a regular guest, sometimes with George Moore and George Bernard Shaw, at Sigerson and Shorter's home in suburban St. John's Wood, a gathering place for journalists, poets, and artists. Furthermore, Sigerson's gift for friendship was well-known in her circle, especially with regard to encouraging literary women; for instance, she introduced Florence Dugdale, the literary journalist (and, later, Thomas Hardy's secretary and second wife), to friends in London and helped her find work in Dublin as companion to Lady Stoker, the sister-in-law of Bram Stoker.[38] Sigerson and Florence Dugdale Hardy would continue their friendship,

with Sigerson and Clement Shorter visiting the Hardys several times at their home at Max Gate in Dorset.[39]

In addition, Sigerson's poetry appeared, often literally next to the works of Yeats, Tynan, and Lionel Johnson, in journals such as *The Bookman*. Johnson's *Ireland: With Other Poems* (1897) begins with the poem "Ireland (To Mrs. Clement Shorter)."[40] Sigerson was known not only as an Irish poet but also as an acknowledged writer of the pan-Celtic movement of the 1890s. Elizabeth Sharp – the editor of *Lyra Celtica* (1896), an important, though uneven, anthology of Irish, Scottish, Welsh, Cornish, Breton, and Irish American verse – selected Sigerson's poems, together with work by Yeats, Ernest Rhys, and Nora Hopper.[41] Sigerson's appearance in *Lyra Celtica* recognizes her place in both the national (Irish) and cosmopolitan ("Celtic") revivals of the 1890s.

Sigerson's emplacement in Irish, pan-Celtic, and London literary networks sheds light on the vibrant transnationality of fin-de-siècle literary culture. Both Bruce Gardiner and Norman Alford have written on the Celtic background and interests of the Rhymers' Club: the founding members were Yeats, Ernest Rhys, Lionel Johnson, and T.W. Rolleston, all poets of Irish or Celtic descent or with a deep interest in Irish literature and culture.[42] These literary friendships and networks point to the sociality between the writers of the Irish Literary Revival and the vibrant cultures of Aestheticism and Decadence in London; they also reveal how so-called outsiders forged a new poetry that melded Gaelic and Anglo-Irish letters and ideas for English audiences. In *Ireland's Literary Renaissance* (1916), Ernest Boyd lauds Sigerson's poems and those of others for successful hybridity: "The spirit was Celtic, if the form was English."[43] What I would add here is just how pivotal poets like Sigerson were to both the Irish Literary Revival and fin-de-siècle literary culture in hybridizing not only "spirit" and "form" but also aesthetics and politics. Sigerson's later political poems on behalf of Irish independence, especially her broadside poems of 1916–17, are a case in point.

Irish National Independence and the Poetics of Radical Empathy

During the Great War, Sigerson composed and printed a series of broadside poems, essentially poems in pamphlet form, at her own small printing press, housed in the basement of her home at 16 Marlborough Place, St. John's Wood.[44] As indicated by the following titles, the series was politically charged, arguing for Irish independence and for non-participation

in the war: "God Save Ireland," "Made in Germany," "Sold, By Our National Party – An Emerald Isle," "Extermination," "Atrocities," and "Irishmen, Do You Know Your Foe?"

These poems tap into the ages-old ballad tradition in which popular songs of the people were disseminated widely in the form of broadsides or broadsheets.[45] In "Sold, By Our National Party – An Emerald Isle," Sigerson personifies Ireland as "Erin," a familiar mother-figure, and employs easy rhymes to criticize Irish politicians who have compromised on the goal of Home Rule:

> And our beautiful Home Rule bill,
> We think we are getting it still,
> Oh, it ought to be nice when you think of the price
> Of our regiments for Germans to kill.
> ...
> [I]f we but reason they call it high treason
> And shut us in prison away.
> ...
> Erin sits like a fool awaiting Home Rule
> While her sons must all die and decay.

The regular three-beat lines barely contain Sigerson's scathing tone. The ballad's tension is sustained by sharp internal rhymes that highlight England's betrayal of Ireland: for instance, "nice" with "price" (the price is not nice, the price being Irishmen sent to war); and "fool" with "Rule" (the suggestion that it's folly to follow English "Rule"). The internal rhyme, "reason" with "treason," suggests harsher truths: there is no reason to England's realpolitik, just the rule of force backed by political rhetoric, even further, to "reason" with England is tantamount to an act of "treason." The most salient rhyme – "Home Rule bill" with "to kill" – points to a clash between diplomacy and brute power. Sigerson leaves space, however, for reconciliation by separating the deadly rhyme with two intervening lines that end with "still" and "price." The poem demonstrates Sigerson's skill in expressing her political beliefs in ballad form: the broadside retains its balladic rhythm while synthesizing its aesthetics with its politics. The poem thus taps into the folk tradition of the ballad by providing accessible internal rhymes that serve to increase the torque of its political language.

The issue of Home Rule recurs throughout Sigerson's broadside poems. As Roy Foster has written, by mid-1914 the British government

had in essence conceded Home Rule: the third Home Rule Bill was on the statute book; however, all discussion of its implementation had been suspended because of the war.[46] In "Irishmen: Beware!" Sigerson draws attention to the uncertainty surrounding Home Rule, advising her readers: "Be neutral – you have not Home Rule." She pushes this idea further in "Extermination: We Asked for Home-Rule and They gave Us – ?": "Will you help England in her plan of extermination? Celts will 'you yield to the Saxon' the land your Fathers died for?" Sigerson calls up the ghosts of history when she addresses the Irish people as Celts and the English as Saxons, reminding her audience that the struggle for Home Rule extends far into the past. The word "extermination" explicitly evokes genocide, bringing to mind the image of the bodies of the dead and soon-to-be dead, both "the ghosts of history" and Erin's "sons," those Irishmen fighting in the war and those about to enlist in the British army.

The broadside poems were written during a time of extreme political turbulence in Ireland, England, and Europe. With the Military Service Act of 1916, Britain inducted into war its first conscript army.[47] By April 1916, around 150,000 Irish soldiers were fighting in the war, with the numbers set to increase if England were to impose conscription on Ireland.[48] In a bid for Irish national independence and to prevent future conscription of Irish soldiers, a small group of nationalist intellectuals, writers, and activists staged a political rebellion on Easter Monday, 24 April 1916 in Dublin, known as the Easter Rising. On the following Saturday, Patrick Pearse, the leader of the rebellion and president of the provisional government proclaimed during the Rising, surrendered to British forces, which had bombarded Dublin, decimating the city centre. An estimated 450 Irish citizens and English soldiers died, with 3,500 arrested and more than 2,600 wounded.[49] Although the initial Irish reaction to the Easter Rising was mixed, the military execution of fifteen rebel leaders by the British government was felt as an outrage and led to solid support for the independence movement.[50] In the aftermath, the most prominent of the rebel leaders – Patrick Pearse, James Connolly, Thomas MacDonagh, Joseph Plunkett, Sean MacDermott, and Tom Clarke, among others – were seen as martyrs for national independence. They comprised the core of the "sixteen dead men," a grouping that denoted the executed fifteen leaders as well as Roger Casement, the Anglo-Irish diplomat who was hanged for treason in London in 1916. I will provide more details on Casement and Pearse below, but here I also want to mention Countess Constance Markievicz, the artist and aristocrat who was probably the most famous of the women rebels who fought

during Easter Week. Markievicz was sentenced to death at Kilmainham Gaol, where rebel leaders were imprisoned, but the sentence was commuted because of her gender.[51] In June 1917, the British government declared amnesty for all Easter Rising prisoners; Markievicz was released and returned to Ireland.[52]

Written in the wake of the Rising, the broadsides contain equal amounts of urgency and frustration. Given Sigerson's radical empathy in her earlier work, the broadside poems might suggest that she had reached its end in her Irish nationalist views. It would be a mistake, however, to draw this conclusion. The poem "Made in Germany" rehearses the pattern of "An Eastern God" from *The Fairy Changeling*, in which Sigerson animated an alienated, foreign deity through dialogue and empathy. Most strikingly, "Made in Germany" catalogues examples of political oppression on a global scale. With the example of England and Ireland in mind, Sigerson notes how the Russians are oppressing the Turks, the French the Alsatians, and the Japanese the Chinese ("Pekin"). In "Irishmen: Do You Know Your Foe?," Sigerson reaches beyond Western geopolitical interests to include the frequently forgotten story of emerging East Asian states. She calls attention to Korea and to Japan's colonization of the Korean peninsula.[53] These examples furnish evidence for the radical empathy still at work in Sigerson's poems. She deploys empathy to erode the notion that the struggle for Irish independence is merely a nationalist struggle – that is, by extending empathy on a global scale, she invites her readers to reconsider their narrow definitions of Ireland and nationhood and to grapple with and understand the global struggle for political autonomy.

Empathy, dialogue, revival, political action: in the broadside poems of 1916–17, Sigerson pushed the radical empathy she had cultivated in her earlier poetry to the limit in an attempt to forge a vital connection between aesthetics and politics during a time of military and political turbulence. From the publication of *The Fairy Changeling* in 1898 to her death in January 1918, Sigerson experimented with this radical poetics, employing it to generate empathy for the cause of Irish national independence after the Easter Rising and in the final years of the Great War.

In addition to the broadsides, Sigerson wrote political poetry specifically in response to the Easter Rising. In "The Choice," she commemorates the life of Roger Casement, the Dublin-born consular official who in 1911 was knighted by the British government for his extraordinary work in uncovering human rights abuses in Africa and South America.[54] In 1916, Casement was convicted of treason and sentenced to death for his efforts to bring

German arms and ammunition in support of the Rising.[55] A campaign for leniency failed when the British government controversially allowed excerpts from Casement's private diaries to circulate: the so-called "Black Diaries," which detailed Casement's homosexual affairs, turned public opinion against him.[56] Casement was hanged for treason in August 1916.[57] His remains were not returned to Ireland until 1965, when he was interred in Glasnevin Cemetery, the main Catholic burial ground in Dublin.[58]

Long before 1965, Sigerson's poem repatriates "Sir Roger Casement," previously knighted in Britain, to Ireland, as the "Irish Casement." Sigerson commemorates Casement's dedication to the goal of national independence by using balladic figures from Irish folklore as a protest, as it were, against the new, brutal order of state executions: Casement gives up England's honours to take up "a hempen rope, / And banshee cries upon far Irish hills."[59] In Sigerson's vision, so complete is Casement's return to Ireland that his voice keens rather than speak the English language.

In "The Star," Sigerson stages a similar protest in commemorating Patrick Pearse, a key architect of the Rising.[60] The founder and headmaster of St. Enda's, an "influential nationalist school,"[61] Pearse is remembered as "a dreamer," "poet," and "singer," who "fell to earth … grasping at stars." But the context of the Irish revolution erupts into the pastoral vision with mention of "the red battle-field," "men of war," and "prison bars." As in the poem about Casement, Sigerson restores Pearse to an imaginary Ireland: the ending of the poem repositions his fallen star, now "[s]et in the green sky for all to see."

Sigerson's expansive "green sky" resonates with Yeats's phrase "Wherever green is worn" in the last stanza of "Easter, 1916."[62] Contemporaries and friends, Sigerson and Yeats provide evidence in their most powerful writing for the widespread and indelible impact of the Rising on Irish poetry in the years after 1916. In their political poems, we have two contrasting responses to political action *in medias res*. As Foster notes, Yeats's poem expresses a "central ambivalence" about the Rising.[63] One of the cruxes of the poem is the idea of bodily sacrifice for a political cause, which Yeats severely questioned.[64] In the poem, Yeats abstracts his language, pointing rather to the effects of sacrifice as debilitating and calcifying: "Too long a sacrifice / Can make a stone of the heart."[65] Maud Gonne, the nationalist writer-activist (and Yeats's lifelong friend and love interest),[66] famously disagreed with Yeats, writing in response that "sacrifice has never yet turned a heart to stone."[67] "Easter, 1916" asks the difficult question of whether the sacrifice was an error in judgment: "Was it needless death after all?"[68] Possibly "needless," because the British government had conceded Home Rule, as Yeats knew well, by mid-1914.[69]

Yeats also delayed the publication of the poem for political reasons concerning his and Augusta Gregory's efforts to secure Hugh Lane's paintings for the city of Dublin.[70] The poem eventually appeared in October 1920 in *The New Statesman*.[71]

In many ways, the poem's legacy is Yeats's uncanny performance of ambivalence, exemplified by the phrase "a terrible beauty is born."[72] A vatic declaration, yet non-specific in its declaration, it is perfectly suspended between the passive and the active: a thing is merely born, yet the terror associated with it activates it. The poem's main function, perhaps its most celebrated aspect, is that it gave both Yeats and his readers time and space to ponder the Irish revolution. For Yeats, it gave him some twenty years to revisit the question of poetry's engagement with political action: in "Man and the Echo," he asks hauntingly, "Did that play of mine send out / Certain men the English shot?"[73]

Taking a different tack, Sigerson's broadsides and political poems turn away from the prospect of *ars longa* and face the other side of the dictum: *vita brevis*. Sigerson's final collection of poems, *The Tricolour: Poems of the Irish Revolution*, was dedicated to the idea of Ireland as an independent nation as symbolized by the three colours of the Irish flag (green, white, and orange). There was a poignant urgency behind the poems: Sigerson was seeking to commemorate the Easter Rising leaders and their comrades from the passage of time, while acutely aware of how little time she herself had left. The opening "Editor's Note" explains:

> The publication of this book is a sacred obligation to one who broke her heart over Ireland. Dora Sigerson in her last few weeks of life, knowing full well that she was dying, designed every detail of this little volume – the dedication to the tricolour, and the order in which the poems were to be printed. Any profit that may arise from the sale of the book will be devoted, as are all the copyrights of the author, to a monument which she herself sculptured with a view to its erection over the graves of the "Sixteen Dead Men" when circumstances place their ashes in Glasnevin [Cemetery].[74]

Phrases such as "sacred obligation" and "broke her heart over Ireland," as well as the dedication of all the copyrights and royalties from her books, testify to Sigerson's political commitment. But it is the phrase "she was dying" that paradoxically brings alive the idea of "sacred obligation," of dedicating "all" to Ireland, and of her identification with the "sixteen dead men."

The sculpture, titled *Monument to Patrick Pearse and His Comrades*, was completed after her death (figure 9.1).[75] The pietà currently stands at

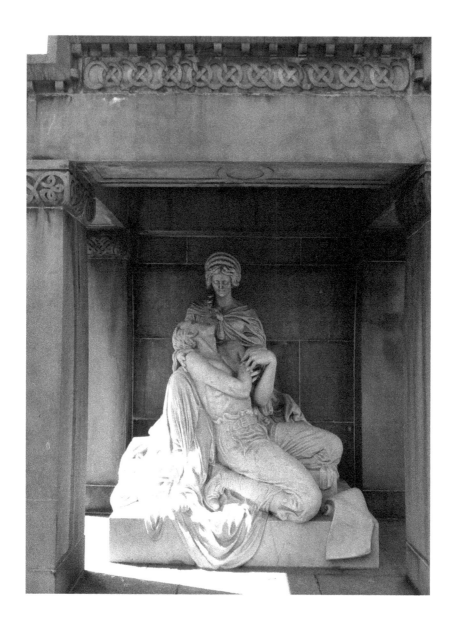

Figure 9.1 Dora Sigerson, *Monument to Patrick Pearse and His Comrades*, Glasnevin Cemetery, Dublin. (Photograph by So Young Park.)

the entrance of Glasnevin Cemetery.[76] Traditional in following the form of a mother-figure holding a male child, the pietà is unusual in its inter-mingling of the two figures: they seem to be of equal weight and signifi-cance, united by their gazes turned toward each other and their equally powerful hands touching and comforting each other.[77] The pietà of equals offers a visual metaphor perhaps of how Sigerson envisioned the intertwining of aesthetics and politics in her life's work.

Framing Sigerson's Legacy

Sigerson's friends became dismayed by her increasing support for Sinn Féin, the Irish political organization that rose to prominence after the executions of Patrick Pearse, James Connolly, and other leaders of the Easter Rising.[78] Long-time friend Louise Guiney confided to Clement Shorter her disagreements with Sigerson over politics:

> [S]he spoke of the Sinn Féin and I could not pretend to be sympathetic ...
> It was the thought of her which always made me wish nature and heredity
> had taught me to like Sinn Féin. I feel our divergence much ... I'm so sorry
> I mentioned Sinn Féin again. Its poets go to my heart, at any rate, and their
> self-broken wings.[79]

Despite their friendship, Guiney was frank in refusing to empathize with Sigerson's nationalist politics. The novelist Marie Connor Leighton, a friend of both Sigerson's and Shorter's, also commented on the poet's growing political involvement: "Forgetting political differences, I loved her for her brightness, her frankness and sincerity, her absolute pure-mindedness."[80]

The most problematic accounts were left by Tynan and Shorter. Tynan had introduced Dora Sigerson to Clement Shorter; they married in 1896 and moved to London. Perhaps the long friendship motivated Shorter to ask Tynan to write the posthumous tribute to Sigerson in *The Sad Years* (1918). This brief memoir establishes a biographical arc that other writ-ers have followed in describing Sigerson's life. Tynan begins by prais-ing Sigerson's beauty, emphasizes the poet's love of animals, mentions her support of Parnell, and neglects to discuss her writing.[81] Likewise, Tynan's obituary, "Dora Sigerson (Shorter): A Memory," published in *The Bookman*, treads carefully around Sigerson's politics by focusing on the poet's beauty as a young woman: "Dora Sigerson was at that time like a young Muse. She had a beautifully-shaped head which she did not

conceal by masses of hair. Her dark hair was worn short, not cropped. She had beautiful eyes, firmly-moulded features, creamy-pale skin, and vividly red lips. She was indeed of remarkable beauty in those days."[82]

Tynan's language revives Sigerson's "remarkable beauty" at the cost of obscuring her artistic achievements. Tynan's sculptural language – "beautifully-shaped" and "firmly-moulded" – evokes then occludes Sigerson's work as a sculptor, the designer of the monument to Pearse in Glasnevin. What's implied but not explicitly stated through the deflective references to Sigerson's role as a beautiful "Muse" is the nationalist turn that her politics took toward the end of her life. The term "Muse" ascribes passive beauty to Sigerson and displaces the more disturbing and politically charged term "Martyr," a term that Sigerson might have used to describe herself. Tynan alludes to it briefly by suggesting that Sigerson died from heartbreak caused by the Easter Rising and its aftermath.[83] Clement Shorter corroborates this view: "It was the strain of the War and Ireland's association with it that killed her. She suffered heartbreaking anguish during the Irish Rising of Easter Week 1916."[84]

The etiology of death by an excessive love for Ireland fails to recognize the significance of Sigerson's poetics of radical empathy that extends from her early poems of the Irish Literary Revival to her later political poetry in support of Irish national independence. Before her death, Sigerson left another interpretation of her political vision. Among her papers found by Clement Shorter were these words:

> My mind [was] in its excitement, rising with the soul of my land, dying with the deaths of my countrymen and friends. Fifteen times was I shot thro' the heart, and once stood by the hangman's noose, but I rose in the glory of the dead, as I had risen before, from the murdered corpses that make the soul of my country ... Like a prisoner I peep from my window. And at night am I haunted by the reproachful dead. Like a dead drone do I lie on the hive of the bees. Like the stricken beasts do I creep into a corner to die. Strike then, oh Lord, that all of me may cease! Or let me live now that the spring comes.[85]

In this passage, which reads like a prose poem, Sigerson rehearses the dispersal of the self that we see throughout *The Fairy Changeling*. Sigerson experiences death fifteen times and "once by the hangman's noose." Through radical empathy, she revives for readers the political executions of the Easter Rising leaders in Kilmainham Gaol and of Roger Casement in London. Pearse's fallen star that she restored to a "green sky" recurs

in the rising she imagines for herself and her country: "I rose in the glory of the dead, as I had risen before."

But the passage also revives her early experiments during the Decadent 1890s. The phrase "my mind [was] in its excitement" evokes Yeats's lines from "The Song of Wandering Aengus," written in 1897: "I went out to the hazel wood, / Because a fire was in my head."[86] In Sigerson's iteration, the fire is within the mind and body of a woman poet who broke bounds by writing political poetry at a precarious and dangerous time. In this passage, she extends the empathy for the missing body of the male beloved, explored in *The Fairy Changeling*, to herself, the woman poet. Continuing her project of empathy, Sigerson widens her imaginative vision to encompass the living, the dead, drones, bees, and "stricken beasts," as well as a non-human power that can decide to "strike" the already "stricken." This ranging, inclusive vision reimagines the woman poet as a figure who undergoes a diasporic diffusion that haunts the living, who herself becomes a revenant poem of longing for Ireland and all her ghosts of history.

How, then, are we to remember Dora Sigerson? *The Fairy Changeling* of the 1890s, the broadside poems of 1916–17, and her later political poems identify Sigerson as one of a handful of women writers who honed her poetic craft on a Decadent strain and used the force of a radical decentring and extension of empathy in the service of a political vision. As her distinguished body of work attests, she also followed that political vision back to a point of need: the need for empathy, a radical empathy, that would constitute the heart's core, as it were, of a collective, humane response to the new modern era of diaspora, dislocation, and alienation.

NOTES

1 W.B. Yeats, *The Celtic Twilight: Men and Women, Dhouls and Faeries* (London: Lawrence and Bullen, 1893), British Library, London, Ashley 2282.

2 W.B. Yeats, "The Song of the Old Mother" and Dora Sigerson, "All Souls' Eve," *The Bookman* 6, no. 31 (April 1894): 10.

3 Sigerson published under various names, including "Dora Sigerson," "Dora Shorter," "Mrs. Clement Shorter," and "Mrs. Dora Shorter." For the purposes of this chapter, I use "Dora Sigerson," since many of her works from the 1890s were published under her maiden name, and also to avoid confusion with her husband's surname.

4 During his career, Shorter edited *The English Illustrated Magazine* and *The Tatler*, as well as the works of the Brontës and George Borrow.

5 Louise Imogen Guiney, "To Dora Sigerson," 5 April 1895, in *Letters of Louise Imogen Guiney*, ed. Grace Guiney (New York: Harper, 1926), 65.

6 Guiney, ed., *Letters*, 65.

7 See letters from Quiller-Couch, "To Dora Sigerson," 1 October 1900, and "To Clement Shorter," 28 March 1907 (British Library, London, Ashley MS 5750 [ff. 8–9]). In the letters Quiller-Couch tells Sigerson that he overheard an old clergyman reciting her poem "Ireland," and asks her permission to include that poem and two others in *The Oxford Book of English Verse*.

8 "Authors and Artists," *The May Book: Compiled by Mrs. Aria in Aid of Charing Cross Hospital* (London: Macmillan, 1901), n.p. Sigerson is listed as "Mrs. Clement Shorter."

9 Talia Schaffer, *The Forgotten Female Aesthetes: Literary Culture in Late-Victorian England* (Charlottesville: University of Virginia Press, 2000), 46.

10 Marion Thain, "Poetry," in *The Cambridge Companion to the Fin de Siècle*, ed. Gail Marshall (Cambridge: Cambridge University Press, 2007), 237.

11 Sigerson's poem "Cecilia's Way" appears in *Literature and Culture at the Fin de Siècle*, ed. Talia Schaffer (New York: Longman, 2007), 243–4. "With a Rose" and "The Wind on the Hills" are included in *Nineteenth-Century Women Poets: An Oxford Anthology*, ed. Isobel Armstrong, Joseph Bristow, and Cath Sharrock (Oxford: Clarendon Press, 1996), 791–2.

12 Thomas Hardy, "Prefatory Note," in *A Dull Day in London and Other Sketches* (London: Eveleigh Nash, 1920), 8.

13 George Meredith, "Introduction," in *The Collected Poems of Dora Sigerson Shorter* (London: Hodder and Stoughton, 1907), viii.

14 Evelyn A. Hanley, "Dora Sigerson Shorter: Late Victorian Romantic," *Victorian Poetry* 3 (1965): 224; Caroline Zilboorg, "A New Chapter in the Lives of H.D. and Richard Aldington: Their Relationship with Clement Shorter," *Philological Quarterly* 68, no. 2 (1989): 245; Ellis Ni Dhuibhne, ed., *Voices on the Wind: Women Poets of the Celtic Twilight* (Dublin: New Island Books, 1995), 83.

15 Clement Shorter, *C. K. S., An Autobiography: A Fragment by Himself*, ed. J.M. Bulloch (n.p.: privately printed, 1927), 134.

16 Holbrook Jackson, *The Eighteen Nineties: A Review of Art and Ideas at the Close of the Nineteenth Century* (London: Grant Richards, 1913), 22–3.

17 See Dora Sigerson (Mrs. Clement Shorter), *The Fairy Changeling and Other Poems* (London: John Lane, 1898); subsequent page references appear in parentheses in the main text.

18 Linda K. Hughes, "Women Poets and Contested Spaces in *The Yellow Book*," *Studies in English Literature, 1500–1900* 44, no. 4 (2004): 850. See also Margaret D. Stetz, "*Keynotes*: A New Woman, Her Publisher, and Her Material," *Studies in the Literary Imagination* 30, no. 1 (1997): 89–106; and Laurel Brake, "Endgames: The Politics of *The Yellow Book* or, Decadence, Gender, and the New Journalism," *Essays and Studies* (1995) (Cambridge: D.S. Brewer, 1995), 38–64.

19 Hughes, "Women Poets and Contested Spaces," 850.

20 Gregory Castle, *Modernism and the Celtic Revival* (New York: Cambridge University Press, 2001), 59.

21 Hughes uses the term "revenant" to describe Graham R. Tomson's poem, "Vespertilia" (855).

22 Dora Sigerson, "A Cry in the World," in *Verses* (London: Elliot Stock, 1893), 93.

23 Sigerson, "A Cry in the World," 93.

24 Sigerson, 94.

25 Katharine Tynan, "Dora Sigerson: A Tribute and Some Memories," in *The Sad Years* (New York: George H. Doran, 1918), xi; Hardy, "Prefatory Note," 7. Tynan's "Dora Sigerson: A Tribute" was reprinted from the *Observer*, 13 January 1918.

26 Guiney, *Letters*, 154.

27 Thomas Hardy, "Performing Animals. Mr. Hardy's Protest. To the Editor of the *Times*," 19 December 1913 (Beinecke Library, New Haven, General MSS 111, box 2, folder 67).

28 Angela V. John, *Evelyn Sharp: Rebel Woman, 1869–1955* (Manchester: Manchester University Press, 2009), 151.

29 Deborah A. Logan, "Kathleen's Legacy: Dora Sigerson Shorter's Vagrant Heart," *The Victorian Newsletter* 97 (2000): 17–18. For an informative and concise account of the struggle for Irish political independence, see Declan Kiberd, *Inventing Ireland* (London: Jonathan Cape, 1995), 191–4.

30 R.F. Foster, *Modern Ireland, 1600–1972* (London: Allen Lane, 1988), 397. For a detailed account of the Home Rule campaign, see 461–76.

31 Castle, *Modernism and the Celtic Revival*, 4.

32 "First Senate Meeting (aka Governor General Now in Residence)," British Pathé (canister: G 938, film ID: 440.33), 18 December 1922, www.britishpathe.co. See also R.F. Foster, *W.B. Yeats: A Life*, vol. 2: *The Arch-Poet, 1915–1939* (Oxford: Oxford University Press, 2003), 228–9. Foster dates the first senate meeting as happening on 11 December 1922 (229).

33 Shorter, *C. K. S.*, 136.

34 Tynan, "Dora Sigerson: A Tribute," viii. Tynan recalls fondly a Sunday in 1887 on which Dr. Sigerson, Dora Sigerson, and the Yeatses visited her in the country and began their long friendships.

35 See letter from W.B. Yeats, "To Dora Sigerson Shorter," 21 June 1899
 (British Library, London, Ashley MS 2288).

36 Yeats, "To Dora Sigerson Shorter," 21 June 1899.

37 John Butler Yeats, *J.B. Yeats: Letters to His Son, W.B. Yeats, and Others, 1869–1922,*
 ed. Joseph M. Hone (New York: E.P. Dutton, 1946), 34, 58.

38 Robert Gittings and Jo Manton, *The Second Mrs. Hardy* (Oxford: Oxford
 University Press, 1981), 39, 54. Michael Millgate, *Thomas Hardy: A Biography
 Revisited* (Oxford: Oxford University Press, 2004), 425.

39 Michael Millgate, *Thomas Hardy,* 404. Sigerson and Hardy met in September
 1905 in Aldeburgh. See also Matthew Campbell, "'A bit of shrapnel': The
 Sigerson Shorters, the Hardys, Yeats, and the Easter Rising" (forthcoming).
 My thanks to Professor Campbell for letting me read an advance copy of his
 essay, which delineates the complicated friendship between the Shorters and
 the Hardys, as well as the significance and the contexts of Sigerson's domestic
 elegies and later political poems. The essay offers illuminating comparisons
 between Sigerson's poetry and that of Hardy and Yeats.

40 "Ireland (To Mrs. Clement Shorter)," *Ireland, With Other Poems* (London:
 Elkin Mathews, 1897), 1–9.

41 Elizabeth A. Sharp, ed., *Lyra Celtica: An Anthology of Representative Celtic
 Poetry* (Edinburgh: Patrick Geddes, 1896). William Sharp, the poet and
 literary journalist, introduced and provided notes for the volume. (William
 Sharp also published poetry and fiction as "Fiona MacLeod," a literary
 secret that was not revealed until after his death in 1905.) The anthology
 was published by Patrick Geddes, the editor of the Scottish journal the
 Evergreen, a rival publication to London's *The Yellow Book* that celebrated the
 "Celtic Revival" located in Scotland and northern Europe.

42 See Norman Alford, *The Rhymers' Club* (Victoria: Cormorant Press, 1980);
 Bruce Gardiner, *The Rhymers' Club: A Social and Intellectual Story* (New York:
 Garland, 1988).

43 Ernest Boyd, *Ireland's Literary Renaissance* (New York: John Lane, 1916), 59.

44 The British Library's Ashley Catalogue notes that "[t]he type-setting and
 printing were entirely the work of her own hands" (5:182). Dora Sigerson,
 "A Series of 12 Broadside Poems and Leaflets" (1916–17), British Library,
 Ashley MS 4259 (also identified as "Irish Pamphleteering Broadsheets"). In
 the folder there are eleven different broadsides in total (and one duplicate
 copy). They are on individual sheets and are not paginated.

45 On this topic, see Graham R. Tomson, "Introduction," in *Border Ballads*
 (London, 1888), x–xv.

46 Foster, *Modern Ireland,* 470.

47 Paul Fussell, *The Great War and Modern Memory* (Oxford: Oxford University
 Press, 2000), 11.

48 Foster, *Modern Ireland*, 471.

49 Kiberd, *Inventing Ireland*, 193. R.F. Foster, *Vivid Faces: The Revolutionary Generation in Ireland, 1890–1923* (New York: W.W. Norton, 2015), 243.

50 Kiberd, *Inventing Ireland*, 193.

51 For a detailed account of Markievicz's court martial and imprisonment in Ireland and England after the Rising, see Lauren Arrington, *Revolutionary Lives: Constance and Casimir Markievicz* (Princeton: Princeton University Press, 2016), 138–56.

52 Arrington, *Revolutionary Lives*, 143.

53 Korea gained independence from the Qing empire (China) in the final years of the Joseon dynasty (1392–1910). In 1905 it became a Japanese protectorate. Japan annexed Korea in 1910, making it a colony till 1945. See Andre Schmid, *Korea between Empires, 1895–1919* (New York: Columbia University Press, 2002), 10.

54 Foster, *Vivid Faces*, 396.

55 Foster, *Modern Ireland*, 444n.

56 Foster, *Vivid Faces*, 137–40, 246–7; Kiberd, *Inventing Ireland*, 47.

57 Foster, *W.B. Yeats*, 2:52. Casement was hanged on 3 August 1916 in London.

58 Foster, *Modern Ireland*, 472n.

59 *Poems of the Irish Rebellion* (London: privately printed by Clement Shorter, 1916), 5–6. This edition was limited to twenty-five copies, and included in the collection *Love of Ireland: Poems and Ballads by Dora Sigerson (Mrs. Clement Shorter)* (1916). "The Choice" also appears in two posthumously published collections: *Sixteen Dead Men and Other Poems of Easter Week* (New York: Mitchell Kennerley, 1919), 39–41; and *The Tricolour: Poems of the Irish Revolution* (Dublin: Maunsel, 1922), 28–9.

60 "The Star" appears in both *Sixteen Dead Men*, 77–8, and *The Tricolour*, 61–2. The book jacket for the 1922 Maunsel edition advertises the works of Patrick Pearse and J.M. Synge.

61 Foster, *Vivid Faces*, 21.

62 W.B. Yeats, "Easter, 1916," in *The Poems*, ed. Daniel Albright (London: Dent, 1992), 230. All references to Yeats's poems are from this edition.

63 Foster, *W.B. Yeats*, 2:63; Kiberd, *Inventing Ireland*, 213.

64 See Foster, *Modern Ireland*, 477–8. Controversially, Patrick Pearse understood "bloodshed as cleansing" (477) and espoused "the theory of nationalist blood sacrifice" (478).

65 Yeats, "Easter, 1916," in *The Poems*, ed. Albright, 229.

66 Senia Paseta, *Irish Nationalist Women, 1900–1918* (Cambridge: Cambridge University Press, 2013), 31, 115.

67 Quoted in Foster, *W.B. Yeats*, 2:63.

68 Yeats, "Easter, 1916," in *The Poems*, ed. Albright, 230.

69 Foster, *Modern Ireland*, 470.

70 Foster, *W.B. Yeats*, 2:64. Lane was a prominent art dealer (and Gregory's nephew), who left a valuable bequest of modern paintings to Dublin in a codicil to his will. The codicil, however, was not legally witnessed, leading the National Gallery of London to challenge the bequest after Lane's death on the *Lusitania* in 1915.

71 See Foster, *W.B. Yeats*, 2:58–9, 64–6, 684n51.

72 Yeats, "Easter, 1916," in *The Poems*, ed. Albright, 228.

73 Yeats, "Man and the Echo," in *The Poems*, ed. Albright, 392.

74 *The Tricolour*, "Editor's Note," n.p.

75 A photograph of the sculpture is included in *The Tricolour* (Maunsel, 1922), 40.

76 In Glasnevin the *pietà* is identified as the "Sigerson Memorial." A plaque affixed to the memorial reads: "Dora Sigerson Shorter, poet and sculptor, designed this group and caused it to be set up to the eternal memory of the heroes of Easter Week, 1916." Also on the plaque is Sigerson's poem, "The Sacred Fire" (included in *Sixteen Dead Men* and *The Tricolour*). Observations made during a site visit, 5 July 2014.

77 Sigerson's *pietà* of equals contrasts with Yeats's image of the mother who calls her young child's name in "Easter, 1916": "When sleep at last has come / On limbs that had run wild" (*The Poems*, ed. Albright, 230). In these lines, the Easter Rising rebels seem to occupy the place of the child in Yeats's analogy, though this might be a schematic reading given the complexity and syntactical slipperiness of the poem. Kiberd links "The Stolen Child" to "Easter, 1916," positing that Yeats saw the rebels as stolen children, taken away before their time (*Inventing Ireland*, 114).

78 On Sinn Féin's change in status from fringe group to a major political party during the revolutionary years, see Foster, *Modern Ireland*, 468, 485; and Kiberd, 191–4.

79 Guiney, ed., *Letters*, 237.

80 Shorter, *C. K. S.*, 147.

81 Tynan, "Dora Sigerson: A Tribute," viii–ix.

82 Tynan, "Dora Sigerson (Shorter): A Memory," *The Bookman* 53, no. 317 (February 1918), 154.

83 Tynan, "Dora Sigerson (Shorter): A Memory," 154.

84 Shorter, *C. K. S.*, 149.

85 Shorter, 150.

86 Yeats, "The Song of Wandering Aengus," in *The Poems*, ed. Albright, 76.

The Boom in Yellow:
The Afterlife of the 1890s

KRISTIN MAHONEY

In December 1928, the Leicester Galleries, London, hosted an exhibition of the artworks of the fifty-six-year-old Max Beerbohm titled "Ghosts": a retrospective that included numerous caricatures of figures associated with the insubordinate artistic culture of the 1890s, when "Max" – as he was fondly known by his followers – made his remarkable debut with essays amusingly defending modern cosmetics as well as caricatures of leading aesthetes such as Oscar Wilde. The exhibition included Beerbohm's caricatures of well-known members of the fin-de-siècle literati: Oscar Wilde (whom Beerbohm satirized on several occasions); aesthetic theorist Walter Pater walking in the meadows of Oxford in 1891; the combative Marquess of Queensberry, who led the fray to imprison Wilde for committing acts of "gross indecency" (*c.* 1895); the publisher John Lane, who fostered both Wilde's and Beerbohm's respective writings (*c.* 1895); and novelist Henry Harland and artist Aubrey Beardsley, who for some time jointly edited *The Yellow Book*, which caused such a sensation when John Lane and his business partner Elkin Mathews brought it out as a hardcover quarterly periodical in April 1894. All of these men, who enjoyed great prominence in London during the 1890s, had passed away: Pater in 1893, Beardsley in 1898, Queensberry in 1900, Wilde in 1900, Harland in 1905, and Lane in 1925.

In the exhibition catalogue, the middle-aged Beerbohm characteristically apologizes for his own anachronism, feigning embarrassment at the irrelevance of his work to the modern moment. He lives in Italy now, he notes, and it is very hard for him to keep up: "so very many people with faces and figures unknown to me have meanwhile become famous that I have abandoned all hope of being 'topical.'"[1] Nevertheless, he suggests that perhaps the visitors to the gallery would not mind "looking at some

people who flourished in past days."[2] He first addresses his fellow spectres from the Victorian era: "Those of you who are as old as – or almost (and even that is saying much) as old as I – will perhaps like to have the chords of memory struck by the drawings on these walls."[3] But he also continues to suggest that "even the young ... may conceivably feel a slight thrill" while contemplating the "ghosts" in the gallery.[4] "I have noticed," he writes, "that the young in this era have what those in my own era hadn't: a not unfriendly interest in the more or less immediate past."[5]

The "not unfriendly interest" in the 1890s to which Beerbohm refers had been on the rise since the publication of Holbrook Jackson's well-received *The Eighteen Nineties* (1913). Jackson, along with his co-editor A.R. Orage, played an instrumental role in the revival of *The New Age*, shaping it into one of the founding periodicals of modernist culture.[6] An influential figure in the 1910s, Jackson helped cultivate a renewed attentiveness to Decadence during the modernist period.[7] Beerbohm's caricature of a few years earlier, his well-known *Some Persons of "the Nineties"* (figure 10.1), speaks directly to this revival of interest in the personages of the fin de siècle. While we often turn to this image out of interest in the figures represented, the topic of this caricature is not the 1890s per se but the attraction that decade held for the critics of the 1910s and 1920s. The full caption reads "Some Persons of 'the Nineties' Little imagining, despite their Proper Pride and their Ornamental Aspect, how much they will interest Mr. Holbrook Jackson and Mr. Osbert Burdett."[8] Burdett's *The Beardsley Period*, which had appeared in 1925, and Jackson's *Eighteen Nineties* presumably stand in here for a whole host of critical texts on the 1890s published in the early twentieth century: W.G. Blaikie Murdoch's *Renaissance of the Nineties* (1911), Arthur Ransome's *Oscar Wilde: A Critical Study* (1912), Elizabeth Pennell's *Nights: Rome and Venice in the Aesthetic Eighties, London and Paris in the Fighting Nineties* (1916), Bernard Muddiman's *The Men of the Nineties* (1920), Bohun Lynch's *Max Beerbohm in Perspective* (1922), Joseph Pennell's *Aubrey Beardsley and the Other Men of the Nineties* (1924), and Richard Le Gallienne's *The Romantic '90s* (1925), to name the more prominent studies. Even the excessively proud and ornamental dandies of the fin de siècle might have been surprised, Beerbohm suggests, by the alacrity with which future generations set about canonizing their set.

In this chapter, I examine the early twentieth-century proliferation of non-fiction prose concerned with the "Yellow Nineties" (as the era came to be known due to the association of the colour yellow with the cultural irreverence of the *Yellow Book* era). Here, I focus on what it was about the

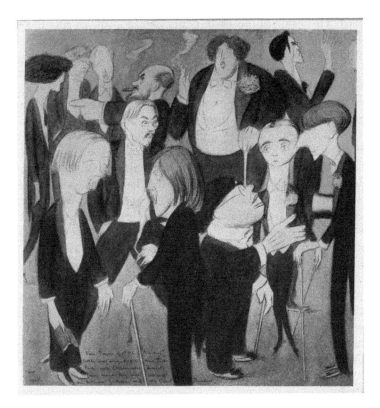

Figure 10.1 Max Beerbohm, *Some Persons of "the Nineties,"* in *Observations* (London: William Heinemann, 1925), plate 20. Left to right: Richard Le Gallienne, Walter Sickert, Arthur Symons, George Moore, Henry Harland, John Davidson, Charles Conder, Oscar Wilde, Will Rothenstein, Max Beerbohm, W. B. Yeats, Aubrey Beardsley, and Enoch Soames. (© Estate of Max Beerbohm, Berlin Associates. Photo reproduced courtesy of Joseph Bristow's collection.)

1890s in particular that seemed so politically useful and rich to the critics of the early twentieth century. What kind of thinking did the analysis of Decadence allow these writers to do that dwelling on Romanticism or Pre-Raphaelitism could not? In his *Men of the Nineties*, Muddiman refers to the 1890s as the "age of the critical function."[9] I argue that it is Decadence's "critical function" to which commentators of the 1910s and 1920s were drawn. Decadence's spirit of rebellion and critique operated as a model of enthusiasm that always remained at the same time sceptical, critical,

and apart. The vision of the 1890s generated by critics during the 1910s, 1920s, and 1930s was meant to serve as an antidote to the chauvinism of wartime and the despair of the interwar period. Decadent satire and cosmopolitanism were understood as appealing alternatives to jingoistic enthusiasms – ones that seemed to lack the "critical function" altogether.

The Decadent period was celebrated by the critics of the early twentieth century as a moment of rebellion, critique, and rebirth. Attending to the proliferation of criticism on the 1890s in this later period sheds new light on the aggressive dismissal of Decadence on the part of the high modernists. While Vincent Sherry's recent work on modernism and Decadence has demonstrated effectively that Decadent visions of temporality, decline, and "existence as aftermath" remained central to the modernist ethos, modernist authors and artists nevertheless endeavoured to repress their indebtedness to the late-Victorian past.[10] This repression was motivated in part by a desire to privilege their work as entirely novel and unique. It was also motivated by a wish to disentangle themselves from any association with the era's effeminacy. Miranda Hickman, for example, has recently argued that the vilification of the fin de siècle in the pages of Wyndham Lewis's *BLAST* emerged from nervousness about linking Vorticism too clearly to Aestheticism and the sexual and gender identities with which the movement had come to be associated following Wilde's trials. While *BLAST* explicitly condemns "the Britannic Aesthete" and the "dandy," the periodical, with its bright cover, its striking typography, and its project of shock, exhibited a clear indebtedness to *The Yellow Book*, which had, of course, been issued by the same publisher, John Lane.[11] The first issue of *BLAST* included an advertisement for a complete set of *The Yellow Book*, which ran for thirteen volumes through 1897. To counteract these all-too-visible connections with the "Yellow Nineties," the Vorticists, according to Hickman, employed a set of stylistic strategies, including ferocious diction and angular, geometric images, in order to "evict the specter of the male Aesthete qua homosexual from their midst."[12] Cassandra Laity similarly argues that early forms of modernism register a homophobic desire to reject and repress any connection with the feminized male associated with aestheticism.[13]

It is certainly the case that the modernist condemnations of Decadence had much to do with the movement's association with queer desire. In his essay 'The Place of Pater" (1930), for example, T.S. Eliot links the Aestheticist tradition to licentiousness and excess, arguing that Pater's view of art, which was so influential for the Decadents of the 1890s, was "not wholly irresponsible for some untidy lives."[14] As Pater was deeply

influential for Wilde, the comment is often understood to be a reference to Wilde's trials. It is, however, not only homophobia, I would contend, that motivates the blasting of Decadence on the part of "the men of 1914."[15] If we take Wyndham Lewis and Ezra Pound at their word, the "Yellow Nineties" were by the 1910s considered flimsy, archaic, and passé. They had been blasted into the past. Pound, for example, in his edition of *Poetical Works of Lionel Johnson* (1915), speculates that Elkin Mathews chose him to write the preface to the volume in order to provide "some definite proof that Lionel Johnson was still respected by a generation, or, if you will, by a clique, of younger poets who scoff at most things of his time."[16] Pound would seem to be an unlikely choice to edit the works of this alcoholic, queer, Decadent poet, who famously struggled with homoerotic desire in his poem "The Dark Angel" (1893): "Malicious Angel, who still dost / My soul such subtle violence."[17] Johnson, a prominent participant in the Rhymers' Club, was rumoured to have died by falling from a bar stool in the Green Dragon public house in 1902, and thus would have been linked in the modernist imagination with the more abject and pitiful elements of the Tragic Generation. Pound reconciled himself to the task of editing Johnson's work by extricating him from these Decadent contexts and insisting on the masculinity and modernity of his poetry. In making a case for the relevance and vitality of Johnson's work, Pound argues that his poems, unlike the poems of his 1890s peers, "hold their own now."[18] This view results from the fact that the poems possess "neatness and hardness," characteristics that distinguish them from the work of other poets of the fin de siècle, who have "gone out because of their muzziness, because of a softness derived, I think, not from books but from impressionist painting. They riot with half decayed fruit."[19] Pound takes it as a given that Decadence has "gone out." The movement, he insists, is in the 1910s considered entirely out of fashion and out of date.

This, however, was not the case. The fin de siècle exercised a remarkable draw on the early twentieth-century imagination, and Decadence remained a vital part of cultural conversation throughout the modernist period. Modernist efforts to minimize the significance of Decadence, to blast it to pieces, could be understood as arising from a real anxiety about an aesthetic that was often posited by critics as more vital and effective than modernism. In *John Lane and the Nineties*, for example, James Lewis May – a critic and translator who had served when he was younger as a bookseller's clerk at Lane and Mathews's The Bodley Head – counters Lewis's assertion that the "artistic spirit of the Eighteen-Nineties was *The Yellow*

Book. The artistic spirit of to-day is *BLAST.*"[20] He argues that "*The Yel-
low Book* has had no successors, and I think it never will. It, if anything,
was *sui generis.*"[21] As much as the "men of 1914" might have ridiculed
the "Yellow Nineties," a whole host of prominent critics and intellectu-
als writing in the 1910s, 1920s, and 1930s found the modernist aesthetic
comparably wanting. They turned to the Decadent "critical function"
as a font of rebirth and hope. Examining the works of these critics pro-
vides insight into the making of the myth of the 1890s and the manner
in which that myth might have provoked and troubled the modernists,
operating as a divergent strain of modernism, a spectral form of compe-
tition for new avant-gardes, haunting the critical discourse of the early
twentieth century.

 Haunting might be the best term to describe the persistence of the
1890s in the early twentieth century, and it was Wilde in particular who
remained present and visible long after the century turned. Wilde's plays
continued to be staged in the years immediately following his death in
1900, both in England and across Europe.[22] However, it was not simply
his work that remained in circulation. Wilde himself, his words and his
persona, lingered as a ghostly presence in the early twentieth century.
As Joseph Bristow has noted, the *Los Angeles Times* devoted a full page to
sightings of Wilde on the West Coast in 1908.[23] In 1913, a *New York Times*
correspondent investigated the rumours that Wilde was still alive and
determined that "no one is now in Paris who saw Wilde dead."[24] That
very same year, the performance artist Arthur Cravan (the pseudonym of
Fabian Lloyd, Wilde's nephew-in-law), published a posthumous interview
with his uncle in his Surrealist magazine, *Maintenant.* Wilde's memory
also survived in the warm memoirs published by members of his circle
who operated as mediums channelling his epigrammatic wit into the
modern moment. These works relied heavily on Wilde's own words, as
if through excessive quotation Wilde might be brought back to life and
back into the present. In *Letters to the Sphinx from Oscar Wilde and Reminis-
cences of the Author* (1930), for example, the Decadent woman writer Ada
Leverson reproduced her old friend's letters and telegrams as well as
witty offhand remarks. (On being slapped on the shoulder and greeted
by a stranger, Wilde replied, "I don't know you by sight, but your manner
is familiar."[25]) Laurence Housman, an author and illustrator whose works
appeared in *The Yellow Book,* chose to compose his *Echo de Paris* (1923),
which details a meeting between the author and Wilde after his release
from prison, as a dialogue, reanimating the "arresting quality" of Wilde's
"brilliancy of conversation."[26] (Housman's post-prison Wilde remains

whimsical and aphoristic in his speech, telling the younger men who have gathered to meet him: "If you were wise you would learn life only by inexperience."[27]) Though the American journalist and novelist Anna de Brémont, a friend of Wilde and his mother, expresses a good degree of criticism of Wilde's tendency to "pose" as well as the effects of a "battle between the feminine soul and masculine brain" on his psyche in *Oscar Wilde and His Mother: A Memoir* (1911), she nevertheless relays in detail the words spoken to her by a figure she seems to find at once tragic and alluring.[28] It is post-prison Wilde in particular, refined and remade by suffering, whose manner of speaking she finds most beautiful. A chapter devoted to an encounter with Wilde in Paris following his release reproduces with great reverence and sympathy their conversation concerning the happiness he experienced in prison as he "found [his] soul."[29] These loving memoirs ensured that Wilde's aphorisms, epigrams, and poignant turns of phrase continued to circulate in the decades following his death, allowing his voice and his insight to haunt popular discourse.

The Wilde constructed by these loving memoirs also translated well into radio. In 1941, Housman's dialogue was broadcast on the BBC with the film star Francis L. Sullivan voicing Wilde. Sullivan's performance along with Jean-Joseph Renaud's "The Last Months of Oscar Wilde in Paris" (1937), in which the French playwright "[drew] on his own memories of ... that great writer and conversationalist," kept Wilde's words in the air.[30] Wilde's plays were also broadcast frequently. *The Importance of Being Earnest* (1895) was a particular favourite, with broadcasts airing on the BBC in 1924, 1925, 1927, 1934, 1935, 1936, 1937, 1938, 1939, and 1940. Wilde's minor plays, such as *Lady Windermere's Fan* (1892), were often produced for the radio as well.[31] The BBC's *Radio Times* listing for the 1928 production of *Lady Windermere's Fan* highlighted Wilde's persistent popularity, asserting that "as a play-wright Wilde still holds the rage. ... Even now, in the very different atmosphere of 'after the war,' there is a fin-de-siècle spark about, for instance, *Lady Windermere's Fan* that makes one sympathize with the excitement that pervaded the London of the *Yellow Book* cult when it was first produced at the St. James's Theatre in February 1892."[32] These broadcasts allowed the spectral presence of Wilde's legendary wit to haunt the airwaves, an aural phantom of the 1890s speaking via modern sound technologies to a new generation.

Wilde's ghost haunted the screen as well. Numerous prestige productions of Wilde's work appeared in the 1910s and 1920s, as part of the film industry's efforts to legitimize cinema by linking it to literature and theatre. Phillips Smalley's 1913 production of Wilde's *Picture of Dorian*

Gray (1890, rev. 1891), for example, was written by Lois Weber, a woman film pioneer who went on to play a significant role in Universal's prestige productions. The "aesthetic" qualities of Wilde's work could apparently endow the emergent realm of cinema with a high-art aura. More high-profile and heavily marketed adaptations of Wilde's plays premiered in the 1920s. Ernst Lubitsch's 1925 adaptation of *Lady Windermere's Fan* was greeted with tremendous enthusiasm. This reception was certainly a reflection of Lubitsch's bankable reputation, as indicated by the *New York Sun*'s description of the work as a "directorial triumph."[33] Wilde's reputation, however, also played a significant role in the warm reception of the film. The *New York American* described the film as "brilliant with little darting shafts of wit, almost as piercing as the words of Oscar Wilde."[34] A review in the *Los Angeles Times* noted that Wilde's "epigrams have retained their magnetic sparkle even today, though the plays were written before the close of the Victorian era."[35] This is not to say that Hollywood disregarded Wilde's sexual dissidence and his capacity to generate scandal. Alla Nazimova's production of *Salomé* with its Beardsleyesque costumes and set design appeared in 1923, and United Artists marketed the film as "an orgy of sex and sin," while *Photoplay* warned audiences that the movie was "bizarre."[36] Nevertheless, though his capacity to shock had much to do with his appeal to Hollywood directors and producers, Wilde's attractiveness to a medium in pursuit of legitimacy indicates that the rehabilitation of his literary reputation was by this point under way.

The rehabilitation of Wilde's reputation was assisted by those memoirs composed by surviving members of his circle in the 1920s and 1930s, which confronted directly the homophobia that had placed his literary standing in jeopardy. Housman's *Echo de Paris*, for example, concludes with a footnote denouncing the "insensibility" of the "blight" that fell on Wilde's literary reputation following the trials as well as the "cowardice and superstitious ignorance" with which the topic of homosexuality has been approached.[37] In *Letters to the Sphinx,* Leverson aggressively defends Wilde's character, describing him as "a man incapable of being either cruel or hard" and "the most generous man I have ever met," and she speaks derisively of the "friends" who had been, prior to the trial, "fighting with each other … to flatter and make much of him" and, following the verdict, "refused point-blank to receive him at all."[38] *Oscar Wilde: Recollections* (1932), by the Decadent artist and book designer Charles Ricketts, pretends to be a translation from the French of the imaginary author Jean Paul Raymond, and the title page of the first edition lists both Raymond and Ricketts as authors. A note by Thomas Lowinsky in

this edition states that that "by this artifice" Ricketts hoped to create "a sympathetic audience for his words of passionate indignation at the fate of his friend."[39] In the opening pages of the *Recollections*, the narrator recounts his encounter with an elderly Englishman named Ricketts in Tunis. Ricketts rails against the "public school spirit" in England, which fosters hostility against "individual thought."[40] This "fear of ideas" and the "popular British bias against art, artists, and even culture," he argues, generated the "Wilde tragedy."[41] He insists that Wilde possessed "the kindest and most childlike nature" and defends the model of "intellectual" love or "romantic friendship" that Wilde endorsed, an affection that is "spiritually fruitful" and "a stimulus to thought and virtue."[42] He concludes that "the verdict has left a stain upon our humanity and culture alike."[43] The publication of such strident defences of Wilde in the early decades of the twentieth century promoted the revisiting of his work and a reconsideration of the models of sexual and gender dissidence associated with Decadence.

It was not, however, only Wilde's ghost that continued to walk the earth. While writings about Wilde and adaptations of his works certainly helped keep the "Yellow Nineties" alive and well in the twentieth century, survivors from the 1890s also played a role in extending the timeline of Decadence. Memoirs published in the early twentieth century by key figures with ties to *The Yellow Book* and John Lane's "Keynotes" series, such as Netta Syrett, Evelyn Sharp, and Ella Hepworth Dixon, kept the avantgardism of the fin de siècle before the public eye. In *As I Knew Them: Sketches of People I Have Met on the Way* (1930), Dixon breathlessly relays her memories of evenings at parties with Wilde or spent in the "dull green velvet" parlour of W.B. Yeats as well as her moments of contact with the "bachelor hosts" of the "gay 'nineties," Marc-André Raffalovich and E.F. Benson, and with the "consumedly amusing" Max Beerbohm.[44] Sharp's *Unfinished Adventure* (1933) showcases the "happiness and friendships" that accompanied her entry "into the charmed circle of authors and poets and artists that revolved round" *The Yellow Book*'s publisher and editor, Lane and Harland.[45] In *The Sheltering Tree* (1939), Syrett provides intimate glimpses into the friendships and festivities that animated the "Yellow Book set" (the "excited talk" that led to the establishment of the infamous journal, the eccentricities of the Beardsley siblings, Ella D'Arcy's infamous aversion to hard work), treating the bohemians of the 1890s as objects of continued interest while at the same time acknowledging that the Bright Young Things of the 1920s might perceive this movement as "outmoded."[46] Certain survivors from the period, however,

seemed blithely unaware that anything about the period could be viewed as passé and refused to assimilate to the shifting trends of the modernist moment, continuing to practise a decidedly Decadent aesthetic in the 1910s, 1920s, and 1930s. In addition to Max Beerbohm's series of well-received exhibits at the Leicester Galleries in the 1920s and Vernon Lee's persistent presence in public intellectual discourse into the 1930s, Ada Leverson, who had first made a name for herself in the 1890s by parodying Decadence in *Punch* and *The Yellow Book*, published novels populated with male and female dandies and peppered with Wildean aphorisms during the 1900s and 1910s. The public responded enthusiastically to her Decadent humour and style, celebrating her novels' "dainty malice and delicate satire," their "faint flavour of the clever stories which were written for the 'Yellow Book,'" as well as their "witty epigram" and cleverness.[47]

Charles Ricketts similarly kept the "Yellow Nineties" before the public eye in his designs for the stage. Ricketts's costume designs, with their exaggerated silhouettes and intricate patterns, resembled Beardsley illustrations decorated with a Decadent palette of rich and highly symbolic colour. In 1906 the Literary Theatre Society staged Wilde's *Salome* (1892) along with his unfinished drama *A Florentine Tragedy*, and the synopsis of dresses Ricketts designed for *Salome* reads like a piece of Decadent verse:

> Salome, dressed in a mist rising by moonlight, with a train of blue
> and black moths.
> Herodias, in a peacock train of Dahlias and a horned tiara.
> Herod, is robed in silver and blue lined with flame decorated with griffons,
> sphinxes and angels.
> The scene is all blue on blue.[48]

Roger Fry's response to the production indicates that Ricketts's designs spoke successfully across the Victorian/modern divide: "C. Ricketts did the staging with ideas of colour that surpassed belief. I've never seen anything so beautiful on the stage."[49] Into the 1910s and 1920s, Ricketts continued to inflect his costume and set designs with Decadent imagery, peacock feathers and jewels, exposed flesh and elaborate headdresses, and he worked with some of the most innovative twentieth-century playwrights, designing for Yeats and Synge and Shaw, bringing to his productions of the "new" drama of the twentieth century an opulent, fin-de-siècle sensibility.

For those who could no longer speak for themselves, a new generation of post-Victorian dandies operated as advocates and representatives. In 1928, for example, the biographer A.J.A. Symons published *An Anthology of "Nineties" Verse* with Elkin Mathews. The volume was bound in a striking yellow cover decorated with an image by Aubrey Beardsley. Beardsley's sinister and erotic images of androgynous men and women were featured frequently on the cover of *The Yellow Book* during his tenure as art editor for the periodical (1894–5). Symons mimicked the design as well as the content of *The Yellow Book*, as if he wished to reanimate the outrageous periodical and bring an aesthetic only recently deceased back to life. In his introduction to the collection, he acknowledges that the poetry of the period resembles "elderly furniture that has not yet attained the prestige of antiquity."[50] Symons, however, celebrates readers whose vision focuses on the middle distance, at a moment only recently past: "To those whose reading does not end with Wordsworth or begin with Joyce, who retain what Pater called a 'sweet depravity of ear,' the poetry of the 'nineties, within its self-imposed and unstrained limits, offers many and varied savours and essences."[51]

The following year, Symons further cultivated this taste for the middle distance by founding the Corvine Society, which celebrated the Decadent writer Baron Corvo (Frederick Rolfe), who was the subject of Symons's best-known work, *The Quest for Corvo: An Experiment in Biography* (1934). Symons marked the establishment of the Corvine Society with a set of elaborate banquets, the second of which was attended by Wyndham Lewis, one of the most vociferous detractors of the 1890s aesthetic.[52] The presence of figures such as Lewis at such events suggests that the modernists' professed distaste for or disinterest in the 1890s must have been little more than a pose. Similarly, Beerbohm's visitors' book indicates that he received Ezra Pound, T.S. Eliot, and Ernest Hemingway at his home in Rapallo.[53] Many modernists actively pursued contact with the men who had survived the fin de siècle and their literary remains. Though the "Yellow Nineties" awaited them at every turn, in the galleries and on the screen, in the book stalls and on the radio, the most avowedly modern of the moderns seem to have purposefully sought out further knowledge of their most immediate precursors, begrudgingly paying homage to an aesthetic that refused to fade into the past.

Of all these resurrections of the "Yellow Nineties," the spectral presence that demanded the most serious attention was certainly the earnest and urgent criticism on the period written by both witnesses, such as the Decadent poet Richard Le Gallienne, and younger men, such as the writer

and caricaturist Bohun Lynch, who saw in the period a potential locus for regeneration.[54] These critics, whether speaking as representatives of the recent past or as young men longingly nostalgically for a past they never knew, shared an aversion to the term "Decadent." It was "the Beardsley Period," "the Yellow Nineties," "the Romantic Nineties," "the Renaissance of the Nineties," but rarely "the Decadent Nineties." The term is used sparingly, if at all, by critics who wish to focus on the regenerative effects of an aesthetic they associate with opposition, revolt, and reformation. Even Jackson, who employs the term to a far greater extent than any of the other aforementioned critics, insists that "the Eighteen Nineties ... were not entirely decadent and hopeless; and even their decadence was often decadence only in name, for much of the genius denounced by Max Nordau as degeneration was a sane and healthy expression of a vitality which, as it is not difficult to show, would have been better named regeneration."[55] May associates with the period a "vivid sensation of freshness and light, as of a morning in Spring." The phrase *"fin de siècle"* conveys to him "the suggestion of something a little daring, a hint of reckless, elegant abandon. It can hardly be denied, I think, that, at all events in literary and artistic circles, there was a sort of ferment, in those days. There was something in the air. The Golden Age was returning."[56] For such a golden age, the term "yellow" might be preferable. As the Italian American novelist and biographer Frances Winwar notes in her *Oscar Wilde and the Yellow Nineties* (1940): "There was something vivid and daring about the color, something of the times, like the golden bloom of the age on a century that was nearing its close – not to death but to greater achievement. Both yellow and fin de siècle began to have connotations open to many meanings but all leading to a definable sense of modernity, challenge, emancipation." [57] Winwar was an outspoken opponent of Italian Fascism in the 1930s and 1940s, which helps explain her attraction to the critical capacity of the period. In her eyes, the spirit of the "Yellow Nineties," its scepticism and rebelliousness, facilitated the rebirth of a culture, so that the term "Decadent" necessarily begins to appear like a misnomer. Elizabeth Pennell, an American writer who lived in London during the 1890s and frequently hosted salons attended by Wilde, Beerbohm, and Beardsley, prefers the term "Fighting Nineties," for, she argues, "people ... were much more awake in the Nineties, much more alive, much more keen about everything, even a fight, or above all a fight." [58] It was a period "of insurrection, of vigorous warfare," when "the incident, or work, or publication that roused any interest at all was the signal of the clash of arms, for the row and the rush."[59]

It is certainly the case, as Talia Schaffer has argued, that these critics were working to demonstrate that "the period was vital, brash, and embattled – qualities valued during the modernist period during which they were publishing."[60] However, they also wished to posit the heady spirit of the decade as a model for recuperation in the interwar era, so that it became necessary to repress terminology linked with decay and degeneration. In the process of linking the 1890s with rebirth, many of these critics go one step further and disparage the modern present as a moment of destruction and decay, a truly decadent moment that might stand to benefit from renewed contact with the critical ethos of the "Yellow Nineties." Evelyn Sharp, a feminist writer who had herself been published in *The Yellow Book*, states in a 1924 essay published in the *Manchester Guardian*: "One is constrained to wonder if anywhere in the young world today there is a literary and artistic circle so full of vitality and promise as the one, absurdly labelled decadent, that produced those thirteen volumes perfectly printed and turned out at *The Bodley Head* as few books, I think, are turned out in a post-war world."[61] Le Gallienne similarly transposes the association with decay onto the present, arguing that, while "to-day we have less sowing, or even reaping, than running to seed," the "amount of creative revolutionary energy packed into [the 1890s] is almost bewildering in its variety. So much was going on at once, in so many directions, with so passionate a fervour."[62] In these writings, the revolt and regeneration of the fin de siècle are repeatedly privileged over the insurrectionary methods of the moderns.

These critics also seem to share a belief that one may take for granted the political nature of the Decadent project. What has taken modern criticism quite some time to comprehend – that Decadence was politically engaged – went without question for many of these critics. This was a group of authors and artists who, in the eyes of such commentators as Jackson, Burdett, Muddimann, and Murdoch, contested commercialism, industrialization, and all types of unthinking jingoism. Le Gallienne refers to the 1890s as "romantic." He does so "because their representative writers and artists emphasized the modern determination to escape from the deadening thraldom of materialism and outworn conventions, and to live life significantly keenly and beautifully, personally and, if need be, daringly; to win from it its fullest satisfactions, its deepest and richest and most exhilarating experiences. The will to romance: that, in a phrase, was the motive philosophy of the '90s."[63] The Decadents' will to romance must, according to Le Gallienne, be understood in relationship to their critical spirit, their oppositional relationship to their own present. The

central characteristic of the period was, according to Jackson, "a wide-spread concern for the correct – that is, the most effective, the most powerful, the most righteous – mode of living."[64] "The renaissance of the Nineties was," he argues, "largely social."[65] While critics in the latter half of the twentieth century have often lambasted Decadence's asocial and apolitical preoccupation with play, pleasure, and finery, the majority of early twentieth-century criticism on the 1890s expresses sincere admiration for the Decadents' oppositional stance, their antagonism and critique, their earnest desire to remake the world and experience.

It is this tendency to critique and protest that the biographer and critic Osbert Burdett foregrounds in *The Beardsley Period*. Burdett was intimate with members of the "Uranian" circle, such as Forrest Reid and Edward Perry Warren, whose writings celebrate "boy-love" and the beauty of youth.[66] Pater was enormously influential for this circle, and, in his writing on Pater, Burdett seems most interested in the sexual dissidence associated with the Aestheticist tradition.[67] In *The Beardsley Period*, however, he preoccupies himself primarily with the economic valence of Decadent critique. These young men, Burdett argues, represented a "protest against a commercial society."[68] Their satirical works express their "distaste for the conditions of our industrial society." Their investment in romance and decoration "[carried] their imagination beyond the taint of [this society's] grasp." Their ties to paganism and mysticism "[encouraged] their faith in the existence of a different order."[69] These characteristics should not, according to Burdett's argument, be misread as evidence of escapist tendencies on the part of the men of the Beardsley period. Their aloofness and archness, their devotion to beauty, and their love for all things occult served to strengthen their capacity to perceive lack and vulgarity in the industrial world. "They were disillusioned people," Burdett writes, "without sympathy or understanding for the world in which they lived, who found hardly any living activities in that world to correspond with their susceptibilities to beauty."[70]

In teasing out the political significance of their distaste for commercialism, Burdett comes around to the crux of what it is the men of the Beardsley period have to offer to the men of the interwar period. The conditions against which the men of the Beardsley period revolted have not disappeared. They have, in Burdett's mind, only intensified. The modern European, Burdett argues, "is now bred into a slave society that he cannot understand, define, or even recognize, for industrialism establishes a state of slavery more corrupting than any previously known in the world because the master is not a man but a system, and

the whip an invisible machine. With this it is impossible to enter into any but inhuman relations, and in such an inversion of humanity all the instincts become perverted at their source."[71] The war was a direct result of this perversion, "a warning that the industrial epoch will destroy itself."[72] Burdett is drawn to the emphasis on perception in the works of the fin de siècle, for, he argues, it is the "blunting of [modern] faculties" that facilitates acquiescence to brutality and commercialism. Were modern Europeans alive at every moment to the world around them, forever "courting new impressions," they would perceive injustice, and their capacity for protest and revolt would be vitalized.[73] Burdett must, however, close his book without concluding, for, as he states, "the historical process in the course of which the Beardsley period arose is not yet over." He ends by speaking longingly of "disillusion," an attitude that for him "implies a conscience that is still sensitive," but disillusion, he argues, is "out of date" and "has been replaced by indifference."[74] The book is one long scold, an expression of thorough exasperation with the modern present that offers the clarity and acuity of Paterian perception as the only potential antidote to the victory of the commercial spirit and its disastrous consequences.

In celebrating the disillusion of the 1890s, Burdett foregrounds the apartness and aloofness that is so central to the Decadent stance, and he makes the political significance of this apartness explicit in the opening of *The Beardsley Period* when he describes the scene of the fin de siècle as "not local or patriotic but cosmopolitan."[75] In the eyes of many critics who were drawn to the fin de siècle during the interwar period, the "Yellow Nineties" represented a promising model of cosmopolitan detachment. In *The Powers of Distance* (2001), Amanda Anderson demonstrates that throughout the nineteenth century British authors tested the "progressive potentiality" of distancing one's self from one's community, one's nation, or from objects of study, but she also argues that this ideal was radicalized at the end of the century by Oscar Wilde: "Wilde seeks to protect the process of thinking that he associates with self-consciousness or criticism from any constraint, limit, determination. ... In being so freed, thought is also released from the limitations of any given viewpoint and ascends to the realm of disinterestedness, which is also, paradoxically, the realm of unfettered self-realization, or individuality."[76] In particular, Wilde's model of detachment constitutes a radicalization of Matthew Arnold's ideal detachment, according to Anderson, because Wilde has conflated disinterestedness with radical freedom and the conditions for the fullest possible self-expression.

In a sense, however, this radicalization of Arnold's ideal of disinterest-edness was initiated by Pater himself, who, while celebrating personal pleasure and subjective response, simultaneously endorsed a hyperki-netic detachment from any philosophy, school of thought, or creed that might delimit the subject's perception. "How" Pater asks, "may we see in [every pulse of our experience] all that is to seen in them by the finest senses? How shall we pass most swiftly from point to point, and be pres-ent always at the focus where the greatest number of vital forces unite in their purest energy?"[77] We must, as Pater puts it, avoid forming habits, reject facile orthodoxies, and eschew any belief system in which faith might limit our capacity for perception. This hyperkinetic detachment became a central element of 1890s Decadence, contributing to the devel-opment of the "critical function" in the work of the men of the Beardsley period, and it was this sense of detachment that Beerbohm celebrated in his obituary for Beardsley, in a passage that Lawrence Danson insists must be understood as somewhat self-referential. In Beerbohm's view, Beardsley had always remained "rather remote, rather detached from ordinary conditions, a kind of independent spectator. ... This kind of aloofness has been noted in all great artists. ... It is because they stand at a little distance that they can see so much."[78]

When exhausted and exasperated critics writing during the interwar period turn to the "Yellow Nineties," it is often due to their interest in the Decadents' capacity for radical aloofness. Bohun Lynch, for example, argues that, while the Beerbohm of 1922 may have "dropped some ... of [the] flippancy" he displayed in the 1890s, "he does not suffer, or should not, the reproach of being called earnest," a term Lynch characterizes as "a very terrible reproach."[79] "We mean by earnestness," he writes, "that seriousness which is set forth not only without humour but which makes manifest the impossibility of there being a sense of humour behind the sense of importance. Earnestness is an inalienable and indispensable quality of propaganda, of the sermon."[80] Earnestness, it would seem, is standing in here for all sorts of blindness, the impaired vision brought about by dangerous political passions or religious fervour. Humour, the critical function, and detachment operate as antidotes to this kind of blindness. They preserve the capacity for perception and balance. Beer-bohm's refusal to abandon humour emerges in Lynch's work as a brand of heroism. Resistant to the dramatic allure of earnest passions, Beer-bohm remains outside, apart. In Lynch's words, he "keeps the balance true."[81] All political positions are equally subjected to Beerbohm's satiri-cal scrutiny. As Lynch argues in response to Charles Marriott's critique

of Beerbohm's caricatures of Labour, "Max has satirized the social out-look from all three points – Aristocracy, Labour, and Business," so "none of them need complain." He "recognises that all stories have two sides to them, and no truth is absolute."[82] In remaining detached, his vision remains clear. His sympathy remains open to all but bound to none.

Beerbohm, like his contemporary post-Victorian aesthete, Vernon Lee, survived to see the Great War and drew on his connections to Pate-rian tradition in remaining stubbornly immune to the allure of jingo-ism. In turning to the 1890s, critics like Burdett attempt to foster simi-lar connections with this model of detachment, to establish apartness from nation as an antidote to the aggressive energies of the interwar period. The Russian literary critic Boris Brasol, for example, in his *Oscar Wilde: The Man, the Artist, the Martyr* (1938), celebrates Wilde's quest to "become a citizen of the world." [83] "To the Anglo-Saxon," Brasol notes, "the cosmopolitan mind is, and always has been, an enigma full of most mischievous potentialities, an amoral phenomenon mortifying by reason of its heterodoxy from his own parochial standards."[84] The Anglo-Saxon, it is implied, could learn much from the mischievous potentialities of Decadent detachment. However, the Anglo-Saxon world seems to have become increasingly disconnected from the mischievous potential of cosmopolitanism, by the Great War certainly, but perhaps even earlier than that, by the destructive manner of conceiving of nation initiated during the Boer War. The literary critic W.G. Blaikie Murdoch, who expressed an enthusiasm for the Aestheticist tradition in the 1910s, pub-lishing appreciations of Algernon Charles Swinburne and the Decadent poet Arthur Symons, similarly argues that the most serious blow dealt to that tradition occurred during the Second Anglo-Boer War (1899–1902). Murdoch asserts that during that conflict "the country's resources were drained, and people were unable to spend money on books and pictures, while, simultaneously, interest in these things was submerged in patriotic anxiety and ardour."[85] "Imperialism," he argues, "is the enemy of art," and the escalating nationalism at the close of the decade extinguished the possibility at the time of its opening.[86] Writing only a couple of years later, Jackson makes a similar claim, arguing that the 1890s were the battleground for two types of culture, one represented by *The Yellow Book* and the other represented by the "Yellow Press." The first type was ascen-dant in the first half of the decade, a moment of "literary and artistic renaissance," while the latter type, marked by "a new sense of patriotism degenerating into jingoism," found its expression in the discourse sur-rounding the Boer War.[87] The decade concluded, then, with the nation

"bitten by an unseeing pride, expressing itself in a strangely inorganic patriotism, [forgetting] arts and letters and social regeneration, in the indulgence of blatant aspirations which reached their apotheosis in the orgy of Mafeking Night."[88] Writing in the years immediately preceding the Great War, both Murdoch and Jackson eulogize the hope with which they associate the spirit of the Yellow Nineties, an ethos that was brutalized by the Boer War and soon to be devastated by the much larger traumas on the horizon.

Interwar critics writing on the 1890s, however, seem to understand this ethos as a hostage, as opposed to a casualty, of the modern moment. If considered carefully enough, if attended to properly, then perhaps, they suggest, the spirit of the period could be reinvigorated and brought to bear upon the wounded present. If the nation had forgotten arts and letters and social regeneration, perhaps it could, through contact with Decadent writers and artists, be reminded. While critical works on the 1890s composed in the 1910s, 1920s, and 1930s express disparate visions of the fin de siècle, they also share a sense that the Decadent ethos had not (as I have noted) been blasted into the past, or, if it had, ought to be retrieved, for the peculiar type of revolt that Decadence represented was much needed in the years following one world war and preceding another. If new kinds of violence seemed possible, an older model of critical detachment, drawn from the work of the more or less immediate past, seemed increasingly necessary. What I hope to have demonstrated is that the modernist dismissal of the Beardsley period was in fact a rebuttal, an anxious response to the ongoing touting of that period's power and allure. In addition, much of the scholarship that has been conducted in the past few decades, which has implicitly responded to and contested the modernists' contempt for Decadence and the tradition of dismissive criticism that contempt inaugurated, was begun much earlier by critics writing in the early twentieth century. As we continue to reconsider the politics of Decadence, we might be well served by returning to the critical inquiries written in the immediate wake of the fin de siècle, when many of the period's ghosts still walked the earth.

NOTES

1 *Catalogue of an Exhibition Entitled "Ghosts"* (London: E. Brown & Phillips, 1928), 7–8.

2 *Catalogue of an Exhibition*, 7–8.

3 *Catalogue of an Exhibition*, 7–8.

4 *Catalogue of an Exhibition*, 7–8.

5 *Catalogue of an Exhibition*, 7–8.

6 As Ann Ardis notes, *The New Age*'s relationship to modernism was extremely complex, and the periodical often featured caustic satires and critiques of modernism. In her work on *The New Age*, Ardis highlights the periodical's commitment to Guild Socialism, which often inspired negative presentations of modernist visual and literary art. See chapter 5 of Ardis, *Modernism and Cultural Conflict, 1880–1922* (New York: Cambridge University Press, 2002), 143–72. Nevertheless, *The New Age* did play a significant role in fostering conversation about modernism during the early twentieth century.

7 Jackson was quite prolific, producing more than twenty books before his death in 1948, and he was responsible for early biographies of Bernard Shaw (1907) and William Morris (1908).

8 Max Beerbohm, *Observations* (London: William Heinemann, 1925).

9 Bernard Muddiman, *The Men of the Nineties* (London: H. Danielson, 1920), 19.

10 Vincent Sherry, *Modernism and the Reinvention of Decadence* (Cambridge: Cambridge University Press, 2015), 238.

11 Wyndham Lewis, "Manifesto – I," *BLAST* 1 (1914), 15.

12 Miranda B. Hickman, *The Geometry of Modernism: The Vorticist Idiom in Lewis, Pound, H.D., and Yeats* (Austin: University of Texas Press, 2005), 41.

13 See Cassandra Laity, *H.D. and the Victorian Fin de Siècle: Gender, Modernism, Decadence* (Cambridge: Cambridge University Press, 1996).

14 T.S. Eliot, "The Place of Pater," in *The Eighteen-Eighties: Essays by Fellows of the Royal Society of Literature*, ed. Walter de la Mare (Cambridge: Cambridge University Press, 1930), 105.

15 The phrase "the men of 1914," which Wyndham Lewis uses to refer to Eliot, Pound, Joyce, and presumably himself, is drawn from his *Blasting and Bombardiering* (London: Eyre and Spottiswoode, 1937).

16 Ezra Pound, "Preface," in *Poetical Works of Lionel Johnson* (London: Elkin Mathews, 1915), vi.

17 Lionel Johnson, "The Dark Angel," in *Poems* (London: Elkin Mathews, 1893), 67.

18 Pound, "Preface," xiv.

19 Pound, "Preface," xiv, viii. As Joseph Bristow notes, "the incisive tone of the preface proved so upsetting to some readers that Mathews withdrew the volume from sale." "Introduction," in *The Fin-de-Siècle Poem: English Literary Culture and the 1890s*, ed. Bristow (Athens: Ohio University Press, 2005), 31.

20 J. Lewis May, *John Lane and the Nineties* (London: John Lane, 1936), 88.

21 May, *John Lane and the Nineties*, 88.

22 For a detailed timeline of performances of Wilde's plays, see Michelle Paul, "Performance Timeline of the European Reception of Oscar Wilde," in *The Reception of Oscar Wilde in Europe*, ed. Stefano Evangelista (London: Continuum, 2010), lxxvii–cv.

23 See Joseph Bristow, "Introduction," in *Oscar Wilde and Modern Culture: The Making of a Legend*, ed. Bristow (Athens: Ohio University Press, 2008), 26.

24 "No One Found Who Saw Wilde Dead," *New York Times*, 9 November 1913, C4.

25 Ada Leverson, *Letters to the Sphinx from Oscar Wilde* (London: Duckworth, 1930), 25.

26 Laurence Housman, *Echo de Paris* (London: Jonathan Cape, 1923), 15, 14.

27 Housman, *Echo de Paris*, 23.

28 Anna, Comtesse de Brémont, *Oscar Wilde and His Mother: A Memoir* (London: Everett & Co., 1911), 100.

29 De Brémont, *Oscar Wilde and His Mother*, 187.

30 "'The Last Months of Oscar Wilde in Paris,' Regional Programme London, 23 November 1937," *BBC Genome*, https://genome.ch.bbc.co.uk/cdeb1f0e50e74416bc7dfdcc6807cfd8.

31 The BBC aired productions of *A Woman of No Importance* in 1924 and 1925, *An Ideal Husband* in 1924, 1926, and 1932, and *Lady Windermere's Fan* in 1926 and 1928.

32 "*Lady Windermere's Fan* – 2LO London – 17 April 1928," *BBC Genome*, https://genome.ch.bbc.co.uk/333eec2abcfa43f39c08d2c0124d2411.

33 Quoted in Charles Musser, "The Hidden and the Unspeakable: On Theatrical Culture, Oscar Wilde, and Ernst Lubitsch's *Lady Windermere's Fan*," *Film Studies* 4 (2004): 21.

34 Musser, "The Hidden and the Unspeakable," 20.

35 Musser, 22.

36 Quoted in Petra Dierkes-Thrun, *Salome's Modernity: Oscar Wilde and the Aesthetics of Transgression* (Ann Arbor: University of Michigan Press, 2011), 158; quoted in Patricia White, "Nazimova's Veils: Salome at the Intersections of Film History," in *A Feminist Reader in Early Cinema*, ed. Jennifer Bean and Diane Negra (Durham: Duke University Press, 2002), 62.

37 White, "Nazimova's Veils," 55, 56.

38 Leverson, *Letters to the Sphinx*, 23, 47, 36.

39 Charles Ricketts, *Oscar Wilde: Recollections* (London: Nonesuch Press, 1932), 7.

40 Ricketts, *Oscar Wilde*, 11.

41 Ricketts, 10, 11.

42 Ricketts, 23, 31.

43 Ricketts, 57.

44 Ella Hepworth Dixon, *As I Knew Them: Sketches of People I Have Met on the Way* (London: Hutchinson & Co., 1930), 192, 133, 250.

45 Evelyn Sharp, *Unfinished Adventure: Selected Reminiscences from an Englishwoman's Life* (London: John Lane and The Bodley Head, 1933), 56.

46 Netta Syrett, *The Sheltering Tree* (London: Geoffrey Bles, 1939), 80, 83.

47 Review of *The Limit, Star*, 18 March 1911, 2; Review of *The Limit, Westminster Gazette*, 1 April 1911, 7: Review of *The Limit, Vanity Fair*, 15 March 1911, 298.

48 From a synopsis of addresses Ricketts wrote for Robert Ross, quoted in *Robert Ross: Friend of Friends*, ed. Margery Ross (London: Jonathan Cape, 1952), 127. At the time of his imprisonment on 25 May 1895, Wilde had been working for about eighteen months on the draft of *A Florentine Tragedy*, which he had been circulating among actors and theatre managers, including George Alexander at the St James's Theatre. Even though Wilde expressed a wish to return to the drama during his two-year sentence, he proved unable to finish the play. In 1904, his literary executor Robert Ross discovered manuscript and typescript pages, and he undertook to reassemble the text that Wilde had completed. The opening scene, however, was missing. The English poet Thomas Sturge Moore composed two hundred lines to serve as the opening scene. The text, which was staged in a private performance for the Literary Theatre Society in London, was first published in *The Collected Works of Oscar Wilde*, ed. Ross, 14 vols. (London: Methuen, 1908), 2:83–114.

49 Quoted in Eric Binnie, *The Theatrical Designs of Charles Ricketts* (Ann Arbor: UMI Research Press, 1985), 41.

50 A.J.A. Symons, *An Anthology of "Nineties" Verse* (London: E. Mathews & Marrot, 1928), xvii.

51 Symons, *An Anthology of "Nineties" Verse*, xx.

52 See A.J.A. Symons, "A True Recital of the Procedure of the Second Banquet Held by the Corvine Society, December 12th, 1929" (London: Corvine Society, 1929).

53 Beerbohm's visitor books from his home at Rapallo are in the Max Beerbohm Collection at Merton College, Oxford. Ezra Pound and T.S. Eliot visited Beerbohm's home on 23 December 1925, and Pound visited with his wife repeatedly over the years after they themselves settled in Rapallo. Hemingway visited in 1922.

54 For a discussion of Richard Le Gallienne's significant contribution to the culture of the 1890s, see Emily Harrington, "Richard Le Gallienne and the Rhymers: Masculine Minority in the 1890s," chapter 5 in the present volume.

55 Holbrook Jackson, *The Eighteen Nineties: A Review of Art and Ideas at the Close of the Nineteenth Century* (London: Grant Richards, 1913), 19.

56 May, *John Lane*, 37.

57 Frances Winwar, *Oscar Wilde and the Yellow 'Nineties* (New York: Harper, 1940), 239.

58 Elizabeth Robins Pennell, *Nights: Rome & Venice in the Aesthetic Eighties, London & Paris in the Fighting Nineties* (Philadelphia: J.B. Lippincott, 1916), 118.

59 Robins Pennell, *Nights*, 120.

60 Talia Schaffer, ed. *Literature and Culture at the Fin de Siècle* (New York: Longman, 2006), 3.

61 Evelyn Sharp, "A Group of the Nineties," *Manchester Guardian* (1924), 7.

62 Richard Le Gallienne, *The Romantic '90s* (New York: Doubleday, 1925), 137.

63 Le Gallienne, *The Romantic '90s*, 270–1.

64 Jackson, *The Eighteen Nineties*, 14.

65 Jackson, 48.

66 *Defence of Uranian Love* (1928–30) by Edward Perry Warren (1860–1928) (published under the pseudonym Arthur Lyon Raile) begins with a section titled "The Boy Lover." Forrest Reid's Uranian novella *The Garden God* (1905) focuses on the love between boys at school. Burdett was close friends with Warren and worked on a biography of him that was completed by E.H. Goddard after his death. In his commonplace book, E.M. Forster recollects that Burdett once "tried to get off with Forrest Reid in the lavatory of the Savile Club." *Commonplace Book* (Stanford: Stanford University Press, 1987), 102.

67 Burdett cultivated a vision of a Pater possessed by secret desires and urges. In his introduction to *Marius the Epicurean* (1885), he represents Pater as barely able to contain his hidden passions, asserting that "the choice for him lay between an almost rigid restraint and the uncurbing of energies that might have proved more than he could master." Osbert Burdett, "Introduction," in *Marius the Epicurean* by Walter Pater (London: J.M. Dent & Sons, 1951 [reprint of 1934 edition], x). He also defended Pater from the homophobic attacks of modernists such as T.S. Eliot. In a review of *The Eighteen-Eighties: Essays by Fellows of the Royal Society of Literature*, he expresses exasperation with Eliot's stuffy and moralistic critique of the role Pater played in leading "a number of writers in the 'nineties' to lead 'untidy lives'" and berates Eliot for behaving like an "arid governess." Cf. Eliot, "The Place of Pater," 105.

68 Osbert Burdett, *The Beardsley Period, an Essay in Perspective* (London: John Lane, 1925), 15.

69 Burdett, *The Beardsley Period*, 264.

70 Burdett, 267.

71 Burdett, 268.

72 Burdett, 289.

73 Walter Pater, *The Renaissance: Studies in Art and Poetry – The 1893 Text*, ed. Donald L. Hill (Berkeley: University of California Press, 1980), 189.

74 Burdett, *The Beardsley Period*, 290.

75 Burdett, 7.

76 Amanda Anderson, *The Powers of Distance: Cosmopolitanism and the Cultivation of Detachment* (Princeton: Princeton University Press, 2001), 153.

77 Pater, *The Renaissance*, 188.

78 Quoted in Lawrence Danson, *Max Beerbohm and the Act of Writing* (New York: Oxford University Press, 1989), 230.

79 Bohun Lynch, *Max Beerbohm in Perspective* (New York: Alfred A. Knopf, 1922), 74.

80 Lynch, *Max Beerbohm in Perspective*, 74–5.

81 Lynch, 153.

82 Lynch, 158.

83 Boris Brasol, *Oscar Wilde: The Man, the Artist, the Martyr* (New York: C. Scribner's Sons, 1938), 192. Brasol seems to have exhibited a progressive sensibility in his enthusiasm for the ethos of cosmopolitanism. However, it is also important to note that he was a monarchist and that he is believed to have translated into English a forged document, "The Protocols of the Elders of Zion," which purported to outline the Jews' plan for world domination.

84 Brasol, *Oscar Wilde*, 192.

85 W.G. Blaikie Murdoch, *The Renaissance of the Nineties* (London: A. Moring, 1911), 73.

86 Murdoch, *The Renaissance of the Nineties*, 73.

87 Jackson, *The Eighteen Nineties*, 54.

88 Jackson, 54.

Contributors

Kasey Bass is Professor of English at Lone Star College-CyFair. Her research focuses on late Victorian women poets, especially Mary Coleridge, about whom she has published in *Victorian Poetry*. She is currently working on a project titled *The Letters of Mary Coleridge* and completing a monograph titled *The Dramatic Monologue at the Fin de Siècle: Women Writers and Literary Inheritance*.

Megan Becker-Leckrone is Professor of English at the University of Nevada, Las Vegas. She is the author of *Julia Kristeva and Literary Theory* (Palgrave Macmillan, 2005) and a former editor of *The Pater Newsletter* (2007–11). Her recent essays appear in *Wilde's Other Worlds*, edited by Michael Davis and Petra Dierkes-Thrun (Routledge 2018); *Reading Victorian Literature: Essays in Honour of J. Hillis Miller*, edited by Julian Wolfreys and Monika Szuba (Edinburgh University Press, 2019); and *The Microgenre: A Quick Look at Small Culture*, edited by Molly C. O'Donnell and Anne H. Stevens (Bloomsbury, 2020). Her current research in medical humanities is centred on a book-length study, "The Materiality of Migraine."

Joseph Bristow is Distinguished Professor of English at the University of California, Los Angeles, where he conducts much of his research in the fin-de-siècle collections held at the William Andrews Clark Memorial Library. His recent books include (with Rebecca N. Mitchell) *Oscar Wilde's Chatterton: Literary History, Romanticism, and the Art of Forgery* (Yale University Press, 2015) and *Oscar Wilde on Trial: The Criminal Proceedings, from Arrest to Imprisonment* (Yale University Press, 2022). He has edited two previous collections of essays for the University of Toronto Press: *Wilde Writings: (Con)Textual Conditions* (2003) and *Wilde Discoveries: Tradi-*

tions, Histories, Archives (2013). He co-edits (with Rebecca N. Mitchell and Charlotte Ribeyrol) *Studies in Walter Pater and Aestheticism.*

S. Brooke Cameron is Associate Professor of English at Queen's University, Kingston. Her first book, *Radical Alliances: Economics and Feminism in English Women's Writing, 1880–1938*, appeared from the University of Toronto Press in 2019. Her essays have recently been published in *Victorian Literature and Culture* and *Victorian Review.*

Emily Harrington is Associate Professor of English at the University of Colorado, Boulder. Her study *Second Person Singular: Late Victorian Women Poets and the Bonds of Verse* appeared from the University of Virginia Press in 2014. She has published essays in several leading journals, including *Nineteenth-Century Literature.*

Kate Krueger is Director of the Honors Program and Professor of Literature at Clarkson University. Her previous positions included Director of the Honors Program in the College of Liberal Arts and Sciences at the University of Illinois at Urbana-Champaign, and Associate Professor of English at Arkansas State University. She is the author of *British Women Writers and the Short Story, 1850–1930: Reclaiming Social Space* (Palgrave Macmillan, 2014). Her recent essays have appeared in *Victorian Periodicals Review, Women's Writing,* and *English Literature in Transition, 1880–1920.*

Kristin Mahoney is Associate Professor in the Department of English and the Center for Gender in a Global Context at Michigan State University. She has published essays on Aestheticism and Decadence in *Victorian Studies, Criticism, English Literature in Transition, 1880–1920, Literature Compass, Nineteenth Century Prose, Victorian Review,* and *Victorian Periodicals Review.* Her book *Literature and the Politics of Post-Victorian Decadence* was published by Cambridge University Press in 2015. Her second monograph is *Queer Kinship after Wilde: Transnational Decadence and the Family* (Cambridge University Press, 2022).

Diana Maltz is Professor of English at Southern Oregon University. She is the author of *British Aestheticism and the Urban Working Classes: Beauty for the People, 1870–1900* (Palgrave Macmillan, 2006) and the editor of Arthur Morrison's *A Child of the Jago* (Broadview Press, 2013), W. Somerset Maugham's *Liza of Lambeth* (Broadview Press, 2022), and *Critical Essays*

on Arthur Morrison and the East End (Routledge, 2022). She is presently completing a monograph, "Fictions of the New Life," which examines writings by socialist feminists in utopian communities at the fin de siècle. Her newest aesthetic work, a study of aesthetic caricature in William De Morgan's 1906 novel *Joseph Vance*, appears in *Evelyn and William De Morgan: A Marriage of Arts and Crafts* (Yale University Press, 2022).

Beth Newman is Associate Professor of English at Southern Methodist University. She is the author of *Subjects on Display: Psychoanalysis, Social Expectation, and Victorian Femininity* (Ohio University Press, 2004) and the editor of teaching editions of both *Jane Eyre* for Bedford Books (second edition, 2014) and *Wuthering Heights* for Broadview Press (2007). Her work appears in *ELH, PMLA, NOVEL: A Forum on Fiction, SEL, Victorian Review,* and *Victorian Poetry,* and is forthcoming in *Victorian Studies.*

So Young Park is Professor of English at Gustavus Adolphus College, where she teaches courses in nineteenth- and twentieth-century British literature. She has published on Victorian poetry and fiction, as well as on Korean popular culture. As an Andrew W. Mellon Digital Humanities Fellow, she developed a course on Korean Drama and its transnational contexts that used digital media tools to analyze popular culture. Her research in Victorian studies focuses on women writers of the 1890s, collaboration, and the visual arts.

Julie Wise is Associate Professor of English at the University of South Carolina–Aiken, where she teaches courses on British literature, on women's literature, and on writing. She has published several articles on Victorian poets and poetry, including essays in *Victorian Poetry* and *English Literature in Transition, 1880–1920,* and is currently completing a book manuscript about fin-de-siècle women poets and modernity.

Index

Note: Page numbers in *italics* indicate a figure.

Reid, Forrest, 330; *The Garden God*, 338n66
Religio Medici (Browne), 283n35
religion: Aestheticism and, 128–9, 144–5, 149; Dearmer and, 127, 128, 129, 145, 149; Meynell and, 156, 159, 165, 166–7, 171, 172, 175n28
Religion of a Literary Man, The (Le Gallienne), 198n33
Renaissance, The: Studies in Art and Poetry (Pater), 4–5, 158, 166, 172, 220, 231n61, 231n65. *See also* "Conclusion" (*The Renaissance*)
Renaissance of the Nineties (Murdoch), 5, 6, 16, 29, 62nn7–8, 318
"Renascence of Wonder, The" (Watts-Dunton), 62n8
Renaud, Jean-Joseph, "The Last Months of Oscar Wilde in Paris," 323
Republic, The (Plato), 209, 280n2
Resta, Enrico, 241
Revival of Irish Literature, The (Duffy), 301
rhyme, 7, 12, 13, 17, 191, 247, 303
Rhymers' Club: "boyish" men and, 199–200n59; collective publishing, 178, 179, 182, 188, 190, 192–4, 195–6; Decadence and, 178–9, 182, 193, 197n3; exclusion of female writers, 181, 192; feminine ennui and, 54, 193–4; femme fatale and, 192–3; founding of, 178; homoeroticism and, 194; humour and, 190–2; Irish Literary Revival and, 302; male bonding and, 190, 191–2, 194, 195; male claims to feminine traits and, 54, 180, 181, 188, 194–5, 199–200n59; minor poet status and, 53–4, 179–81, 182, 186, 190, 194, 195–6;

print and, 195; Dollie Radford and, 181, 239; woman as muse and verse and, 191–2; Yeats and, 31, 178, 192, 194, 197n3, 302; *The Yellow Book* and, 179. *See also* Le Gallienne, Richard
"Rhymes and Rhythms in Hospital" (Henley), 12
Rhys, Ernest: "At the Rhymers' Club: A Toast," 190, 192, 195; Irish Literary Revival and, 302; pan-Celtic movement and, 302; "Quatrain: Les Bourgeoises," 193, 194; Rhymers' Club and, 178
rhythm, 11, 161, 162, 164, 166, 186, 277, 303
Rhythm of Life, The (Meynell), 49, 160
"Rhythm of Life, The" (Meynell), 159, 160, 161, 164, 169, 171, 172, 173
Richard Le Gallienne (Macdonald), *52*
Richards, Grant, 53
Richardson, Anne-Marie, 75
Richardson, LeeAnne M., 237, 239, 252n3, 255n37
Ricketts, Charles, 34, 324–5, 326
Riewald, J.G., 226n3, 229n39
Ripostes (Pound), 61
Ritson, Joseph, 18
Robinson, Agnes Mary Frances, 267
Rolleston, T.W., 178, 302
Romance of a Shop, The (Levy): conclusion of, 99–100; feminine gaze in, 76, 78, 81, 96, 97–9, 103n27; *flânerie* in, 42, 73–4, 75, 76, 78, 80–1, 96–7; gender role reversal in, 73; male gaze in, 96–7, 104n44; narrative form in, 83–6, 97; New Woman literature and, 43; photography in, 75–6, 84–6, 93, 95, 96; plot of, 41–2, 73; urban experience in, 41–2, 75, 78, 80–1, 82, 103n27

THE UCLA CLARK MEMORIAL LIBRARY SERIES